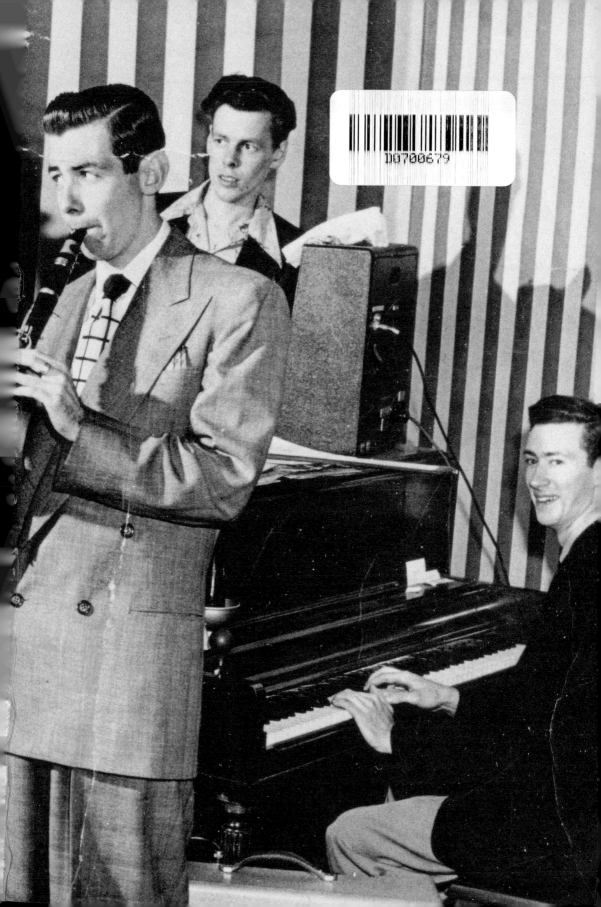

For five years, starting in 1977, Toronto painter Nancy Love painted paintings with and to and of the simultaneously played music of the CCMC.

She would set up her materials in a corner of the concert hall of the Music Gallery, at its first location, 30 St. Patrick Street, in Toronto, then spontaneously paint while the musicians spontaneously composed. CCMC played two public concerts a week during that time and Nancy Love was almost always there. The work she did then is an original contribution to the aural/visual analogies of abstract gestural art and abstract gestural music. Recorded hand dancing.

Many beautiful works were produced, developing many different approaches. This (September 29, 1981) is one of the best but should not be taken as typical, like the music to which it is related, Nancy Love's CCMC paintings are very varied.

—Michael Snow

1948-1993

Music/Sound

The Performed and Recorded
Music/Sound of Michael Snow, Solo and with Various Ensembles,
His Sound-Films and Sound Installations

Improvisation/Composition from 1948 to 1993

Edited by Michael Snow
with texts by the artist, David Lancashire, Raymond Gervais,
Bruce Elder and others

Art Gallery of Ontario │ The Power Plant
Alfred A. Knopf Canada

The Art Gallery of Ontario is funded by the peo-
ple of Ontario through the Ministry of Culture,
Tourism and Recreation. Additional operating
support is received from the Municipality of
Metropolitan Toronto, Communications Canada
and The Canada Council.

The Power Plant, Contemporary Art Gallery
at Harbourfront Centre is a registered Canadian
charitable organization supported by its member-
ship, private donations, and all levels of govern-
ment. The Power Plant gratefully acknowledges
the assistance provided by The Canada Council,
the Ontario Arts Council, the Municipality of
Metropolitan Toronto, the Toronto Arts Council,
and Harbourfront Centre.

The Michael Snow Project
Proudly sponsored by AT&T
Organized by the Art Gallery of Ontario and
The Power Plant–Contemporary Art Gallery
at Harbourfront Centre
Special funding made available by
the City of Toronto
Additional financial support from:
Museums Assistance Program of the Government
of Canada
The Exhibition Assistance Program of The
Canada Council
Government of Ontario through the Ministry of
Culture, Tourism and Recreation
City of Toronto through the Toronto Arts
Council
The Municipality of Metropolitan Toronto

Special thanks to:
Bowne of Canada, Ltd.
Canadian Filmmakers' Distribution Centre

Canadian Cataloguing in Publication Data
Main entry under title:
Music/sound : the performed and recorded
music/sound of Michael Snow
(The Michael Snow project ; 4)
Co-published by the Art Gallery of Ontario,
The Power Plant, Toronto, and Alfred A.
Knopf Canada
ISBN 0-394-28054-7

1. Snow, Michael, 1929– . 2. Jazz musicians
–Canada – Biography. 3. Artists – Canada –
Biography.
I. Snow, Michael, 1929– . II. Art Gallery of
Ontario. III. Power Plant (Art gallery). IV.
Series.
ML417.S56M88 1994 786.2'092 C94-930172-8

Cover: Detail from *Tap*, 1969.

Distributed by Random House of Canada
Limited, Toronto

Table of Contents

Music/Sound is a volume in a series of books that are part of The Michael Snow Project. Other books in the series are:

VISUAL ART
1951–1993

This catalogue of the Michael Snow retrospective contains three components entitled *Exploring Plane and Contour, Around Wavelength,* and *Embodied Vision.* In the first part, Dennis Reid, curator of Canadian Art at the Art Gallery of Ontario, examines the drawings, paintings, collages, foldages, photo-works, sculptures and films of Michael Snow from 1951 to 1967. Reid takes a comprehensive look at the development of the Walking Woman theme and investigates Snow's early paintings. Much of this examination is done by referencing the early critical writing on Snow.

The second part, written by the Art Gallery of Ontario's curator of Contemporary Art, Philip Monk, focuses on Snow's seminal work *Wavelength* and the other sculptures, films and photo-works produced in a three-year period from 1967 to 1969. Monk takes an intense look at a critical period in Snow's development. The artist has abandoned The Walking Woman and is exploring issues of seeing, issues that reference the properties of each specific media, for example, the use of the zoom shot in his film *Wavelength.*

The last section by Louise Dompierre, associate director/chief curator at The Power Plant, presents the paintings, sculptures, photo-works, sound installations, music, holographic works, films and books of Michael Snow from 1970 to 1992. Dompierre traces the development of Snow's work over the last twenty years,

exploring the artist's concern for the properties of photo-based imagery. Included also are essays by Derrick de Kerckhove, who analyzes Snow's approach to holography, and by Richard Rhodes, who examines the artist's public commissions.

Published by Alfred A. Knopf Canada / The Power Plant / Art Gallery of Ontario

THE COLLECTED WRITINGS
OF MICHAEL SNOW

This comprehensive anthology of Michael
Snow's published and previously unpub-
lished writings presents a history of a great
Canadian artist, beginning with his early
attempts at defining art and proceeding
to his emergence and recognition on the
international art scene. The texts are chrono-
logically presented, and, if they are read
in the same manner, this sequence gives
a sense of the evolution of Snow's ideas
and his career.

Since many of Snow's texts are meant
to be seen as well as read, some are repro-
duced in facsimile. Other texts were per-
formed at one time, that is, tape-recorded
in advance and then lip-synced or mimed
by the artist, rather than simply read, when
they were first performed. Also featured are
texts printed on Snow's record album covers
that are meant to be read while listening
to his music. In addition to these less tradi-
tional forms, the book contains more typical
essays, articles and interviews. Snow writes
on the work of other artists as well.

Collected Writings acts both as a record of
contemporary artistic thought by one of
our leading Canadian artists and as a history
book revealing important moments in the
cultural life of this country since the Fifties.

Published by Wilfrid Laurier University
Press/The Power Plant/Art Gallery of
Ontario

PRESENCE AND ABSENCE
The Films of Michael Snow
1956-1991

Edited by Jim Shedden, with contributions
by Jonas Mekas, Annette Michelson, Bart
Testa, Bruce Elder, Kathryn Elder and
Steve Reich

Snow's filmmaking, widely considered
among the most important in the history
of the avant-garde, overarches the duration
of his career. Film is, perhaps, the medium
where the sum of Snow's aesthetic con-
cerns is witnessed: i.e., the nature of time,
representation, consciousness, construction,
language and transcendence. This book
constitutes the most complete resource
guide on Snow's filmmaking activity, com-
bining a career overview with critical essays,
anecdotal items, bibliography, filmography,
film and video-related projects and a
chronology.

Forthcoming title, to be published in 1994

Michael Snow—piano, Alf Jones-trombone, Terry Forster—bass and Larry Dubin-drums at the House of Hambourg, an important "after-hours" Jazz club, filmed in *Toronto Jazz* — directed by Don Owen and produced by the National Film Board in 1962.

Mmusic/Ssound

A much more than 4 bar intro by Michael Snow

This bboook will attempt. This book is. Somehow. Tentative (French). Allegro (Italian). Rubato (Tomato). Sometime (4/4) in 1961 I (Michael Snow) standing on the corner of Davenport and ? Street at 6 am with Larry Dubin (further references to him in this booook), stoned. We'd played at the Westover Hotel with Mike White's Band from 9 to 12, then went to what we called a "session" ("jam" was understood) where we and other visitors both known and unknown to us, played medium tempo blues in F, for at least four hours (Quartet?). Chorus after chorus played by "who-the-hell-is-that?" on tenor sax with the rhythm section (Larry/drums, unknown/bass and me/piano) and then just when I thought I'd have a chance to solo "who's-that?" on alto sax (P.J. Perry?) started. Chorus after chorus I "comped", Larry swung.

For some reason I'm writing from a mind-photo taken of us from above (Heaven? Larry's dead) (I'm alive) saying "Yeah and man he blah blah man ... and then man I blah blah ..." on that street corner, tired but excited, seeing the day arrive, about to go home to sleep ('til noon, soon). Maybe later, after-noon I'd get to my studio on Yonge Street, almost opposite to where ("now") Sam's Record Store "is" and paint.

This book owes its existence to Louise Dompierre, Dennis Reid, Philip Monk, the Art Gallery of Ontario, The Power Plant Gallery, Bruce Mau and:

First I bought "Our Serge-ant Major" by George Form-by. Very funny. Next a Duke Ellington album on Victor. Very weird but I liked it. Boogie Woogie, Blues. Started to play piano. Jimmy Yancey! Cripple Clarence Lofton, Montana Taylor, Speckled Red, Wesley Wallace, Meade Lux Lewis. Learned some of Yancey's pieces, played at parties at Yancey's in Chicago. He, impressed, said he'd teach me more. Louis Armstrong; Jelly Roll Morton, Kid Ory, Johnny Dodds, New Orleans

Wanderer, New Orleans Boot-
blacks, Jelly Roll. Bessie
Smith, Wanda Landowska's
J.S. Bach's Goldberg Varia-
tions, Earl Hines, James P.
Johnson, The Lion, Art
Hodes, Tut Soper, Bud Jaco-
bson, Pee Wee Russell (made
unissued record with him),
Bix Beiderbecke, Edmond
Hall, Vic Dickenson, Span-
ier, Wingy Mannone (worked
in Detroit with him), Bela
Bartok, Berg, Webern, Bunk
Johnson, George Lewis, Jim
Robinson, Baby Dodds, Kid
Howard, Thelonious Monk,
Ken Dean, Don Priestman,
Roy Glandfield, Ron Sulli-
van, Bud Hill, Bob Hack-
born, Lyle Glover, Clyde
Clark, Club Mediterranee,
La Rose Noire, Dave Lanca-
shire, Sidney Bechet, Miles
Davis, Charley Parker, Fats
Navarro, Bud Powell, Duke
Jordan, Max Roach, Dizzy
Art Tatum, Billie Holiday
Duke Ellington! Lawrence
Brown, Cootie Williams,
Rex Stewart, Johny Hodges,
Ben Webster, Coleman Haw-
kins, Lester Young, Sonny
Rollins, Art Blakey, Clif-
ford Brown, Red Garland,
John Coltrane, Ravi Shank-
ar, Jimmy Rushing, Mike
White, Alf Jones, Ian Arno-
tt, Larry Dubin, Ernie Os-
sachuck, Ian Henstridge,
Terry Forster, Mo Prior, My
Mother, Debussy, Mozart, J.
S. Bach, Rameau, Scarlatti,
Vivaldi, Gagaku, Cecil Tay-
lor, Charley Mingus, Ornet-
te Coleman, Don Cherry,
Steve Lacy, Haydn, The
Beatles, The Rolling Ston-
es, Kenny Davern, Archie
Shepp, Roswell Rudd, Albert
Ayler, John Tchicai, Sonny
Murray, Paul Bley, Carla
Bley, Gary Peacock, Henry
Grimes, Milford Graves,
Mike Mantler, Lamont Young,
Steve Reich, Phil Glass,
Bob Dylan, Glen Gould, Ash-
kenazy, Messiaen, John Cage
Udo Kasemets, Xenakis, Bo
Diddly, B.B. King, Otis
Redding, James Brown, The
Supremes, Dino Lipati,
Frederic Chopin, Ravel,
Paul Haines, Joyce Wieland,
Doug Pringle, Stu Broomer,
Harvey Brodhecker, Jim
Falconbridge, Cape Breton
music, Jean Carignan,
Orchestre Perron, Isadore
Soucy, Perotin, Neil Young,
Gustav Leonhardts', J. S.
Bach's Goldberg Variations,
Beethoven, Torelli, Giovan-
ni Gesualdo, Stravinsky,
Gerry McAdam, Gord Rayner,
Jimmy Jones, Nobby Kubota,
Harvey Cowan, Graham Cough-
try, Bob Markle.

That list was written as my contribution to the "notes" for the two LP record album called *The Artists' Jazz Band* issued by the Isaacs Gallery in 1973. All the players were asked to write something to be printed on the jacket. Mine was the here-reproduced attempt to say "thank you" to the many musicians whose music I've been affected by. Bringing that up to date would make it a very long list indeed, but that is one of the things this book attempts to do and in the process (January 1993) also calls for another, this time, very sad listing.

My opening anecdote mentioned Larry Dubin, a great percussionist who died in 1978. Since then, Alf Jones/trombone and Terry Forster/bass have died. During the 1992 phase of assembling this book I was saddened to hear of the death of Mike White, trumpet player and leader of the remarkable band with whom all of the above including me (still writing!) played.

Painter/saxophonist Bob Markle of the Artists' Jazz Band died in 1991 in a road accident and at the end of 1992 came the shocking news of Greg Curnoe's demise in a highway accident. Curnoe was a marvellous visual artist but was also one of the founder performers in an extraordinary group the Nihilist Spasm Band (in London, Ontario) with whom I had the pleasure to perform on several occasions. Curnoe played drums and kazoo.

I am grateful and honoured to have been granted the pleasure of assembling this book. By some cosmic throw of the dice it's not being guided or directed by one of the names on the list, but by *me*.

Music at all times has a social function (of course it does have its solitary side, too) so I was very anxious to make this book ensemble playing. It's true that I'm the leader of the band and that I called the tunes but the players have all responded beautifully and generously on their own instruments and in their own voices. Thank you Dave Lancashire, Raymond Gervais, Bruce Elder, Paul Dutton, John Kamevaar and other past and present members of the CCMC.

Anecdotes can be of some generic interest but given the expectation that ninety-nine percent of the readers of this book will have had no direct listening experience of the music being discussed, I've tried to allow the musicological/socio/aes-

thetic/philosophical aspects to take some solos.

Many readers' absence of contact with "improvised music" is in part due to both the nature of the music business and "classical" demands for *products*. Here I would like to interest the reader in the important, indeed still revolutionary factors (to me and many other musicians) involved in a purely extemporaneous music.

Except for your own inner voice this is all silent text — there is no music here, so I hope the reader will attempt to obtain some of the available recordings under discussion, or to attend concerts to hear for her/himself those sounds the writers of the texts herein hear. Hear hear!

Bruce Elder's text is an important categorization of my music/sound efforts, but I would like initially to direct the reader (this *is* the introduction) by the following sono-biography....

In the beginning (begun by Dave Lancashire in his "Blues in the Clock Tower") Mr. Snow played "Traditional" Jazz. He was mostly affected by the Jazz forms up to the "Swing" era. Later he became more involved in "Modern" Jazz or Bebop (influenced by Thelonious Monk, Charley Parker, Miles Davis, et al). At the "session" described in the opening paragraph of this essay he was somewhat nervous because these were "Modern" events and the Bebop musicians tended to be dismissive of the "moldy fig" music he'd been mostly associated with.

Back to the first person (Adam?): a very few months after I'd asked Dave Lancashire if he would write about our paleolithic period, I was contacted by Jack Litchfield who, I was astonished to hear, was writing a book about the same musical events. As a teenager he had discovered the concerts and dances of the new Jazz Bands of which I was a member (usually led by trumpeter Ken Dean) and others with whom we shared a messianic spirit, and often personnel. Of these, the Queen City Jazz Band, led by pianist Clyde Clark, was the most important.

Jack Litchfield had been so excited by the music that he kept a diary where he noted not only dates and locations but what tunes were played and which musicians played solos etcetera.

I was amazed and moved by this. Jack published his book *Toronto Jazz 1948-*

TORONTO JAZZ
1948-1950

by
Jack Litchfield

1950 in 1992 and much of its information and many photographs from it are included here. His *Canadian Jazz Discography* was previously published by the University of Toronto Press.

The earliest manifestations of the "messianic spirit" of our small group of converts were two attempts to present publicly some of the rare recorded music we were so crazy about. Jack Litchfield was present at the first of these and wrote about it:

```
My first introduction to the jazz fraternity in Toronto came on
Thursday, March 6, 1947, when the Jazz Society of Toronto held a concert of
recorded jazz, and invited the general public.  They presented a
well-balanced program of twenty-eight records covering the dixieland, New
Orleans, blues, Chicago, and revival schools of jazz.  Although I had been
collecting records for five years, the variety of styles came as a revelation
to me.  I can still remember sitting on those wood chairs before the meeting
began, reading the handbill, and wondering what NORK and ODJB meant!
```

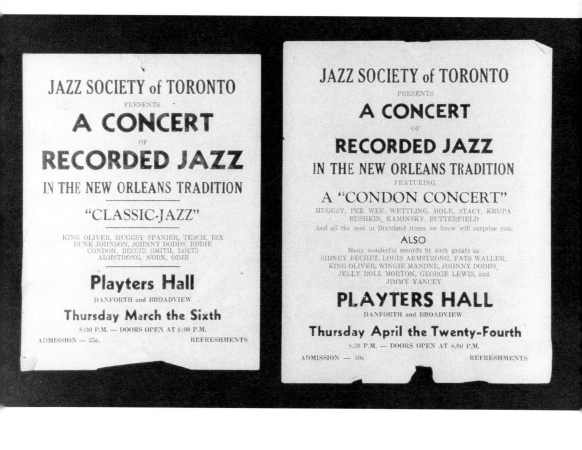

The script, which I typed badly and (as badly?) read at the first of these events, still exists. Here it is:

theme.

Intro.

I. the first on the program tonight i s weary blues by the armstrongs hot seven which consisted of the hot fives personnel plus peter briggs tuba,and baby dodds drums.outstanding here is louis fine chorus and johnny dodds excellent low register solo.

WEARY BLUES

2. one of the newer bands that shows great promise is the pacific jazzband which has red gillham cornet,jack crock clar.,jack buck, tromb.,russ bennett,guitar,ray jahnigan piano.,pat patton bass, gord edwards drums.they whale into red wing.

RED WING

3. jelly roll morton has long been one of our favourites and the addition of the dodds brothers enhances this record even more.incidently morton composed this tune in honour of a barber friend of his whose shop was called the wolverine here is

WOLVERINE BLUES.
4. pretty doll by condons band was the basis of the recordugly chile recorded by brunies.george thought eddies version was too tender but well leave that up to you.noticable in the band is fats waller under the psued of maurice who shows his fine ability for ensemble playing.on the record we here also marty marsala,pee wee,brunies,wettling,condon,fats,and al morgan.
PRETTY DOLL.
5. high in the list of famous blues singers is bertha chippie hill.though she lacked the greatness of bessie,nevertheless she had a powerful voice capable of swinging and greate rhythm and conveying great conveying great falling she can be heard now backed louis and richard m jones singing that fine old blues
TROUBLE IN MIND.
6. among the most widley liked jazzmen are edmond hall and sid deparis who was present at torontos first jazz concert. accompanied by vic dickenson,james p johnson,sid cattlett a shirley,and john simmons the boys play
EVERY BODY LOVES MY BABY.
7. probably the greatest master of the boogie blues style is jimmy yancey whos imagination and infallible sense of rhythm mark him as one of the greatest.he can be heard now playinghis own composition jimmys stuff which incidently is his first recorded solo ,done in 1939 for Dan Qualeys solo-art label, now extinct. Jimmys stuff
8. one of the most colourful characters in jazz today is wingy manone,. If you want to get the complete lowdown on wingy just wait for wingys own volume coming out sometime this year its enticingly entitled "trumpet on the wing " and itll prob-ably nose out mezzs really the blues for jive talk.wingy and kay starr sing vocals on this and are backed talk by a good band whose personnel we are uncertain of but our guesses are

16

The changes in Jazz language (which maintained a certain consistency through Dixieland Jazz to its next historical phase, namely "Swing") brought on by the great Bebop musicians Dizzy Gillespie, Charley Parker, Bud Powell, Thelonious Monk and many others were radical when they happened, and, seemed to me, at first, to threaten the qualities of the music in a dangerous way. What they did do was, of course, absorbed eventually and the issues that were being struggled over, dissolved into the ongoing stream of the music.

The use of not only the tune being played but its underlying chord sequence from which to derive variations, was a feature of all Jazz from the beginning (and I don't mean Toronto 1948!). This usage reached a crescendo with Bebop's more sophisticated harmonic knowledge but then was totally blown away by Ornette Coleman's linear approach and Cecil Taylor's pan-harmonic free phrasing. Miles Davis and John Coltrane's modal phase had the same effect but less emphatically.

My experience of these now vanished issues involving the arrival of Bebop was a profound one. Even though a discussion of the details can no longer be generative (perhaps I'm wrong – many young musicians play from "changes") I believe that discussions of what happens when one undergoes changes of values and revises and reconsiders previously strongly held beliefs can be something of value forever(!). Hence I've attempted in assembling the material in this book to move from descriptions of the particularities of these "revolutions" to the philosophy and psychology of them.

As well as trying to make an introductory auto-categorization of my music/sound activities here, I will discuss certain musical events and issues not mentioned in the other texts but which I believe to be important to the composition as a whole.

The reader will note this volume's distinct and dynamic design style. I am responsible for the conception but in practice the beautiful design/layout is by Bruce Mau. Since the subject itself is a "collage" of my extremely varied work with sound, much of it is history or reminiscence and because "records" or "recording" (in both their general usage and specifically music usage) are an important part of its story, it seemed appropriate to use many varied typefaces and lots of facsimile memorabilia

ASK ME NOW

G-7 C7 F#-7 B7 | F-7 Bb7 E-7 A7 |

Eb-7 Ab7 | F7 Bb b9 | Eb⁷ D7 |

Db maj B b7 | Eb7 Ab7 | B7 Bb7 A Ab7 |

repeat

bridge

Eb-7 Ab | Db maj Bb-7 | Eb-7 D7 | Dmaj |

²Db maj | Bb-7 | Eb7 | Eb-7 Ab7 | C7#9

repeat first 𝄋

in the form of xeroxes and photographs.

Some parts of the score will have you reaching for a magnifying glass. Please consider this the equivalent of reaching for the volume button: the text is quiet and needs amplification. Difficult scores sometimes require many rehearsals. But please, don't turn down *this* volume!

Visually, there's occasionally "distortion", some "bent notes", "blue notes", "growls", "wa wa", "static", "white noise" ... sometimes (3/4) the images of faded relics are "muted." "Tempo" is involved, and "transposing."

The design style is particularly relevant to the music of the CCMC, which could be described as a sound "collage" style, drawing on all possible sound sources.

Yes, the look of the book is intended to mirror (or echo) the importance of recording, of recorded music to its narrative. Without the 1920s recordings of Early Jazz, the Toronto bands of 1948 with which I played, would have had no model, no school. The importance of the various means of making permanent the evanescent moment is infused in the reproductive means of this object. We've attempted a synaesthetic.

Change of theme: the performer or composer categorization bears some relevance. I continue to be a performing musician. I played and play piano first and foremost. I started to play trumpet in the Fifties but played it most with the CCMC beginning in 1972. I also played other keyboard instruments with the CCMC (electric piano and synthesizer) in addition to flugelhorn, guitar and percussion.

Beginning in 1948 I composed a few Jazz tunes. All the pieces on my 1973 Chatham Square label LP were composed by myself, as were all the pieces on my more recent, 1987 *The Last LP*, issued by Art Metropole. *Two Radio Solos*, a cassette issued in 1989 by a Toronto company called Freedom in a Vacuum is "improvised" shortwave radio playing, not (strictly speaking) composition, but the more recent 1990 CD *Sinoms*, issued first by the Musée du Québec and now by Art Metropole, *is* composition.

The improvised music I've been involved with might more accurately be described as the product of "spontaneous composition", an issue discussed in detail in this book, particularly in "History of the CCMC and of Improvised Music".

Chord changes for "Ask Me Now" by Thelonious Monk
in Michael Snow's *Book of Changes*. Probably 1962.

Mr. Snow has played many solo piano concerts. One of the most successful was in a series of piano recitals called *The Tradition of Innovation* at the Music Gallery in 1987.

Mr. Snow had the honour of sharing the night with a wonderful pianist and "performance artist", Elyakim Taussig. An interesting review written by Robert Everett-Green appeared in *The Globe and Mail* newspaper. Mr. Snow has also done some piano duet concerts with a fine young pianist, Bob Wiseman.

Change of medium: SOUND-TRACKS for all my fifteen films have been totally under my control and direction. Creatively working with sound/image relationships has been an important area of my film work.

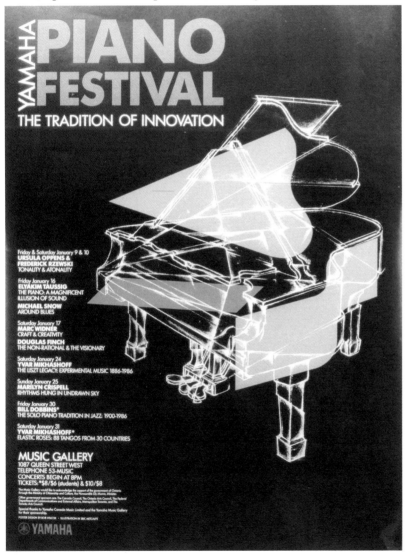

Taussig and Snow give pianos novel workouts

BY ROBERT EVERETT-GREEN
Special to The Globe and Mail

Never trust a pianist who wears red socks with his tails. This was the lesson to be learned at Elyakim Taussig's program at the Music Gallery Friday evening.

Taussig's The Piano: A Magnificent Illusion of Sound, made up the first part of a double bill in the Music Gallery's Yamaha Piano Festival series.

The socks were the first sign that this sober title did not quite jibe with the spirit of Taussig's witty presentation, which included tricks with video monitors, simultaneous performances with record players, and a singing coffee endorsement.

The pianist began with a silent performance of Liszt's Liebestraum, moving his hands in sinc with two video representations of hands actually playing the piece. A headset kept Taussig — but not the audience — in step with the monitors' audio track. In effect, three performances seemed to be going on simultaneously, and yet no sound of any could be heard.

It seemed at first like a fairly simple gag. Instead of being allowed to soak in a warm bath of romantic reverie, we were given the cold tea of watching Taussig exercise the body English of an Enraptured Pianist. Instead of music, we got theatre — which, of course, is part of what Liszt was up to when he invented the romantic code of keyboard etiquette.

But the joke became more complex — and more serious — with the addition of the video monitors, which gave us more than one thing to look at. True, it was all Taussig playing the Liebestraum — but divided between a living presence and a represented one. In this age of television, Taussig seemed to say, which has the greater authority?

That question, which every listener answered according to what he spent more time looking at, was one of the leitmotifs of Taussig's games. It was more bluntly stated when he launched into a live performance of Chopin's Fantasie Impromptu, while on-stage turntables played the recorded versions of four other pianists simultaneously. The result was a ludicrous battle for the listener's ear.

Again, the joke had its complexities, this time involving philosophical baggage inherited from the nineteenth century. The romantic ideal of the performer-genius (typified by Chopin) implies a unique inspiration, private audience with the Muse. And yet for anyone to perform Chopin's Fantasie Impromptu, he must play the same notes as everyone else, and follow the outline of the generic Fantasie held in the mind of every listener. Put everyone's performances (or even five of them) together, and uniqueness is replaced by a comical but true representation of what this generic Fantasie would sound like.

The uniqueness of the repeatable again came up in a heavily-edited video clip showing Taussig beginning and rebeginning a lecture on the subject. Both here and in the Chopin caper, Taussig seemed to be implying that it is, above all, technology that makes the old notion of the unique event questionable, or even ridiculous.

It's no small feat to take these kinds of open-ended ideas and weave them into a hilarious show, and yet that is what Taussig has done. Not that everything in Friday's concert had a didactic payoff: Taussig's performance of Scriabin's Nocturne for the Left Hand, while his right wielded a chicken leg and cigar, seemed to have no other purpose than to draw a good laugh (which it did).

Perhaps because of the amount of stage-business he had to keep in mind, some of his "straight" performances were not up to his usual high standard. It must be difficult to give a socko rendition of the Liszt transcription of Beethoven's Fifth

Elyakim Taussig: red socks.

Michael Snow: another art.

Symphony (first movement) when, a dozen bars from the end, you must slap a wig on your head and sing a little ditty in praise of Old Vienna Coffee.

The program's best moment was an inspired skit on curtain calls that followed the Beethoven. Taussig jumped up from the piano bench, bowed to the applause, and walked out. Meanwhile an assistant had switched on an applause track, which continued after the clapping in the hall had ended. Taussig returned, acknowledging the recorded acclaim, which triggered more applause in the hall. Again and again he came back, and each time the audience in the hall applauded, first out of conventional courtesy,

then in recognition of the joke. Finally the whole absurd situation took on a kind of self-propelling energy that few professional comics know how to provoke.

Yet Taussig is not a professional comic, but a serious concert pianist. At least some of the time.

•

Michael Snow's recognition as a visual artist seems to have pretty much blotted out discussion of his abilities as a pianist. This may be part of the price of becoming a star. Becoming celebrated for one kind of activity means that serious efforts in another may be taken as a sign of dilettantism.

Perhaps it was for that reason that Snow felt obliged, in the program notes for his part of Friday's Music Gallery concert, to give an exhaustive account of his musical activity, which spans 40 years. He needn't have bothered. His performance was proof enough that the man is a pianist graced with great style and invention.

He also has terrific chops, to judge from some of the virtuosio breaks of his 50-minute improvisation, Around Blues. The set was a homage to the form and tradition of the blues, and featured many souvenirs of pianists Snow admires Jimmy Yancey and Jelly Roll Morton, among others.

Around Blues was built around a quirky chorale, played at the outset with glancing chordal blows in the right hand while the left held down the keys of sympathetically resonant strings. Variations on this eerie figure came back again and again, between episodes of smoky blues and sideways vamping actions.

This engrossing set had lots of nervous edge, a quality that is probably as much a function of temperament as of stylistic choice. Snow is not a naturally loose player, which makes his blues sound a bit tightly wrapped at times, in spite of his excellent rhythmic sense. Still, there was a tremendous drive to many of the purely improvised sections.

Around Blues was taped by the CBC, and will be broadcast on a future edition of Two New Hours, the new-music program of the FM service.

The recognition of recording (phonography) as an aspect that must be considered entered my work with the 1963 film *New York Eye and Ear Control* and is equally important in the aesthetics of all the LPs, cassettes and CDs that have appeared under my name. The many CCMC recordings are "documentary" ones.

In 1967 at Expo in Montreal I presented a work at the Youth Pavilion titled *Sense Solo*. This consisted of twelve separate reel-to-reel tapes I had recorded from all kinds of recorded sources (and some Found on the site). These were played simultaneously from twelve different giant loudspeakers in the large round auditorium space, loud and in total darkness. One could move about in this sound environment and of course it changed, but from one vantage point it was also continually variable, a torrent of sound. In the darkness a band (with which I'd played the previous summer at a coffee house on Yorkville Avenue in Toronto) assembled itself in the centre of the circular space. The musicians included some of the earliest "free" players in Toronto: pianist Stu Broomer, saxophonist Jim Falconbridge, trombonist Harvey Brodhecker and drummer Ron Sullivan, whom I knew from my Dixieland days. (He plays trombone and trumpet, too.) The band gradually added live acoustic on-the-spot music to the recorded music being played through the loudspeakers until the tapes, all of unequal length, gradually ran out and the sound, which at first had been only emanating from the speakers on the periphery of the auditorium, ended up being "live" and coming from the centre. When I did this work I was unaware of John Cage's conceptually similar pieces that pre-date *Sense Solo* by several years.

This was a radical work from which I learned a lot. There was an audience of some thirty to forty people; any survivors, please get in touch with me — I'd like to know what you remember/thought/think of it.

Background to the aesthetics of this work: in 1965 through 1967 there was a great deal of impressive work in the "multi-media" or "mixed-media" form. These were attempts at "synaesthesia" in the Wagnerian tradition of a "total Art" aimed at affecting most or all of the senses.

Despite the strength of much of this work that I saw (mostly in New York, where

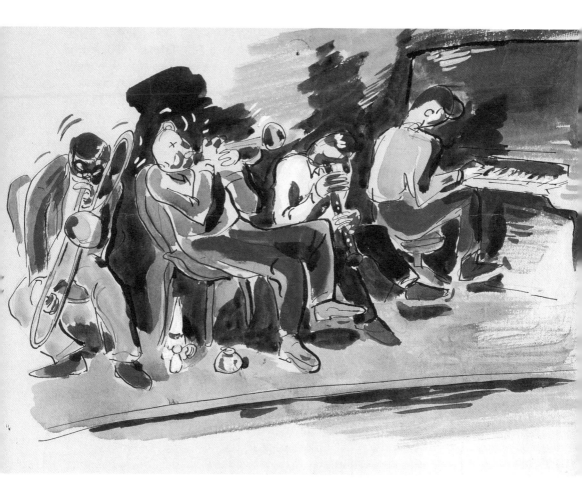

Watercolour painting by Michael Snow of four members of Ken Dean's Jazz Band, 1949. Left to right: Roy Glandfield–trombone, Ken Dean–trumpet, Don Priestman–clarinet and Michael Snow–piano.

I lived from 1962 to sort of 1972) I felt the situation clarified *my* belief in concentrated focus, so *Sense Solo* was aimed primarily at the ears. I first presented a sound installation work called *Hearing Aid* at The Kitchen in New York in 1976 (subsequently shown in numerous other locations). This is a sculptural work, not a "concert" work, and it is discussed in the Elder/Snow text "On Sound, Sound Recording..." in this booooook.

As part of the holographic/sculptural installation/exhibition *The Spectral Image*, which I designed (at Expo '86 in Vancouver), I made a sound component that formed a quiet chord which filled the huge (fifty-five by twenty metres) exhibition building. As one walked into the space this quiet but huge chord revealed its individual pitches. The first notes were the highest, descending in thirds to the lowest at the far end of the building. The source of the sound was in sixteen loudspeakers placed high on the beams of the building. Each speaker played a single sine wave tone. The electronics for this work were devised by Norman White.

I used the elements of this work to make a new sound environment installation *Diagonale*, which was exhibited at the gallery of the wonderful organization Obscure in Quebec City. For many years they have been doing adventurous exhibitions, mixed media installations, video and film showings and concerts. I have played two solo piano concerts under their auspices and a duet concert with Nobuo Kubota. All the mixing for my CD *Sinoms* was done with musician/engineer Jocelyn Robert in the studios of Obscure. They also have a fine "new music" group Bruit-t-tv, which has played at, as well as many other places, the Music Gallery in Toronto.

Back on track (sound): an important work for the evolution of my sound and image concerns was the thirty-five minute black-and-white film titled *New York Eye and Ear Control*, finished in 1964. I had begun to realize that the coexistence of moving pictures and sound had barely been investigated. By and large movie sound is atmospheric (mood music) and synchronous (reinforcing the "willing suspension of disbelief" necessary to the "realism" of narrative film). Lots more can be done.

Reproduced here is a page from the catalogue of the New York Film-makers Co-op, an important distributor of "Experimental" films, formed in the early Sixties

by Jonas Mekas and others. The text about ... *Eye and Ear Control* is by Richard Foreman, a great playwright, whose plays staged in New York in the Sixties and Seventies remain in my memory as the most powerful and original theatre I have ever experienced. He was a frequent attender of screenings of Experimental films and was present at the first tumultuous screening in New York of ... *Eye and Ear* ... at the Lafayette Street Theatre/Film-makers Cinemateque in 1964.

● SNOW, Michael:

"All that survives entire of an epoch is its typical art form. For instance: painting (in all its enormity) comes to us intact from the New Stone Age.

"Film is surely the typical art of our time, whatever time that is. If the Lumieres are Lascaux, then we are, now, in the Early Historical Period of film. It is a time of invention.

"One of little more than a dozen living inventors of film art is Michael Snow. His work has already modified our perception of past film. Seen or unseen, it will affect the making & understanding of film in the future.

"This is an astonishing situation. It is like knowing the name and address of the man who carved the Sphinx."—Hollis Frampton

A TO Z (1956) 16mm. 6½ min. Blue and White. Silent (16FPS.). Rental: $10.00

"A cross-hatched animated fantasy about nocturnal furniture love. Two chairs fuck."—M.S.

NEW YORK EYE AND EAR CONTROL (A WALKING WOMAN WORK) (1964) 16mm. 34 min. Rental: $40.00

"One of the major achievements of the sixties. Mike Snow postulates an eye that stares at surfaces with such intensity ... the image itself seems to quiver, finally gives way under the pressure. A deceptive beginning—silent: a flat white form sharply cut to the silhouette of a walking woman, for no apparent reason propped against trees, rocks, seashore. But slowly—under attack by time, light, and an incredible growing music so aggressive it begins to bypass the ear and attack the eye's habits of seeing. Each time a cut wipes away this absurd idiogram-woman, she reappears—supported against the threat of the destructive eye by the S-O-U-N-D!—that insists on building a space in which objects can sustain themselves. The spontaneous generation of human beings—(glimpsed once before as an omen—a thin musician goes from car into house in a single abrupt shot that through its matter-of-factness is more—an oracle). Beautiful women match their profiles against the silhouette, which has now gone through fire (a black dream) and remains as only an empty window of a shape. Impossible to tell—is the thrill we feel now a responding (amidst the noise) to the super-lucidity of the image of girls (wives and mistresses) matching themselves against an archetype that is now only a cut-out emptiness? Or do we sense that these images of profile just failing to hug profile introduce something erotic, but not yet named ... More human images, love making—a HUMAN epic now still ruled by the after image of the "WALKING WOMAN". As in no other film yet seen, its alternately soft and granite images lift us toward the year 2000; capturing not events, not objects, but again and again registering a "placement" of consciousness—the subject matter of the future, really. Human energy on film. Gently shifting control of the montage from the head (the wit, the unconscious) down to the solar plexus, where it learns to breathe, spontaneously and deeply."—Richard Foreman.

"This film contains illusions of distances, durations, degrees, divisions of antipathies, polarities, likenesses, complements, desires. Acceleration of absence to presence. Scales of "Art"—"Life", setting-subject, mind-body, country-city pivot. Simultaneous silence and sound, one and all. Arc of excitement, night to daylight. Side, side then back then front. "Imagined" and "Real". Gradual, racial, philosophical kiss.

"Conceived, shot and edited by myself in 1964. I selected the group of musicians: Albert Ayler, Don Cherry, John Tchicai, Roswell Rudd, Gary Peacock, Sonny Murray. It is one of the greatest "jazz" groups ever. The music used on the soundtrack and other takes from the recording sessions have recently (1966) been issued on record (ESP-DISK' 1016). Paul Haines wrote the prologue which appears in the film. Walking Woman Works (1960-67). The Eternal. The Spectrum. The Glissando. The Alarm Clock. Black and White. Thirty-four Minutes. Forty Dollars."—M.S.

The film brought together previously separated areas of interest: Jazz and photography/film.

I and my then wife Joyce Wieland moved to New York in 1962. I'd just commenced what was to be a long project, the *Walking Woman Works* (1961-67) and was in the process of trying to stop playing music (this was a new stage of an ongoing argument with myself about concentrating on one medium). I continued to have this argument for years. Still have it, though not as intensely as in the early Sixties.

However, partly by finding a loft (rented from a fine bass player, Steve Swallow) next door to another loft lived in by an extraordinary poet (in many media) Paul Haines, who was a Jazz afficionado who heard everything and knew everybody AND by living across the street from Roswell Rudd who'd had the same schooling as myself in Traditional Jazz but was the most fantastic new Free trombonist (bringing the flexible growls and trombonistic slurs of Vic Dickenson and Tricky Sam Nanton back into Jazz in a *new* way that opposed the precision of the then dominant J.J. Johnson), I found myself in the middle of a confusing and excitingly creative stage of the development of "Jazz".

Since there were few places to play publicly and the musicians were often looked down on by the general Jazz audience, I made my studio available for rehearsals/sessions to Paul Bley, Carla Bley (the Jazz Composers Orchestra started there), Archie Shepp, Roswell Rudd, Milford Graves, Cecil Taylor and many others. Thus mine was a privileged hearing of some marvellous searching. Generally I did not play at these events.

Standard Time (1967), an eight minute film, used "played" radio sound as did a section of the 1974 film *Rameau's Nephew...* (four and a half hours in length) and the two pieces on *Two Radio Solos*, a cassette issued in 1988 of music made in 1982. "Playing the Radio," a text discussing the history and issues involved in the use of radio sound appears in my *Collected Writings*.

Wavelength (1967) used a forty minute continuous electronic glissando against and with sync sound of traffic, speech, breaking glass and played-on-the-set radio.

Electronic sound was not easily available in 1966. I'd decided I wanted to record

a long glissando and thought of using a trombone or a stringed instrument and taping at different speeds, but asking questions led me to Ted Wolff who worked, I think, at Bell Labs in New Jersey, and he solved this problem by making the sound with a sine wave generator. The glissando starts low (fifty cycles) and rises over forty minutes to above the recording capabilities of optical sound.

Back and Forth (1968-69), fifty-three minutes, has an image that at first pans left to right and right to left continuously at various speeds, then later up and down. During the pans the sound is that of a machine and there's a percussive "clack" at each end of the panning image. The machine sound varies with the speed of panning so what we have here is sound in sync with the movement of the entire picture and not with something depicted *in* it. Certain spoken sounds are used also with the speaker visible on screen but this sound is submerged in the louder one of the machine.

Wavelength and *Back and Forth* are discussed at greater length in both my *Collected Writings* and *Presence and Absence*, edited by Jim Shedden in this Art Gallery of Ontario/The Power Plant set of books.

Sometime in 1968 I started paying attention to a leaking faucet in the sink in our loft at 123 Chambers Street in New York. It was fascinating. I'd get stoned and listen. Rhythmically and tonally there was wonderful and mysterious variety. I made a tape recording of it to "magnify" and analyze its mysterious irregularity for a larger pattern and just to generally enjoy a record of it. Composer Mike Sahl had a program on WBAI and played this tape. Beautiful radio!

Joyce Wieland suggested that we make a film of it, so we arranged the scene together and shot it. It's the same sink in which my hands tap in *Rameau's Nephew...* but in this film, *Dripping Water,* we used some of my original tape set against the picture so that the sound in the sink is *not* in sync, although often it seems to be. Irregulars set against irregulars sometimes phase together. Jonas Mekas wrote about it in the *New York Times* (August 1969).

DRIPPING WATER (1969). Made with Joyce Wieland. 10½ min. Colour. Sound.

"You see nothing but a white, crystal white plate, and water dropping
into the plate, from the ceiling, from high, and you hear the sound
of the water dripping. The film is ten minutes long. I can image only
St. Francis looking at a water plate and water dripping so lovingly,
so respectfully, so serenely. The usual reaction is: 'Oh what is it
anyhow? Just a plate of water dripping.' But that is a snob remark.
That remark has no love for the world, for anything. Snow and Wieland's
film uplifts the object, and leaves the viewer with a finer attitude toward
the world around him; it opens his eyes to the phenomenal world. And
how can you love people if you don't love water, stone, grass."
-- Jonas Mekas

The sound for *La Région Centrale* is all electronic. Beeps (or "pulses" or "beats") occur at five different pitches and various speeds in synchronous relation to the different speeds and directions of the image (a mountainous landscape) in continuous motion. A development of the implications of *Back and Forth*, the movement of the camera here was much more complicated, being all spherical, elliptical or curved motions made possible by the invention of a machine to move the camera that was conceived of by myself and designed and built by Pierre Abbeloos of Montreal. *La Région Centrale* is three hours long and was shot in 1970.

Side Seat Paintings Slides Sound Film (1970, twenty minutes) is a filming (from a fixed position) of the projection of slides of my paintings from 1953 to 1963. The carousel slide projector was set at automatic, fifteen seconds per slide. The Arriflex single system camera was tripod-set at an angle to the screen (a "Side Seat"). The particular 16mm camera used film with a magnetic sound stripe on it and had a variable speed motor. While the fixed-period real time slide projection was being made, the shooting speed was gradually changed in an arc, gradually gaining speed at first, then slowing (above and below the twenty-four frames per second). When played back (at twenty-four) the sound slowly went lower and slower, then higher and faster, then back again and the image went darker, then brighter. The sound was my voice identifying each painting (very difficult to see for various constantly changing reasons) by title, year, medium and size. This is a sync sound temporal poetry stretching.

Sometime after making *Back and Forth* I had the idea to perhaps make a theatre piece, a play in which the entire set (a room) would be moved back and forth, the reverse of the camera's back and forth motion in the film. The idea was actually used in the first section of a film I finished in 1982 titled *Presents*, ninety minutes in length. With the camera stationary, the set — an apartment designed and constructed by myself — moves back and forth and also dollies forward in lurches and then tilts, all movements made by the subject, not the camera. During these movements many objects on the set react by swinging, shuddering, or falling. An actress puts on an LP record of Janos Starker playing the Bach solo cello suites. Actually

Table-top sequence from *Rameau's Nephew by Diderot (Thanx to Dennis Young) by Wilma Schoen*, by Michael Snow, 1972.

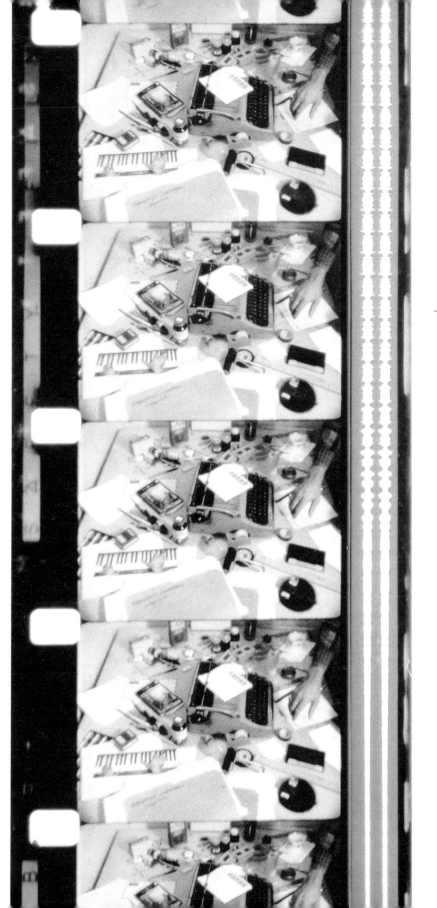

playing on the set the needle skips and jitters with the movement, sliding across the record at the end and reversal of direction of the "panning" moves. It's a beautiful sync sound situation. Even the action of bow across cello, though not seen, is perhaps subconsciously known by the viewer/auditor and is appropriate to the actual image gestures.

The film *Rameau's Nephew by Diderot (Thanx to Dennis Young)* by *Wilma Schoen*, finished in 1972 (three years in the making) and four and a half hours long is my most exhaustive (some say "exhausting") investigation of sound/image relationships. It centres around recorded speech and the many never-before-used possibilities of shifting what was recorded as sync sound and establishing varied sound-source-indications in the picture. Composed of thirty distinct separate sequences, almost all involving actors, it is impossible to describe. A hint: in one sequence male hands arrange and rearrange a large number of objects on a desk top. Pens, pencils, papers, books, portfolios, rulers, a coffee cup and other objects are arranged, sometimes in categories (objects of a certain colour are put together, all rectangular objects are grouped, thin, long things are lined up, etcetera.) A female voice-over describes the activities of the hands but her verbal description is sometimes in sync with what's happening on the screen, sometimes before something happens, and sometimes after. Past, present and future slide against each other and an extraordinary tension is produced by this play of prediction, simultaneity and history.

I shot the scene of the hands moving the objects, then from the film itself wrote a description of what happened. I then had Joyce Wieland read and record this text so that its duration (stop-watched) was exactly the same as the picture and printed them together.

Snow Seen, a wonderful book about my film and photographic work by Regina Cornwell and published in 1980 by Peter Martin Associates (now unfortunately out of print) contains a fine scene-by-scene description of this film, appended to a remarkable text on it. This list is reproduced in *Presence and Absence*, one of the books in *The Michael Snow Project* with a new and equally impressive article on

Rameau's Nephew... by Bruce Elder.

I discussed another film with an interesting image/sound situation in an interview with Pierre Théberge published in the Montreal magazine *Parachute* (#56, 1989).

.... 1
ͻɪ relationships
.... might make something...
....ally make scribbl
I firs ₚₐᵣₐ꜀ₕᵤₜₑ ₅₆ *1989* s at
"foɪᴄy are about forms,
shapes, procedures.

There are a number of lines or areas I've been exploring, for example in film, trying to make the possibilities of the camera a protagonist, so to speak. I've made a lot of work on camera movement, and thinking about the nature of tracking, trucking or travelling shots has resulted in my recent film *Seated Figures*. I remember I was thinking about different kinds of surfaces that the camera could move over; a surface, a floor, or a road are planar. So I became interested in doing something which, in current jargon, probably is formalist and modernist: a moving picture which is absolutely parallel to the picture plane, to the screen. That could

-12

be done by running the camera along walls but the idea of filming roads and fields horizontally and of making a transformation from horizontal recording to vertical projection interested me more.

Then there is the sound track. Here comes the audience again! After I had decided on the process for making the image, I didn't know what to do for sound (sometimes the ideas come together). After a lot of internal debate, I decided on an idea which involved constructing the sound of an audience watching the film. The more I thought about it the more worried I became, because I chose to include the kinds of sounds that audiences for my films have made in the past: generally they yawn, they crumple paper, they talk and cough. I decided I could make a dangerous attempt to concretize and perhaps exorcize distraction. Distraction is the infuriating *ordre du jour*, but I tried to turn it into a formal aspect of the work, to see how it would merge or not merge with an actual audience. I knew it was dangerous because it could definitely undercut seeing the image which is a very pure visual experience. I suppose that has happened but it seems to provoke some unusual feelings.

Coda: "A Shave and a Haircut Two Bits!"
Now, here comes Dave Lancashire with his trambone!
Oh play that thing!

Other texts by Michael Snow on music/sound are available in *Collected Writings*, one of the books in the series of Art Gallery of Ontario/The Power Plant publications entitled *The Michael Snow Project*. Complete texts which appeared on his record albums *Musics for Piano, Whistling, Microphone and Tape Recorder* and *The Last LP* are included as well as essays on the Artists Jazz Band, the CCMC and Larry Dubin.

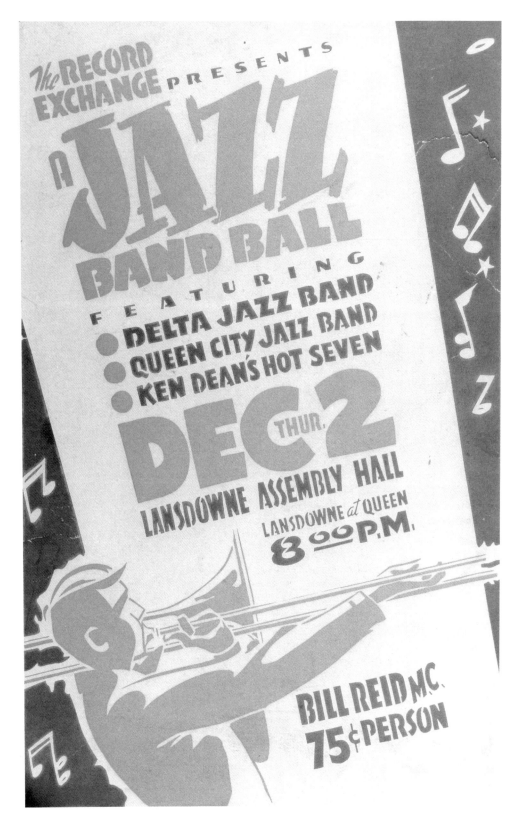

Blues in the Clock Tower

by David Lancashire

It was snowing the night I saw the poster. It was stapled to a lamp post and the street light above gave just enough light to make out the words "Jazz Band Ball." For anyone who liked hot music – which is what they called Jazz back then – those were exciting words. There wasn't much hot music around Toronto. It wasn't unknown, of course – Jazz had been played in Canada since the 1920s, usually in watered-down form, or as a sideline in dance bands. But the poster on the lamp post on a December night in 1948 looked like this might be the real thing. For 75 cents admission, it said, you could hear three bands at Lansdowne Hall in Toronto's West End – the Queen City Jazz Band, Ken Dean's Hot Seven, and the Delta Jazz Band. Like just about everyone in Toronto, I had never heard of any of them.

When I got there, the Ken Dean ensemble was attacking the final chorus of "That's A Plenty" and a few couples were jitterbugging in front of the stage. Everyone in the band's front line was a teenager. Somehow, though, they managed to project the seasoned, hip look I expected of Jazz musicians. Ken Dean's cornet was wreathed in smoke from a cigarette clamped in his hand. The trombone player was leaning back, languid, one foot tapping on the afterbeat, his eyes closed. Behind them, his left hand driving the band along like a locomotive, his right hand pulling the ensemble together and stabbing out accents above the horns, was a skinny 18-year-old at the piano.

To an awe-struck novice listener, it was amazing music – and instant glamour.

Next page: Ken Dean's Hot Seven, Lansdowne Assembly Hall, Toronto, Dec. 2, 1948. Jitter-buggers foreground, Roy Glandfield–trombone, Don Priestman–clarinet, Ken Dean–trumpet, Pete Jack–drums, Ralph Montemurro–guitar, Wallie Boychuk–bass, Michael Snow–piano. This is the concert which the poster described in "Blues in the Clocktower" advertised.

The piano sounded like all the legends about Jazz come to life: the riverboats, the New Orleans whorehouses, Chicago cabarets and Prohibition speakeasies. That night in 1948 I became smitten with Jazz, an infatuation that has lasted all my life. Within a few months I was playing trombone occasionally, and badly, in the bands. The piano player and I became good friends, and that, too, has lasted ever since. The piano player's name was Michael Snow.

"Playing Jazz was the most exciting thing in my life then," Snow says, recalling the years before he was established in the international art world as a painter, sculptor, photographer, film-maker, holographer

"More than that – it was the only thing in my life. Music gave me a *raison d'être* long before I got interested in art."

Music later became more than an excitement for Snow. For a time, it gave him a way to make a living, playing in a Dixieland band in a scruffy downtown hotel that's a strip-tease joint today, and accompanying some of the great luminaries in Jazz – Buck Clayton, Cootie Williams, Dicky Wells, Vic Dickenson. ("They're so arcane and obscure now, those names. They had a certain currency once, but almost nobody today has the faintest idea who Tricky Sam Nanton was.") In the daytime, he was painting.

Improvising music, after all, isn't so different from abstract painting, which is what first brought Snow to prominence as an artist. A twisting of the melody here, a brushstroke and an alteration of perspective there – it's the invention, the sense of discovery in the act, that has always engrossed Snow.

First, though, came the discovery of the music itself. He talked about it not long ago at his home in midtown Toronto, drinking coffee in the kitchen. In the next room, beyond the big Heinzman grand piano, his wife Peggy Gale was cajoling their young son Aleck to get ready for bed. Snow's face is weathered and the hair is grey, but the ready-to-go laugh, the enthusiasm and the self-joshing conversational shrugs haven't changed much since the night at the Jazz Band Ball.

"As a kid, I was never interested in anything at all – I just wandered around in a daze of zeroes. That changed one day when I came across an album of Duke Ellington records, *Victors*. It flipped me. It had "Black and Tan Fantasy", "Stompy

Deep in the heart of a soulful jazz solo is young Don Priestman, 18-year-old clarinet player with Ken Dean's Jazz Band—dispensers of delightful Dixieland music. At left is Leader Ken Dean on trumpet. Also shown are Drummer Cy Ware and Ken Glandfield on bass. The band, a Toronto-born-and-bred group, sticks to the old New Orleans style.

—Globe and Mail.

Youthful Toronto Band In the Dixieland Groove

Some 15 years ago, when the public became suddenly conscious of jazz and swing bands and began supplying the money that made a big business out of dance music, another and earlier form of jazz died an unnoticed death in order to make room for the "new" music.

Dixieland jazz, which was born in and around New Orleans and weaned on the riverboats of the Mississippi, was the inspiration for the various "new" forms of jazz that replaced it in the public's fickle heart. So Dixieland died—at least for a while.

Today there are indications that this music is coming back. Although many teen-agers have ears only for bebop, the latest jazz phase, an older generation still prefers Dixieland. Some of the old-time Dixieland jazz men, like Sidney Bechet, still get by playing their old music.

And here in Toronto there is at least one group of Dixieland musicians causing a lot of excitement. Surprisingly enough, the band is a very young one; the six members range in age from 18 to 22.

Ken Dean's jazz band was formed less than a year ago, the members having gradually come together after playing individually with other groups. Dean, a 20-year-old trumpet player, who sparks the band with his hot and hectic horn-playing, is currently a University of Toronto student who was born and raised in Toronto's east end. He has been playing around town with various pickup groups for five years.

While at Upper Canada College he met a piano player named Mike Snow, and together they roamed from jazz band to jazz band. Mike, who lives in Rosedale, eventually heard clarinetist Don Priestman, 18, who in turn knew a trombonist named Roy Glandfield. Roy happened to have a younger brother who played string bass.

Last September Dean left the Queen City Jazz Band, another young group which is still in existence, to form his own Dixieland outfit. And since then, the six young men have been attracting more and more attention—first in the east end, then all over town—with their refreshing outpourings of jazz in the New Orleans tradition.

Not long ago four of the boys went to Chicago for three weeks, and a memorable holiday it was. They sat in with some of their idols: Bechet, Dick McPartland, Jim Yancey and Danny Alvin. They spent most of their time visiting the little clubs where the Dixieland die-hards still hold forth in that city.

It is a tribute to the ability of Dean's boys that they were offered bookings in Chicago as a result of the little bit of playing they did during their visit there. But they came back to Toronto, determined to keep the band intact.

Ken and the boys, who play concerts and dance dates in such places as the Balmy Beach Canoe Club, the Polish National Hall and the Centre Island Association Clubhouse, don't think it particularly remarkable that they play Dixieland jazz in this day and age.

"What else is there?" asked drummer Cy Ware, last to join the group, is just as enthusiastic as the charter members and has no kind words for such fads as bebop.

All of the boys, in their earlier stages, had picked some idol or other from the Dixieland hall of fame and, intentionally or otherwise, tried to model their playing after their respective idols. To Don, the clarinet player who spends his days at Malvern Collegiate, Sidney Bechet (who usually plays soprano sax) was something of an inspiration.

Trumpeter Dean still thinks, as he has for some years past, that Louis Armstrong, Muggsy Spanier and Wild Bill Davison are the best. His playing reflects their influence on him.

Roy Glanfield has been a George Bruins and Brad Gowans fan since he began playing his trombone seriously (a mere two years ago), and the contributions he makes to Dean's band's playing shows it.

Roy and his younger brother, Ken, work these days, as does Cy Ware. The jobs aren't particularly important: they are just something to make a living; the job all the boys want becomes quite obvious when the band swings into such old jazz classics as At the Jazzband Ball, When the Saints Come Marching In, or Muskrat Ramble.

Both Dean and Mike Snow, a student at Ontario College of Art, hope to finish their schooling, but, like the other four bandsmen, they are much more keen on the future of Ken Dean's jazz band.

The gang gets together as often as possible to rehearse—usually twice a week. They still spend a lot of time listening to jazz records, picking up a bit of technique here, a part of a phrase there. Musically, they are still growing and, more important, willing to grow.

Of one thing, however, they are certain: If and when the Ken Dean Jazz band begins to click it will be as a Dixieland band—no bop or any other so-called progressive style will sway them from that objective.

Jones", all 1930s stuff. It was very, very beautiful. Then I heard a few more things … it might have been Jelly Roll Morton playing "Mamie's Blues", or Jimmy Yancey playing Boogie Woogie, and I knew right away that was what I wanted to do, and I started to play the piano. It was the first thing I found that I really cared about.

"My mother had been trying get me to take piano lessons for years but I always refused – sometimes I'd even hide. At home we had two pianos, the grand upstairs (that's the one I still have) and an upright in the basement, and I started to play down there. And one day – this story is a family cliché – she came downstairs quietly and heard me. She was astonished. 'You're playing the *piano!*' she said.

"She is a very good pianist herself, a Classical pianist, but she never disapproved of my playing Jazz. To this day she is pleased – she's still surprised, in fact. I was at her place the other day and I played "Happy Birthday," and then some variations on it, and she said, 'I don't understand – how can you do that?' She always asks that.

"So there I was, playing Boogie Woogie and going to Upper Canada College. That was where I got to know Ken Dean. He was the first person I met who was also hooked on New Orleans Jazz. He was playing trumpet in the school military band and he played a lot better than I did. There were practise rooms in the clock tower at Upper Canada and we used to sneak into them and play Blues together. If someone had come along from the music department we would have been thrown out – we weren't music students.

"They had compulsory sports at Upper Canada, every afternoon at 3:30. I'd have my bicycle hidden in the bushes and when the sports started I'd ride down to the Promenade Music Centre on Bloor Street and listen to Jazz records. That turned out to be really important, because that was where I met Roy Glandfield and his brother Ken. Roy played trombone, Ken played bass. Some days Don Priestman was there too; he played clarinet. We'd sit in a booth and listen to the records and Roy would always bring a little flask with gin in it, and Tom Collins mix. By the time I rode home on my bike sometimes I was plastered.

"Somehow we decided to form a band, with Ken Dean as leader."

Kids getting together that way today would be playing Rock in a garage band,

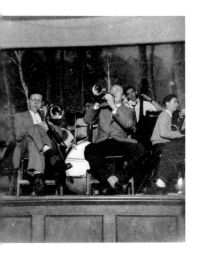

Ken Dean's Jazz Band.
Concert at Polish-
Canadian Hall, Toronto,
February 1949.
Jimmy Johnson–drums,
Ken Glandfield–bass,
Michael Snow–piano,
Ron Sullivan–trombone,
Ken Dean–trumpet,
Don Priestman–clarinet.

38

with a battery of electronics and a ready and waiting audience from the rock-and-roll crowd. In Jazz in the 1940s, there weren't any electronics. Even the phonograph at Mike Snow's house in Rosedale, where Dean and the others got together to rehearse and listen to records, was made from an orange crate. The records were 78 rpms and the needle in the pickup arm was a cactus thorn. After every couple of plays someone would take out the thorn (you bought them in packages) and sharpen it with sandpaper.

As for an audience, it was practically non-existent in Toronto. And in the pre-TV 1940s there was no publicity industry to pump up an instant following. (For a while, though, the band did have a volunteer promoter and booking agent – a high-school student named Robert Fulford.) New Orleans-Chicago Jazz, hot music, was esoteric music – most people had never heard anything like it. The swing era was still alive then and big bands were popular, but the playing of Sidney Bechet and Muggsy Spanier attracted only a few fans. They felt like members of a select club, possessors of inside knowledge. They were the sort of people who listened to King Oliver and Bunk Johnson on "The Ten Ten Swing Club," a Saturday afternoon radio program on CJCL.

The show had a half-hour section devoted to small, hot bands, written by Clyde Clark, a chemical engineer and part-time piano player. Clark was an encyclopedically informed Jazz fan and he supplied some of the show's records from his own collection. To the Kid Ory and Eddie Condon fans listening in, Clark was the prophet preaching in the wilderness. His program, like the concert, was called "The Jazz Band Ball." ("I used to listen to it religiously, and that's the right word," said Snow.)

"Clyde was the person who really started it all," says Ken Dean. "His show was the only place you could hear the music, and we all listened. Clyde had the only Jazz band in town, too, the Queen City – it was the first band I played with. Mike Snow and I were hangers-on to that band – we'd go to rehearsals and listen."

"When I first heard Mike playing piano he was just starting out," Clyde Clark recalls. "But even then he had great ideas. And he just got better and better. But at first he had no conception of the structure of a tune – he'd get carried away and

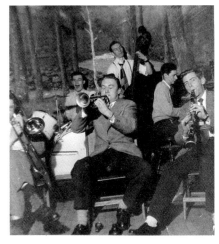

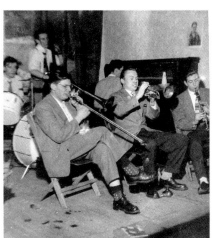

forget when he came to the end of a chorus. On a 12-bar blues he'd play 11 bars and then 135/8 bars or something. I invited him up to my house and showed him how tunes were constructed."

By this time the Ken Dean band was beginning to play around town, at the tennis club on Centre Island (where the jobs started at midnight), at the Balmy Beach Canoe Club, in legion halls and Polish wedding halls. The band would hire the hall and sell tickets at the door. "Union scale for professional musicians was $6 a night then," Ken Dean remembers, "so if we made a few bucks at the door it wasn't bad. Sometimes the Jazz Society of Toronto would book the hall – it was really just four guys from East York Collegiate but it sounded official, and that way we could get a permit and sell beer. My mother had a Buick opera coupe – we used to get seven musicians in it, and the drums and the bass and the odd girl or two. Man, we were cool."

"These lads are the pioneers of 'the real jazz' in Toronto," proclaimed an August, 1948 article in *The Record Exchange*, a mimeographed magazine that sold for 10 cents a copy. "We weren't the pioneers at all," Ken Dean says. "There had been marvellous bands in Canada since the twenties and thirties, but we were what was happening then." Alex Barris, an entertainment reporter on *The Globe and Mail*, got interested in the band and plugged it in the paper. "Pianist Mike Snow provides just the right driving rhythm so necessary for good Dixieland," Barris wrote after a concert dance at Balmy Beach.

"Piano players now are all trained and they can play anything," says Ken Dean. "Mike didn't have any of that training. Somehow he just picked it up, but he was a damned good piano player. He sounded like a modern Jelly Roll Morton." Trombonist Bud Hill recollects that "Mike was a hell of a player. He had a terrific left hand, stride-style. Everybody in town wondered how he did it." Clyde Clark recalls that it was Snow's right hand that set him apart – "he had a great right hand."

Left hand, right hand – the evidence confirms that Snow was adept with both. The evidence is a dozen or so primitive, 78 rpm records from the 1940s on which his playing can be heard, faintly and through some extraordinarily loud scratching. The 10-inch acetate discs were made by Eric Cuttiford, a young machinist who was

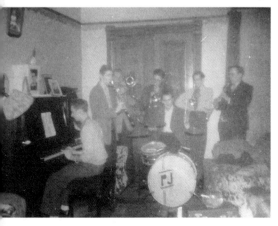

Bottom right: Ken Dean's Jazz Band in concert at a high school in Toronto, probably 1948.

Left and top right: Session at somebody's house, Toronto, probably 1947. Michael Snow–piano, Don Priestman–clarinet, Roy Glandfield–trombone, Ron Sullivan–trombone, Rudy Maxim–drums, Art Schawlow–clarinet (later co-inventor of the laser and a Nobel prize winner), Ron Bessey-trumpet.

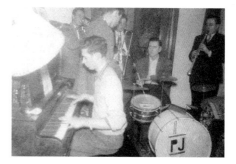

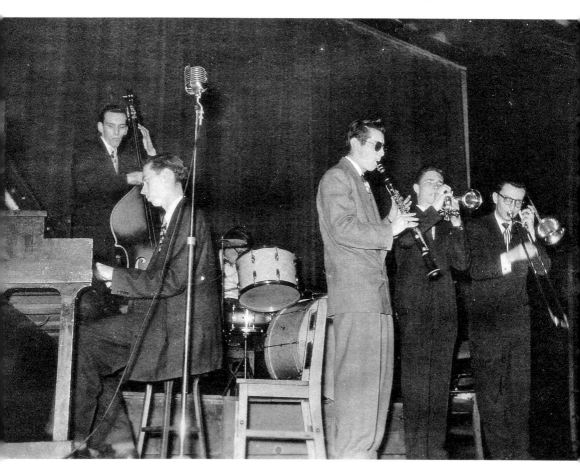

41

attracted to Jazz through Clyde Clark's radio program. "You could hear wonderful records on the radio but you couldn't buy them in Toronto, so I decided to copy them off the air," says Cuttiford, who now lives outside Cleveland, Ohio. "Then I met Mike and Ken Dean and began hanging around, and I started recording the band, too."

Tape recorders were unknown then, so Cuttiford built his own disc recorder, a 90-pound contraption in four separate parts that took two or three people to carry around and operate. "It was a Frankenstein monster." Cuttiford — the band called him "King Cutty" — set up his microphone in the Polish halls and sometimes in Michael Snow's living room. "I used to joke about pushing Mike under a bus so I could issue a Michael Snow memorial album and make a legend of him. "A few of the discs were made by D'Ariel D'Angelo, who had a rehearsal studio on Dundas Street in Chinatown.

The sound quality of the worn-out discs is appalling today, but the energy of the band is undiminished. Ken Dean's cornet sets the pace and dominates the music, but Snow's two-fisted piano playing — sparkling in the ensembles, filling in the holes, punching out stop-time choruses on the fast numbers — is clearly the engine of the band. Most of the tunes are classics that in the intervening forty years have become Dixieland warhorses: "That Da Da Strain," "Dippermouth Blues," "Make Me a Pallet on the Floor," "Willie the Weeper" … Some are original Blues, such as a piano-trumpet duet called "McDougall and Brown," named after a Toronto undertakers' firm. Another duet is "Broadview and Danforth," commemorating the location of the old Playters Hall, where Snow and the others put on two concerts of recorded Jazz in 1947 to win converts to the music. ("King Oliver, Muggsy Spanier, Tesch, Bix, Johnny Dodds," says a poster. "Admission 35 cents.")

"I learned about theory from some mimeographed pages that were in the piano bench at home," Snow said. "They were from a piano teacher called Howard White, I think. It might have been the first part of a course my mother hoped I would take. Anyway, it outlined how chords are built. It showed a scale, thirds, fifths and so on, and how to find the scales, the circle of sevenths, how F resolves into B flat. That was the start of my harmonic training. It opened up the whole thing. Once you can

Eric "King Cutti" Cuttiford at Lake Simcoe, Ontario, Summer 1949.

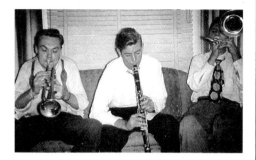

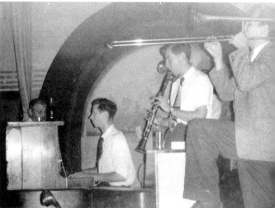

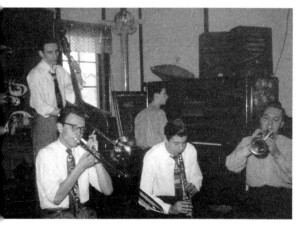

Top right, bottom left: Ken Dean's Jazz Band at
two different Jazz clubs, the side-view one is at the
Mil-Arm Inn.

Top left, bottom right: A session in someone's apart-
ment. Dean, Priestman, Glandfield. Michael Snow —
"It's all how you hold your tongue."

find a scale and the relative minor you can start to see — the piano is very visual. There are still some keys I'm not fluent in, but I know what's there, thanks to those little pieces of paper."

"Jazz musicians, especially pianists, guitarists and bass players, need to know the underlying chord structure of the tunes they play. I used chord books that I bought, and info from other musicians. For a lot of pieces, I worked out the 'changes' myself."

Snow's son came into the kitchen with a drawing for his father to admire. "Hey, Scoot, let's see what you've got," said Snow. "Ah, a space ship." The boy pointed out the stabilizers and the engines and his father asked how they worked. They talked for a moment and then the boy smiled and waved goodnight. "That reminds me of when I was a kid and I used to draw comic strips," said Snow. "One of them was called Airplane Ace — it wasn't the space age yet.

"The time when the band was starting was very educational. When I met the others, Roy and Ken Glandfield and Don Priestman, they were reading books I had never heard of. I hadn't read anything. I didn't know you were supposed to read. I studied what I was supposed to study and that was all. But these guys said 'Hey, read.' Roy and Ken were high-school dropouts, but I got an incredible education from them and Don. ("On the other hand," says Priestman, "we learned a lot about painting from Mike. It had never occurred to me to look at a painting before that.")

"We'd listen to Louis Armstrong records and argue about clarinet playing and talk about the books," Snow said. "That went on for a year or two. I read James Joyce, *Ulysses*, Flaubert and Stendhal, Dostoyevsky, *USA* by John Dos Passos, Lin Yu-t'ang, Philip Wylie — we had a little school going. It was amazing."

(The education level among many of the musicians was fairly substantial. Ken Dean became a corporation attorney — although he kept playing trumpet for forty years and was more or less the patriarch of Dixieland Jazz in Canada — Don Priestman taught English at Ryerson, Clyde Clark was a research chemist. And a clarinet player in the Delta band, Art Schawlow, later co-invented the laser and won the Nobel Prize in 1981.)

"There was a fair amount of drinking going on, too," says Snow. "It was part of

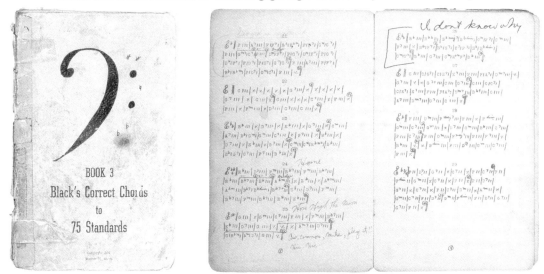

the tradition. Ken Dean's family had a cottage on Scarborough Bluffs, which is probably all city by now. One weekend we went there with beer and all the horns and we drank so much we were falling down. That happened here and there.

"Sometimes the talking would go on all night. Once we were listening to records and we walked together back to Rosedale – it took hours – arguing all the way about the function of the clarinet: should it be played like Johnny Dodds and George Lewis, or a less linear, more harmonic way, like Pee Wee Russell? The sun was coming up and we sat on my front porch arguing about this stuff. My father came out to get the paper and there we were, saying 'you can't play thirds to the trumpet like that.' My father said 'Oh my God.'

"We weren't a revival band that specialized in one set style, like the Lu Watters or Turk Murphy bands did. With us it was more mixed up, and there used to be lots of arguments about that. The real New Orleans purists thought Louis Armstrong was an impostor, that everything after Bunk Johnson was a negation of the music. But we didn't feel that way. We liked Louis and Wild Bill Davison both. Our style depended on the tunes, but the repertoire was basic Dixieland.

"It was about that time that we started going to Chicago. We went three or four summers in a row. We'd go by bus and we'd stay for a week or so at the YMCA and sit in with bands and jam wherever we could. We would just go into a club and ask if we could play. Some of the clubs were dives – the place on North Clark Street where we heard Lee Collins, a New Orleans trumpet player, the Victory Club, had sawdust on the floor. We played there. We got to know Bud Jacobson, a clarinet player from the early Chicago days, and he introduced us around. He and his wife would have us for meals; they were good to us.

"The most wonderful thing for me was when we went to two parties at Jimmy Yancey's house. Yancey was one of the masters of Boogie Woogie piano but he had to make a living as a groundskeeper at a baseball stadium, for the Chicago White Sox. Three of them were there at the party, playing: Cripple Clarence Lofton and Albert Ammons and Yancey himself. And I played, too. They were floored that some scrawny Canadian kid knew their stuff. Now there are lots of white kids who play

Black's Correct Chords
to
100 Standards

Copyright 1946
WARREN M. BLACK

Top: Mama Yancey, Roy Glandfield, Michael Snow.

Centre: In the kitchen, group including Don Priestman,
Roy Glandfield, Albert Ammons (one of the great
Boogie Woogie piano players), Kay Jacobson, Michael
Snow, Mama Yancey.

Bottom: Roy Glandfield asleep in the Yancey's bathtub.

47

the blues, but not then. Yancey couldn't believe it. Wow! He said he'd take me as a pupil. Roy Glandfield fell asleep in a bathtub at Yancey's place.

"The racial situation was really strong in those days. When we tried to get a cab to go to Yancey's, on the South Side, for example, the driver said 'No — I don't go there.' And when we ran out of beer at the party and I said I'd go and get some, they said 'No you won't, you don't go out there unless we go with you.' Apparently it was dangerous for whites. We had never run into that sort of thing before, but of course we knew that race was a really big issue in the music, the division between black musicians and white musicians.

"One of the outstanding white Jazz musicians was Pee Wee Russell, and in 1950 he was staying with the Jacobsons. He was a wreck — as far as I could tell he was living on gin — but his playing was very strong. Steiner Davis, the record company, was going to record him and Pee Wee asked me to play on it. We made the record — I've got a test of it — but it was never released. The tune was "Ja-Da," and Pee Wee played lying down on a sofa."

Back in Toronto, Snow was by this time getting engrossed in art. It had been a slow start. "I was always drawing, but it wasn't a serious thing to me. Then in high school in my graduating year they gave me the art prize, which surprised me. I wasn't particularly interested in the subject. But I decided after fifth form to go to the Ontario College of Art. I didn't know what else to do — it didn't occur to me that you could make a living as a Jazz musician; there weren't enough jobs. I was putting a lot of study and a lot of feeling into it, though.

"At the art college I got involved in painting about the same way I had gotten into Jazz: some things moved me and so I started to do them. But I was painting things that didn't have anything to do with school. There was a wonderful teacher, John Martin. He encouraged me and gave me books to read. None of the teachers knew anything about my piano playing.

"I graduated in 1952; I was at OCA for four years. When I got out, I still didn't have the faintest idea how to make a living at painting, and I didn't have any big ambitions about my piano playing. It was just so much fun to play. We played occasionally

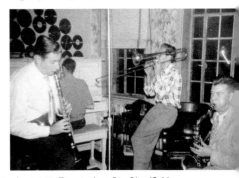

Chicago, September 1949. Torontonians Roy Glandfield–trombone, Don Priestman–clarinet, Michael Snow–piano with Chicagoans Bud Jacobson–tenor sax, Harry McCall–drums. A recording session at the studio of S.D. Records, the owner of which, John Steiner, is third from left in the listening-to-the-playback photo.

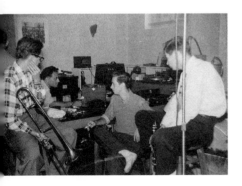

Top: Ken Dean's Jazz Band, St. Regis Hotel, Toronto, August 1951. Bud Hill—trombone, Bob Hackborn—drums, Ken Dean—trumpet, Bill Burridge—bass, Don Priestman—clarinet, Michael Snow—piano.

Centre: Bob Hackborn—drums, Michael Snow—piano, living room of Snow family home, 110 Roxborough Drive, Toronto, February 1953. This duo played many sleazy jobs in Toronto in the early '50s: The Warwick Hotel, The Elliot Hotel, Larry's Hideaway (The Carleton Hotel, Jarvis and Carlton), etc. Photo by Georgine Strathy.

Next page: Ken Dean's Hot Seven. Colonial Tavern, Toronto, Spring 1950. Roy Glandfield—trombone, Ron Sullivan—drums, Jimmy MacPartland—great Chicago trumpet player, Ken Glandfield—bass, Ken Dean—trumpet, Don Priestman—clarinet, Bill Hicks—guitar, Michael Snow—piano.

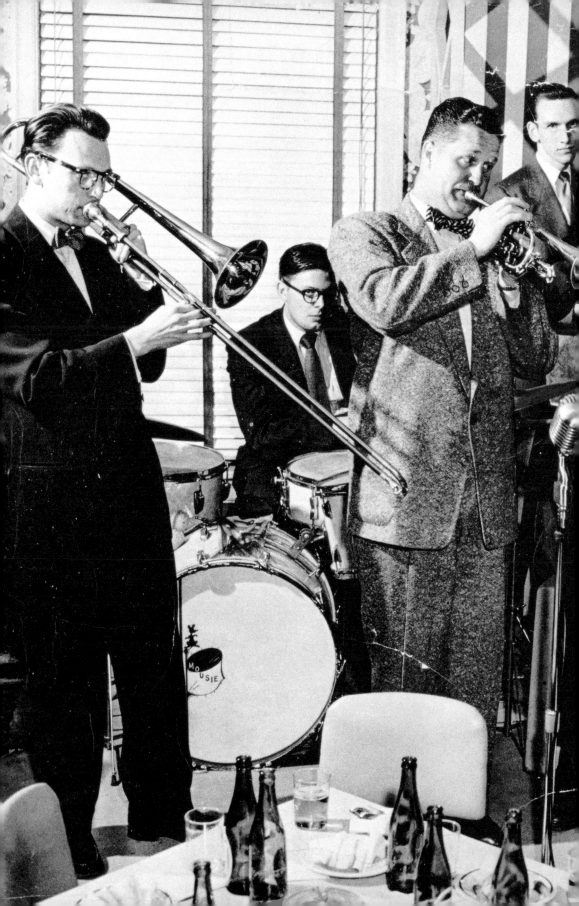

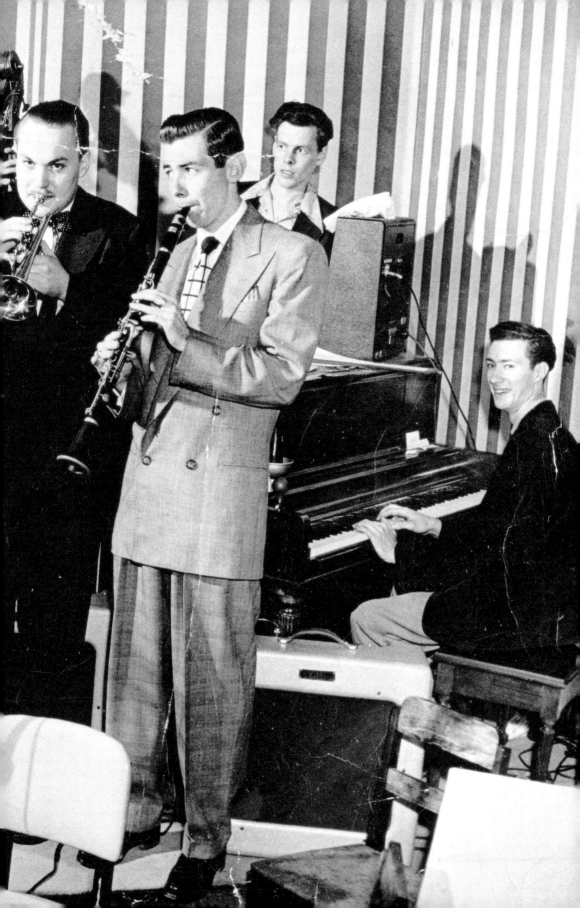

for 10 bucks each, but that was all. I got a job as the juniorest of juniors at an advertising agency. The place did catalogues for Eaton's or Simpsons or outfits like that. I was terrible and the job was awful. At the art college I had met Bob Hackborn, who played drums, and we decided to go to Europe together. The last day at the ad agency we were supposed to finish at 5, and I knocked over a bottle of India ink, spilled it all over everything, and I was there for hours, cleaning up.

"You had to go to Europe by boat in those days. We went from New York to Paris. I went with $300 and lived for more than a year. Bob Hackborn brought along his drums, big crates full of drums. I had been playing trumpet for a while before we left and somehow in Paris we heard that a band was looking for a drummer and a trumpet player. So we auditioned. I only knew about three tunes on trumpet, all of them in the key of F, and at the audition we played two of them, "Lady Be Good" and "Blue Skies," or whatever. All the guys in the band were blacks, from the French colonies, Martinique and Guadaloupe, and they were studying dentistry in Paris. They were knocked out by our playing and they said 'Okay, you're hired.'

"The job turned out to be for the Club Mediterranée, which is famous now but it was new then. We went to a resort in Italy, at Golfo di Barrati on the Tuscany coast, another on the island of Elba, and then Yugoslavia. The pay was room and board and $7.50 a month, in lire, plus tickets for drinks. The band played these merengues and sambas and things; they had a violin and an accordion. I couldn't really play the trumpet, except blues and "When the Saints Go Marching In," and I was so poor on the instrument I was hardly capable of learning anything more. We were living in tents and I was too embarrassed to practise. Everybody would hear. So at night I'd do my two numbers and then I'd play the bongos and drink. And try to get laid."

Snow got up and walked to the refrigerator. "It's about time for a drink," he said. "We've got beer, and there are other things around here somewhere." He came back to the table with a bottle of calvados. The interlude in Italy was familiar territory to both of us: I had come down from Vienna to Barrati that summer and joined the band in mid-season. We worked together in Rome, too, for a few days, and then moved to another Club Med camp on the island of Elba. Then Snow and Hackborn

Left, below: Club Mediterranée, Golfo di Baratti, Tuscany, Italy, June 1953. Dave Lancashire–trombone, Michael Snow–trumpet, Bob Hackborn–drums, Pierre Chon Chon–guitar, Jean "Baratti"–singer and m.c., Gerard ?– piano, Maurice Beauregard–bass. Photos by Rinaldi Cel Ati, Piombino, Italy.

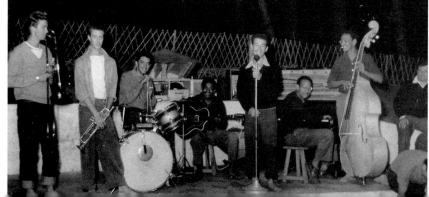

Michael Snow–piano, Pierre Chon Chon–guitar.

Parade. Club Mediterranée, June 1953. Photos by
Rinaldi Cel Ati, Piombino, Italy.

Right: Michael Snow–trumpet with accordianist and
violinist of the Club Mediterranée band: Gaston ? and
Maurice Beauregard.

The circular bar near the "piste de dance" on the beach,
Club Mediterranée, June 1953, two members of the band
plus Michael Snow. Photos by Bob Hackborn.

Bob Hackborn in front of his and Snow's tent, Club
Mediterranée, June 1953.

"Fête des Fleurs" Day parade, Paris, May 14, 1953. The band shown here, which included Bob Hackborn on drums and Michael Snow on piano, also included some exceptional French musicians. On trumpet Jacques Chretien, the trombonist was Mowgli Jospin, who was a member of the Claude Luter band, an important "New Orleans Revival" group in the '20s King Oliver style. They played regularly in a "cave" club called Les Trois Maillets in St. Germain Des Pres near Notre Dame Cathedral. Hackborn and Snow "sat in" there and also with the bands of André Rewellioty and Michel Attenoux, who was a protégé of the great New Orleans soprano saxophonist Sydney Bechet, who lived in Paris in the '50s. Attenoux's group, occasionally with Bechet, played at The Vieux Colombier. Lil Hardin, who had been pianist with the classic Louis Armstrong Hot Five (and was married to Armstrong) also lived in Paris and played solo at Les Trois Maillets as well as at Metro-Jazz another "cave" at 14 rue St. Julien le Pauvre. The presence of these and other Jazz originals made Paris an exciting Jazz milieu. The French had been among the earliest and most scholarly apprecia- tors of Jazz. There was a wave of interest in New Orleans/Dixieland/Chicago/Blues all over the world in the '50s, a movement to which Hackborn and Snow and their Toronto friends belonged. Young, white

musicians formed groups in New York, Chicago, San Francisco, Holland, Germany, Australia. In England one of the important "revival" musicians was the Louis Armstrong-inspired Humphrey Lyttleton, whose band Hackborn and Snow also "sat in" with in London in 1953. In Paris they also played at "Le Chat Noir," a colourful Jazz "boite" often attended by Jean Paul Sartre and other intellectuals, where two of the musi- cians in the Club Mediterranée band heard Hackborn and Snow, which led to their successful audition for the job described in "Blues in the Clocktower." The Club Mediterranée had only recently been formed and had resorts (where everyone lived in tents) in four locations. The summer of '53 band played at three of them: Golfo di Baratti near Piombino on the coast of Tuscany, on the island of Elba, then on the coast of Yugoslavia in Montenegro. The Yugoslav musicians described in Snow's anecdote quoted in "Blues in the Clocktower" were also converts to "hot music," and they sat in with the Club Mediterranée band where this photo was taken. It shows two of them: Roga Cirovic on trumpet and Stevan Stevanovich on trombone with Michael Snow on trumpet and Pierre Chon Chon on guitar. Becici-Budva, Yugoslavia, July 1953. Paris photo by Bob Hackborn.

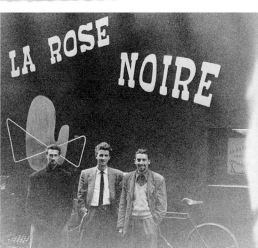

Top: Dave Lancashire and Michael Snow, Dusseldorf, Germany, November 1953.

Bottom: Michael Snow, Dave Lancashire and Bob Hackborn in front of the "cave" Jazz club La Rose Noire, Brussels, Belgium, October 1953. Photo by Bob Hackborn.

Right: The La Rose Noire band: Dave Lancashire— trombone, Leon Baudasche—drums, Jacky Jun—alto sax (sitting in), Baron Jacques E. de Negre—bass, Michael Snow—piano, Roger Asselberghs—clarinet, Henri Carels—trumpet, October 1953, Brussels, Belgium.

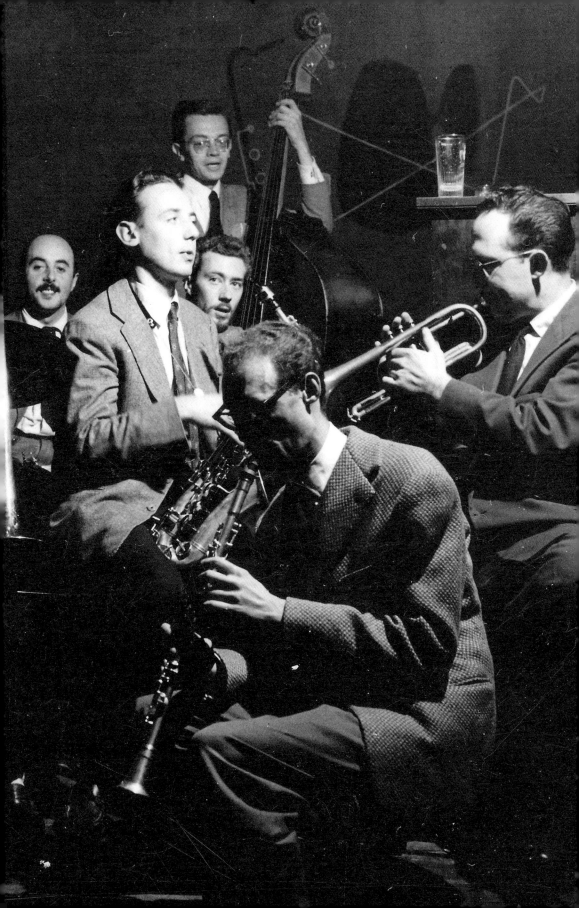

and the dental students packed up to finish off the season in Yugoslavia.

"On the boat to Dubrovnik there was an incredible storm in the Adriatic and everybody was sick. When we arrived at 3 or 4 in the morning, the storm was over and we were approaching a long concrete dock and it was very mysterious and strange and we heard Dixieland Jazz from somewhere in the town. Bob and I ran toward it. There was a club facing out toward the water and a band was playing 'Muskrat Ramble' and we ran up to them and yelled 'Louis Armstrong, Sidney Bechet,' and we all laughed together."

When the holiday camp closed in autumn, Snow and Hackborn returned to Paris and hitch-hiked to Brussels, where I was playing in a Jazz club called La Rose Noire. The two Canadians walked in, wearing plaid shirts, and sat in with the Belgian band. The club owner promptly fired his piano player and hired Snow. We worked there together for about two months and one night we almost got blown away. Clifford Brown, Quincy Jones, Art Farmer and several other sensational players from the touring Lionel Hampton orchestra came in and jammed with us. It was a baptism in modern jazz. In Paris a couple of days later, Quincy Jones wrote and recorded a tune called "La Rose Noire."

"That winter Bob and I got a job at Méribel-les-Allues, a ski resort in the French Alps," Snow resumed. "That almost finished me off. We played in a bar and it was kind of interesting. But the guy who hired us — he was supposed to be a famous writer of some sort — had this woman, very wealthy. She had her own airplane. Somehow the guy thought I was making out with her, which I wasn't, and he threatened me a couple of times. One night he got into a rage and said 'I'm going to kill you,' and he went and got a gun. Everyone was trying to talk him out of it — you know, 'Don't shoot the piano player.' Hackborn and I ran away and there was a chase. The guy had this big dog, and we were scuffling and running and falling in the snow. We made it through the night and a couple of hours after breakfast the police came and arrested him, but not because of what had happened. It turned out that he was an impostor, a criminal with a record, and off his rocker."

After more than a year in Europe, playing and visiting art museums, Snow

Bob Hackborn—drum, Michael Snow—trumpet, a mysterious celebration on the SS Columbia, somewhere in the Atlantic, Summer, 1954. Photo by Bob Hackborn.

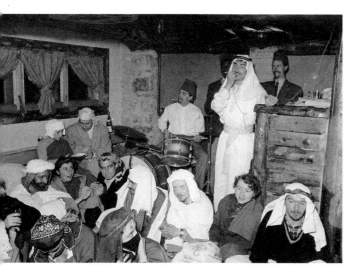

Top: Hotel Grand Coeur, Meribel-les-Allues, France.

Centre: Michael Snow, piano, and Bob Hackborn, drums, at two costume nights in the bar of the Hotel Grand Coeur, February 1954.

Bottom: The lady in question with Michael Snow, Hotel Grand Coeur, February 1954.

returned to Toronto. A joint exhibition at Hart House (with fellow painter Graham Coughtry) of drawings he had done on the Continent led to the offer of an animation job at Graphic Films; he was pleased to find work, and intrigued by the film process. "Joyce Wieland, my first wife, was working there and that's where we met. We were married for twenty years. Graphic Films was run by George Dunning, who later did the animation for The Beatles' *Yellow Submarine* movie."

"I was playing whenever I could. One job was playing intermission piano for Earl Hines at the Colonial. I worked with Wingy Manone, the Dixieland trumpet player, at the Crest Lounge in Detroit, and I had a quintet of my own one season at Stratford. Up till then I had been playing mostly moldy fig music, which was what they called New Orleans Jazz at the time Bebop was beginning to spread. Bebop split the Jazz world into two camps. At first I was scared by Bop — all those strange chord progressions and the shifts in rhythm. I couldn't make any sense out of it; I wondered what the hell they were up to. The first time I went to New York was in 1949 or so and I walked into a club on 52nd Street and Charlie Parker was playing. It was probably the most amazing band in the world but I can remember the feeling of hysteria I felt. I just wanted to get out. It drove me crazy.

"But Bebop was the music that was going through a creative stage and I was getting interested in it. Still, the only really long-term music job I had was with a Dixieland outfit, the Mike White Imperial Jazz Band (photographs of the band appear in "Les Disques," pages 196-200). I played in it from '58 till '62. A lot of that time we worked at the Westover Hotel, near Dundas and Sherbourne streets. Now it's a table-top dancing place, the Filmore. We became very popular and a lot of people started going there."

"Some of those were rough places," says Eric Cuttiford. "Mike played at the Warwick Hotel, too, at Jarvis and Dundas, and guys would slap him on the back and say, 'Hit that thing, kid, I can't hear it.' There were the usual ladies of the evening, and gangsters hung out there. Mike used to say he wouldn't play piano unless he had his back to the wall for protection."

"At the Westover, Mike White got the idea of bringing in guest musicians," said

Dear viewer, please compare these two photos. Two different occasions but it certainly is the same band! Bob Stagg—clarinet, Bob Hackborn—drums, Ken Dean—trumpet, Michael Snow—piano, Paul "Slim" Chandler—valve trombone. The photo with the bottles was taken at a frat party at the University of Toronto, one of many places where Ken Dean's band played, summer 1955. The other, same band, is a concert at Hart House, U of T, also the summer of '55 (p. 61).

Now please consider the other same band photo (p. 62), clarinet and trombone switched, same jacket and pants, taken in the basement of my family's house, 110 Roxborough Drive, Toronto, also summer '55. Then there's a close-up. Bob Stagg unfortunately committed suicide in the '60s and Slim Chandler died of a heart attack when he was in his forties (the '70s). Photos by Bob Hackborn. — Michael Snow

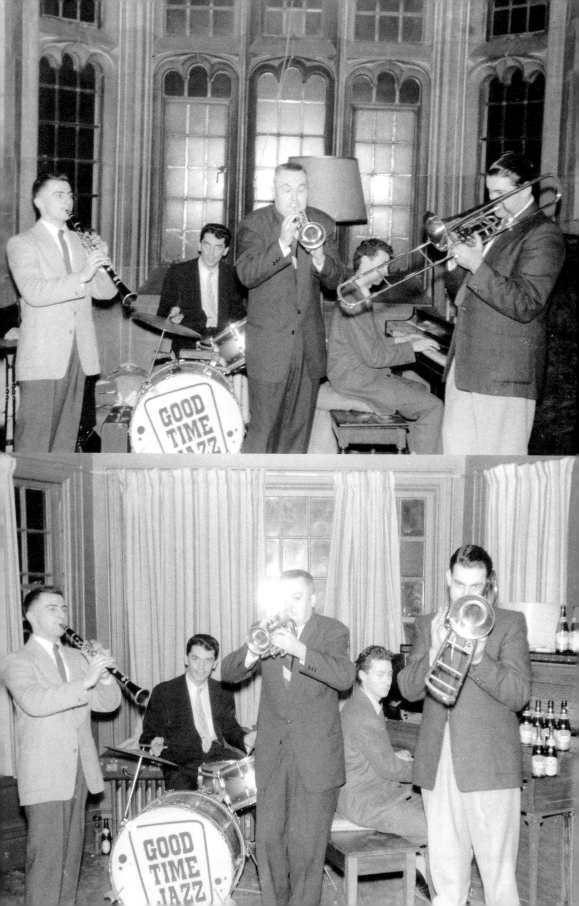

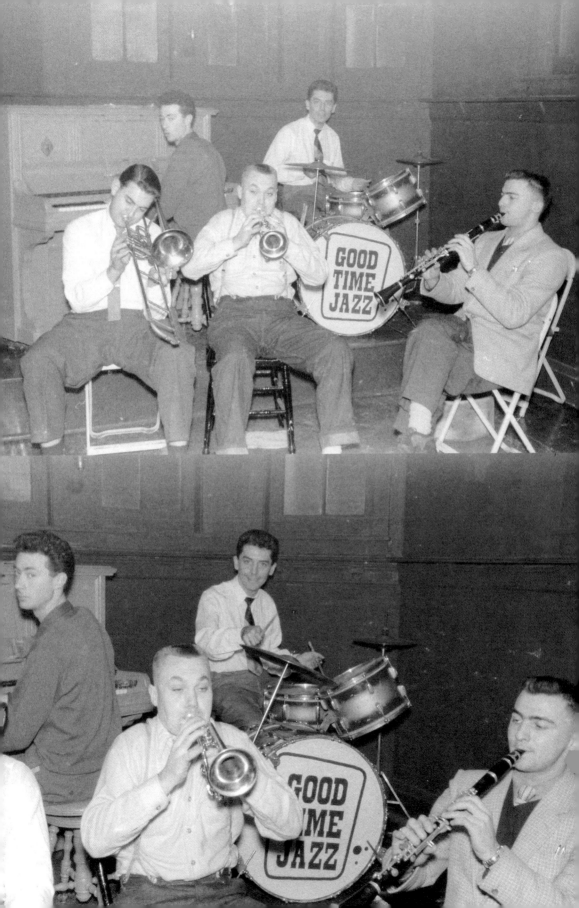

Snow. "They invited all those wonderful people that I got a chance to play with: George Lewis, Rex Stewart, Jimmy Rushing, let's see, there was Paul Barbarin, and Edmond Hall and others. I was always kind of scared about playing with them, to tell you the truth – for one thing I can't read music, and sometimes they brought arrangements with them that you had to read. We just did the best we could. Probably they didn't think much of the band. It was musically adequate, though, and they were gentlemanly about it. What I don't understand now is that I never made any attempt to see them off the job, or sit around and talk with them. Such a wasted opportunity! I could have learned so much. But I was really working hard at painting then, all day in the studio, and there was only so much time and energy.

"Mike White was an exciting trumpet player. There were actually two bands. The first had Bud Hill on trombone – he was a marvellous musician – who I think would have become famous in Jazz circles if he'd chosen to go to New York – and a fine clarinetist named Ian Arnott. We recorded an LP for Hallmark, a Toronto label, in 1958, called *Dixieland Jazz with Mike White's Imperial Jazz Band*. The second edition of the band had another good trombone player, Alf James – I used him in a quartet of my own – and we played in places like the Park Plaza. I have some tapes of CHUM broadcasts made there in 1962. We made a 45 rpm record, too, for Astral Records, which has a tune of mine on it, called Theft.'

"I was turning more and more to so-called modern Jazz and I was trying to play it. I had some quartet jobs of my own, at George's Spaghetti House and a few other places, playing Thelonious Monk tunes and Miles Davis and Charlie Parker things. Don Owen made a film about that time, *Toronto Jazz*, for the National Film Board, and the quartet was in it. Larry Dubin came into the Mike White band on drums and Terry Forster on bass – Forster was an all-round professional musician who had worked a lot with Teddy Wilson – and the rhythm section started to get pretty modern for a Dixieland band. We were playing in the New Orleans format but with a Bop influence. I think it may actually have killed the band. People started to complain. They'd say 'Stop fooling around, you guys.' They wanted the same old beat; it's part of the idiom. But Mike White liked what we were doing and he switched a

A recording studio in Toronto, probably in 1958. Bob Stagg–clarinet, Michael Snow–piano, Bill Burridge–bass, Joyce Wieland–listening.

little bit and started to play Ellington things, more modern material. And so the band started to lose its audience.

"Jazz is propelled by the discoveries musicians make, and then there is a stage of definition, into a recognizable style and a format. Playing within the format is like performing Classical music — everything is set out in advance. Playing Dixieland today, playing it well, can be exciting, but it's like playing Mozart. Nothing new happens in it. You can invent some different choruses, but it isn't a music of discovery any more. I wanted to be involved in something that was making up its own format, a music that contained more surprises."

Snow's pursuit of new ideas, his determination to see what lay beyond every horizon, influenced his music as much as it did his painting. The exploring carried him so far from the moldy fig Jazz of the early days that some musicians who knew him then now speak of his playing in the past tense, as if he didn't play at all any more.

"For a while there, in fact, I pretty well did quit playing. After I left the Mike White band, Joyce and I moved to New York, and I decided to give up the piano. That was in 1962. I thought if I wanted to be a painter, I had to be a painter. For a long time there had been a tussle between the various things I was doing. I had a loft and I worked away in it. That was when I started making films, too. Living across the street was Roswell Rudd, a trombone player who played 'free' music, what they called the 'new thing' — you know, no chord changes, no melody. He knew all the people in the new movement — Archie Shepp, Paul Bley, Steve Lacy. But his background was Dixieland, and so was some of the other musicians', so it was congenial when we met.

"Roswell was broke and wanted to sell his piano. I bought it for 50 bucks and moved it into my loft. These guys weren't playing in public because they were feared and hated, so I made the loft available to them. We started to have sessions, a lot of them. Everybody played at my place — the Jazz Composers Orchestra started there.

"I didn't work with them, though. I didn't know how to play that way. I would only try to play after a session was over. But I was lucky in having a contact with that kind of music; it gave me an opportunity to hear people working on it. You

have to learn how to improvise in that free way. Doodling is one thing but trying to make something is another."

Snow also made a point of listening to Cecil Taylor and Ornette Coleman, two musicians who obliterated the remaining rules about Jazz and demolished its foundations. While some musicians were trying to figure out whether Coleman was a tone-deaf fraud or a genuine revolutionary, Snow was studying the process.

"Hearing those two in person gave me a little more understanding. But Roswell and the others were still stuck on the business of having to play some kind of composition. He had a band with John Tchicai and they played fixed lines, tunes, and then they improvised. Albert Ayler did that, too. I thought that was stupid, for what they were trying to do. In 1964 I was making a film, *New York Eye and Ear Control*, and when I chose the band to make the sound track I specifically asked them not to play compositions, just to play free.

"The form of the music wasn't the only thing that was changing then. Socially, Jazz had changed, too. It had always been part of the community. From New Orleans to Kansas City and Swing and Bebop, it all had some sort of social grounding. It reflected what was going on in the community and it had a sort of acceptance among the people. But now, Cecil Taylor isn't liked by the black community. Albert Ayler gets booed when he performs. The blacks are into the music of James Brown. Jazz started to lose its roots about the time it started abstracting the rhythm and the harmony. That was about the same time that Rock and Rhythm and Blues began replacing Frank Sinatra.

"For that matter, I don't think Jazz exists as a growing thing any more. Free-style players like Cecil Taylor and Ornette brought things to the music that opened it up to a lot of other influences, and so the continuity has disappeared."

Snow took his glass off the table and strolled to the grand piano in the next room. He sat down on the stool and began playing a slow, Blues-like introduction that suddenly picked up speed and turned into "Struttin' With Some Barbecue" — moldy fig music, with the left hand pumping like a piston. "I can't play this way any more," he laughed after a chorus or so. "In the early Jazz rhythm sections, everybody

 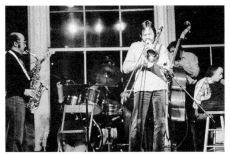

This page and overleaf: The Artists Jazz Band in concert at The Kitchen, New York, 1975. Nobuo Kubota—saxophones, Graham Coughtry—trombone, Gerry McAdam—guitar, Jimmy Jones—electric bass, Terry Forster—acoustic bass, Gord Rayner—drums, Bob Markle—tenor sax and piano, Michael Snow—trumpet and piano.

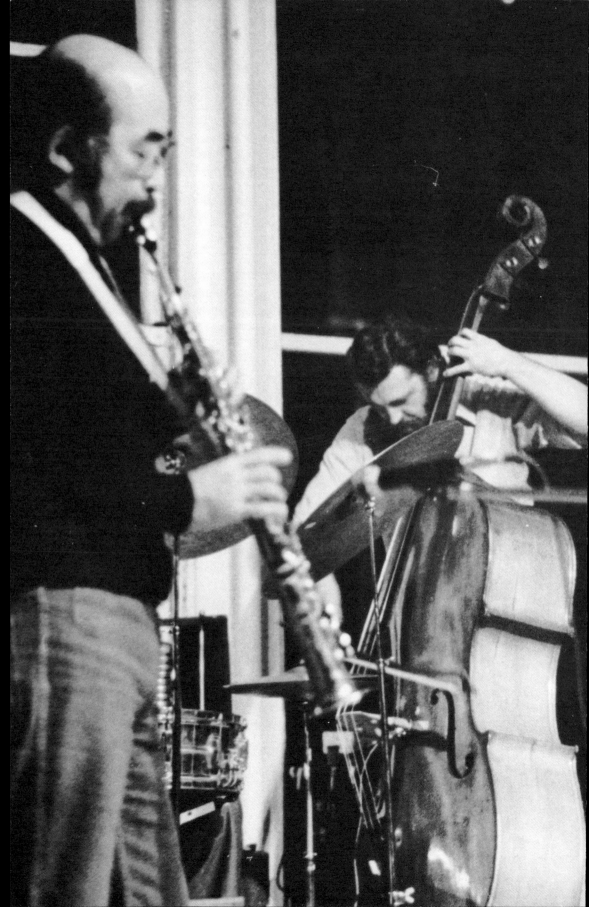

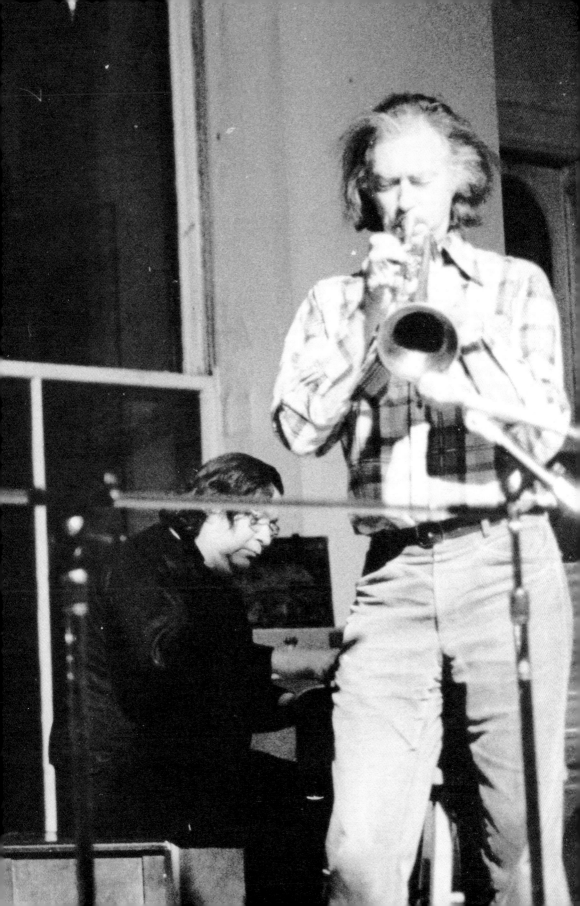

played the same thing at the same time, all sounding on the same beat. That was one of the things that gave the music a certain kind of propulsion. It was similar to that Motown rhythm, like the Supremes." He thumped the piano 1-2-3-4 with the flat of his hand.

"One of the things that started to happen in the Swing bands and then really took over in Bebop was that the duplication was taken apart. Piano players stopped playing with a stride left hand, no more metronomic rhythm; they played punctuation. The rhythm section opened up, the bass could be heard and the drums were freed from being strict timekeepers. That was the beginning of the end of the rhythm section.

"The early players' solos were all based on ragtime, orchestral style. The left hand played the rhythm section and the right hand played the horns. It was a complete piano style. People like Earl Hines drew from all the possibilities of the instrument. They played with two hands, with a bottom and a top and relationships between – not contrapuntal like Bach but truly pianistic music. That's what I understood, even from Yancey. It was like Mozart – a lot of intelligence between the parts, between the two hands.

"I got further into free music in the summers in the '60s when I'd come back to Toronto. The Artists' Jazz Band had started here by then. Gord Rayner, Graham Coughtry and Bob Markle and the others bought instruments – they didn't know how to play them, they just began. I thought it was pretty funny, but Terry Forster was in with them and he loved it. So that made me think, and I began to play with them."

In 1972, Snow left New York and moved back to Toronto, where Larry Dubin invited him to join a group of experimental free-style players. That led to the formation in 1974 of the CCMC – (originally the Canadian Creative Music Collective), with which he plays to this day, in weekly concerts at the Music Gallery in Toronto. The idea was to "organically grow its own new music through spontaneous collective composition," to quote the liner notes from a CCMC cassette.

"It is demanding to listen to, gorgeous to some ears, upsetting to others, but

unmistakably adventurous," I wrote about the CCMC in 1978. "A typical CCMC performance might begin with a barrage of fast, chopped notes played in clusters, building up into a frenzied dash and suddenly falling into a quiet pool of sound ... half the band moves around the room tapping out a percussion passage of bells, iron bars, empty artillery shells casings and a marimba (sometimes they also chant, drop heavy objects on the floor, rattle tin cans and turn on radios and randomly twiddle the dials) ... the whole band glisses upward into an intense roar that approaches audible levitation.

"The effect can be rich and moving ... it can be irritating, it can be almost frightening, like a thunderstorm. After a few minutes of this sort of thing, an orthodox chord or a recognizable scrap of melody (both happen occasionally) comes as an abrupt shock.

"And the band isn't much help when it comes to explaining the music: the liner notes on their records talk about it in phrases such as 'spontaneous, fluid, organic, self-regulating ... individual designs converge on a dynamic present ...' To someone whose idea of jazz is Kid Ory or Buddy Rich, that means about as much as the initials CCMC, which the band insists no longer mean anything at all. 'The letters can stand for anything you want, just like the music,' grins Snow."

Orthodox musicians, including some who played with Snow in the early days, are liable to dismiss the CCMC's output as anarchy, or worse. Ken Dean, for one, says, "I wouldn't disparage it, but what they play isn't music. It's a collection of sounds."

That isn't too far from Michael Snow's own assessment, which is "what we are doing is shaping sound."

In a recording of two pieces called "Interpretation of Dreams" and "Time of the Essence" (from CCMC '90, a pair of cassettes released in 1990), Snow sets out to bridge the chasm between the sonic mayhem of the CCMC and the very roots of Jazz. He was accompanied by Al Mattes, playing a guitar synthesizer, which can sound like anything from a symphonic string section to a car crash. On the recording tape, eerie computer music resolves into suspenseful piano chords and then bursts into a chorus of Ragtime. Passages of hectic rummaging by both instruments sud-

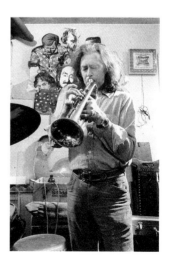

Michael Snow at the piano. Michael Snow on trumpet.
Photos taken at an Artists' Jazz Band session at Gord
Rayner's studio on Spadina Avenue, c. 1972.

denly subside into a yearning, 3-o'clock-in-the-morning ballad. And machine noises and mosquito buzzes from the synthesizer give way to a few bars of rich, smokey Blues — an echo from the Upper Canada clock tower in the 1940s.

"I love the sound of that," said Snow. "Old-style Jazz is great music, in the real sense of the word. Unfortunately for many people 'Dixieland Jazz' means football game or election campaign music but at its best it can still be an extraordinary form. Collective free improvisation is to me a natural development from the ensemble style of early Jazz. The Louis Armstrong Hot Five records are as good as the Beethoven Quartets. And what the New Orleans Wanderers played ranks with the Brandenburg Concertos. Listening to things like those can bring tears to your eyes."

Biography

David Lancashire reviews Jazz books for *The Globe and Mail* and *Smithsonian* magazine. A newspaper reporter (*Quebec Chronicle Telegraph, Montreal Herald, The Globe and Mail*) and a would-be trombonist on the side, Lancashire left the Toronto Jazz scene in 1956 when he wrote to Chou En-lai and obtained a visa to visit China, which had been closed to North American journalists for seven years. Working for The Associated Press of New York, he was the first reporter for any U.S. news organization on the Chinese mainland since the Communist takeover in 1949. Lancashire stayed with The AP as a foreign correspondent for 20 years, in the Far East, the Middle East and Europe, writing about wars and revolutions, politics and economics, opium dens and rigged elections, papal visits and Miss Universe contests. He resuscitated the trombone in Beirut, played in pit bands for *The Boy Friend* and *Guys and Dolls*, and with friends, between *coups d'état*, formed a quartet that was the only Jazz band in the Middle East in the 1960s. Returning to Canada (1976), he was chief feature writer for *The Globe and Mail* and wrote occasionally about Jazz. He is now an editor for the paper.

The poster and the pianist. Photo by the author, forty-three years later, October '91.

The Artists' Jazz Band recording
the two LP album released by the
Isaacs Gallery at Eastern Sound
Studio, June 1973. Smoky photo
sequence by Michael Snow.

The shock waves generated by these recordings will be felt long after the final note has been sounded. After all, the
sheer audacity of some of Canada's finest "artists" producing the most challenging Jazz-oriented music yet committed to
tape in Canada is something to think about. Damn it - they didn't even warn us! And if I was a practicing union music-
ian I'd have it banned. How dare these upstart amateurs come through with the intensity and vividness of New York's
best when the jazz spectrum of the established (recognized) musicians is still solidly based in the past.

Of course it could all be a gimmick. After all most painters are crazy - but that's why so many of them are geniuses.
They are beyond us mere mortals and there's no reason why their vivid imaginations can't be transformed into any spectrum.
Playing an instrument is a technical problem - playing music is a continually changing gift. The Artists Jazz Band has
ten years of experience behind it - even though only a few notes have spread further than Gord Rayner's Spadina Street
loft. What started out as a bizarre approximation of the jazz world's most satirical stylists has developed into a musical
identity and unity of purpose which transcends itself. Their music is together - in the sense that they understand the
forms within which they work and have the confidence to execute the most daring ideas to come to mind.

The only constant in the artistic mind is change - and the music will remain as flexible as the men who make it. They view
music as seriously as their other endeavours but the irrational wit which permeates their contemporary view of life is
readily apparent in their music. Having successfully overcome the established ideaology of the "art" world they have now
delivered a broad-nosed riposte at Canada's music machine.

Be yourself, be creative and overcome the fear of survival in a world governed by materialistic conformity. This is what
the members of the Artists Jazz Band have been doing for many years - perhaps this is why they can play music.

John Norris, Editor Coda Magazine.

The Artists' Jazz Band

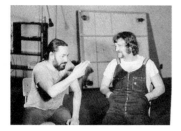

coda *1974 - by JOHN NORRIS*

CANADIAN NEW MUSIC

The Al Neil Trio Retrospective:
1965-1968
Lodestone Records lr-7001

The Artists' Jazz Band
AJB ST57427-57430

Eugene Chadbourne Volume One:
Solo Acoustic Guitar
Parachute Records P-001

Three records of Canadian "Avant Garde" music, indicative of the fact that contemporary improvised music of considerable worth is being created North of the Border. There has been some for a time, of course, but recorded evidence of the fact has been negligible. As it is, only one of these records - Chadbourne's - is being produced in anything more than a "limited edition for collectors". Which is too bad, since the AJB and certainly Al Neil have music to offer that's worth hearing to more than one or two hundred people. But then these two particular releases aren't all that they could be on that score. The AJB would come off better with some editing, and the Al Neil Trio record doesn't fully convey the depth and power of the music that Al was getting into with his groups during the late sixties.

The Artists' Jazz Band, comprised of visual artists living in the Toronto area, has been together in some form or other for about fifteen years. Michael Snow is a highly accomplished jazz trumpeter: the technical abilities of some of the other members is virtually non-existent, something which underlines the fact that this group represents, and no doubt envisions itself as a direct challenge to many traditional notions about what a jazz band is. Such as the notion that members of a band need to master an instrument before they can play music on it. Actually, this record pretty well proves the contrary; in fact, the weakest moments are always caused by the intrusion of someone's imperfectly formed technique into the very (of necessity) freely created group improvisation. In other words, the AJB convincingly demonstrates that as long as musicians listen to each other and con-

centrate on blending their sounds together, it is not necessary that they have any technical ability in order to play good music. Whether or not really great music could be created in this manner is still open to question, but a good deal of what the AJB does on the best two tracks here (Looks Like Snow and Raynershine) is considerably better than anything that many thoroughly-trained people on the scene will ever come up with. The other two tracks, Is It Addicting, an intentionally bizarre outing to the tune of Are You From Dixie? and the useless Markle-O-Slow are another matter. Here the band tries to do things it can't, and the results aren't good, to say the least. Actually, Is It Addicting works well enough since it's a satirical effort anyway, but it's too long. Seemingly AJB felt that each track had to take up an entire LP side, and in this case five minutes would have been plenty of time to get the point across. A single record of the two best tracks would make a much more convincing and recommendable, item than this two-record set. As it is, the AJB has succeeded in demonstrating a rather revolutionary point, one which should provide the "real" musicians in the Toronto area and elsewhere with an interesting challenge. After all, if guys who "can't play" sound this good, what are all the thoroughly-accomplished instrumentalists who don't sound good going to do with their hard-earned chops?

Finally Eugene Chadbourne. Although originally from Colorado, Eugene has spent the last five years in Calgary, and has done most of his performing in

CCMC*



*Choose Celect Mark Corroborate:
Craven Cowards Muttering Curses
Criss Crashes Murmurs Clanks
Charles Carl Mark Cedric
Carol Cynthia Myrtle Chloe
Cracked Craniums Mystic Culmination
Careless Choir Muffling Chords
Creaking Croaking Mashing & Crushing
Canadian Composition Making Continuum
Ceaseless Calling Muffles Crying
Cottage College Maison Camp
Completely Canadian Monster Circus
Cool Crisp Moroccan Celery
Consolidated Canned Meat Carvers
Canada Council Muffin Chewers
Chortle Chortle Muttered Chrie
Caucasian Confessional Muscle Committee
Clever Crescendos Mundane Chords
Crown Cheek Mouth Chin
Calgary Clive Marcella Cute
Crafty Climax Mare Copulation
Common Courtesy Mocks Credulity
Chinchillas Certainly Maintain Culture
Chin Cheek Molar Canine
Camels Contain Monumental Caverns
Candy Camouflages Musty Camembert
Captain Cook's Muff-diving Crew
Cunning Cunnilinguists Meat Clandestinely
Canadian Creative Muddling Club
Can Cats Make Coons?
Certified Careless Mush Concept
Cemetary Collects Million Creeeps
Christmas Cards Mailed Carelessly
Count C Major Chorde
Canucks Counsel Marital Celibacy
Cool Customer Mails Clock
Crusty Cunt Maligns Cock
Corny Classical Music Coos
Corn Cabbage Molluscs Chestnuts
Cardinals Come More Celibately
Clip Clop Manure Crop
Cold Cuts Mean Chow
Calculated Cohabitation Moderately Condoned
Cool Cherub Milks Clara
Cocaine Cocaine Marijuana Cocaine
Cocaine Creates Marshmallow Cranium
Carbon Copy Mimics Credentials
Chinese Communist Military Civilization
Clarabell Considers Mother Cute
Catchy Canuck Melody Convinces
Croatians Condone Macedonian Cooking
Crude Crutches May Collapse
Caught Cheating Multiply Cost
Cenozoic Creatures Mesozoic Critters
Cyclops Centaur Minotaur Circe



Céleri Champignons Mayonnaise Cornichons
Capitaine Cartier Massacres le Canada
Calvados Cointreau Madeire Cognac
Chablis Cidre Mélasse Chartreuse
le Corps de Celine Me Confort
Chapeau Chemise Mouchoir Cravate
Cuisine Cubaine Médiocre Cuisine
Cake Cake More Cake
si si Mexican Club
Camembert Cheese Mit Cherries
Canadian Corny Music Committee
Casually Corny Mixed Chorus
Come Cream My Corn
Carpathian Carpet Making Company
Canada Comforts Moon Cherishers
Canadian Cache Manufacturing Company
Cold Cash Makes Collisions
Corinthian Capitol Mystic Church
Cathys Collision Made Crumples
Cheap Cheese Munching Cowards
Canadian Cool Music College
Cheese & Cash Marketing Council
Chicken Chalet Motel Concern
Cerulean Crayon Marks Colour
Ça-ca Chalice (Merde Container)
Crouche Crouche Means Crunch
Crushing Cookies Makes Crumbs
Charley Chaplin Movies: Cinema
Cherry Custard Marijuana Custard
Cement Cook Marble Cunt
Cantelope Cauliflower Mango Chutney
Calcified Creeps Mortifying Cinderellas
Crustaceans Cause More Crustaceans
Coherent Chaos Manifests Creation
Cardboard Cartoons Move Culture
Castrate Criminally Motivated Commies
Castrates Choir Murmurs Cries
Christ Crucified Mixed Choir
Cardinals Cook Miss Cunts
Casey's Cooking Misplaces Cheese
Cenozoic Creatures Mate Communally
Convoluted Condoms Make Children
Coca Cola Mambo Combo
Carters Certified Meatless Condoms
Cottage Cheese Makes Curds
Cracked Critical Mass Collapses
Chinese Cookies Mister Customer?
Calcium Copper Magnesium Cadmium
Centre Célèbre Magnifique Canadien
Café Chocolat Milk Crème
C'est Cher Mais Convenable
Chocolat Cru Maladroit Cuiller
Cycles Cosmique Mal Choisis
Chandelles Cubistes Manquent Cire
Curnoe Chambers Molinari Corr



Cross Canada Musical Cruise
Careless Crew Misses Craft
Comment Changer Mouton Cadet?
Chansons, Cris Mélange Constamment
Crud Collects Munchy Cysts
Criss Cross Meander Collapse
Community Coroner Mounts Cadavre
Cream Cheese Mit Crackers
Critics Commendations Mean Crap
Costly Concubines Money Consumers
Cézanne Corot Matisse Chardin
Computer Caught Memorising Chords
Country Club Members Concerto
Cherubim Constantly Mumble Canticles
Cheese, Crackers Mouse Caught
Canadians Collect Mistakes Casually
Cantering Colts Milking Cows
Chaste Cock Mens Club
Chicks Celebrating More Come
Cow Coyote Moose Chat
Con Cru Manque Cruel
Compagnie Curieuse Maniaque Cruel
Crazy Cosmopolitan Music Cult
6 6 aime 6
Christmas Cake Mix Canned
Cows Chew, Milk Comes
Carousing, Chuckling Mirth Caper
Cold Crab Meat Compote
Coffee Cup (Mug, Container)
Contemporary Canadian Ministry of Cultur
College Conservatory Museum Council
Cock and Cunt Motel Cabins
Cance Collar Mattress Cake
Choice Chance Miss Crash
Carbon Charbon Means Coal
Curtain Climax Middle Conclusion
Crooked Croatians Miss Christmas
Crusty Croissant Masticated Critically
Carcinoma Causes Many Cadavres
Cigarettes Conflagration Matches Cinder.
Cosmic Cycling Multiplies Contacts
Cotton Cops Munch Crabapples
Confluent Cultures Mix Classes
Communism Civilian Military Conquest
Capitalism Cheap Monstrous Curse
Central Chimney Mounting Cretans
Crap Crap & More Crap
Costumed Cuties Materialistic Cannibals
Careless Curtsies Mask Courtship
Creamed Corn Mashed Carrots
Contrapuntal Clavier Music Creaks
Calling Crooked Merchants Clever
Converse Contains More Corn

MUSIC GALLERY Editions MGE 6

VOLUME THREE

CCMC's Continued More CCMCs
Constant Comment Mitigates Criticism
Comatose Crippled Men Calling
Ceaseless Crying Moans + Caws
Cool Corpse Mortuary Corpe
Canada Council Moves Cautiousily
Cool Cacophony = Multiplexed Communication
Cackling Chuckling Mumbling Company
Chords Crescendo Mixolydian Cycle
Canadian Cry Mercy Circuit
C'est Chaud Mais Chouette
Chaque Chien Mange Chats
Courage Courage Musique Cessera
Court Circuit Moins Current
Comment Changer Mitaines Charmées?
Cretons Croutons Moutons Croissante
Chose Curieuse Musique Cannibale
Chien Chaud Moutarde Cole-slaw
Chaque Cri Me Choque
Chicoutimi Chicago Montreal st. Catherines
Cris Curieux Mais Charmants
Cerveau Craqué Mind Cracked
Concert Canadien Musique Contemporaine
Chahut Chassant Monsieur Chopin
Ca Coute Moins Cher
Carcinome Curieux Médecin Confus
Chefs de Canada Manquent Confiance
Chaleur Cuit Mon Corps
Cuties Ceaselessly Munching Crotches
Chef Carême Mélanges des Choses
Caverne Ciel Montagne Colline
Cul Crotté Maigris les Crapuleux
Crashing Crushing Mashing Colliding
Chose Chose Même Chose
Carson Calhoun Murdoch + Charlesworth
see see Mediterranean sea
Canadian Catholic Mens Club
Cozy Calm Massaging + Caressing
Cuddling Curves Moistens Cunts
Chuck Can't Marry Cornelia
Chilling Carnage Murder + Catastrophe
Christopher Columbus Mister Cortez
CCMC Composes Many CCMCs
Certainement Choix des Mélomanes Canadiens
Can Coda Magazine Cope?
Can't Collect Money Competently
Closed Cardboard Matches Can!
Certus Citibus Mernum Cranum
Cheer Cheer 'eM Cheer
Cadillac Car Money Costs
Canadian Cycle Manufacturing Company
Christians Covet Moslem Church
Contemporary Chamber Music Concert
Customers Could Make up CCMCs too!
Centrality Cried Mister Copernicus
Chocolate Chips Mmmm Cookies
Caged Compositions Mar Creativity
Courage Confidence Mastery Certainty
C___ C_____ M___ C_____
C____ C__ M_____ C____
C_ C___ M__ C___
C__ C_ M_ C_
CCMC

Cover, Michael Snow and the CCMC.
CCMCs by the CCMC and friends
Engineering and notes, Peter Anson
Recorded at The Music Gallery,
30 St. Patrick Street, Toronto, Canada
Produced with the assistance of the
Samuel and Saidye Bronfman Family Foundation

CCMC stands for and behind the music on this record. The CCMC is six of us, Casey Sokol, Michael Snow, Allan Mattes, Nobuo Kubota, Larry Dubin, Peter Anson, who have been playing together in Toronto and elsewhere since January 1975.

Probably we all came to this music for different reasons. We came to it because we wanted to address the immediate issue of mind/body making music, or because our idea of music had outgrown all symbolic containers (western notation having reverted, in a sense, to its medieval approximateness), or because we wanted to create not only a new work or a new instrument but a new composer, a six-brained, twelve-handed individual, to see what it would come up with.

What it came up with has the complexity of nature, and the order of nature, which depends in part on the "composure" of the listener's own sensations and thoughts, the person who hears him/ herself reflected or resonated in the music surely penetrates to the heart of the matter. The music, in Robert Ashley's words, "welcomes self-consciousness and works with it in order to see through the illusions that are sustaining it." From the musicians' standpoint, these illusions form the sensuous layer of structure, the "chemical" movements that travel through the composition like blushes. And the music can act through this layer to make us more aware of the corresponding layers of our own being, our thought/ feelings.

In free music the sounds/thoughts of each person are presented to a context of the sounds/thoughts of all the other persons, and they also shape this context. Everything is illuminated by every-thing else; the gratuitous is continously transformed into the necessary. In such a relativistic framework just about every way of observing (or preserving) the music changes it. In a sense the music materializes in stages, with the recording as the final stage. But even the recording is not a fixed quantity with a single value. Our experience of it remains subject to change. In selecting the material for this record we had to take into account this fluidity, which is in ourselves, and we have tried to choose music that most consistently presented itself to us as the action of a group intelligence.

CCMC VOLUME THREE

*OCTOBER FOURTH
10/4/77 22:05 Three sections. 1:About 7½ minutes, with Nobuo Kubota, alto saxophone; Michael Snow, trumpet with mutes; Casey Sokol, piano; Allan Mattes, bass; Larry Dubin, drums. 2:("sea travel") Peter Anson, guitar; with bass, drums, trumpet and alto. 3: Begins with (Snow, Kubota) marimbas and electric piano (Sokol) and hammered guitar, then two pianos (Snow, acoustic), then Dubin on marimba with bass and ostinato piano (Snow). A fourth, lyrical section begins with Kubota on soprano saxophone, fades during a transition.

*SEPTEMBER TWENTIETH
9/20/77 12:03 Three sections. 1:Allan Mattes, clarinet and bowed bass; Peter Anson, guitar; Larry Dubin, Casey Sokol, bottles and percussion. 2:Sokol, piano; Dubin, drums; Mattes, bass; Anson, guitar. 3:(Sokol) plucked piano and autoharp; Anson, guitar; Mattes, bass; Dubin, ABS pipe drums and percussion.

*JUNE SEVENTH
6/7/77 8:55 One movement of a very long piece. Casey Sokol, piano; Larry Dubin, drums; Allan Mattes, bass; Nobuo Kubota, tenor saxophone; Michael Snow, trumpet.

Is it all read now?

This page and overleaf: Jimmy Jones—bass, Larry Dubin—drums, Michael Snow. Three reviews of *CCMC Volume Three*

I have not been able to discover the name of the author of the text on page 76 nor where nor when it was published. I suspect it was written by the exceptional American guitarist Eugene Chadbourne, living at the time in Calgary, or it might have been written by the equally exceptional Toronto poet Victor Coleman who was very involved in the Music Gallery for many years.

One of the reviews on page 77 is by Harry Freedman, an exceptional Toronto "classical" composer, whose music has been somewhat influenced by Jazz. This article was published in *Music Works* magazine, Toronto, volume 5, number 2, March 1978.

The other review is by American critic Art Lange and was published in *Coda* magazine, Toronto, no. 21, February 1978.

CCMC Volume 3
Music Gallery Editions MGE-6
$6

To say that there is a polarity breaking out in improvisational music and to say that the CCMC are the center of one faction is both true and untrue. True in the sense that unfortunately the CCMC lately has been getting listened to and written about by people (or not written about by people of the same leaning) who 1) Basically cannot listen because they have been conditioned to one narrow interpretation of creative music that fans the mythology of individual creative genius at the expense of a possibility of social communication through music including through musicians to each other; 2) That believe that the presence of a graphic notation, simple in design (easy enough to remember) is the security blanket of an intellectual toilet training without which improvisational music in this era cannot proceed in a creditable manner.

The untruth (pausing for a soft drink) is that whilst the CCMC is justifiably irate at such stupidity the problem lies more in the jazz tradition, whence one aspect of the CCMC creative music emanates and to which often an audience, complete with diapers, comes expecting that tradition, just that tradition and only that tradition. Again it is not the music's fault, jazz or otherwise but the D.J. rattle, music rags and cover sleeve hype which so mesmerizes the avid listener to cream him/herself everytime the words SOLO, CHOPS, SPEED, FEROCITY come into print. This is further complicated by the 'avid listener' one

day waking up and becoming a musician, struggling, weighted down by all this flotsam and jetsam trying so hard to emulate what the music through the cover notes tells him/her is real, failing and then having the naive audacity to turn on other musicians who obviously are trying something else and saying to them, Hey Bananas, you stink!

The CCMC's musical context, thankfully, is more complex than the inspiring but limited jazz tradition with its black and white pretenders to the throne. Supposedly we had reached times where mutual co-existence of acoustics had taken place but in reflection who were we to suppose?

The CCMC's third album came out just prior to their extensive Canadian tour which physically, at times, must have been like trying to take Stalingrad. The three pieces are **October 4th** on one side and **September 20th** and **June 7th** on the other. Conveniently, the titles also tell when they were recorded, all dates refer to last year. The record is well-pressed not over compressed, and their recording techniques are improving. Which is to say that you can adequately recognise the acoustics of the space - The Music Gallery, which if you've been there and heard the CCMC and can now hear them & the space on record gives the publication that extra plus.

I, as they know, would rather see and hear them live than listen to their record and whenever I do hear them I would rather be playing with them more than just through my blood circulation and as they say who takes notice of reviews, but reviews are hopefully to interest others in gaining accessibility - at least music reviews.

The album is a pleasant surprise, the music sounds exceptionally fluent and though I 'hate' to admit it, the sonic balance seems to work better on this record than it often seems to live, helped most likely by the absence of visual attract/distract-ions.

October 4th is a cut in point where the brushes of Dubin and the vibrating foil (trumpet) mute of Snow become one and the same and in the second section where the bass of Mattes and Peter Anson's guitar match perfectly. (The bass in the first section registers almost as a cello.) Further in, the music goes into genetic multiplications with marimbas and piano's and a hammered guitar and becomes much more interesting than the cut's cover notes imply - Dubin's marimba playing joined by Kubota's soprano, a phased bass and guitar.

The other full ensemble piece - **June Seventh** is quite different with two unexpected gaps: one when the piano goes 'dead' (silence) and another further along. Spatially it's perhaps the most challenging of the three pieces.

September 20th is unashamedly beautiful with sensitive communication between Anson and Sokol, the guitar adding to Sokol's plucked piano and autoharp. This work excellently highlights the interactions of Larry Dubin, Al Mattes, Peter Anson and Casey Sokol.

The CCMC's music is ultimately layered and without suffication, this third album accurately displays their hard workings as a homogenous social unit with homogenisation, so drink it up - the protein and carbohydrate components are about equal and there's very little fat.

The music on this record is awkward, gangly, fluid, stiff, transparent, opaque, beautiful, and ugly, all at the same time. These musicians (Casey Sokol, Michael Snow, Allan Mattes, Nobuo Kubota, Larry Dubin, and Peter Anson) are attempting to stretch and ultimately break out of the structural box which encompasses even the freest of creative music today. Since they adhere to a "music of the moment" or spontaneous creation through collective interplay, the music's structure is a tenuous though completely valid one. The members of CCMC have obviously been playing this music, alone or together, for quite a while as their music holds the listener's interest through an effective measuring of tension and relaxation of musical material; attained mainly through addition and subtraction of voices along the way, and through the utilization of subtle variances of tempo and texture within each piece.

Each of these players seem to have developed their own instrumental voice; nowhere here does one hear imitated or memorized licks or cliches, despite the diversity of "styles" of music which the CCMC reflects. The ensemble sound is, as a result, continually fresh; for example, their use of various percussion instruments in order to quietly urge the music forward in no way resembles the sound or usage of these same instruments by a group such as the Art Ensemble of Chicago.

One of the joys of this music is the way each of these three recorded pieces slowly evolves through excellent ensemble empathy. There are moments of lucid, liquid, shimmering sound between sections containing a deluge of notes, where the texture becomes more sparse and two or three instruments combine for some gentle, subtle sound inducement. Pianist Casey Sokol is especially effective in this regard: while his chord clusters and single note flurries help to propel the music in its up-tempo sections, his inside-the-piano strumming and plucking affords some lovely sounds in a more lyrical situation, almost seeming to be short "ballads" between the high energy collectives.

There are, of course, certain problems inherent in this approach to spontaneous collective composition. There are moments here of pointless pointillistic playing, a sense of vamping until a new direction springs out of the ensemble. Once it does, however, it is to CCMC's credit that they are able to pick it up immediately and sustain it to a logical conclusion; in other words, despite the myriad difficulties and uneven possibilities which must be avoided, CCMC's musical solutions are, more often than not, completely natural and musically rewarding.
— *Art Lange*

MUSICWORKS

HARRY FREEDMAN VOLUME FIVE NUMBER TWO MARCH 1978
CCMC VOL. III 85 ST. NICHOLAS STREET, TORONTO M4Y 1W8

The liner notes of the CCMC's new album (CCMC Volume Three, Music Gallery Editions MGE 6) include a statement of why the group was formed. 'We came to it,' it says, 'because... we wanted to create not only a new work or a new instrument but a new composer, a six-brained, twelve-handed individual, to see what it would come up with. What it comes up with can be heard at the Music Gallery any Tuesday or Friday evening. It is music in the making—immediate, spontaneous, unpremeditated, unrepentant. Nothing new about that. The same can be said about jazz, flamenco, or any of the instrumentalists of the 18th and 19th centuries. Beethoven, for instance, first attracted attention and indeed established his reputation, not for his composition or even for his dazzling keyboard virtuosity, but for his improvisational ability. In fact, the music the CCMC creates is closer to jazz than to anything else, but where jazz relies for its organizational discipline on external elements—the chord progressions and the rigid pulse—this music relies on nothing but its own 'being'. Nothing is imposed, nothing taken for granted. It simply begins and grows. And it grows through a process which more than anything else defines its difference from jazz: it is a group process in a way that jazz never has been, not even in the early New Orleans days. Yes, there are solos, but in the context of the structures that evolve from this 'six-brained, twelve-handed composer', the solos seem to take on the function of interludes. (It is in fact one of the marks of the mastery of the idiom that the group has achieved in the relatively short time they have worked together (3 years) that these interludes seem to happen at just the right time.)

Again, the liner notes describe the process perfectly. '...The sounds/thoughts of each person are presented to a context of the sounds/thoughts of all the other persons, and they also shape this context. Everything is illuminated by everything else; the gratuitous is continually transformed into the necessary.' Exactly. One of the results, and what for me is the most exciting thing about the group, is the emphasis on texture as a structural element. It's an element that I am much concerned with in my own music, and I admit freely and gratefully that listening to the CCMC has often given me ideas for future works. In one evening, I mentally jotted down ideas for two string quartets, a work for woodwinds and percussion, and an orchestral work.

Mind you, the results aren't always equally exciting,—simply because not all ideas are equally inspiring, as any creative artist knows. This is particularly critical in music like this where so much depends on the ideas presented, where the emphasis is on the process rather than the product, where the process *is* the product. Not surprisingly then, some sections don't work too well. But far more often, when the ideas are right and the chemistry is right—WOWEE!

There are sections on all three recordings issued by the CCMC that come under the WOWEE classification. What this latest release does show unmistakably is how far the group has come, how they have developed since the first two records were released just over a year ago. It shows in the music. But it also shows in a way that seems to have nothing to *do* with the music. The record jacket was designed by Mike Snow and consists of very articulate liner notes as well as a list of dozens of phrases all of whose acronyms are CCMC. Constant Comment Mitigates Criticism. Canada Council Moves Cautiously. Chaque Chien Mange Chats. Cuties Ceaselessly Munching Crotches. Critics Commendations Mean Crap. And so on. The list was contributed by the members of the group, probably at one of those parties—you know? It's not hard to imagine the fun they must have had and the feeling that must have permeated the gathering. It's the same feeling that comes through in their music—loud and clear.

(HARRY FREEDMAN IS ONE OF THE FINEST CANADIAN COMPOSERS)

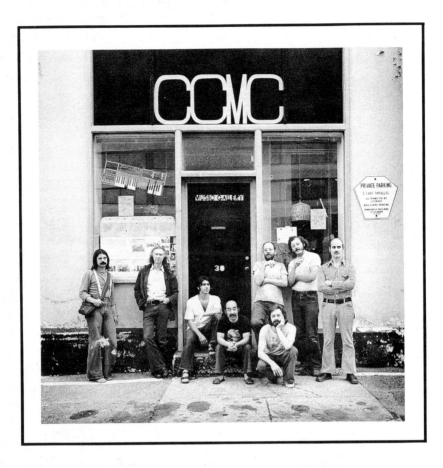

Cover of LP *CCMC Volume One*. Group photographed
in front of the Music Gallery, 30 St. Patrick Street,
Toronto, 1976. Left to right: Peter Anson, Michael
Snow, Casey Sokol, Nobuo Kubota, Bill Smith, Graham
Coughtry, Al Mattes, Larry Dubin.

A History of the CCMC and of Improvised Music

by Nobuo Kubota, Allan Mattes and Michael Snow

On June 23, 1991 Nobuo Kubota, Allan Mattes and Michael Snow met to tape record a discussion. The following is a slightly altered record of their conversation. The group called CCMC went through many personnel changes since 1975. At the time of this conversation, these three musicians were the only remaining "founders" of the original eight and Kubota had just announced his decision to no longer perform with CCMC.

Michael Snow: Well, I think I've said before that there'll be some catalogues when I have the retrospectives and one of the things discussed was that there should be a catalogue on music. So I thought it would be a good idea if we three of the founders of the CCMC got together to try to talk about the evolution of the CCMC; but not only that but about improvised music in general and the specific way we've been doing it. A history like that would include all the developments you went through Nobi, from starting out playing saxophone to arriving at when you made that cage and all the other things you did.

Al Mattes: Cage. We had cages for a while.

Nobuo Kubota: And now it's only two people. We started with – how many were there in the beginning? There must have been eight or nine.

MS Yeah, well actually, that's another thing: I'd like to try to use this tape just as it is transcribed and use it relatively straight, without too much re-writing or anything like that. So, trying to be methodical about it, I was, I was thinking that maybe it would be interesting if first Al could talk about how he got into playing at all, 'cause it seems to me that you (NK) and I joined something, joined Casey, and Al, and Peter, in a way, you came from the AJB, and I came from sort

of the AJB, and somewhere else, but if you could tell the story of how you got to be doing what you were doing with Casey and Peter –

AM What happened was, is that Casey and I were living in a house together in Rosedale that belonged to a friend of Arden's. And I had gone to, I was back at university, at York, studying music. And I was writing, you know, studying Jazz, and composition, and electronic music, and oh, yeah, all that stuff.

MS But you'd played before you went there?

AM Oh yeah, I'd played since I was five years old –

MS What did you play?

AM I played the accordion for eleven years and then I played the guitar from the time I was sixteen. So I was about thirty. And I'd played Rock and Roll, and Jazz, and I'd played, you know, Blue Grass and in bar bands, but never anything really profound. And then at a certain point, I'd taken a year off to practice the guitar, it was my wood-shedding year, I delivered pizza at night, and uh, practiced all day. And uh, the year after that, I moved to the country, and while I was living in the country, I thought, "Well I'd like to make music my career so I'm going to go back to university and I'll get a degree in music." So I went, I knew Casey, and uh –

MS How'd you know Casey?

AM I met Casey through Peter Anson. And this is long –

MS How did you know Peter?

AM How did I know Peter ... Peter was a poet, who worked for, had some connection to the House of Anansi, either he had a book of poems published, or something like that. And through that, he met Arden who used to typeset and also work for House of Anansi, and so through Arden, I met Peter, and I had lived with Peter in a co-op on Summerhill Gardens, around the corner from you.

MS Yeah.

AM So my history with Peter goes back, oh a long, long time, long before the CCMC. And we had always played music together –

MS What kind of music was that?

AM Well, we, at one point, we got into electric-acoustic music, and we had a little studio — we were doing improvised music, but it was sound. And we had a little studio in that house on Summerhill Gardens, and we would, you know, play with feedback- and uh, play with –

MS Geez, what year was that?

AM Oh, god ... '67-'68, and we had multi-track stuff, and we had bags of coins, and then we'd jingle the coins, and then record the sound, and then slow it down and speed it up, and flange the tape recorder, and Peter actually bought a couple of little oscillator boards from an electronic surplus store, and then figured out — we used resistance and capacited substitution boxes, because in those days of analogue circuitry, if you changed the value of the resistor: in a circuit, an oscillator circuit, you would change the pitch, or if you changed the value of the capacitor, you would change the tone. So our first thing was to get resistance substitution boxes, which are little boxes, and you put two leads on them, and you hook them up, in place of the resistor, and then you just twist the knob, and it goes ... boo boo be boo boo be boo boo boo boo. Right? And you do the same thing with the capacitor. And so you'd have these two things and you could wiggle them back and forth. And then Peter got on the idea of making a keyboard using clothes pegs and brass tacks. So he used all these brass tacks, which he stuck into the clothes pegs, and had wires running from the brass tacks so when you pushed down on the clothes peg, it would lift up, and there was a tack on the top side of the clothes peg, and another tack on the piece of wood above it, and and it would make a contact, and in there was a resistance, a resistor bridge, and a capacitor bridge, and each one of them, each one of those contacts actually brought into play a different capacitor, or a different resistor. So we had a little keyboard that we played on, right? And we played guitar together –

MS So let me get this, this is before you went to York?

AM Oh yeah, this is in '68, I was a probation officer –

MS Oh, that's very interesting. I never knew that before, that's very interesting. So you chose to go to York, and the reason for going to York was?

AM Well, I decided that I had to get serious about music. I was going to make music a career and I knew Casey, Casey was teaching at York. Casey was an old friend of Peter's . He was Peter's brother's best friend when they were growing up together in New York. So through, uh, Peter I had met Casey, and, uh, when I, when I spent this year wood-shedding in Toronto, I lived on King Street,

just at King and Spadina, with Arden. And, Peter and Casey would come over and we would play. You know, it was hard for Casey, of course, because he didn't have an electric piano. But, we would get over and jam, we had a percussion player, and there was a trumpet player, and we were trying to play Jazz — we were writing tunes and practicing them, and inventing these, heads, and improvising on them, but we were, doing that kind of thing. And then I moved to the country, for a year, to continue practicing and have a baby with Arden. And then, while I was out there, I decided, "OK, now I'm going to go back to school and study music." So I went back to York to study music, and in the process, I was exposed to a lot of different kinds of music. From Richard Teitelbaum, from David Rosenboom, from Trichy Sankarin, who I studied South Indian drums with. And I studied Jazz, and Jazz theory, and I was writing these, heads and practicing, and doing all that kind of stuff, and I played, uh, bass and, uh, electric bass, and, uh, the South Indian drum Mridangam. And then, in about February or so of my last year at school, David Rosenboom had a birthday party, and he lived in a loft, in around Wellesley there, uh, on St. Joseph's or something like that. So I went to his birthday party, and Rosenboom had an electric piano, and there was, I believe there were some amplifiers there. And we started to play. Casey started to play, and it seemed like a good idea to go and get our instruments. So I went running off and got my guitar, or my electric bass, I guess, I brought my electric bass. And, Bill Smith was there. And Bill Smith pulled out his saxophone, and Casey and Bill and I started to play. And it was just the first time I had ever had a free blow, like it was just free improvisation. And I can remember, like, we just wailed! It was, I'm not sure if Peter was there or not, but it was very, very exciting!

MS Gee, that's, that's interesting too!

AM And what happened was that Peter and I had this little Jazz thing that we were doing in the basement of the house where I lived in Rosedale. The basement was set up as a kind of studio. And we had, we played with a number of different drummers and we had a trumpet player, and Gregg Gallagher, uh, I think, was hanging out at the time, and we were, just getting together, and blowing, and just trying to play, trying to play each other's tunes. Of course we could write stuff that was much more difficult to play than we could actually play, so, a lot of the time we were trying to figure out how you solo on top of these, angular, uh, discourses that people were creating. And, uh, all of a sudden this free improvisation happened, and it was just ... the reasons for doing all that other stuff, just didn't make any sense. Some of my teachers had told me

that I should probably be looking for people to play with who wanted to play the kind of music that I wanted to play, and I really didn't know what that was. But as soon as that happened, uh ... we got Peter doing it, right? And then Peter became a real convert. "This was the *only* way to make music," right? (laughing) So there was Peter and I — you know the way Peter is, right? So, there was Peter and I, and Bill Smith, wailing away in the basement, and we got Casey to come down. And Casey at that time was playing with York Winds, and —

MS But, had he been improvising for years?

AM He had been improvising for years, but he never took it seriously. He got very, very excited by the energy and the free improvisation stuff. So he started sitting in a little more regularly. And then Gregg, Gregg Gallagher, who was playing with us really wailing away, said he knew a drummer who would just really dig this music, and he could bring him. And we'd tried a couple of drummers, kids from York, and that kind of stuff, but nobody could really do it. They were more into like, rattle rattle tink tink squeek squeek, you know, that kind of stuff. Percussion players, you know, lots of dinging on the bell of a cymbal, and bells in the background. And so Gallagher brought Larry in, and Larry played, and said, "I want to tell you guys one thing", he said, "I'm the drummer for this band. You can play with other drummers, but I am the drummer for this band!"

MS It must have been a great moment for him actually.

AM It was. For him it was wonderful to have *found* people who could play, who really did what he wanted to do. So, we were now Greg and Bill playing horns and Casey on keyboards, and Peter on guitar, and me on electric bass, and we were playing in the basement of 210 Douglas Drive, which you guys know ... and then, Larry said, "I know a couple of players that should come," and I forget whether it was Mike first or Nobi first, I can't quite remember but it was —

NK It was Mike first —

AM I think, yeah, and then you brought Nobi in, right? You said, yeah, I think you brought Nobi in —

MS That sounds right —

AM Yeah, I think you brought Nobi in, and then we played in the basement twice a week, and under a number of different incarnations, you know we called ourselves Raw Flesh because it really was almost like a noise band, the volume was so loud, and the energy was so high. And then, uh, we called ourselves The Toronto Sympathy Orchestra for a while, and, uh, then, this had all taken place, it all had happened very, very quickly ... it started and then we started playing together very regularly in

the fall. So that must have been the February, that must have been after Rosenboom's birthday, or maybe Rosenboom's birthday was in the summer ... seems to me it was more summery, because I can remember doing this kind of stuff through the fall, and then, we played a gig at A Space, and we started getting onto that, and I was getting out of school, and I called a meeting — we didn't play music that one night, and I said we should talk and we should put in a grant application right? So we all sat around, brainstormed, and we came up with the name, and, uh, I wrote a grant application to the Explorations Department (at the Canada Council) —

NK Right. (laughter) –

AM And I asked them for a hundred thousand dollars to start a music gallery, right? And, uh, they gave us twenty grand, and we started. And, you know, twice a week.

NK That was amazing, that we did that whole year on twenty thousand –

AM Well, we didn't. I got six more from the Ontario Arts Council ... we did it on twenty-six! (laughter) Well, also, both of us went on unemployment insurance.

MS Al, you once mentioned that playing along with Coltrane records was very important for what happened to your ideas –

AM Yeah, that's what was happening when I was learning how to play the bass, what I was doing was, I was living in the country, and of course I had no money, we were living in a barn that I'd renovated, very pregnant with Kaz, my daughter, and what I would do is supplement my income by selling bread at the local health food store. So what happened was that while, you know, bread takes four hours to make right, you have to knead it and you have to mix it, and you have to let it rise and blah, blah, blah ... so what I would do is I would put on a Coltrane record and listen to it while I would spend the twenty minutes on the process, and then I would have roughly forty minutes to wait in between while the bread was rising or whatever, you know baking or rising or second rising and so during that time I'd flip over the Coltrane record, and play along with it with the electric bass. And my idea was to try and emulate saxophone or Coltrane-like phrases as an approach to the playing of the electric bass –

MS Yeah, as opposed to playing the bass in the band, you were trying to play like a horn, in a way. Yeah, that's interesting.

AM So that's why I ended up playing the electric — I haven't played the electric bass for years, but, uh, I was thinking of starting it again actually –

MS I don't really know that much about how Casey came to what he was doing at

that time, but, uh, knowing that he was a Classical pianist and he'd said that he'd improvised for a while. To me that was kind of strange and interesting because I came to free improvising from improvising on themes in Jazz. And to me, improvising was in Jazz, and he hadn't come to improvising from Jazz. Do you know anything about that?

AM Well, he had played for years. Casey was almost a kind of prodigy on the piano, uh, but he played a tremendous amount when he was young, uh, but part of this thing, part of the thing that he did was he used to work in the Catskills, in the resorts ... so he would have to play a variety of kinds of music. You know –

MS He had to make medleys and just come up with a tune, that kind of thing.

AM And there was some improvisation in that. So, uh, the thing is, I think also that, Casey just as a piano player, because of his interest in music and his theoretical approach to it, had probably thought about improvisation in some way and had improvised ... when he told me that, uh, you know that's part of his background, uh, as a musician and as a child growing up, he used to make up, go to his father and say, you know, "What does F U R P S T O F P spell?", and his father would always try and pronounce actual letters that he said, and that, I think kind of put in Casey's mind anyway some idea of the fact that reality is what you make it, you know, that you can kind of stretch it that way. And then his, his first piano teacher was Peter Anson's father, and Peter Anson's father was a Jazz player.

NK Oh, was he? I didn't know that.

AM Yeah. Yeah, he was a Jazz fanatic, right? He could, like you, could listen to a record and say "Oh, that's Big Bill Broonzy playing the blues in C" you know, da da da da da ... you know, he knew the history in and out, and he really knew the records, there was a right way and a wrong way but as a piano teacher, he recognized, you know first of all Casey was very good, and he recognized that, but he also would not confine himself to teaching one way or the other. So they always did a little of the Jazz stuff, and a little of this and a little of that, and there was, improvisation, I think was part of it. But, he didn't come at it from the point of view of teaching Jazz piano. I mean, Peter's father made his living as a piano teacher, that's what he did, he was, the local piano teacher.

MS A lot of what you just said I've never heard before, I didn't know some of that ... now Nobi, how did you get started playing?

NK I started playing, uh, in high school, got my first horn –

MS What kind?

NK Which was a Conn. It was a silver alto-saxophone, and I was always interested in Jazz, from a very early age, and listened to all the Jazz greats, and then I finally got a saxophone. And I started practicing, and playing – I learned how to play it myself, my parents didn't send me to or weren't about to pay for –

AM Saxophone school –

NK Saxophone lessons.

MS Did you play any tunes?

NK Yeah, I used to practice tunes.

MS Well, like, what kind of things, were they more like sort of Bebop things, or –

NK Bebop things and Jazz standards, and vocal standards, stuff like that. And I just kept playing, and at some point I stopped playing when I was in university. Then when I finished, when I finished university, I went to work for Irving Grossman. He gave me my first job as an architect. And as a result, I met all the artists, because Graham Coughtry was living with Irving at the time.

MS Yeah.

NK Remember? In that place on, uh –

MS On Spadina?

NK No, on uh –

MS Oh, on Sultan –

NK Sultan, right.

NK Yeah, that's how I met Graham, and then, then through Graham, I met you, at some point, and then I met Gord and Bob Markle, and started hanging out at the Pilot Tavern and drinking every night with the artists ... and that was my, you know, my, my first exposure to the art process. And it sure felt a lot better than architecture, at the time –

MS So you hadn't done any, any visual art before that?

NK No, no, I hadn't.

MS I never knew that either, that's interesting.

NK Gord was living on Yonge Street. There was a beautiful old building, near the Isaacs – and he invited me to use the space.

MS Isabella? Or –

NK No, it was right off Yonge Street, and you went up these big wide stairs, right up to the third floor, and the entire third floor was his studio. And, I don't know if Graham was sharing with him, I don't think so. And so he said, "Use it, use the studio." So I started painting, and I was doing kind of hard edge painting, because that came right out of

architecture, and minimal sculptures, and minimalist painters – Ellsworth Kelly and all those people –

MS I just saw a retrospective of Ad Reinhart –

NK Oh yeah –

MS At the Museum of Modern Art. It was *incredibly* good, uh, it was fantastic. Amazingly beautiful, beautiful, beautiful things. I didn't know his work very well when some of these things were happening in the Sixties, I liked it, but I didn't know, and this is a retrospective, so you just see ... and it's great, great, great. Anyway, go ahead –

NK – And so I started uh hanging out at the Pilot Tavern with all the artists ... and eventually I lost my job as an architect. (laughter)

MS And you were working for Irving?

NK No, I was working for somebody else by that time. And you know, drink every night until closing. And I'd go home drunk, and I couldn't make it to work in the mornings. And over a period of two years, it just, I just sort of –

MS Slid into the lifestyle of being an artist! (laughter)

AM (laughter) Well, actually you were too drunk to be an architect, maybe there was nowhere to go but art!

NK I was going into work at noon. I started going into work at ten, and then it was eleven, and then it was noon, and then it was after lunch. And then, the guy said "You're not very interested in this work, are you?"

AM Were you doing good work?

NK Well, no, not particularly. You can't, when you're working for someone else you can never do your own stuff...so, I got fired. Well, I didn't, you know, it was a kind of a graceful –

MS "Would you mind leaving!"

NK No, he said, uh, he said, "You're not very happy here, are you?", and I said "No. I guess I'll quit." So I did, and that was my last job, as an architect. And I went to teach design at the New School ... where Gord and Graham and Bob and all those guys were teaching.

AM Was John Symes there?

NK With John Symes. And then, Gord got a studio somewhere on Spadina.

MS Oh, the one he had for so long?

NK Yeah, the one he had for so long. And that's where we started playing, the Artists

Jazz Band.

MS Well, how did that happen? Did they say, was something said, like, "Let's all get together and play" or –

NK Jesus, I can't remember now.

MS I mean, obviously, everybody decided to start playing, Gord started to play drums –

AM Well, Gord started to play drums. I think he was playing drums before, wasn't he?

MS I don't know.

AM I think so. And Graham had a trombone, and Bob Markle had a saxophone. And I had a saxophone. Geez, I really can't remember how it all started. But I do remember that —

MS Wasn't it for a gig? Wasn't it for a benefit gig for the New School?

AM No, we were playing –

MS Playing at Gord's was the thing. And it was just part of the way of living, it seems to me.

NK Yeah, yeah.

MS Everybody was such – they were all Jazz maniacs, and everybody just got really stoned, everybody drank and smoked and sniffed and took everything. So there was this whole party thing, plus the fact that everybody played. This is my feeling about it, it, would just mean that you'd *also* play, that's part of this way of living.

NK Yeah, we must have gotten together and played, you know, some, as a beginning, and then said –

MS Or, or what! I mean you know. "Bring your horn, we're having-" you know, "I'm having a party Saturday, or something, come bring your horn."

NK Yeah. Gord was always playing with records. He would play the Jazz records, and play drums with them. And, and I guess, gradually, somebody, sort of, Bob Markle, or somebody, would bring his horn and then start playing. And, uh, so we used to play, Gee, we used to play two, three times a week – I think, in the beginning. Because I just lived across the street, and Graham lived just down the street, on Spadina –

MS Yeah, near Switzer's, kind of, wasn't it?

NK Yeah, near Switzer's. And I lived above Gwartzman's, and Gordon was across, across the street. And we used to actually talk to each other (laughter), over the windows and yell at each other across the street. And I guess that's how we got started.

MS Well, those sessions, for me there's

something legendary about the whole thing that happened, when everybody got together and got so stoned. And the humour was so amazing, everybody was so funny, I mean, Rayner is incredible, and Markle was wonderful, too, it seems to me that Gordon was the champ, and Markle was a bit behind, and then there was Graham, and then there's sort of you and me running along behind in a way. But it was so funny, it was unbelievable, and the playing would just develop out of this sort of conversation, saying something, from the feeling of living something. It was quite amazing.

NK Yeah, we would wander into the studio, and sit down, and have a beer, and have a smoke, and talk, and laugh, and say, "let's go!", right? And, we used to go and play ... Gerry McAdam!

MS Yes, we mustn't forget him. A wonderful guitarist. So where did Gerry come in, yeah, do you think?

NK Oh, Gee. I don't know, there's Gerry and there was John O'Keefe. Remember John O'Keefe, the writer? Who worked for, uh, Sign Publishing.

MS Yeah, well, he never played anything, did he?

NK He never played anything, but he was always there and Gerry McAdam lived next door. One side or another of Bedford Avenue, and so, he was playing guitar and singing, and then it was that era of the Sixties, he got started in the Sixties sometime –

MS Yeah, I think it might be said to be '61, or something like that.

NK Yeah. And then, eventually it became a thing where we would constantly meet and play. And then you came and played, at some point.

MS Yeah, well, the first time I heard it, I thought it was really silly. And, you know, it probably was in a kind of way. Uh, and then I'd hear it occasionally. I went to live in New York in '62, and every summer, come back, so each summer, year after year, I'd go to Gord's place and play.

NK Yeah, whenever you were in town.

MS Yeah, and I suppose it got better, but it also got more possible for me to actually hear what was going on, and to really appreciate it. And I guess part of that was the fact that, uh, that Larry Dubin and Terry Forester were into it then, too, cause Terry, Terry played with

me, Terry, Larry and I played in the Mike White Band together. Terry was an all-round professional bass player, with even more range than Larry, because he could play different kinds of gigs, and the fact that he thought it was great affected me. I mean, I remember one conversation with him, he was just urging me to come, it was on the phone, to come and play with you guys. And he was saying how terrific it was, and I was saying, "Well, what the fuck does he mean?", you know?

NK Well, even when –

MS In my mind was this: "What does he mean — you could play," 'cause I'd played in bands with Terry. I had this sort of superior attitude to the AJB, and I wondered what he meant, 'cause I couldn't really hear it. To me, it was still these guys just trying to play, you know. But that's an interesting thing, too, because it brings up this thing about generalization of style, that, uh, I think that, partly you did this thing but Markle did it even more because I think you know more about the instrument than Bob ever did. But, there's this whole thing of playing, or being an actor, in a way, with the instrument. And, sort of trying to be what it is that you admired on the records. But you don't know how they did it, and you're not thinking about how they did it, but you're sort of *being* it, for a while. And it's a *representation* of that thing, because obviously Markle could never play what Coltrane played, he would never understand it technically, and it really has its technical, formal bases. Coltrane used different scales, and worked out different ways of doing –

NK He was very influenced by Lester Young.

MS Yeah, yeah. But no, I think one of the interesting things that happened with improvised music, is this sort of generalization of style. I mean, people that couldn't play like Coltrane, because they couldn't even play the fucking tunes, can give a representation of the quality of Coltrane's playing, which Markle did occasionally. And I could really not understand it, and in a way I still can't, how it could be effective. That Markle could really make music, and 'Trane was much bigger, you know? 'Trane had this big world, you know, with all kinds of levels to it, it's intellectual as well as all

these other emotional things. Bob didn't know anything, I would say, really, about what 'Trane was doing, but when he'd get stoned and start playing (laughter), he'd bump into some really interesting shit, you know! Incidentally that's what was supposed to have been so amazing about the Punk Rock episode in England in '77 … that people who couldn't play went ahead and played! The AJB started in '62.

AM Yeah, that also, I mean, the other thing you have to keep in mind is, you know, it's a two-way street, it's a path that, you're on the same path, as the musician that you're playing with, so that, the fact that Markle would occasionally bump into things, it might be that a casual observer on the outside might observe a certain energy transference, or, if the band seemed tighter, but not appreciate at all what you're saying. And that's in your ears and it's your mind that takes that energy and transfers it in a way so that you're grooving on what Markle's doing. So that –

MS Well, yeah, I suppose that's true, but I'm just talking about music. It's just shaping a sound –

AM So am –

MS Markle would shape sound, sometimes I'd feel — "Whew! That is just beautiful!", you know? But he didn't have the control, he didn't have the world of resources that Coltrane had, so how could it even possibly equal it?

AM I'm not saying it equals it. What I'm saying is that it's what you're hearing it with, it's how you interpret what Markle's doing, it's your ears that are saying that Markle would bump into these great things, or whatever.

MS Yes, that's true.

AM Yeah, so in a situation with someone like Coltrane, what happens is, because he can do it all the time, or ninety percent of the time, you know, a much larger percentage of the time than Markle could, you have a different relationship as a listener to that music. You can get involved in it — it offers you the chances to access it –

MS I think what I was saying before, about my, my apprehension of the AJB is a little bit related to that. It's that, really, I started to hear more clearly what they were doing. And it's really good music! That's all. And at first it was just, uh, really incoherent. It was just babies with these instruments. And I think it probably was. It did improve, but the way it improved was to make clear the whole business of making music as just shaping something, so it has a quality of defini-

tion, you know, aurally and emotionally and intellectually. And that's what was happening in the music.

AM Well, if it's an ensemble –

MS But, the thing that baffled me in a way, it still does, is that, how, where does it come from? That Bob could have played so much good music, without really, having a pinch of the knowledge, and, it's not just knowledge, that whole pyramid of stuff that 'Trane was working out of. I mean, I still find that amazing, how does anybody – I mean, to me it applies to you too, Nobi, I always loved your saxophone playing, and I used to think, "Now, what the fuck is he thinking about?", because I, because of playing the piano, I know how chords are constructed, and I, and I studied how Jazz players worked out their ways of making variations, and some of them have to do with different attitudes to the chords, but they know what the chords *are*, and all that kind of stuff. But I always thought, when I was listening to you, that you didn't know about chords, but, you had a sense of harmony that would always arrive at some kind of surprise, and I often couldn't find it on the piano, that you would do some sort of thing that would kind of change key –

NK Like a cluster thing –

MS Because since you didn't play "chordally", or harmonically, and you never really, as far as I know, knew how to play all the various arpeggios or modes, or even just major scales, or something like that. So, uh, where does it come from?

AM Well, when you practice all the time as a group, the AJB continued to play, so as a group what happened is that the individuals within the group, and the group as a whole learned their chops. I mean when they started to play, they were all babes in the woods, but they approached it from an emotional kind of perspective, and they played so often, you can't help but get slightly better, and –

MS But, what were they doing when they played, and if anybody played at home, what were they doing? I'm saying that against the background of what I did when I played, before I found out how to free improvise — was I always played tunes, and I tried to develop ways of improvising on the tunes and all that kind of stuff –

AM See, I can't do that at all, I absolutely cannot, I've been practicing at home, and I do it, I can do it on Country music, right? Or maybe I could

improvise a solo on "Summertime", I could do it on Country music, but I could never understand how people could take a melody, and improvise on the melody –

MS But that's what I know.

AM Yeah, that's what you know! But I could play back up guitar, see I can play pretty little guitar fills in figures, around a melody, I have no problem with counterpoint, I have no problem with, I've got a great harmonic sense, and, especially if you're playing standard stuff on the guitar, like Country music, or Rock and Roll, or even a lot of kinds of Jazz, you simply have to find the scale –

MS Did you study harmony?

AM I did when I went back to university, but I'd played guitar for years before that, and the thing that I really couldn't do, was do these solos, I could play a thousand different folk songs, and I could play Ragtime — I mean I was a very good guitar player, I was playing you know, "Maple Leaf Rag" on the guitar. But, I could copy stuff, but I can't, I couldn't, I could do the fill ins, but I couldn't do what is considered a solo. Then I switched to the bass at a certain point, when you have the bass, I still can't do it on the bass, like you know, you're playing a Jazz tune, right, and the bass will be just going, ding, ding, ding, playing and stuff, and I could do that, and then the bass player gets a solo. I don't think like that. I don't think at all like that. But, what I do, is I make up melody lines all the time, like what's happening is, in my head, when I'm playing music is, I'm singing, and I'm just making up a line. And it's a combination of, it's like what I've heard, and it's very Jazz-oriented –

MS Well, that's the Ornette Coleman way actually.

AM Yeah, but I don't, I can't take a head, I mean I could write a head, and learn it on the guitar so that I could read the notes, 'cause I could read music, and I could write it, and then I'd play it two or three times, you know, and then I would improvise. But if I was going to improvise, it would always be free improvisation, because once I've played it (laughter), I don't want to play it again, it's boring! You know?

MS Yeah, well, that's an important thing actually, for why one would want to improvise. It's just that it opens up a whole business of that – everytime you play, it's new music! And that's pretty terrific. (laughter)

AM It is! It's a great way to shape the time that you're in. Every time that you've got to play music, it's a nice way to shape it, I mean even if you're practicing, but if you're practicing free improvisation, it's a nice slice of, uh, it's a nice way to deal with the world.

MS Nobi, I always thought that your playing was sort of "Johnny Hodges", in a way. But, did you listen to him at all?

NK Oh yeah, I listened to Johnny Hodges a lot.

MS When you started to play, is it a little bit like I was saying about Markle, you get involved in trying to play the things that you've heard that have moved you?

NK Yeah, exactly. Like if I'm listening to, say, well, let me say another very interesting thing, is that Gord Rayner, Graham Coughtry, Bob Markle, and myself, have absolutely *no* idea of the traditional forms of music. Just, you know, C, D. What's a D?! You know, absolutely no idea, and so I think, we, at least, I would then emulate Jazz, Jazz musicians that I really liked. And I would listen, I would listen to Coltrane, and become very excited, like emotionally really excited, and know that the excitement comes from the manner in which John Coltrane is playing this music. And so, when I'm playing with the AJB, I would superimpose that kind of preconceived feeling about being really high from the music, and try to reproduce it –

MS That worked very well!

AM I think that's where the effectiveness comes in, when you can, and that might be the thing that you're reaching for in terms of Markle. But it seems to me, that one of the things that musicians do and their music does, is to provide pathways for people to get in touch with emotional states. And a composer tries to trick you into, or lead you, whatever the phrase is depending on, whether you're being harsh on composers or not, tries to lead you on a kind of journey that, contains, has emotional benchmarks, and you just have to look at the kinds of, the 'Italian instructions', vivace and allegro and all those kinds of things that carry a certain amount of emotional baggage with them because some of the terms have gotten into common usage. So, I think that's one of the functions of, uh, musicians. And when you start to be able to, yourself, get in touch with a certain emotion –

NK That's right –

AM That you might have experienced by hearing 'Trane, or by hearing Charlie Parker, or by Pharoah Saunders, and I think that Pharoah Saunders, see for me, Pharoah Saunders has to enter into the equation there –

MS Yeah – I played once with him in New York.

AM Because the last records of John Coltrane, when he was playing with Pharoah Saunders, were

the records that I started listening to when I became interested in Jazz. I can't play, I don't know any standards, I mean I don't even know what they are, I only heard Charlie Parker for the first time two years ago, right? (laughter)

MS Amazing. What do mean, you hadn't heard them (?!)

AM I mean, I might have heard it, but I never did know it was Charlie Parker. See I came at it from a completely different way, and what happened was, I heard the risk taking, and I heard out of Pharoah Saunders and John Coltrane, especially on "Om", I heard the fact that you could move farther and farther away outside of what the chordal underpinnings would normally dictate that you could do.

MS Yeah, that's good. Yeah, yeah.

AM Right? So, and I could hear that much, and so what would happen is that freed me so that instead of playing along with the electric bass, you know, I also had a saxophone at that time, I was trying to learn to play the saxophone, but I was living in the country, and I couldn't practice in the barn, and I couldn't practice in the house, because the women in the house didn't like it. (laughter)

NK The women didn't like it!?

AM Because the cows, uh, next door –

MS The cows?

AM Yeah, because, you know, they don't like it ... I actually, it kind of implied that I was, uh, when I was practicing at milking time that there, it was disturbing the cows –

MS Oh, it probably was!

AM The sound carried, you know. I had a soprano sax, but I think that what happens is you get in touch with, as you're able to get more in touch with that emotional thing, then you can start conveying it, providing access for the audience –

NK That's right.

MS Yeah, well, you can take this definition back – I was thinking about Eric Metcalfe when he invented the persona "Dr. Brute."

NK Oh, yeah.

MS What he did comes out of the visual art world, and he made a kazoo saxophone, and what it is is a representation. There is this Vancouver thing, and Hank's involved in this too, Hank Bull, that's not so much playing music, as representing it? And, and, uh, the AJB at first, seemed to me to be like that. But, this is the thing, I don't think there's anything more we can say about this, really, but what is important is the point where it stops being representation and becomes itself.

NK That's right. It turns into a –

MS And you begin to create something. Which is, I mean, it's a very, a very interesting thing how music can be made, by people who can't play. I mean, you imagine, I have these tapes where we (the AJB), it was Christmas time and we tried to play "Joy to the World", well, it's just a scale! You go duh, duh, duh, duh (laughter) and nobody could play it! But they tried and it's something else!

AM Hard to find! –

NK And it would be all wrong, and –

MS But it's a wonderful tape! And the other one I've got is trying to play "Mood Indigo": dah, dah, dah semi-tone changes!

NK That was very humorous music. Very satirical, I mean, we used to play heads all the time! That's what we did.

MS Sort of, yeah!

NK That's what we did, we'd say, "This is our head,"–

MS Or, you were going to play "Milestones": duh, dum, duh – (extreme laughter)

AM Hah, and all these different notes that were added! (laughter) That reminds me of the Portsmouth Sym-*phony* Orchestra.

MS I've never heard that, have you ever heard it?

AM Yeah, yeah, I've heard it, I mean not live, but I had a record of it at one time –

MS Beethoven piano concerto.

AM But these people — in the Portsmouth Symphony are all people who simply wanted to play. One guy, the originator of the orchestra, he kind of wanted to be a conductor. He got them all together, and supplied them with music, and he gave the downbeat, and they all know something of the music, like they know Beethoven's Fifth, everybody knows dah, dah, dah, dah and they all have music, and they can sort of play in tune and they play, but they play with a lot of gusto and fervour. And they tackle it.

MS Yeah, that's interesting –

AM And they're not afraid of making mistakes. So what comes out is this, it's, it's a kind of caricature of, of the music as it's written.

MS The *sound* could be interesting, their mistakes make a new music, like the AJB and "Joy to the World."

NK It actually did make a whole new music.

AM It can, but what it does is actually –

MS Is it more funny, like Spike Jones or something?

AM No, it's not like Spike Jones, but what it is, is it gives you, um, it's like it's a different instru-

ment. One of the things that's really affected me in terms of thinking of music is, uh, from David Rosenboom: the idea that, whenever you go out to play, it would be nice to be able to create a new instrument that was exactly you for that night, right?

MS Yeah!

AM And so his whole thing about, uh, he was trying at one point when I was studying with him at York, to figure out a way of analyzing his Beta brainwaves, you know, he was one of the pioneers of Brainwave music, and he wanted to use computer analysis to analyze the, uh, Beta component of his brainwaves, 'cause he thought within that, he could find out where, uh, the thoughts related to music lay, which could control the synthesizer, or, the thoughts that were as a result of music being played — whatever the processes were, he could write a program. So, he was trying to get it so that to start a concert, this synthesizer computer would play a note, and if that note was pleasing, there would be a certain reaction, and if there was, then the synthesizer would play another note, and the second note would be chosen based on the brainwave reaction to the first note. And then the interval in between would be measured, and then gradually the computer would evolve a piece of music that was under the control of the brain, uh, and the person would never touch it, just sit there and meditate, and the computer, basically you can think of it as the composer, is trying to please the performer, right? So, that idea of having a new instrument every time, that's why when we first started, I used to make so many things —

MS Yeah —

AM You know, I made all these gong racks, collected brake drums, and cannon shells, and tuned gold mining pans. That was all to create other tonal possibilities, other instruments that you could approach. The Portsmouth Symphony is like that, that cluster of sounds which appear. You know that it's Beethoven's Fifth, or Mozart's, something or other. You know it, because you've heard it, and the phrasing is right, because they play the dah, dah, dah ... it's not, but it's just that the duh's are not all together, you know (laughter). And the pitch is wrong, but they're emoting in the right kind of way, and you can get this image of the guy conducting, and you don't know —

MS Is it any good as music?

AM It's interesting, and it is really a commentary on the times, I think, more than anything else. 'Cause you have to remember that, along with all this development is the whole phenomenon of what was happening in terms of the evolution of music, and the evolution of art music, and the kind of stuff that was happening with Alvin Lucier using brain-

waves to, um, amplify kettle drums in the Isaacs Gallery, you know, that piece that was done. Where you're starting to get a real interesting crossover between music and visual artists and artists getting into that kind of thing — and Harry Partch, these instruments were designed to be, um, looked at as well as to be played, I mean they're all handsome to look at —

NK Yeah, yeah —

AM So there was, this whole thing was happening, you know, there was the Scratch Orchestra, Cornelius Cardew, you know?

MS Yeah, that whole idea that since any sound was usable, amateur sound could be usable too. Which leads to thinking, well, an amateur player could play interesting music, which gets back to what I was worrying about. It ties in with the widening of range, of allowances as to where sound could come from. It's being able to hear all kinds of sounds, and that's Cage's influence, in one, in one sense. So, it starts to apply to, you know, any sound, or a sound that's made by an untrained person, too.

AM I think that any sound, or sound made by untrained people, can be useful, and can be listened to as music. It's just that, by and large, my experience is, is that if the people aren't very good at it, it's not worth listening to, for me —

MS Yeah —

AM They might enjoy it, but unless they're able to develop sufficient skill to provide, either a musical challenge to me or access to some emotional data field within me, that is interested in being explored at that particular point, then I'd rather not hear that.

MS Well, that's one of the things we found out with the CCMC, of having people sit in — how often it was *bad*. You know, sometimes when people in the audience who couldn't play, just couldn't stop themselves from coming up and playing something. It was always awful. And it's, it's surprising how frequently it was awful. And I sometimes used to think to myself, "Hey, maybe I'm being hard on it, because they've butted in, and I want to exclude them, so I'm not listening, you know?" So, I'd start listening, and it still turned out to be shit!

Al, you mentioned this, uh, making instruments thing, and it reminded me that in the AJB, you Nobi, made some things, it seems to me there was some xylophones, or something or other?

NK Xylophones, and tin — we had a lot of

tin cans, noisemaker stuff started to come into the music –

MS And that's pretty interesting, 'cause I used to read, you know how these histories get written, that the AACM were the first people to use these little instruments and toy instruments, and, uh, that kind of stuff. Some kind of historical claim, but the first time I heard it, was, was with you guys, with the AJB.

NK Yeah, that's true. We started playing at the Isaacs Gallery. And, we continued played in the Isaacs Gallery until we got kicked out for making too much of a ruckus in there.

MS What, were they, uh, announced things or –

NK No.

MS You just completely used the gallery –

NK We just used the gallery to play the music.

MS On, on Yonge?

NK On Yonge Street.

MS: Well, for a while there was a piano in there, wasn't there?

NK For a while there was a piano in the back room. And, and so that's where we used to play. And there was, uh, Ian Henstridge used to come and play and Gord Rayner, Graham Coughtry, Bob Markle and –

MS Oh yeah.

NK And Wimp Henstridge, a great saxophone player. He taught me a lot about the sax and different scales ... that was where we first got started. And by the time we moved into Gord's studio, the music had *formed* into a particular style. And we would play heads! We'd play heads. And we'd begin with a head and end with a head!

AM How would you know when to come back to it?

NK Oh, we had it all figured out. Gordon would do one of those –

MS Oh, he'd do a signal of some kind?

NK Boom, boom, boom, and then we'd come in, and we practiced that. You know, once or twice. (laughter) And, we used to make up, uh, songs ... like "Is it Addicting?" Remember that one?

MS Oh yeah, yeah, that's true. That's on the first AJB album.

NK And everybody sang: "Is it addicting? Is it addicting? When you ... when you," uh –

MS "Stick that" –

NK "When you stick that needle right in your arm-" (laughter) And we used to go on,

and people used to listen to us and go, "Uh, well –" It was very, very humorous music.

AM Well, the attitude was so completely different. I remember when you came to the, to the, uh, CCMC, you asked us if we had heard of the AJB, and Larry, of course had, and Gregg had probably heard about it, but the rest of us hadn't, but you said that the band had been playing together for a number of years, and doing this kind of stuff, but you thought there was only one of them in there that could really, that was really a musician, and had a musician's approach to it, and could you bring him. And that was — (laughter) I hate to go on print with that. But, I remember you saying that when you brought Nobi in. Then, I mean we used to really kick ass in the basement. I mean, I know that Henry Tarvanin, you know, the theatre director, lived across the street, second house in. And he used to say, I saw him several times, he said, "Boy, you know, it's a wonder no one ever called the cops" (on us), you know?

MS Yeah. We used to just steam in there.

AM We were playing 'til 11, 12 o'clock at night.

MS Well, Larry would never stop playing anyway! I mean, Larry played all the time.

NK Then we used to go upstairs and listen to it.

AM Uh, did we do that?

NK Yeah, sure, we used to go up in the living room and listen to it, a tape of it. That started then.

AM And we did it twice a week. You know, I remember a couple of times, we actually did it in, uh, before we had the electric pianos, Casey would try and convince us to go upstairs, and we would do it in that little music room.

MS Oh, yeah, that's right, yeah. So, when the music had already started, who was in the CCMC, and why do you think? It was big band, it was really incredible.

AM Who was in it ? Well, there was still eight people in the band, and Graham, uh, wasn't involved at that point, but there was Bill Smith, and Nobi, and you, and Casey, and Peter, and me, and Gregg Gallagher. Yeah. And then what happened was, I remember, everybody chipped in to, uh, help renovate the gallery, like everybody did something, except for Bill Smith.

NK We did a lot of work.

AM We did a lot of work. Michael made the sign. And, uh, the night we opened, Gregg Gallagher, um, wanted us to play tunes. And Larry put up a sign saying "NO TUNES ALLOWED."

NK No tunes. That's right.

AM And Gregg quit the band. So, we were down to, at that point we were down to seven.

NK And Graham used to come and play with us –

AM And Graham used to come and play, until I told him not to come anymore.

NK Or when we built that studio. Remember the studio we built, behind that wall?

AM Yeah, remember the first thing we did, is we had to build a bandshell, right? So we built that bandshell out of masonite, or tentest, we hung all of that stuff out. We had sanded the floors, and we had painted the walls, put in lights, we found lights in the garbage, they were renovating the bank building across the street, and Peter and I went and scavenged all those great industrial lampshades. We had all of that, uh, all of that stuff, and we were doing our twice-a-week concerts. Nobody came. The first night, remember opening night? It was January 25th, and it was so cold, and there was no heating in that building –

NK We had rented that industrial heater-

AM And there were no chairs, so everybody brought old cushions, and people sat on the floor, and we played, and our friends came. David Lee came, and Laura was there, and Arden was there, and, uh, we would fire up that big space heater, and drive the heating in the building up to eighty degrees –

NK Then turn it off –

AM Then turn it off and play again! Too cold, we stopped and fired her up again. (laughter) It was really great, Larry would just come there every day … Larry used to race me for the parking space. I always thought it was grossly unfair, you know? 'Cause he did nothing! And I did, I had to do all the work, to organize that space and raise all the money, Larry would be able to get there earlier in the morning, because I had my kids to drop off at daycare, and he would get the parking space. And, he would sit in the back room and play the drums, for like, eight hours! Got his own space in there, night and day. Just play, you know. And he started, his idea was that what it should be is a place where musicians would just drop in and play with him. (laughter) Whoever wanted to –

MS And that's a pretty good idea!

AM It *was* a good idea, but we could have never survived like that. We didn't. Our first concert, our first concert after, um, CCMC, we played, we were the only ones to play in February, the only ones to play in March, and in April, I prevailed upon David Rosenboom to do a concert. And that was the first gi' we had. We did something like, uh, twelve, or fifteen concerts the first year. Our season started in the following September. And we had, you know, Maury Coles, and –

NK Oh, Maury Coles! Geez, do you see him?

AM I haven't seen him for years. I was thinking about him the other day.

MS What was it, was it every Tuesday and Friday concerts, that we played at first? And for how many years did we do that?

AM About seven years. Or six years. We certainly did it 'til after Larry died. And then we let that new kid in the band, what's his name?

MS When did John Kamevaar join the band?

AM John keeps on saying, "You know, I've been in the band ten years now guys, or eleven years, or whatever it is, that's a long time, you know — and I still get treated like the new guy. I've loved this band. I love this music."

MS Well there's only two originals left, and, in fact, you're the original!

AM Yeah. I'm the original, Well, you guys are actually the –

MS Well, we're all the originals, in a way.

AM But Nobi doesn't play anymore.

MS Yeah. That's too bad.

NK It is.

MS (laugh) Play again!

AM He can't. He's forgotten everything he ever learned. But uh –

MS Yeah, well, smoke some dope and it'll come back.

NK It'll always come back, yeah, like riding a bike!

AM You never forget. But I think our music has evolved a tremendous amount. I mean, I think if you went back –

NK Oh, it's gone through incredible changes.

MS John Kamevaar has been a major part of those changes. As I remember it, he used to come and listen to us … wasn't he a student of yours at OCA, Nobi?

NK Yeah, that's right. I brought him in.

MS After Larry died we were all so shaken up we couldn't consider finding another drummer. Who could compare with Larry, anyway? So for a year or two it was Casey, Nobi, Al and me, right?

AM Well, Peter Anson was on the tour of Europe, when we left on the very day Larry died. But after that Peter left the band and John joined.

MS Peter plays some beautiful stuff on the first records.

AM Yeah, he was a terrific musician.

MS John's evolution is sort of like yours, Nobi. With us, anyway, he started playing drums and guitar but got more and more involved with electronics. His

90

last three years of stuff is wonderful ... he uses quoted material ... like from a sound effects record in "Things Go" on the blue *CCMC '90* cassette, in a personal way. I mean the reflex, when and how to place what ...

AM Yes, and the more recent keyboard sampler work is really beautiful, too. Occasionally the blend of electronic sound is so total that I can't tell where it's coming from, him or me.

MS What he does is more atmospheric, if that's the word, than what you're doing, though. It's really different. Your sound is totally constructed, whereas his has a representational aspect.

NK John played great when we played that week of concerts in Avignon, in France.

MS Too bad we didn't issue something from those tapes. I don't have them, do you, Al?

AM I have, I have probably twelve years worth of cassettes. I have all those –

MS Do you ever go back sometime and just pick one out arbitrarily, say Tuesday, March 3, 1980. I have as many tapes as you, some of them I never got to listen to, even. They still have their original "covers" on. I should add for the benefit of possible future readers that CCMC records *all* concerts.

AM I think, I think I've listened to every one.

MS Wow.

AM I've listened to every one. But, I can't even begin to estimate how many hundreds of tapes. I've got them in boxes. They just go up on the shelf. Tapes are piled three high on the shelf and four deep and there's probably –

MS Remember, probably about five years ago, somebody from I suppose it was Casey's class, a woman was going to go –

AM Yeah, she did –

MS What did she do? She went over all the tapes?

AM She did, she listened to all the tapes –

MS My God!

AM And she wrote down on the, uh, tape cover, who was playing, uh, on each of the tapes. Because when we first started, we always taped everything, but we didn't know things like: always write down all the names of the people that were there, how long the piece was ... I mean Peter used to be the recording engineer, and he would do it and play at the same time. Remember the first thing we had was that cupboard that we had built, um, that was made out of pressed wood, with all these hinged doors, with locks on them. And, that's where the studio was kept, so that Peter could, sit in the concert hall

and record it.

MS Well, I'd like to make explicit, but I guess it can't be, what one does, when one improvises. I mean, I had to learn how to do it myself, out of this background of having played variations rather than making the whole thing up. And it really took me a long time. And, at first –

NK To what, to just –

MS To just play, and not to play 'on' something.

NK On something. To just play whatever you wanted to, well, whatever.

MS Yeah. How did you, I mean, at first I didn't know, I do now, but, I mean, what do *you* do, when *you* do that?

AM The thing is, when you improvise on a theme or a melody, or do a variation, which is probably, I think a very key word that you just used, in terms of variation rather than improvisation. I think what happens is that you have reference points. Certainly, you know, a Jazz combo, the piano player's providing a harmonic reference point, and the bass player and the drummer are providing a combination of harmonic and rhythmic reference points so that the improviser has a lot of touchstones, uh, to come back down to –

NK Right. Plus his own mannerisms.

MS But you're all playing within a form. 'This is the bar of C, and this is the bar of F 7th, and you work with that.

AM What happens when you free improvise, and where the trick is, is that, when you're improvising, or doing those kinds of variations, you think forward, to where those touchstones are. So you're building lines with a foundation underneath you, but I believe you're more in reference to the future. I think when you free improvise, because you're making it up as you go along, you have to be more attached to the past, so that what you're doing, is you're building melodic phrases that, that refer to what you, what you just previously stated, rather than to an underpinning.

MS That's very good.

AM You do the same thing when you're doing variations, but you're not-

MS There's no underpinning (with free improvisation).

AM Yeah, but, but when you're doing the variation thing, you think back to the past — because sometimes you'll build the same kind of line, you know, you'll do a repeating pattern: do, dee, di, do, dee, di ... so that's obviously self-referential.

NK Uh, mm – yes.

AM But in order for free improvisation to work, especially the kind of free improvisation that we do, which is so linear, in conceptual construct, I think

what you have to do is you have to be focused more on where you've come from, at the same time as where you're going to, so that you tend to think in 'larger' musical thoughts. That's what my feeling is, what you're trying to do is to think backwards and forwards at the same time, and it gives an unusual length to your phrases. I think that your phrasing, Nobi, was very unique, and that's what set you apart from other saxophone players. It wasn't necessarily 'breath-based', although it has to be, because you have to breathe when you're playing. But, that's when Mike was talking earlier about, um, you know, your understanding of the underlying chordal thing, is not always explicit, it's because where you would come to rest, was very different from where one would expect you to come to rest. You know, if you're running up a, an arpeggio, whether you know the notes or not, but if you play C, E, G, B natural, the ear hears a, a C major 7th chord, you know, and if, if in your phrasing you stretch beyond that and, and turn back around, and come, instead of on a four beat or something like that, you end up on A flat, or a C sharp, or some other unexpected thing, even if you've already outlined that, if you then proceed to add a C sharp, you know, a C major 7th with a, with a flat 9 on top of it, is not a commonly heard, uh, chord. And I think that's what happens. It's not because of your intentional disruption of traditional harmony, it's because your phrases are different. I think that's because of the fact that you are building music in a different way.

NK Yeah, yeah.

MS It's funny how you can, uh, with a piano, and I guess with any instrument, like sometimes I just sit down and, and I play, my hands play something, and I just listen to it. And if I'm really feeling like playing, there is some implication in the first thing I played. Which I played with absolutely no thought except sat down at the piano and played this chord or this note, or something. But the first notes seem to imply some next move of some kind.

NK Yeah, there are a lot of implications in that –

MS Yeah, there are a lot of ways it could go, but there are some implications in the first gesture that you could –

NK That you make a choice –

MS That you make a choice, and you go to this one, and you go to that one, and all of a sudden you've got, as you've said, I think really beautifully, a 'past', and the past is the reference, the sort of form that's developing, and you can stop it too,

you don't have to, once you recognize that it has a certain kind of shape to it, or it's this kind of system or implies a kind of system, you can stop that, and you can surprise it. I mean, everything is open, formally. But the thing that has to be there is recognition, I think. That's the difference between an amateur and a professional, is that, is that you recognize that it has a character of some kind, and you either strengthen that character, or you cloud that character, or you interrupt that character, but you know by the way that you create the music that you *recognize* that it has a certain character and a certain form –

NK And a specific set of shapes made, right?

MS And I think that a good player, a good improviser does that, but you know, the way you can start from anywhere is really pretty fantastic. And Casey sometimes would play solos that were involved in just slight harmonic changes, 'cause his harmonic knowledge is, as you know, pretty fantastic. And I remember some of these things which weren't, they never had a, a sort of dynamic quality to them. It was just that they were harmonic, only harmonic variations, where you play a number of chord sequences, and then lower this note and raise that one, and you could hear that the choices that he was making were complete, were harmonic. And there were these shifts, and the improvisation was just simply about shifting notes to make this a 3rd and that a 4th, and all that kind of stuff –

AM Yeah, yeah.

MS And you *hear* a mind making these selections.

AM Well, that, I think, also comes when you start approaching your instrument — one of the things that Peter did, uh, and I think there's a certain influence, I don't know whether it comes from Casey, or it came from Peter, or it was mutually agreed to, but it has to do with working with the architecture of the instrument that you play.

MS Yeah.

AM You can see it very obviously when you're playing two-handed pattern pieces and you start with a simultaneous pattern, then you do three against four, you add a note. But I know myself on the guitar, and it's harder on the guitar because you don't have the same kind of sustained possibilities as you do on the piano, and you've only got one set of notes you can play with, not two sets of notes. But

I'll do that. I'll set up a pattern, then change one note, and then you come back again and you lower one note, and you're working within a very small, uh, it amounts to a very, very small change. At York University, what was prevalent at a time, what we were talking about at, uh, or some of us were talking about at school, had to do with information theory.

MS Yeah.

AM And that whole understanding that what information is, is a disruption, or that whole idea that what information is, is like a disruption. It's when something breaks the pattern that your mind is, is running on. So that, um, you get the most when the new information comes in, because it creates new pathways in the brain.

NK Yeah. So it becomes a new game.

AM Yeah. So what would happen is, we would make that kind of music, it was kind of minimal music approach. You start with, very minimalist projection, maybe like a Terry Riley figure, or something like that, you play it for a long, long time, and then you change one note, right? And you gradually evolve stuff. There were a lot of people up at York who were doing that as well. That was in the air at the time, remember, like you know, Teitelbaum, and, uh, whatever that, what was his group called, that he played with?

MS Musica Electronica Viva –

AM Yeah, that's right. But they, Richard told me that when they were doing free improvisation, which, he had been doing for years, when, I mean I went to York, I was out in about '75, so I went '75, '74, started in the Fall of '73. And he'd been doing free improvisation in Europe in the late Sixties, and they played at a club, and went wild — the students got so excited, by the music, that they rioted — it was in the student union building — and they burned it down! (laughter)

AM It was this whole idea of freedom and –

NK Whoops!

AM: And you know 'anarchy', and, uh, down with repression, and anything goes, you can just get out there, and you know –

NK Do whatever you want.

AM Do your own thing! Right? You know, stick it in your arm, right? And is it addictive? Whatever, you just went out and did it. That was, don't forget how much drugs we were smoking in the late Sixties, you know? I mean it was not this — yeah, we were talking about it the other day, you know, you get a lid, right? You remember that, lid, fifteen dollars!

NK Right.

AM You know, remember that Jefferson Airplane song where the guy's singing, "Sometimes the price is fifty-five dollars, prices like that make a grown man holler", you know? What does it cost

now? You can't even find it anymore! But I mean that was a whole off-shoot of the Sixties, hippy movement, you know, and so free improvisation also, don't forget where it grew out of.

NK Yeah, it grew out of there. Yeah, it's part of that whole thing.

MS Well, maybe –

AM I think, I think Ornette's a big influence there –

MS Yeah, but he didn't come out of anything like that. He came out of, you know, just, uh, his own weird way of playing Blues and Charley Parker, and hearing things in his own way. But you reminded me of, this, I've thought sometimes that, uh, in the CCMC, one of the great things about it was, and is, that it's a number of individuals playing together, none of whom are really, uh, they're all individuals, or soloists in a certain sense, and that we really (laugh) couldn't get along otherwise except for music! Not that we would fight or anything like that, but that everybody's very much in their own world. And not having to subscribe to somebody else's thing, which would be playing *their* compositions — not one's own.

NK Yeah –

MS But then even if it was one of our compositions, it would be an aspect of the personalities of the people played.

AM Their musical personalities. Because we all do get along, we have a much broader friendship outside of music.

MS Like sometimes, I can play and ignore the rest of you guys, and it can be very interesting music. You know, just (laughter) the thing is, there's four or five people all playing simultaneously, in the same room –

AM Yeah.

MS And even if we didn't listen to each other, and each of us is playing interesting music, put the music of three powerful music personalities together, and play it simultaneously, even though they're ignoring each other, you've got some interesting music, you know. That's a provocative thing.

AM I think it is — but I wonder, if we were actually to try that experiment, if we were to take three really strong solo performances, a piano player, a horn player and a guitar player, or something like that –

NK That have never played before?

AM No, but who weren't playing together. Take Derek Bailey, you know, Marilyn Crispell, or Cecil

Taylor, um, and Han Bennick. Take three records, one of each of them, three tapes, push all the start buttons at once, and listen to that music –

MS I think it'd be great!

AM I think that it could be, that you would find moments of coincidentally, um, that would make it seem like the music was actually being performed as an ensemble, but I think that it would be, very, it would be very unlike what happens when we play.

NK Yeah.

MS Yeah, well, in fact, we don't *ever* ignore each other totally. But I know there's a place you can go sometimes, that I do, where I just play for myself, but I don't feel like I'm alone. It's like when Aleck plays with the TV on, he's an only child, and he's got the TV on, it doesn't matter whether the sounds on or anything, he doesn't even barely look at it. Sometimes he looks at it. It's just company and he draws while it's on.

AM Yeah.

MS So you know, I'm in my own little thing there, working on this shit, and you guys are too, and I can sort of hear what you're doin'!

AM When that kind of thing happens though, the other people in the band, someone in the band, is probably playing a role in response to you, or –

MS Yes, that's another sense –

AM Functioning as an underpinning, perhaps.

MS Yeah, yeah.

AM I mean I vamp on my synthesized guitar now, but I don't, I don't play chordal things, I play what just amounts to musical commentary, that has the same effect as a chord.

MS But I think that's one of the most beautiful discoveries in improvised music, that there's a social adjustment that happens within the group, that can involve, you know, maybe you can start with this ridiculous idea, that everybody's playing without listening to each other, but there's a subtle relationship, say, you've got five people, well, these two are listening to each other, while the other ones aren't.

NK Um, mmm. It's a matter of degrees.

MS That's a different thing, you know? Where these two, maybe they're not listening to each other, but they're in the same register. It's all bass. Perhaps, or something like that, there's so many, it's almost, almost infinite, but the thing has opened up, in a way, that I don't think anybody, even Derek, in his book on improvisation, which is practically the only book on improvisation, which is amazing, doesn't talk about how, there's so many, there's so many possible inter-penetrating levels, out of which one could make a great piece of music, out of social interaction, and social interaction that includes being, uh, practically autistic, as well as it involves being very aggressive, against, against the rest of them, which can happen. You know, like the way Han Bennick used to play, I think you guys went to hear Han Bennick and Derek, in, uh, Amsterdam. I mean Derek could not be heard all night, and Bennick just played bang bang bang, very loud. And it was great, undoubtedly –

AM There's also, there was also the saxo, uh –

NK Saxophone player. What was his name, uh –

AM I almost had it … Broadman, was it Broadman?

NK Peter Bronfman.

MS Broffman, not Bronfman! (laughter) Brockman.

AM Brottman, I think.

MS Yeah.

AM Yeah. Three of them playing, right? And they just, they really didn't seem like, um, oh, Derek was just not there, Brottman and Bennick were-

MS Yeah, but he continued to play –

AM Oh yeah, he just played –

MS Yeah, well, that's what I'm saying, is that this is an interesting example of an understanding, Derek's understanding that *this* is what is happening – at *this* time, that it wasn't a total negation of his part but just a particular social/musical situation.

AM Yeah.

MS And this is, (laughter) like, "I'm just going to keep on playing my thing," you know? Being myself.

NK Yeah, no matter what anybody else is playing –

MS And he likes Han's playing! I'm sure he thought the whole night was great, and he probably didn't get hurt at all.

AM No. When Derek was doing his touring orchestra thing, "Company", he would have had huge, big bands of people –

MS Yeah.

AM But they didn't all play together. And their way, their idea of, uh, free improvisation is very — I think ours is different, ours is very unique. The Europeans used to comment on that, to me anyway, when we were over there touring. They would say, "You guys don't play the way we do." You know?

In fact some of them didn't think we were doing free improvisation at all, because it was too jazz-like, it was too linear. You know there was an old British school of –

NK Yeah. I remember all those comments. But we played, we always played as a group. The most interesting aspect of the CCMC was its ability to compose as a group.

MS Yeah.

NK Like, you can lump, you can be sort of listening to the music, and hear three or four people as a group, and then isolate another person, and, uh, um, there's always, as you said, there's always an acknowledgement when somebody is soloing, right? Saying, "Oh yeah, this is, this is –"

AM Well, there's not always!

NK It was always, you know, you'd say, "Oh, Mike's playing a solo, it sounds like Mike's playing a solo."

MS Yeah, this is the part, yeah.

NK And then you'd do something, you'd play something, and then you'd think, "Oh, that's interesting. I'm going to play it on top of that!" (laughter)

MS Yeah!

AM And there goes his solo! (more laughter)

NK Yeah, but that always happens with everybody, you know?

MS Yeah.

NK But out of it comes this unique composition because of all the combinations and variations-

MS That's a good point, that we often did make things that had some kind of entirety, some kind of unity, you know — one great example of a total composition is AKA Friday the Thirteenth on our volume 4 LP.

NK And there were always, the compositions, that were always unique, because we all heard each other very differently. Right? And we chose things out of our playing differently.

AM But I don't think that's what happens anymore. You see, I think that the music has evolved, and it might happen occasionally that an individual member within the band, while they're playing, might disappear, in the way that you're talking about disappearing, like wrapping up in your own world and just, um, you know, being aware of the others, that they're there, but it's kind of like "company." I think that that happens, uh, not that often, and when it does, the other people are not in an equally individualized space, but rather what they're playing is appropriate to the general mix. Because I think what's happened now with the band, is that it in fact has created a very flexible voice. The approach, and the technical ability, and the mastery of the language of free improvisation has reached the point where what the band really does is, each night, it creates a unique voice, depending on what components are there. And, what the emotional, uh, reality is of each of the players. So, if you have a tired day, or you're exhausted, or you're bitchy, or you're having money troubles, or whatever, all that stuff is kind of your own personal emotional fodder that is gonna get chewed up and spit out somehow musically, or at least form the basis from which you are going to play, but it's really the unit, it's the CCMC that's performing, and now everyone is submerged as part of a greater unique voice that's moving along. That might not be intentional, that might be an evolution in the way I'm thinking about music, you know? So I admit that both of those things are possible, but I think that more often the latter happened, and it's partially because the numbers have lessened, not when you left, Nobi, because I think you were a big part of that process, but it's since we've lost the steady drummer, and since we no longer have the two piano players. The numbers are right, and adding the voice is a good thing. The music has, I think, the music has evolved in a different way, now the whole thing about solos and all that kind of stuff is not nearly so important, because what tends to happen is, instead, uh, a much more organized or unified musical statement. I really believe that rhetoric that we used to push in the Seventies about five minds or eight minds submerging into one, etcetera, has, in fact, very clearly happened, and we have a language and we have a series of musical ways of communicating to each other that are so ingrained. When we just played in Montreal, one of the people said to me after the concert, "You and Mike, it's hard to believe that you're so close together, you are milliseconds apart in terms of phrasing." I mean sometimes you can't even tell. "Well, we've played together since 1975! It's not written."

MS Yeah. There's some things on the first cassette of CCMC '90, where it's just the two of us, which are amazing. You know a few months had gone by since when it was made, and I re-listened to it and heard it freshly. I just did that last week.

AM Yeah.

MS I mean there are some things that we do simultaneously. And there really isn't even that second, nano-second. It's really incredible, man, I don't know how it happens.

AM Well, it's because we, we've taught each other over the years –

MS Well, we're always surprised, I'm

always surprised too. And I'm still surprised when I listen to the tape even. All of a sudden, there's that one place where I started playing the Blues, and I figure that I got the idea to play the Blues from just a bent note that you just played. It's really good, really good Blues playing, without feeling quotational at all. It's an authentic statement. But, but, the thing is, when I first started to listen to the tape, I couldn't understand why, and I tried to think to myself, why did I start to play the Blues there. But just before I started to play, you played this na na na thing, which caught a whole kind of essence of Blues playing in it, that didn't relate to the rest of the phrase somehow. But it's just this one thing; and I must have got this immediate association.

NK Yeah. And then it went just as well in that direction.

MS It's a surprise, but there's a little source.

AM Well, I think that there are those clues that happen, and if you stop and analyze it, you could try and you could probably work out a flowchart diagram that would show what the communication stuff is.

MS Yeah, with the tapes you can *sort* of do that, but I don't know how far you could get with it.

AM But also remember that in the band now, Paul Dutton's role, you know the voice is a very important thing, I mean basically there's two guys playing instruments now, you know, there's you and I. John is, I mean his pre-recorded tapes are a kind of music, are a kind of musical instrument, but it's a sound source and, and, although it's not always a common use in a way, so that it's a commentary, it is more of a sound source. Paul has a slightly different function, uh, but because he's got words in there, because it's voice, and because of what he's choosing to do with the voice, it too becomes a kind of sound source, it's, I'm not saying it's not a musical instrument — it's the *approach* that is not necessarily musical. You and I are doing that —

MS Yeah, I understand what you mean. Paul brings in a range that at one extreme is talk or yelling (like Fats Waller used to do) but with all kinds of other more musical functions in relation to the rest of the sound. He's very inventive. Also this last year we've had pretty frequently a wonderful drummer, Jack Vorvis, who really adds something. I hope he'll play with us more. But let's talk more about how one gets clues as to what to do next

from the rest of the music.

AM Those clues are more easily seen. What's harder to see, is how the clues come out from Paul, or come out from John, you know? And the flow chart would obviously show that flow through the group, as to how — I mean, sometimes what'll happen is John will put something on his tape and slam the volume up, and you go, "What the fuck is that for?!", you know "Where did that come from?" 'Cause it's like you said before with that Blues note, it's just there, you know. But he will make a very aggressive statement and you can either ignore it, which you probably do at your peril, or, uh, musically at your peril, or you can go with it, it commands your attention. And, all of a sudden, you're right over there. So there's also that kind of a *coup* that happens, but what it is, is we, as players and as friends, have developed our vocabulary and our communication paths so well, that there is something that's going on at another level.

NK Yeah.

AM I mean, I actually *can* hear all the players, you know?

MS Oh, yeah, yeah. I can too, of course.

AM And move through and play along with all of them, and, uh, you know, fit in under this one, but, in volume, but at the same time, I'd be supporting that one tonally and commenting in terms of the tempo stuff with what the fourth person is doing. All of those processes are happening at the same time as I punch my computer and say, "Give me that voice" and then I, I don't know what — it's uncanny, you just put your finger down and hit the string and the sound is in your mind — it's absolutely perfect for what everything has been evolving toward, because you've gone, you've gone through a process, of finding this stuff, sending this stuff up, reaching for it, you know? Peter used to do that —

MS Yeah, yeah.

AM Remember when he had those sequencers? Right? And he had all those boo, be, boo, boo. And nothing would be happening, and he would hit the switch, and it was exactly at the right point, for the sequence to come in!

MS Oh yeah, that stuff is absolutely amazing.

NK Yeah, but we always looked for those things, we always looked for those events to happen. I mean we were constantly aware that anything might happen like that, and we developed this skill to go with it.

AM Yeah, but —

NK: Certain decisions that can be made.

AM But that's part of what it means to, you know, that's why amateurs can't do it, because they haven't learned all of those things. They haven't, um, they don't have the technical ability in some

cases, but you don't have to, you don't have to have the technical capability, what you do have to have is the musical vocabulary that allows the group to communicate in a musical way. And that's very specialized, you know? And that's why guys like, for me, why I found it very difficult to play with Maury Cole. You know, I liked Maury and I liked his playing, but his, the vocabulary that he used, and the signals that he used were not ones I had in common — we didn't even — they weren't –

NK No, it wasn't in common with the CCMC. That's why — same with any –

AM You know, these are good players, you know, they're guys that had an effect, and we played with them a number of times, you know.

NK So that must be a really unique thing that we developed, I mean, it's not something that can just occur, with any group.

MS Well, the thing about everybody playing many different instruments is very important. I was thinking about how the band started, and –

NK Yeah, it's only instruments that, that do that. Remember how they took up almost half the room, it was filled with just instruments of an incredible variety. In fact, there wasn't any room left for an audience.

AM Yeah. Remember that, remember that tour, with twenty-seven pieces of luggage, and the –

NK Oh God!

AM And you made that, you made that box with the gong rack out of fibreglass! Right? And we took the whole box with us to Europe.

MS Yeah, but the first sort of stages of it were, was it you, you made these xylophones out of, uh, B.C. cedar?

NK From B.C. cedar. That was a very important thing.

AM Yeah, yeah.

NK And, uh, we made big xylophones, and Peter made that –

AM Giant koto.

MS And then we got all the gongs. All those big gongs, and the smaller ones. Uh, the year that, uh, Casey spent in the East, and then he came back with all these small gongs.

NK Yeah.

AM Yeah, but we had, before that, we had made a, remember, we made that three-sided rack? You and I made that three-sided rack, and we had all of the brass cannon shells. I brought them all back from Victoria, I bought them at, uh, um, Capital Iron, which is a war surplus store in Victoria. And I had, we had all of those things, and we had the tuned gold mining pans, and the little rosewood marimba that Peter had –

NK And there was another thing, uh –

AM Oh, the tuned drums that I made out of pipes –

NK And we stretched the skins over them, and we had the little tiny ones, remember the little tiny ones?

MS Beautiful, beautiful sound. I love the sound of those –

NK And we made a rack for those.

AM Casey, I think, has those.

MS We used to set, we used to set all that stuff out –

NK There was often a time in a concert when, when suddenly everyone would be playing the drums!

AM And I remember Richard Teitelbaum, when he came to hear us, and he said, "You know, Al," he said, " my prediction is, that in less than a year the CCMC is gonna be a 'Terry Riley Band', because you guys are going to get into pattern music with all this percussion stuff." And I said, "Forget it Richard –"

MS He was so wrong!

NK Absolutely wrong!

MS That's incredible, a fantastic mistake, in a way.

AM Well, he was basing it on his own experience of what happens, you know. I mean, like free improvisation has been around and is, right now, out of favour. I mean, it's not popular –

MS It never was popular.

AM Well, back in the Seventies, you remember there were big festivals, there was the Free Improvisation Festival in Moers in Germany, I mean we played in a lot of, we never played there, but we played in a lot of places and a lot of festivals, and there were people who knew about free improvisation. Now there still are, the same guys, Davey and Ladonna WIlllams and Han Bennick and Misha Mengelberg, and all those people are still doing free improvisation as part of what they do, and maybe in some cases, it's all they do. It's no longer the 'issue' that it was.

MS Well, it hasn't even, it hasn't even really been thought about, all the really radical aspects of it …

NK I don't think anybody, really, mentioned about it, or –

MS You know, yeah, Derek Bailey's book is about the only book, or maybe not about, it *is* the only book on improvisation. And then, we, the articles, or texts, or whatever, or any kind of talking about it is very slim. Like, some of the best stuff was in that English magazine which was called *Musics* or something like that, which was –?

NK Oh yeah, right.

MS You know, there were lots of discussions like this, in a way, when that kind of thing was going on. People were thinking about what the hell they were trying to do and talking about it, and, uh — I have a few copies of those and other than that, I've never really seen anything, anywhere, that ever talks about any, any of the discoveries that are made by improvisers, and what the implications of the whole thing, which are still pretty fantastic.

AM Yeah.

NK Yeah, well, I don't think it's taken seriously –

MS Yeah, it isn't, because for some reason people think –

NK – by, by people that can make a difference.

MS – they always think of it as, that it's *just* improvising and opposed to *what*?! I mean –

AM Well, the only people that could take it seriously, that could make a difference would be official composers.

MS Yeah, but some of them have, but it still doesn't make any difference. But I've had some surprises. A few years ago I was invited to be a visiting Prof at Princeton University, I was asked to attend to paint, film and music. Princeton has always had a very distinguished music department. I did some classes and brought some of our tapes and records, thinking I'd be shaking them up. In fact, they really loved the music and many of them were improvisors. I was surprised to find that the head of the music department, I'm sorry I can't think of his name right now, is *very* involved in free improvisation. We all played some nice music together a couple of times. I was told by the students that there was some faculty grumbling because of this advocacy of improvisation.

AM Yeah, but this music is not accessible to the general public. You have –

MS You said it! (laughter)

AM But, even if we were on giant radio stations and television stations, I mean we have, we built our own bloody concert hall, so that it could be accessible to the general public, and they stayed away in stoves! You know, drove away in stoves, or whatever, what was that? (laughter) I just got one of those T-shirts, you know? Um, but, uh, and the reason is, is that the music is, is very demanding.

It gives you nothing.

NK Absolutely.

AM It doesn't give you rhythm that you can tap your foot to. It doesn't give you a harmonic base that you can –

MS Well, you have to listen to it, that's its problem!

AM Yeah, I know! Well, with most music you can *forget*, you can *forget* what the hell the music's all about, because you can hear the underlying 1, 3, 6, 2, 5, you know, you can hear the chord progression. And, um, so you don't have to listen, you don't have to pay attention to that.

NK Yeah, it's very comfortable.

AM I remember when I was a very young child, like, uh, seven or eight or something like that, the first time I heard Beethoven. The class went to the symphony concert, or something, I don't know, they truck you around to schools, or they play it in schools, and I thought, "Oh! I understand this music! But it couldn't be that hard, because I know where the, where the next note's gonna be, before it's there." Like, I could hear, the melodic line marching through the bass, it's because it's so obvious, I was studying music. But I thought, "Oh, gee, that was very simple!". That Classical music was very simple to me, and so therefore, I wasn't that keen on it. And I never knew, I never understood what that meant. But, the thing is, we don't give people that — no one knows what the hell you're gonna do next, you know? And we've tried with kids –

NK Yeah, did we?

AM Yeah, that's right. But my kids grew up with it, they hate it. (laughter)

MS Geez! That's a sad thing. I would like it if Aleck could hear it.

AM I don't really think they *hate* it, they, you know, they tolerate it. They smile benignly, and pat me on the head, and say, you know –

NK And say, "That was 'fun'!" What a stupid thing to say.

AM "There's –", yeah, "There's my Dad playing his funny music." You know? Kaz says to me, "Why is it, whenever you play the guitar, no matter if you've just got up in the morning, you always look so stoned! You know, your jaw goes open, and your eyes roll back, your head –" (laughter) Right? Arden had a young guitar player staying at her house in Montreal, and this kid was desperately serious about the guitar, he really was going to be a professional guitar player. He practiced all the time. And I went there one weekend, and I showed him a few things, I showed him how to finger pick — he didn't know how to finger pick. And I was just, you know playing the guitar, and, uh, he walked in, and I was doing my usual, just running around the guitar neck.

98

MS Yeah.

AM And I hadn't played anything like that before, around him, because I was trying to be, 'reasonable'. And I said something like, "Oh, uh, this is the way I play, uh, you know, I just do that all the time." And he said, "Well, do you know what you're doing when you do that?" and I said, "Yeah, I hear those notes in my head." You know, I mean those notes coming out – And he said, "That's *good*. Because, otherwise, it would just be that you're jerkin' off!" (laughter)

MS Yeah, well –

AM But I mean, that was the attitude, you know? That, that, um, there was, I think for a lot of people, that's what they think, that we're just jerking off.

MS Yeah, yeah.

AM You know, they think we don't know what we're doing, because we can't do it again –

MS No, I think it's more like that they conceive of it as being, since we're so self-preoccupied, that's where the masturbation thing comes in.

AM Yeah.

MS You know, when you're doing that, you're so concentrated on yourself. And, and, it's very, they think of it as very narcissistic.

AM It is.

MS Yes, it is. I mean that gets back to this thing about there being several individuals in one place at one time. But you know, it *isn't only* that, but I've heard that criticism myself. Actually that used to be said about experimental film, because it didn't give your average spectator what he, or she expected, which was a story and all the other things, it was considered to be masturbatory, that the artist was just sort of jerking off, as opposed to what? I don't know, procreating? But, there's a little bit of truth in it to people who have never heard our music before, because in a, in another kind of ensemble, it's a concentrated sound which is directed *out* by the ensemble. And you can see, I think, probably, when you watch us, that we're very absorbed in what we're doing, and it looks like it's an *individual* absorption, even though, the fact is that were listening to everything. The way we look is just a result of being intensely interested in the music, not the audience.

AM Yeah.

MS But I think it's a shame that they take it that way, because here we are

creating, **as opposed to playing somebody else's music. I mean, we're all in the same boat together, the audience and the band hearing this thing we never heard before. Some people have appreciated that, like Nancy Love.**

NK Nancy Love! She was such an important part of the Music Gallery when we were on St. Patrick Street. We used to play twice a week and she rarely missed a concert! Remember how she used to set herself up at the hall with her paper and paints? It was wonderful to watch the evolution of her work over, uh, was it 4 or 5 years? Remember how the early work was kind of dark, thick and rarely textural – and it evolved into a kind of light, spacial and lyrical calligraphy. It was some of her best work and it reflected so beautifully our music. I always thought she became a part of the band when she was painting – like she didn't even paint or interpret the music but accompanied us or played solos visually, texturally, rhythmically, you know –

MS Yes, what she did was beautiful. It was putting that musical analogy of abstract gestural painting into a musical situation. She painted her own part in the music. But then it's like a tape because we still have the improvisation's total result.

AM Well, it's, yeah, but a lot of people, they listen to it for a while, and then they, after awhile, it becomes like a punishment, almost, you know? Or, not punishment, but they've, they've kind of outgrown it, or they've moved past it, or –

MS Well, I think they want their own minds back. You know how you're involved in your own mind all the time?

NK Yeah?

MS And when we're playing, we're playing that. And it's, and, there could be, uh, sometimes I think, a kind of oppressive weight on having all these minds in your own mind, and you just want to have your mind back! You know?

AM Well, remember there was, remember that big tall guy that used to come by?

MS Yeah. He was an artist or a painter or something.

AM Yeah. I forget what he did, but he used to come all the time, and then he just stopped. And, uh, I used to run into him at the Y, and ask him how things were goin', and, uh, I said, "You should come by sometime." And he said, "Oh, yeah. Right. I should," and da,da,da,da... but, "I've moved on," that was kind of the impression, right? Like I kind

of get the same impression from Nancy.

MS Yeah. What do you think about this, this point of view of it being, it always being, music made by a number of very individual individuals brought together to play music together? It seemed to me that as the music was going along, and still is, that, individually we're all working on certain things. Like, if we practice alone, or even just think about it, we're thinking about something that's slightly independent, it's about certain kinds of musical problems, like what you've done with the guitar synthesizer, you know? It's a development, which, which is your own line, from the electronics and guitar playing, and it's an expansion of it, but you're working on it alone, in a way. When you play alone, you practice, and find out shit – when we play together – and you play that stuff, it's stuff that you're thinking about by yourself, as an individual composer. And I've been doing that myself all along, and working on these certain kinds of things, like these resonance things, or I'll be into this or I'll be into that, especially when I've been able to practice, which is getting less and less. But, anyway, there are certain things that you want to try, and you bring them to the music. So, they could be in several pieces, maybe, because that's what you're working, *you* are working on at that time. And it seems to me that the way Nobi's music developed, was starting with the saxophone, is you playing alto, and soprano, and then sometimes you were, you were playing baritone, but...

AM And tenor, for a while.

MS And tenor, yeah. And then you started to go into all these other areas, which were your own individual thinking, but brought into the ensemble. I mean, there's some big jump in my memory, which maybe you can fill in, about going from saxophones, and occasionally small instruments, to having the cage of percussion instruments. And where does, actually that reminds me, when did you start using tapes? Can you describe the evolution you went through, do you think, in relation to the rest of the music? 'Cause –

AM Tapes were after, tapes were after the cage was built, you started bringing them in, once you had the cage built, and the cage grew out of that –

NK Yeah, I had, the cage evolved from something that was fairly simple. And it had two shelves –

AM Yeah, 'cause you had built something to go on the road. So you could start storing your small instruments.

NK Yeah. And then I started to collect –

AM And then you started making weird things. You know my favourite was the copper tube.

NK Copper tubes, and then –

AM With the, with the bowl down below, and you drop a marble in, and you had a contact mike on it.

NK Oh, yeah. Contact mike on the, uh, on the copper coil. And then I started to collect a lot of the, I used a lot of the music gallery stuff, like the shelves, and the gongs, and percussion –

MS That's right, yeah. Yeah, 'cause we were putting them up, we were hanging them up on various racks, and in a way you amalgamated the racks. That was one thing –

NK Yeah, we were making, we were making racks before I made my cage –

AM Yeah, but the wooden rack, it was shaky, and you wanted something, you started to get more into that, and you wanted something you could take on the road.

NK Right, portable.

AM Right? So that's what happened. 'Cause we were a road band, we did a lot of touring.

NK We took a lot of that wooden stuff on tour.

MS Yeah.

NK Remember we used to have to screw the things together with bolts and wing nuts – by the time we hung all the soundmakers like cannon shells and mining pans, the load on the rack was tremendous!

AM Oh, when we did that, when we did that cross-Canada tour, yeah –

NK It was all rickety. We took it to, uh, Stuttgart too. We had a couple of percussion racks. And everybody played those instruments. But out of that grew, grew the cage, and once I had the cage there, I played less saxophone, because I had all these other, other instruments to play. And I started to collect toys and all kinds of stuff like bells and tape decks and synthesizers — and I tried to play everything at once like a layered texture of noise. But collecting the instruments had a very, seemed to go in a specific direction, you know?

AM Yeah, but one of the things that happened is, remember we played this gig, uh in, Rotterdam, and the reviewer said, that the trouble with our

music was, the musicians, uh, didn't have fun with the music, were too serious! (laughter) And, when we heard that, we, we were all sitting around having dinner, and we, uh, started talking about, "Well, if they want us to be goofy." Right? And then you, you bought that, uh, dart gun, that shot rubber darts –

NK & MS Oh right!

AM And you started the whole thing by shooting rubber darts at the gong.

MS Yes, that was fabulous!

AM It began introducing the theatrical element into the music.

NK Right, right. Whenever we hit a new town or city we would go on a shopping trip...often to toy stores and then incorporate what we bought into the concert –

AM So, you would start, you know, doing that, and then in England, remember, we bought all those bicycle horns –

NK Bicycle horns –

AM And bells! And screwed them on the percussion racks –

NK Yeah!

AM And then we did a piece for bicycle horns and bells, which, of course, no one in, in our English audience liked really, I think we were hitting too close to home or something like that. Or maybe they didn't find it funny. We thought it was hilarious!

NK Oh yeah, we played in that very strange place.

MS In London, eh?

AM Newcastle.

NK No, it wasn't Newcastle. It was, uh –

AM Oh, that terrible man, that made us pay for our beer.

NK Yeah. He really hated our music — couldn't wait to get rid of us. On the outskirts of London, somewhere?

AM Oh, it was, yeah — old Georgian, old Georgian building.

NK Yeah, and then I took the cage on the road, once. Yeah, I did a tour of all the parallel galleries in Ontario and Quebec — boy, that was a gruelling tour.

MS And it's in that film, eh?

NK And it's in that film, that's right. Yeah, yeah, I'm glad that there's a record of it.

AM But, you had gotten into, into the architecture of shapes, you were dealing with design, and, and making instruments — don't forget we did that sound sculpture exhibition –

NK Yeah. I made this analog/electronic piece using stainless steel fins with some transducers and feedback. Yeah.

AM Right? Because what happened on the sound sculpture exhibition, is that you, Mike, made all those trumpets, out of various things. And then

we were *using* those, like you were using some of them, and then –

MS Yeah, I used the "copper tube-o-phone", it's on one of the records.

AM And then you used the plastic hose one, and, and, uh, uh –

MS But, before that, Nob had been playing, uh, that, sort of a, what's that? Like a kind of a plastic tube, with a saxophone, mouthpiece on it.

AM Oh yeah, the –

MS What a strange, strange horn –

AM Yeah, we had one of those in the — remember we had that little toy box?

NK Yeah, we had a lot of toys and instruments, throughout the years.

MS "Free Soap" on the *CCMC Volume 4* LP is the best record of that particular kind of thing of using all the little sounds. And all these funny things that started happening.

NK Yeah, and I had two synthesizers, and a Hawaiian guitar.

AM Then we all got those crackle boxes, right?

NK Crackle boxes, and I bought the, uh –

AM And then you bought the big one.

NK The original prototype from the guy who invented them, Michel Waisvis in Amsterdam.

AM Yeah, right. So then you had that synthesizer, so you actually, you and Peter introduced the synthesizers into the band, because Peter was playing the uh –

MS Bucla.

AM The Bucla, right? Which I still play, or I still have.

MS But I'm interested in the tape thing though, how you got started on that.

NK Jesus, I can't remember what — how that happened, you know? I guess, I guess, when I was building the cage, I was trying to get as much diverse sounds as possible. From, straight percussion gongs, and cymbals, to, uh, to, uh, the synthesizer. And then, then I had those two bears? A bear and a dog that wind up, you know the battery-operated one, with the –

AM Yeah, and the monkey, with the little, uh –

NK And the monkey with the little drum operated by a squeeze bulb. That's getting pretty diverse, and I wanted to get as diverse as possible, and the obvious thing was the tapes.

AM I can remember, I have a very clear memory of you, of you coming into the Music Gallery, and, announcing almost, like saying to me that you were going to start using tapes, that you thought you'd

101

start bringing in some pre-recorded tapes. So you had obviously made that decision, and started bringing them in. But you remember all the wonderful times that Gagaku would come, you remember that –

MS Oh! You put that in such beautiful spots, you know?

NK Yeah, the amazing thing about the Gagaku tape was that I never knew what was happening on the tape until I brought up the volume and it was always uncanny how synchronistic it was with our music.

MS And you really solved it nicely, though, that, having the two-volume pedals, is really, that was a nice idea.

AM And the dolphins counting –

NK Oh yeah, it injected an alien voice into the music.

AM "One, two, three, four!" That was great.

NK Yeah, the sound effects, and the trains and the rain and the storms – French lessons.

AM And the cat purring.

NK That was a tape I made by putting the mike under my cat when she was purring.

AM God, those were the days!

NK Yeah, it was really pushing the idea that you can really do anything you want, in kind of a controlled fashion.

MS Yeah, yeah.

AM Remember when we added the Cat synthesizer?

MS Yeah, well, I used to set up my amp, and the Cat, and the guitar, and the –

AM Electric piano –

MS Actually two electric pianos and the flugelhorn and the trumpet. I guess that was it.

AM God, setting up used to take us a long time.

NK Oh God! It was amazing – do you realize how long it took me to set up the cage –?

MS We would tear down, but then we'd also listen to the tape of the entire night again, sometimes. How come there was so much time? I don't understand.

AM Well, we'd stay there until two or three o'clock in the morning. I mean, we would start, we started at eight, we got there at eight, and we'd get high, and then we'd play forty-five minutes, take a fifteen-minute intermission, get high again, and then we'd play another forty-five minutes. So that's, say if we started at 8:30, that's an hour and a half, and fifteen minutes, uh, you know, uh, an hour and forty-five minutes — 8:30, 9:30, quarter after ten, so the night was still young. Then we'd tear down, which took fifteen, twenty minutes, so it's 10:30, and then you'd start listening to the tapes. It was

only an hour and a half of music- that's 11:30. I mean, often times –

MS: Yeah, that's true.

AM Coming home from there, Casey and I would still have to walk the dogs, and we would stop at Mars and get an apple square. You know, we would detour, 'cause we lived together, we would detour by Mars and buy an apple square, and go home so we could walk the dogs, you know, and eat our apple squares. So that meant that we were — it was 12:30, or sometime, at the latest, but you could get it all in –

NK Yeah. We used to listen to every concert, right?

MS Yeah, but tear down, too, and put all that stuff, those gongs, and we had two grand pianos, and the two electric pianos –

NK They all went under the stage.

AM We didn't have two grand pianos at the old music hall.

MS No, that's right.

AM And that's when we had the bulk of that stuff, you see. By the time we moved in the new Music Gallery, you weren't using the rack.

NK No.

AM The other rack was gone. The three-tiered marimba is still around. The giant koto got trashed in that move. And that box that I, remember that box that I made that had those weighted keys that were like a knife on the –

MS Oh! That was one of the worst instruments ever made! (laughter)

AM I loved it. I really loved it.

MS That's some incredible stuff. For some reason, for some of the funniest parts of it, I can sort of see that upstairs room, on 30 St. Patrick's.

NK Yeah.

MS We used to laugh and do all those stupid card tricks, and invent all the CCMCs. Remember that?

AM Oh yeah, that started in that snow storm. And then we built that huge shelf up there, remember? Peter and I built that enormous shelf to store the archives, right? Hundreds and hundreds and hundreds of tapes! I mean, do you realize how many tapes there are in the basement of the Music Gallery? There's just thousands and thousands of tapes. I mean, I probably have a thousand CCMC concerts on tape myself.

MS I was, I was at this conference in Calgary, Interdisciplinary Aspects of Music, it was called. Very interesting conference. And, uh, I was in a sort of panel, that Murray Schafer was on, and various other people were. Sort of illus-

trious people, generally composers. And Murray, at one point said this statement that sort of added up to, that without the composer, you know the composer is the beginning of everything, and you can't have music — and, uh, I'm not very good in these public things, as a long panel, everybody all in a row like this, and everything. But, I just had this flash thought that I ought to tell this whole story. You know that I'd been with this group that's made up new music, that's really good new music, every (laughter) Tuesday and Friday! Yeah, you know, and that the band's the composer, and it's unrepeatable, and all this shit. But I couldn't say it because it was so big, I just gagged on it.

AM Yeah.

MS And I sat, it still makes me really mad that I did, I feel that I had an opportunity, because there were a lot of very, very hip people there. A lot of really sensitive people. That I had something to say about what I've gone through with improvisation, and I didn't say it, because it's hard to express, and other than that, I'm personally shy, or something, in these circumstances, but, I really regret it, because it's so fucking revolutionary. I mean, like you said, we just made all these compositions, and a lot of them are on tape, but if they did get on record, or if, for example, you just happened to listen to that tape a lot, the strength of the whole thing just got to stand out more and more. Listened to several times the best of our music is susceptible to analysis as the best of any music. And that's the artifact's status – we used to talk about that business, the difference between the playing, which was improvised, and the record of it, which had now become an artifact. And that's a distinction that's pretty interesting, but ... I mean it really is pretty incredible, we just kept on.

NK Yeah, it was incredible music. It takes into account the fact that all the variations in our playing can occur at different instances, and therefore there's a different selection process with the whole group. You know?

MS Yeah.

NK And so that there's always a different choice being made, there's a different combination being made and it's always unique.

MS Yeah, and partly because everybody, just to return to that thing, everybody's evolving individually, with some slight independence from the group music, so we're always feeding some new things that we've just got involved in. You know, Nobi, like what you did with the various stages that you went through, your getting into the voice business is interesting, too.

AM Yeah, Nobi's definitely been the most, uh, involved in terms of evolution of music and instrument style, and whatever. I mean, I started playing the bass and guitar, and I'm still playing the bass and guitar.

MS Yeah, yeah. Except you've expanded what the guitar was possible of –

AM Yeah, well, that's when I got back to the guitar, when I was able to make it a more expressive instrument, for the kind of music I wanted to play. But you've gone through, you know, imagine, a little percussion, and this, that and the other, but you've gone through a whole lot, from the saxophone-

NK Yeah, I've gone through a lot. Remember I had that thing I made for the saxophone, with the different whistles on it. There was a siren, and a duck call on it, too.

MS Oh yeah, that was beautiful too, yeah. Oh, I really like what you've done with the voice. I remember you used to hum, grunt, etcetera, while I played sax, did it start there?

NK I think the whistle attachment to the sax started me using the voice. What concerned me at the time was trying to integrate the whistles and the sax – to bridge the gap between the two sounds. There was also the physical gap of moving the mouth between the sax mouthpiece and the whistles without losing the flow of what I was playing and using the voice seemed to be a good way not only of making the transition but introducing another element. More is best. It also became very theatrical — augmenting the vocal sounds, grunts, and farts with a facial expression.

AM Well, you were considered, by a lot of people, a lot of Europeans that heard you, to be the best improvising saxophone player. I mean you were right up there with, uh, Evan Parker, and Brottman. People thought very, very highly of your playing. And had you pushed — you could have had a solo career in Europe –

NK And push the development that way. Yeah, well, the other things seemed more important at the time.

AM But no, even then, even with the whistles and stuff like that, but, uh, you know, Misha Mengelberg was very impressed with your playing, in particular. Well, I think it's time –

MS Time for what?

AM For a reunion.

MS Yes, we could try that, I guess. We can't get Larry to come back though.

NK Play the record! (laughter) Play the Larry Dubin suite.

MS Well, John can sample Larry's playing and use that, yeah.

AM Yeah, the few solos that we were able to get of Larry.

MS Let me see if there's any other issues — there's plenty more to talk about, but –

AM It's hard to, uh, I'm kind of running out of steam, but –

MS I was listening to the *CCMC '90* things again — I don't know how much you listen to them, but, I really think they're fantastic. And one of them is actually the side that Al wasn't on, it's called, "Things Go" and "Memory Bank". One piece has all these big holes in it, you know that business of just playing a few things, and everybody knows that there is a space to be allowed, and, and, somehow, somebody or other interrupts it, and it's set up as being understood that that's what was going to happen. I was saying to Al last night that we probably couldn't do that with an audience. And I don't know whether there was anybody in the audience that night that we played, but there's a lot of difference in the sound of things that we made when there's one person, or no person there. And it's precisely that business of attention to allowing an emptiness to happen ... is one of the most important things that we seem to not be able – I sort of reluctantly have decided, myself, that we're affected by an audience to the extent that really everybody is afraid to let a silence happen. And I wish that wasn't so, but anyway, it seems to be.

NK Yeah.

MS That particular piece Memory Bank, I think it is, has this business of there's no question that when you go "ping", it's a pause. And it's a long wait, or it's a short wait, or whatever, but the piece's built about that scheme. An isolated sound happens but you know that this isn't the end.

NK I've always been very interested in that aspect of the band. Well, we didn't, as you say, we didn't do it very often.

MS Yeah, often, more often it was continuous, yeah.

NK More often it was continuous, and, and a lot of times, it was very textural. We really got into a lot of textural things. And, uh, that empty space thing just didn't happen that often. *Very* rarely. And what I've always been interested in when that occurred, is that to me, there was no apparent relationship at all to any of the traditional patterns of rhythm. Right? That seemed to be most unique, in that something would happen, and then there'd be this silence which was not measured, but it was –

MS Well, I was wondering about that, actually –

NK It was, it's like a spatial thing for me.

MS Yeah –

NK And then the accent occurs at some point.

MS But I wonder if it isn't measured. I was thinking about that. I mean, when I was listening to this particular piece this last time, I was wondering, whether, isn't it the same thing as what I said about having started to play the Blues just from the implication of one bent note that Al played. But that, that somehow, a tempo was implied by a certain kind of gesture, that, you know, three or four things happen, and it goes 'shlooboom'. And out of that you feel *this* is the tempo, (knock knock knock) Maybe – that everybody feels that, and then, it *is* measured. I mean, this is just for the sake of a useless argument. It's just that maybe the pauses do have to do with an apprehension of a measure, in the phrase you just heard. The phrase is played, then it stops, then there's silence but its got a certain thing, (knock knock knock), and in your mind you're going (knock knock knock) –

NK Oh yeah, I know what you're saying.

MS Almost as if you're playing a part. You know it's going to be three bars and then there's going to be something –

NK Yeah. No, that's not the way for me, it's in the apprehension of a complete space.

MS Which is a more sculptural, or architectural –

NK Which is a more sculptural, or something like that.

MS Yeah.

NK Certainly not measured in rhythmical time or patterned time. Um, depending

on what went before. You know, whatever happened before that implies to me a certain space, and you allow the space to go, and at some point, you make a decision, or whatever. There is also the way we used to throw things and spin cymbals, when the resting point is a kind of anticipation space.

MS Yeah. Well, that sort of brings in this thing of, uh, pre-arrangement, too, because the two public concerts that we've done that haven't been as good as lots of concerts at the Music Gallery, when there was nobody there, are the du Maurier one, and the one we just played recently, which was the Electro-Acoustic Festival in Montreal. I think that we were good, and that we can just play good music, but, you can feel that, and I felt it myself when I was playing, in both cases — I felt that I really couldn't just let go somehow. And if I didn't keep on messing with this, then nobody else would. Or that everybody else wanted me to keep on messing with it because if I didn't, they wouldn't keep on messing with it, or something like that. Some lack of confidence.

AM Do you really think about all that stuff while you're playing? I never think about anything.

MS No, I'm describing it after the fact, in a way, because it's a kind of pressure that I felt while we played the last Montreal thing. And, uh, and a lot of the times at the Music Gallery, where the music has really been open to anything, I never have felt that pressure, and you don't hear it in the music either.

AM Right.

MS You can hear it in the tapes, you know. It's in the music, that there's a kind of 'push', well, the push itself could be beautiful, I mean it could be that the tension is an interesting statement, you know? But anyway, it's a, I think it's an interesting point that we do, apparently, get pushed around a little bit by the fact that there's ten or twenty or thirty or one hundred or no people. And I, I'm sort of surprised by that. Do you think it's true?

NK Surprised how?

MS Well, I didn't think that it mattered much whether there's anybody there. Anyway, I was sort of saying that to myself.

AM If there's an audience there, then we play it for the audience. And if there's no audience there, we play it for ourselves!

MS Yeah, but, it would be better for the audience if we played for ourselves!

NK Yeah.

AM Sometimes.

NK I always try to play for myself, regardless of how many people are there.

AM But I think sometimes, when we play for audiences, that we've played for them. Like when we were on tour, in Europe, I know that —

MS Well, I think that you're right.

AM The attitude was, you played for the audience, but, we were, you get in a different head space, right?

MS Yeah, that was very true.

AM You're out there, you're performing, you know?

MS But a tour's different too, because you start thinking it's a regular thing, whereas, these other things are more special, and that's part of it. There's a tension build-up, where something –

AM Remember at Vancouver Expo, right? The first concert, we held the record for emptying the hall faster than anybody else.

MS You know, last night we were talking about — I shouldn't do this without Nobi — but the effect of the modest amount of pre-arrangements, (Stuttgart, and uh, New Music America, in Montreal).

AM We did also with the concert in, um, Avignon in the bar –

MS Yeah. That was very good too.

AM Yeah. We figured out how to do that.

MS Excellent concert, beautiful concert, yeah.

AM But, when we're talking about pre-arrangements, we have to remember that, they're *fairly* basic, I mean –

MS To say the least!

AM You know, like, uh, "Let's all play together. Oh, O.K.," or, uh, "Let's all start at once," that one used to be a big thing! I remember it took Casey a year to convince us that we should all go on the stage together. He found it really ridiculous that, four people would be out there, one person would be out there, and start to play, and the other four would be in the back room, talking or whatever. And, the music would have started, he felt it was less than professional. (laughter) It was, but who cares?

MS Yeah ... I want to ask Nobi about his memory of Stuttgart.

NK In Stuttgart, oh yeah, where you dumped your shirt.

MS But in relation to this thing about, talking about pre-arrangement, The New Music America one that we played, Nobi, we did have this truly basic arrangement

as you put it, which was going to start with what? These two people, as opposed to these three people or something like that. But we all felt that it worked. And that, the music was very good, partly as a result of that.

NK Yeah, I thought the music was excellent at New Music America.

MS Yeah, so that reminded — last night, we were talking about the other occasion that I remember, which was in Stuttgart, in the Gallery, I guess.

AM It was Oh Canada Day –

NK Oh, yeah, the Oh Canada, no, what was that called?

MS See, I was wondering whether you remember this. We were in this back room, smoking our dope and drinking beers –

AM I remember the hall was a big rounded ceiling thing –

MS Yeah, yeah. And we talked about whether or not we should agree on how we were to start. Uh, and my memory of it is that we finally all agreed that we would start in some way, that the agreement was, that it be long tones, or drones. So we all went, and this is the way I remember and then we all went out and started playing. And *nobody* played that way at all. And, this is why (laughter) –

NK We started playing that way, but it didn't last very long.

AM No, we didn't.

MS No! Well, this is what I was –

AM That's not what happened, no, no.

MS Well, we did. But then the music was fantastic! It was a great concert.

NK Yeah, the music was great, yeah.

MS It was fuckin' incredible. But Al says that that isn't what we agreed to at all.

AM If you remember the tape, I know the tape very, very well, because we used it several times, we used it as a promo thing. There's a lot of natural reverb in that space, and I was using the sequencer at that time, so I had put together a couple of patches that were these "poo, poo, pe, poo" very rapid, uh, arpeggiated figures, that you can get from a sequencer. And we talked and agreed, that we were going to do these rapid, fast tones, but then beforehand, you're right, in the room that we were talking about, you were playing shit disturber, and you wanted everybody to do long tones! But Casey and Nobi, and I, had all these patches set up. You were saying this is what was going to happen, but when we went out there, the thing actually starts with boo, bee, boo boo boo, before any other instrument, right? So, there was no, no even *attempt* to play long tones.

MS There's no way it could be done!

AM It couldn't be done, Casey, Nobi and I had the other thing happening.

NK No, but I do remember that we did decide on a pre-arranged thing. And, uh, I think we did it! And we were really, we were really ecstatic, because it turned out!

AM A lot of that had to do with the atmosphere, and the place, right? It was full of a lot of friends, Edythe Goodridge was there, Spring Hurlbut was there, the audience was really receptive, and it was a particularly excruciating hall, in terms of acoustics. And we knew that the only way that we could handle that hall — that's the reason that we decided to plan the piece — is because we wanted to exploit those acoustics, and we knew that if we had gotten too loud, that would happen is –

NK Oh, it was marble, or something –

AM No, it was a domed ceiling –

MS Where was that place, either Amsterdam or Brussels, where there was an incredible echo. It was in a rebuilt, sort of, uh, warehouse, factory space –

AM Oh, the sugar factory. Refinerie Plank, in Brussels. Oh boy, what a terrible concert that was.

NK I don't remember it.

AM Remember we did three concerts in three days, in Belgium, on a little tour that Andre Menard had organized. And we played at Refinerie Plank, we played at Citadel Park in Ghent, and we played at this funny little town where they wouldn't let us play the piano, because it was made for classical music.

NK Oh, that was in uh, not Ghent, but the other place, Antwerp.

AM Antwerp, right. Yeah, so we played in, in uh, this Plank — we had *fabulous* equipment! Like I had the great bass amp, but it was an old sugar factory.

MS We only had two electric pianos there. We didn't have an acoustic piano.

AM Yeah, it was a sugar factory. And basically raw industrial space that went on and on — it was rooms and rooms and rooms and rooms — you'd get lost even thinking about the space. And it was so reverberant. And the audience was not interested in what we were doing at all. At Citadel Park, that's when that guy, uh, I forget his name, the guy who was curating Documenta, kept saying to us "Don't eat too much, don't eat too much." Right? We were wandering around looking for a restaurant, and he said, "Don't worry about food, we'll get something to eat after." And then, when it was over, he said that we could each invite a friend and there was a "small" dinner laid out for us in the back, so we all

wandered through this gallery, and we got to this room, and there were these *tables*, there were all kinds of people there, and they had laid out this *fabulous* feast! It was an incredible meal, it was like at 11:30 at night.

NK I remember that –

AM And they said that — on each table was a bottle of Chateauneuf du Pape, the guy said, "Unfortunately, you'll have to pay for the wine, it's nine dollars a bottle." And Andr Menard said, "I'll pick up the tab for the Canadian government, we'll pick up the tab." We just — we just had a *fabulous* time! It was a great catered meal and great wine-

MS Well, if we're into reminiscing (laughter) ... how about the throwing things in Rotterdam, and the one in Paris, in the basement in that uh –

NK Oh, in the wine cellar. We almost set that cave on fire.

MS But the greatest throwing thing to me, is, is in Rotterdam. The restaurant that had the peanuts, and –

NK Oh yeah!

MS We were throwing the peanuts, and-

AM God, that was amazing. Pierre Thberge was sitting there, and Alain.

MS Alain Sayag, yeah.

AM It was funny, because we all went, and we ordered these fabulous meals, anything on the menu. It was late at night, we were all feeling really great, so we were having tournedos and all this, and he ordered a hamburger, well done. And they brought him this burnt, burnt black patty! The rest of us are like, oh!, tuckin down this great food, you know. But that was fabulous. Somebody threw the coaster and cut the bottom off Casey's wine glass.

MS Oh, I threw the coaster actually.

AM And then — CHEWM — just took the bottom right off. We really did have a lot of fun.

MS Yeah, and we made a lot of wonderful music.

AM And we made a lot of good — well we're still making good music. May the 7th –

MS Yeah, what do you think will happen to all these tapes? I mean here's all this music that's kind of been preserved? Do you think anyone'll ever listen to it? I suppose not. Not that it matters I guess, really, but –

AM You know how long it would take? (laughter)

MS Yeah, it would take you a long time.

NK Seventeen years.

AM You know, there was one really great piece that we performed in December, um, of this past year. And there's May 7th is a good night, and then, there's like three or four nights in every season that are –

NK Outstanding.

AM Just everything comes together. I remember one time describing it to Margaret, and it was like, everybody had been working as a group, collectively, on a number of musical ideas, uh, that were all in various stages of resolution. And it was, people would, individual players would take turns, or not really take turns, but *had* introduced components into the whole musical potpourri that was being examined by the group. And then, what'll happen, what everybody played was absolutely perfect, and all of those musical ideas that had, that were being explored for three or four weeks previously, were all of a sudden realized, maximized. And then, you just move on. You don't like, play that again next week.

NK No.

AM Cause next week, it's always a kind of let down, but it's new ideas start creeping into the music. Somebody's got a new sound, or a new approach to it, or a different idea, musical idea, or a different sonic resource, or something, you know, who knows what it is. Remember for years, how a lot of our concerts would, not for years, but one year, half our concerts would end up with tipping the chairs over, remember?

MS Oh, Geez, that's right. Yeah, yeah.

AM The concert in Calgary where we ended up playing half the concert on a typewriter, or something like that. And the siren.

MS Oh, the siren was so wonderful. Well, the siren's on *CCMC '90*, too, on that one thing.

AM I remember, one of the first two records, where, uh, we were playing, I forget which piece it is, but we're all playing a mile a minute, right? And, uh, the music was building to this fabulous crescendo, and then it all, it just ends. You know, everybody comes together with an ending. There's one note tagged on, which is on the electric bass and Peter says, "What's the matter, can't you count?" (laughter)

MS Oh, that's great.

AM As if anybody was counting. Oh well –

MS It has been amazing, man, and it still is.

AM: You think of what we were able to do with that music. I mean, not only what we were able to do musically, but how many people we performed for, and in what cities. I mean, seven, eight trips to Europe, nine records, trip to Japan. The only Canadian group to play at the Los Angeles Olympics was the CCMC.

NK We've certainly played at amazing places.

AM Yeah.

MS But, I wish that it had, had more

recognition of what it had been.

NK Yeah, so do I.

MS I can hardly believe it sometimes that, when you look at some of the things that have been written, some of which are complimentary, but they really don't recognize the kind of achievement.

AM It's hard to tell. I mean, maybe *we're* the ones who are wrong.

NK Yeah.

MS Yeah, there's an article which I haven't read, but I scanned over, about the Vancouver Jazz Festival.

AM Yeah, I read it.

MS And the thing was, it seems to me the take on it was that there were some groups trying to do some things that some people might not think are Jazz, but that they were there and yet they wouldn't take us.

AM They would. Ken Pickering invited us. We were supposed to go there this year, *but* —

MS Oh, we couldn't get the other two things.

AM We couldn't get any, he had to withdraw the invitation because neither Calgary, Saskatoon, Edmonton nor Victoria would take us because they get together —

MS I think it isn't Jazz anymore, in a way, and yet what it does, is, really it's one of the few things that *continues* what Jazz had. Like, you're developing a personal voice, which is the same sort of thing as the difference between Johnny Hodges and Charlie Parker, Cannonball Adderley. That's all alto saxophones, you know what I mean? And we're doing that, I mean I think it's not Jazz, but it's a continuation from it.

AM Well, Ken Pickering is the guy who wrote it.

MS We just played this concert at the Electro-Acoustic Music Festival, and one of the comments that was said by several people, was that we'd sort of wrapped up a week of the festival, a week of concerts, uh, contained. And that, it was put, that you guys just played everything that —

NK Oh, that's very nice.

MS And everything else was basically composed music. I mean, there were some pieces with slight improvisation but, mostly it was tapes of people that had worked on it for six or eight months in their studios, and came out and played them there. Some wonderful things, too, like Jean Pich's computer synth piece.

AM Most of it was a lot more carefully con-

structed than some of ours, you know, like —

MS Yeah, but that's where the Jazz thing comes in, is that it's brought out with, with a feeling of the moment.

AM Yeah.

MS Which is the Jazz thing, and it isn't a Classical music thing.

AM Well, one of the things that happens is that I don't know if it's we're getting better, or our ears are getting bigger, or we're getting lazier, but you know, in the early days, there was a kind of enthusiasm, and hell-bent for leather attitude that meant that mistakes were okay because, there were no mistakes. And then there was a period of time in which it was okay to make mistakes, but there were mistakes, there were things that you'd like to take back. "I really wish I hadn't played that note." Uh, or "I wish I hadn't —", you know, I mean I can remember many times, like —

MS I wish I hadn't turned over the table with all the toy instruments on it! Remember you used to do that?

NK Oh yeah. Remember I used to just sweep the whole top off! Aside from the gesture, the cluster of noise when everything hit the floor was fabulous.

AM But, what happens now is, is that there are many fewer incidents when you feel like, uh, "Gee, I'd like to take that note back." or I'd like to take that idea back. And, uh, it happens much less often. And it, um, and I think it's a combination of the fact that our ears have grown, but also we've gotten a lot better. You know? The music is much more together, it's very tasty. I'll be really interested to hear this Japanese band tomorrow night, because these three guys are hot. There've been many faxes going back and forth — they want to mix it with forty-two lines, they want this incredible sound system, they want, like it's huge, it's a big deal, you know?

MS Yas.

AM Yakaz.

NK Yakaz. Well you know, I think that most people don't, a lot of musicians, even if they want to play free improvisation, don't get the opportunity. I think the CCMC, as an experience, is very unique. It's not a common occurrence, and therefore, there's no one looking at that from a critical view, you know?

MS I once tried to force an opinion out of Paul Hodge, who's heard us almost as much as we have, being the sound man, doing the recording, etcetera, for most of our concerts ... and he talked about comparing us to other people who improvise in Toronto and he said, "Most of the time

it's ridiculous compared to what you guys do, the difference is just fantastic. You know they just noodle and they *think* they're improvising."

NK I think very few people get an opportunity.

AM Yeah, they don't have the confidence.

NK They don't have the confidence, or the whole um, synchronistic, coming together of people doesn't occur, like it did for the CCMC. I think it's really unique. And so, there's no ground for, for *learning* how to play this kind of music, for other people. Or the musicians, even if they were interested in it, they might find it difficult to find people with like minds.

MS Yeah.

AM You still got your horn, Nobi? You still got the horn?

MS Why don't ya come and –

NK Yeah, I'm gonna trade it in. I'm going to trade it in for another one.

AM Another horn?

NK Another horn.

MS Oh, good!

NK I'm gonna try to look for a really, uh, really fluid – my horn is a Selmer, it's very, really heavy, and it's built like a tank, and, uh, I want to try to get one that's absolutely fluid.

AM Lighter to play.

NK Lighter to play. Easier to –

AM Faster action.

NK Faster action

MS Would you like to sit in next year? Once in a while?

NK Yeah, I can always come and sit in.

MS Great.

pause

MS I'd like to talk about the difference between what you felt when you were playing it, and what you hear when you're hearing the tape back. Sometimes I've played when I felt kind of blank and not in touch with the music. And then I hear the tape, and the fucking music's incredible and I'm surprised.

AM Yeah.

MS And even my own part in it is really interesting!

AM Yeah, yeah, because you're –

MS What is it?

AM You go to another place when you play. I mean, I do. I find – in the old days, when we first started, and we were playing in the basement, I can remember feeling that I was like a, a conduit, that the energy was coming through my feet, from the

planet and then coming out of my hands, and that really, I was, like, a universal conduit for sound. I was like a human being is like a filter, and all you were doing was filtering the sound of the universe and it was coming out in your hand. And I still think that, sometimes I still think that way, but I believe what happens is you go to another place. That you – for me it's very obvious, like I can't –

MS Well, it's another part of the mind.

AM It's another part of the mind. After we finish playing, I can't turn to the audience and talk, you know, I can't relate — it usually takes me a long — I have to pack up, and put everything away, and then put this aside, before I become, before I can communicate.

NK But you acknowledge before you sit down to play the fact that there's a great possibility that you're going to experience something new.

MS Yeah.

NK And that doesn't occur, in that kind of structured way, in any other time in your, in your daily routine. Right? So you sit down, play with CCMC, and it's an acknowledged fact that you're prepared to be open for very unique experiences.

MS But what about that business of when you hear the music that's happening, and the totality of it, and your own contribution, and you can't figure it out at all! I mean it just is a fucking mess. And then you hear the tape, and all of a sudden it's some other thing, and you remember the moment, in a way, but you're outside it, you have this objective thing, and the music is actually fantastic! I mean that's really an amazing thing, to have, on the one hand, this thoroughly negative feeling about it when you're playing it, and then, hearing it, and then being outside it, and thinking that it was wonderful, or *is* wonderful.

AM It's because there are different parts of your mind that are working, and maybe what's happening is that with your mind, or part of your body memories are of when you're playing, have nothing at all to do with the music. Like you could be thinking abut the fact that you've got a tremendous shitload of stuff to do, or that you just got screwed around by the bank, or that you've got a massive parking ticket, or that you just had a fight with your wife, or who knows, you know? And that process is occupying a certain part of your brain, and the emotional detritus from that is colouring the way that you hear. So when you're playing, you yourself are caught in a kind of a space, in between that conscious, or that one part of you that seems like it's

on rote, you know, which is the part that takes thoughts and turns them into musical notes. And there's a whole complex of associative and neurological pathways that run from the brain, that turn ideas in your head into, into sound, you know?

MS Yeah, yeah.

AM Like there's a process, there's a mechanism that's happening, and you're not in touch with that, but, you're still playing, but the emotional engine that's driving that, is this other stuff. So you, you're at a blank, because of a conflict, or because your mind is in dual processing mode, and two or more things are happening at once. When you hear it back, it turns out that it fits in with other people. Now, whether that's because you, in addition to all this other stuff, were listening, or, in fact, it might also be that you were playing so strongly that everyone else was in behind you!

MS That's right.

AM And then, and then — but you didn't hear that because, you know, you can't, scientists have shown that you can only pay attention to a limited number of things at once. You can hear, at the most, three or four lines of music happening simultaneously, and for most people it's two. You hear two things happening, following two things — try following two conversations at the same time, it's almost impossible.

MS One thing that's important about this is the ability to recognize shape, and not think of it as total chaos, in music. And I think that we have come a long way at a time where in the background is what was done in Classical music, including atonality, and Cage, and Varese, and all these things that introduced a lot of new ways of hearing things. But also, hearing a lot of so-called ethnic music from other cultures sort of prepares an opening. Because, if there was improvisation, there was improvisation done in Western music, by, people like Beethoven and, other composers. They all improvised. But they improvised harmonically. Because, they would never have played any of the things that we play. And, being in a certain continuity, of opening up our musical possibilities. Like my mother, who's a good piano player, her understanding of music is totally based on Chopin, Debussy and Bach and Mozart ... and that's mashing it together. But the music she knows has to do with harmonic imagination.

NK Or response.

MS Yeah. But it's all about that this note is a certain distance from this one, and you know, it's harmonic. But, there's

a point in hearing music, and in the evolution of Western music, which we belong to, where that whole thing opened up, so that it allows *everything* to happen. And that's where we came in.

AM Yeah.

MS You know, because I can think of, say, uh, in 1960, or – you guys started to play in '61, so – but there was an imitation of harmonic playing in there, because you had the base, and –

NK Yeah, it was an imitation of it.

MS I'm just trying to talk about a certain kind of dependence, on other kinds of discoveries, it's not only dependence, but the fact that we belong, to an opening.

AM Yeah, I think we were talking about that earlier — that in fact there were a whole lot of factors that were going along. I mean there was noise music, and *musique concrete*, and there was the invention of the Theremin, and, uh, those kind of science fiction instruments, the invention of the electric guitar —

MS Yeah.

AM That, uh, brought another voice in. The evolution of what was going on in Rock and Roll, the changes in the Jazz scene, the influence of people, like Cage, who brought aleatoric or chance elements into the music, blah, blah, blah — all that kind of stuff. We arrived at a certain conjunction. But simultaneous with that, there was an incredible liberalization that was happening, not only in the arts, but in society as a whole — sexually, in terms of the roles of women, there's been big changes, people's attitudes to politics, people's attitudes to police, etcetera. All those things are happening, and they're all tied together in a very broad sense. So, we are the logical evolution, just as Jazz players are, or Rock players, or Rap music, or any of this other stuff that happens now. They sit as part of the logical evolution of the very first people, who made music. We've just, um, picked a certain aspect of it and decided that this is the area that, that we're involved with. And it happens to be the one that has no controls. I mean, it's basically a very anarchist process. But at the same time, over the years, we've subsumed ourselves, like all true anarchists are supposed to do, to the common good. Our common good is to make music. It's not to make noise, it's to make music. We all know what music is, from our perspectives, and we have a common agreement to make music. So we don't go out there, and just, like the Nihilist Spasm Band, turn their amplifiers up to ten. They make a kind of music but it falls outside the realms of what I think is a good musical expressive form, you know?

MS I think its smaller than what we

do, but it's very good too.

AM So, I think everybody makes their own decisions on those kinds of things as they go along. I just –

NK Yeah, I think, for instance, for myself, I have, I go through periods, where I make, um, I find myself making conservative judgements on what I'm hearing at the time. And this gets back to what, uh, what this conversation started out with, where you sit back later, and you listen to it, and it's terrific. And so that you – but for me, it's possible too that there are moments, where I judge it, from a conservative point of view. But, it's a great way to make music.

AM Yeah.

MS It's the best way to make music. It seems to me to be the right, correct way. Music is a social thing, and it exists in time and it's always of a moment. Even if it's Mozart, being played by some really great interpreter, there is a moment — he's playing in this hall, on this piano, he feels this way, and that kind of shit. And I think that what we've done is really as right a way to make music as was ever made. That was ever thought of.

AM I agree, I agree.

NK Yeah.

MS This is the way you — you get together, and make up the music of the time that you're together.

AM But it's of *very* limited appeal to people who aren't making it. You know, it really is –

MS But why? If you're interested in music at all, and you're moved by music, if you're moved by Bach, if you're moved by, by, by what? Louis Armstrong. Our music is profoundly moving music.

AM Yeah, but you (the audience) have to work much harder, and they have to be aware. See, if you listen to Louis Armstrong or you listen to Bach, or Debussy, you *know* what the vocabulary is. You know the musical gestures — they have relevance to you because you can follow them, the harmonies are there, you can forget about parts of it with impunity. I mean, you cannot listen to the bass lines in the symphony orchestra, and only listen to what the overall effect is, the melody, and the first couple of harmonies.

MS Yeah, but that, that wouldn't be really listening very well, I mean, we're talking about somebody that can hear music. I mean, you gotta, to hear –

NK Well, obviously there aren't that many people that can hear it!

MS But what you're saying is that

people really only hear a superficial aspect of Beethoven, in general.

NK Because there's no place for them to grow that faculty.

MS Well, that may be true, but –

AM If you're listening to it a number of times — if you listen to Beethoven a number of times, you know, you would probably discover what the cello part is, and you might, let's say, listen to the cello's playing, so you go, doo, doo, doo, dee, doo, doo, you might pick up on that. But, in fact, as scientists have shown, it's a rare person that can actually follow more than two musical lines at once, it's a rare thing.

MS Well, I think it's amazing, I mean, uh.

AM It's true.

MS Two!?

AM Yeah. Following more than two. They say, that the most you can hear is four. So what about a conductor?

MS Well, I don't, I don't believe that.

AM Well, there's all kinds of scientific tests that were done on it. I don't particularly have the expertise to tell you how they did the tests, but I remember when this was happening.

MS Well, I don't believe that. I mean, I don't think that my ear is exceptional, and the area that really moved me when I first started to hear music, was so-called Dixieland, or New Orleans music. And I know that I could hear all the parts. Suppose it was the Louis Armstrong Hot Five, the clarinet (played by Johnny Dodds), the trombone (by Kid Ory). And I could hear each separate part, simultaneously, together. I mean I — I think that's crazy to say that there are people that can only hear two lines?

AM There are very few people that can actually *follow*, you know, and *listen* — try, going, try how hard it is at a party to follow, or have two conversations at once, and try and follow them. It's very hard to do.

MS Well, that's not exactly music though. That's something I tried to work with in my film *Rameau's Nephew*. I mean, I think you can hear more than two — I don't know about the average person, but it seems to me that it's not hard to hear more than two lines.

AM From what the psychologists, who did the research say, it is hard. For most people what happens when they hear our music, is they hear one, or two lines, and the rest of it is just cacophony. It's noise, it's getting in the way, um, it's fighting for dominance, I mean ... if you're listening to Rock and Roll, or listening to Jazz, or whatever, you don't

have to pay attention like –

NK Yeah, it's all familiar.

AM I went to a Jazz concert the other night. I ended up mainly listening to, uh, the drummer. Occasionally I would listen to the piano player, but I actually really listened. You know, there's one thing, you can *hear* the ensemble, and you can find your attention darting from one member to the other, but to try and follow simultaneously, a number of different musical lines, it is very hard work! You have to focus really hard, and pay a lot of serious attention, and uh, I mean I've been doing it for a long time, and I find that I don't do it well – I have to work at it. And when I'm listening to something other than the CCMC, or playing along with the CCMC, I have to work at it. It's like a decision that I'm going to do this and follow that. And I think that for most people, listening to our music, they don't – I mean, I've been playing music for forty-two years you know? They don't have forty-two years worth of, of musical, uh, training and background and experience to run against it. They've got what they hear on the radio and what they hear in the clubs. By a large –

NK Yeah, well it's not only what you hear, it's the attitude in which you're hearing this thing, and a lot of people don't, can't develop that attitude. There's no place for them to develop that –

MS Yeah, that's true. It's so isolated, what we do.

NK So it's a very rare occasion when somebody comes in and says, you know, on rare occasion people have come up and said, "Fantastic! That's just incredible!"

MS Yeah, they recognize what's happening.

NK And they recognize it. But that's very rare.

AM Yeah, but they don't come back the next week!

NK Maybe they can't handle it.

AM I gotta go.

MS O.K. I'll turn off this machine.

References: In 1982 the University of Toronto Press published *Jazz in Canada, Fourteen Lives* by Mark Miller. One of the chapters (pages 130-145) is titled "Larry Dubin: Either you play or you don't" and contains quotations from interviews with Dubin and discussions and analysis of the CCMC's music with particular references to the role of Michael Snow in Dubin's career and the CCMC.

CCMC performing at the Music Gallery, 1977. Michael Snow–piano, Casey Sokol–piano, Larry Dubin–drums, Nobuo Kubota hidden by Bill Smith–saxophone, Al Mattes–electric bass, Peter Anson–guitar.

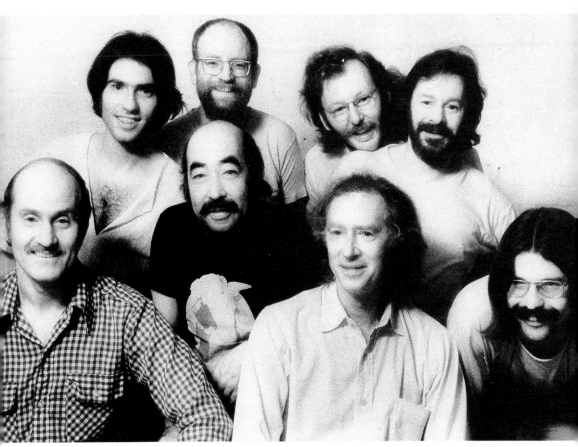

CCMC, 1977. Larry Dubin, Casey Sokol, Bill Smith, Al Mattes, Graham Coughtry, Nobuo Kubota, Michael Snow, Peter Anson.

The Music Gallery, 1977. Michael Snow and
Casey Sokol pianos.

The Music Gallery, 1979. Kubota–alto sax, guest Ed Epstein–soprano sax, Michael Snow–electric piano, Casey Sokol–piano.

The Music Gallery, 1980. Michael Snow, Casey Sokol, Nobuo Kubota, Al Mattes, Peter Anson.

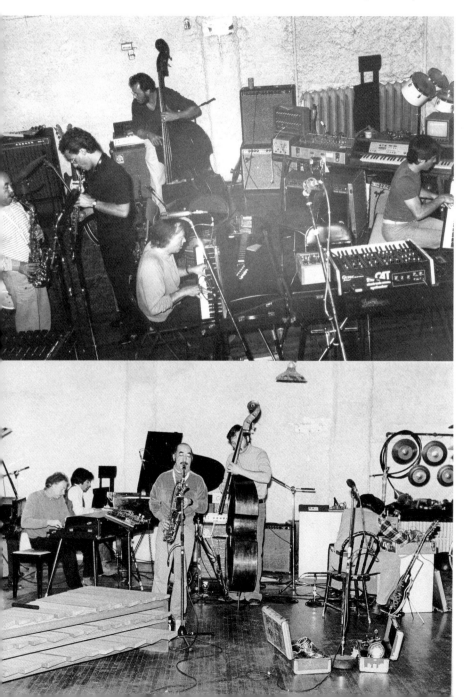

Nobuo Kubota—alto sax and Michael Snow—
copper-tube-o-phone. 1980(?).

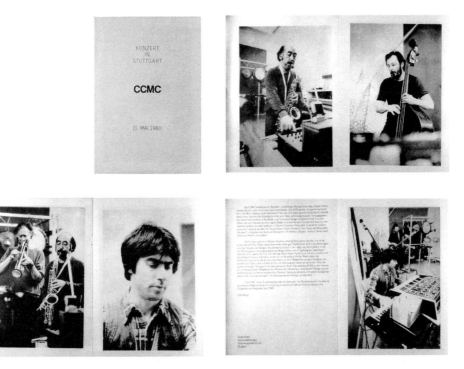

THE MUSIC GALLERY
FALL | 1976

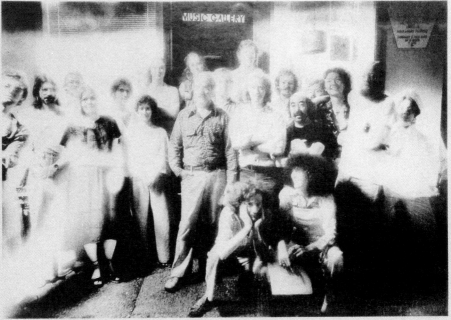

PHOTO: DAVID SMILEY

SEPTEMBER 25	canadian electronic ensemble 9PM
OCTOBER 2	array 8:30 PM
OCTOBER 9	jon hassel & david rosenboom 9PM
OCTOBER 16	mars broomer smith coughtry 9PM
OCTOBER 17	maple sugar 3PM
OCTOBER 23	jaxn sagness 9PM
NOVEMBER 7	workshop: bertoncini & jolles 3PM
NOVEMBER 13	rosenboom solo electronic 9PM
NOVEMBER 14	maple sugar 3PM
NOVEMBER 21	workshop: maxwell davies 3PM
NOVEMBER 27	interspecies music 9PM

EVERY TUESDAY & FRIDAY ccmc 9PM
ADMISSION TO CONCERTS $2, WORKSHOPS FREE

30 st. patrick street · toronto · 368-5975
northwest of queen and university

6ᵀᴴ YEAR

EVERY TUES. & FRI. 9:30PM

CCMC

MICHAEL SNOW · NOBUO KUBOTA · CASEY SOKOL · JOHN KAMEVAAR · AL MATTES

"DYNAMIC AND INNOVATIVE MUSIC. . ." WINNIPEG TRIBUNE...... "SPINE TINGLING EXCITEMENT, **WARM AND FRIGHTENING. . .** EXCITINGLY FRESH, FILLED WITH **A SPIRIT OF EXPLORATION AND SURPRISE**" BOB RUSCH, CADENCE MAGAZINE, NEW YORK **"E = CCMC²"** VIC D'OR, ONLY PAPER TODAY "A SPLENDID AND HARMONIOUS ENSEMBLE. . ." SWING JOURNAL, TOKYO. ". . . ONE OF THE BEST TESTAMENTS TO THE LONG TERM VIABILITY OF ENTIRELY IMPROVISED MUSIC. . ." JAZZ MAGAZINE, PARIS. "GIVING A WHOLE **NEW DIMENSION** TO JAZZ AND TO ALL NEW MUSIC". . . PENNY PRESS, OTTAWA. **"WILDLY BRILLIANT . . ."** PETER GODDARD, TORONTO STAR. "EACH OF THESE PLAYERS HAS DEVELOPED THEIR OWN INSTRUMENTAL VOICE, NOWHERE HERE DOES ONE HEAR IMITATED OR MEMORIZED LICKS OR CLICHES." ART LANGE, CODA MAGAZINE. **"WOWEE"** HARRY FREEDMAN, MUSICWORKS, TORONTO.

MUSIC GALLERY

30 St. Patrick Street
Toronto. 598-2400
Admission $3.00

*CAMEMBERT CHEESE MIT CHERRIES

GALERIA LDK

LABIRYNT

LUBLIN · PSTROWSKIEGO 12

PROJEKCJA FILMÓW

MICHAEL SNOW

ORAZ

KONCERT ZESPOŁU „CONADIAN CREATIUE MIUSIC COLLECTIV TORONTO"

W SKŁADZIE: MICHAEL SNOW, CASEY FOKOL, ALLAN MATTES, LARRY DUBIN, NOBUO KUBOTA, PETER ANSON

25 MAJA 78 GODZ. 19

GALERIA

ARCUS

LZGraf. O.T. zam. 9% 78 10-73.

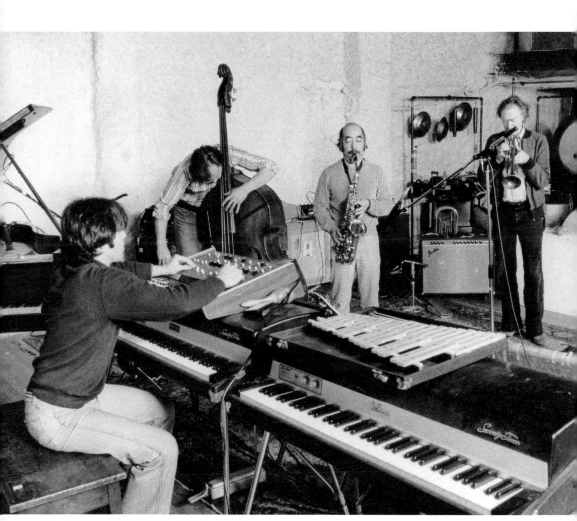

The Music Gallery, 1978. Casey Sokol—synthesizer,
Al Mattes—bass, Nobuo Kubota—alto sax, Michael
Snow—trumpet.

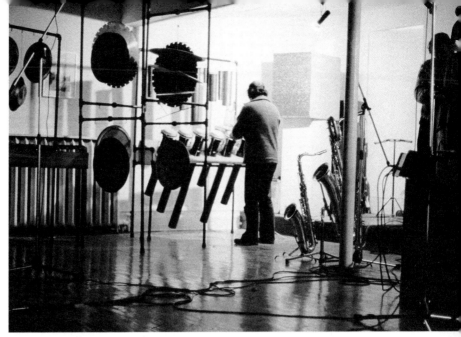

CCMC at Véhicule, Montreal, November 25, 1980.
Photo by Trevor Goring.

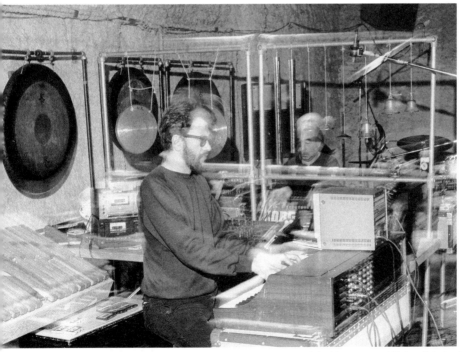

John Kamevaar and Nobuo Kubota, April 23, 1983,
Music Gallery, Toronto.

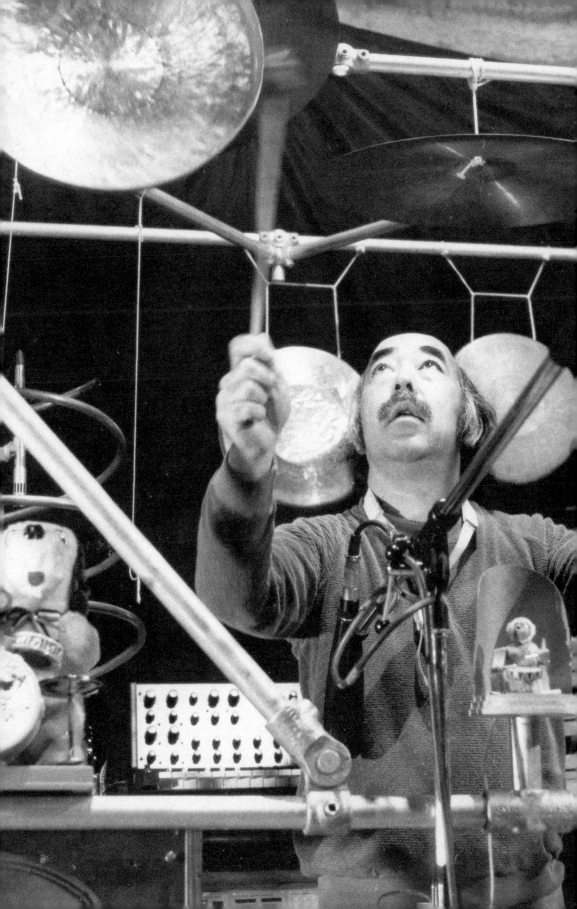

Nobuo Kubota and his
instrument cage. 1982.

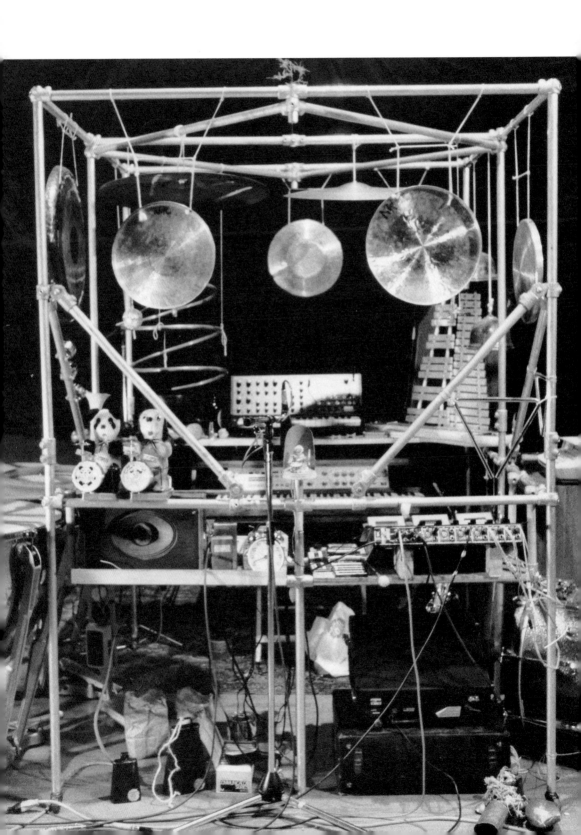

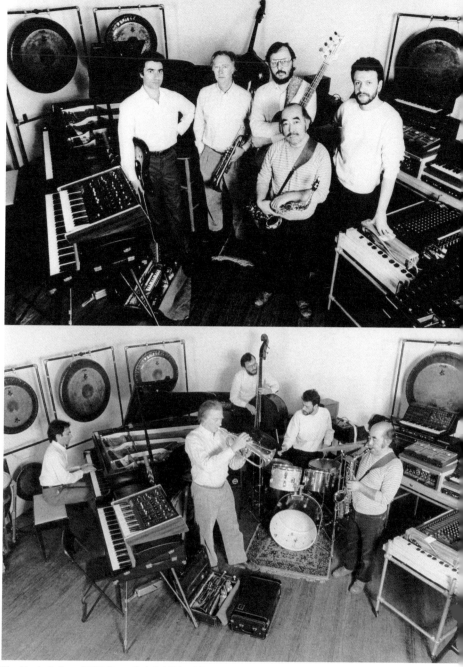

The Music Gallery, 1983 Casey Sokol, Michael Snow,
Al Mattes, Nobuo Kubota, John Kamevaar.

The Music Gallery, 1984 Casey Sokol, Michael Snow,
Al Mattes, John Kamevaar, Nobuo Kubota.

Nobuo Kubota's instrument cage. 1982.

CCMC tour of Japan, February 1987.

Concert in Osaka. Casey Sokol, Michael Snow,
Al Mattes, Toshinori Kondo—trumpet (guest musician),
John Kamevaar.

Concert in Tokyo. Casey Sokol, Michael Snow, Toshinori Kondo—trumpet.
Photos by Shigeo Anzai.

Concert in Tokyo. Michael Snow—piano.
Photo by Shigeo Anzai.

THE FOUR HORSEMEN

THE FOUR HORSEMEN's exciting blend of poetry and performance has earned them an international reputation. The unique mode of artistic expression fashioned by the group employs virtually every sound that the human speech apparatus is capable of producing, both verbal and non-verbal. The Four Horsemen first formed in 1970 and the group still comprises its original members — Rafael Barreto-Rivera, Paul Dutton, Steve McCaffery, and bpNichol. The group's performances have electrified literary, theatre and musical audiences throughout Canada and the United States.

The Four Horsemen have issued two records, two cassettes, and two books, and their work has been broadcast on radio and television. In recent years, the group has focused increasingly on collaborations with musicians, composers, and other poets. One such collaborator, composer R. Murray Schafer, has said of the group's work that "I believe something is happening here that will change the course of modern literature and music too."

RAFAEL BARRETO-RIVERA is the author of two books of poetry, with a third to be released in the fall of 1985. He has also published poems translated from the Spanish and has issued a cassette of his voice-work. His career continues to expand through the success of his publications and of his dynamic performances, which have gained him an international reputation.

PAUL DUTTON is the author of two books of poetry and the co-author of a third. His voice poems have been issued on an album, and two books and a cassette are in preparation. He has performed his work internationally and his poems appear regularly in literary magazines and anthologies.

STEVE McCAFFERY has added musical performances and videotapes to his expanding output of books and cassettes. Renowned for his visual and sound/performance poetry, he has collaborated with artists in various disciplines. He has published seven books of poetry and a novel, and has performed widely in Canada and abroad.

bpNICHOL is the author of numerous books, chapbooks, records, and cassettes. Winner of Canada's Governor General's Award for poetry, he has earned a world-wide reputation for his pioneering accomplishments in visual and sound poetry. His more than twenty books include novels, visual poetry, verse, and children's literature. His performances within and beyond Canada have earned him increasing recognition.

A Merging Emerged

by Paul Dutton

I never really intended to become a member of CCMC. When bpNichol suggested, in 1987, that he and I see if the band-members were agreeable to our periodically sitting in on voice at their weekly Music Gallery concerts, it was, as he put it, "to keep up our chops – just go once a month or so and work out." Our own group, the Four Horsemen, a sound-poetry ensemble formed in 1970 with fellow writers Rafael Barreto-Rivera and Steve McCaffery, performed rarely now; I worked irregularly in duo or group contexts with various free improvisers, but there was no regular ensemble context for our particular brand of voicework (tapping the potential of the vocal apparatus for unorthodox, largely prelinguistic effects and techniques, beyond those normally used for speech or song); and the CCMC/Four Horsemen collaborations of previous years had been very satisfying – had in fact catalyzed our early '80s shift to an almost exclusive use of four-voice free improvisation. This new notion of bp's seemed not only agreeable but exciting.

As it turned out, bp's professional schedule allowed him only limited opportunity for participation through that first year, and his tragic early death occurred in the fall of '88. I had played the first year as planned, finding that the workouts not only helped me keep my chops, but even more, prompted me to develop them. Performing regularly in conjunction with a variety of instruments pushed me to seek fresh technical means of blending and contrasting with them, and the mix of musical ideas led me into new aesthetic territory: there's nothing like bumping up against

other minds to stimulate your own. Then there was the pure pleasure of free improvisation with musicians serious about and expert at that art, which is an on-the-spot, no-second-chance compositional collaboration, with no set key or sequence of chords, no provision of structure or form, no point at which any precise event will occur, nothing established in advance beyond an agreement to begin shortly after taking the stand and to stop some time later. It requires mastery of your instrument (though not necessarily of the conventional technique for it – which certainly characterizes my use of voice), heightened intuition and spontaneity, intense listening, refined rapport, and extremely self-disciplined playing. The shape and emotional character of the work emerges from the collective mind, and as it does, the individual players fit themselves into the evolving form and moods, contributing similar or contrasting effects, reinforcing or redirecting the prevalent feeling, trading motifs, punctuating, underlining, following or taking the lead, dropping out, easing in. It is very much a music of digression and association. Textural considerations usually dominate, but melody can sometimes take over. And just about every type of music that any of the musicians has ever played or encountered might emerge or be alluded to at some point or other.

Like I said, I never intended to become a member of CCMC. I joined the band the way the band plays music: by following the flow. After that first year, I started turning up more frequently and was eventually invited to sit in weekly, my status as a member

of the band – pretty well established by the end of '89 – being formally acknowledged in 1990. Other guest performers came and went during that period (as they have done throughout the group's history and will doubtless continue to do), and the active personnel has changed some (also consistent with group history). Both of those factors have affected the particular sound of the group, but its essential character is constant – a rich, variegated tapestry of sonic and rhythmic textures and colours, of complementary and contrasting effects, of shifting moods and protean forms, occasional blues-drenched passages juxtaposed or overlaid with minimalist effects, dense ensemble roars that somehow collectively stop on a dime, delicate solos emerging from raucous riff-trading, a circus-silly reference or some more subtle musical joke, a nod in the direction of bop or a tongue-in-cheek lounge-music episode, pulse-pounding romps and meditative drones, a roller-coaster ride on a trackless trestle being built as it's ridden. Fun.

CCMC, 1990. Al Mattes, Michael Snow, Paul Dutton
and John Kamevaar.

The CCMC and Me

by John Kamevaar

I'm sure that the opportunity for a musician to become a member of his favourite band is a rare occurrence. I recall my reactions to the earliest contact with the CCMC's music in the late 1970s — the excitement and fascination with the overwhelming complexity of this dynamic process which continuously produced the unheard of. As a drummer I was particularly inspired by the remarkable range and technique of Larry Dubin's playing which, far from merely "keeping" time, refracted, suspended, and proliferated it abundantly, and with a generosity that it failed to reciprocate in his life.

In 1981 I had already played with the CCMC on several occasions, when Nobuo, who was my sculpture teacher at the Ontario College of Art, invited me as a guest for a month. The invitation was extended for an indefinite period. At that time the collective's instrumentation revolved around the jazz set-up of drums, bass, piano and horns. But in addition to trumpet and piano, Michael played electric guitar and synthesizer. Casey's acoustic piano playing was often complimented by his innovative work on the electric piano. Al alternated between the bass, electric guitar and synthesizers. Our alto saxophonist, Nobi, was perhaps the most adventurous one with his assemblage of gongs, chimes, toys, electronics and prepared tapes. Along with my drums I also brought tapes, guitar and synthesizer. We all played on a marvellous array of percussion instruments.

The compositions of the CCMC are freely improvised. The musician is at liberty to

CCMC EN CONCERT à

Montréal Musiques Actuelles
New Music America 1990

Lundi 5 novembre, 17 h
Maison de la Culture Frontenac

16 h **Joseph Kubera** piano solo

CCMC 5:

MICHAEL SNOW

Internationally known as a visual artist, Snow is equally active as a musician, playing piano, trumpet and guitar. In the 1950s and 1960s he played with his own group at several Toronto clubs, with Mike White's Dixieland Band, and with many great jazz musicians: Pee Wee Russell, Rex Stewart, Jimmy Rushing, Cootie Williams, Edmond Hall. He participated in the "free Jazz revolution of the early 1960s in New York. Returning to Toronto he played and recorded with the Artists Jazz Band and was a founding member of CCMC in 1974. Besides appearing on all CCMC recordings, he has issued several recordings under his own name, most recently "The Last LP" and "Two Radio Solos".

NOBUO KUBOTA

A practising architect for ten years before concentrating on sculpture and music, Kubota has completed several public sculpture commissions, and was a founding member of the Artists Jazz Band (1962). He plays saxophones, pioneered many pre-recorded material in improvisation, and has invented many instruments. His recent music has been influenced by Japanese opera, Japanese and Korean Court music, and contemporary sound poetry, integrating his voice with electronic and instrumental sound sources. He was the subject of an NFB film "Kubota", and recently completed a residency at Western Front (Vancouver) where he produced a videotape based on his solo vocal and "mine" performance.

Maison de la Culture Frontenac
2550 Ontario est
Info : 872-7882

ALLAN MATTES

Mattes holds degrees in both music and psychology, and has studied composition and electronics with Richard Teitelbaum and David Rosenboom. He is a designer and builder of acoustic and electronic instruments and has played acoustic and electric bass, guitar and electronics with the CCMC since its formation in 1974. Mattes was director of the Music Gallery (Toronto) for several years and has been the organizer of several international festivals of electronic and improvised music. He was for many years the managing director and national spokesperson for ANNPAC (Association of National Non-Profit Artists' Centres)

JOHN KAMEVAAR

Kamevaar joined CCMC in 1981, playing mainly percussion, electronics and guitar. He has performed in a variety of idioms: with Lubomyr Melnyk, Eric Stach, John Oswald, and collaborated on dance performance. He is a graduate of the Ontario College of Art, where he studied with Udo Kasemets and Nobuo Kubota. His own group, KAISER NIETZSCHE, primarily electronic, has released several cassettes and records on the Freedom In Japan label, a Vacuum label. His recent and a record has been recently released in Japan. His recent musical exploration centre on real-time manipulation of pre-recorded and sampled electronic sound.

UNE HISTOIRE DU CCMC (Chapeau, Chemise, Mouchoir, Cravate)

CCMC a été constitué en 1974. Le projet: jouer professionnellement une musique composée spontanément. Le groupe - Larry Dubin, Nobuo Kubota, Allan Mattes, Casey Sokol, Michael Snow, tous qui jouent plusieurs instruments acoustiques et électroniques - a joué des concerts deux fois par semaine au Music Gallery (Toronto), a fait quelques tournées au Canada et en Europe jusqu'au 1976, le moment que Larry Dubin, grand percussionniste, a mort de la leucémie.

CCMC (Kubota, Mattes, Sokol, Snow) a continué les concerts reguliers au Music Gallery, a fait 4 tournées en Europe, a assisté à plusieurs festivals en Europe (par exemple, Musica Nova, Bremen). En 1981 John Kamevaar (la batterie, des instruments électroniques, la guitare) a entré dans le groupe, qui a continué les concerts au Music Gallery, a fait encore des tournées en Europe et a participé dans quelques festivals (Avignon, Los Angeles Olympic Arts, etc) et en 1988 a fait une tournée au Japon.

CCMC a gravé plusieurs disques et vient de publier deux cassettes (CCMC '90).

CCMC a souvent joué des concerts avec d'autres musiciens invités, incluant Evan Parker, Derek Bailey, Misha Mengelberg, Barre Phillips, The Four Horsemen, Toshinori Kondo, Henry Kaiser entre autres.

En 1989 Paul Dutton, poète connu internationalement et membre du groupe célèbre "The Four Horsemen", est devenu membre du CCMC comme chanteur.

PAUL DUTTON

An author of poetry, fiction and essays, Paul Dutton is well-established in the Canadian and international literary communities. He has also, over the past ten years or so, earned a reputation as one of the best voice improvisors in the world. An exponent of the hybrid literary-musical form called sound poetry, he has worked in literary and musical contexts in Canada, Europe and the British Isles. He was associated for eighteen years with The Four Horsemen, a renowned sound-poetry and voice-improvisation quartet that dazzled literary, theatre and music audiences throughout Canada, the USA and Europe. He has worked increasingly with musicians and composers over the last decade. His treatment of R. Murray Schafer's lyrics for the "Wolf" role in The Princess of the Stars is incorporated into the score, and he originated the role of "Michael" in Schafer's Apocalypsis. Dutton has also worked with jazz musicians in concert halls, alternate galleries and bars.

(CALVADOS CHAMPAGNE MUSCADET COINTREAU)

CCMC

À la frontière des musiques composées et improvisées.

DISPONIBLE AU CONCERT : DEUX CASSETTES NOUVELLES "CCMC '90"

create any sound whatsoever at any time. The sheer juxtaposition of independent processes is as valid a form of orchestration as is rhythmic accord and harmonic intonation. As an ensemble, the group is a sort of schizophonic entity prone to frantic outbursts followed by periods where all is calm and composed. The individual's gestures become elements in a shifting field, attracting, repelling, recombining with other elements. Responses are reinvented. Dissimilation and coalescence are two sides of a coin perpetually spinning in the air. I guess it could be said that we are dedicated to the production of the unpredictable. The aesthetic is proportionate to the context: we come to the *Music Gallery* once a week for a period of time to play music together.

Many of the styles and methods of this century's music are woven into the fabric, often in hybrid forms. Perhaps in earlier times the music of the CCMC could legitimately be described as "free jazz," but at this stage "idiom" is just another material. Musical styles have become sources for quotation, *mechanically*, as in the playback of prepared tapes, the use of samplers and radios, or instrumentally, for example when Michael abruptly shifts from a blues riff to a classical motif, etcetera. Often the result is a very fragmented diversity of references, a confluence of genres.

Strictly speaking, the music is not performed, as it has not been pre-formed in accordance with a model; neither a song nor a general code of prescribed musical behaviour. This non-representational aspect of the music is also reflected in the uncompromising attitude of the group to focus entirely on the creative activity itself. The absence of a certain self-conscious stance, common to many forms of "serious" music (let alone the ridiculous posturing prevalent in pop music), does a great deal to enhance a level of self-expression where the emphasis, refreshingly, can be given to the second word of the term.

Again: the music of the CCMC is improvised. Maybe a useful distinction can be made between extemporization and improvisation – *the former term* signifying the creative process which is perhaps best exemplified in jazz: a "spontaneous" recollection, drawing from a reservoir of accumulated musical knowledge and instrumental ability. Improvisation could denote a special case, an unrealizable "ideal"

where, with regard to form, expression, and technical facility, the musician is as limited by what he knows as what he doesn't know.

Solo

When I joined the CCMC, two distinct musical spheres influenced my activities. On the one hand, there was my involvement in free jazz, primarily as a drummer, having played with saxophonists such as John Oswald and Eric Stach. On the other hand, there was my experience in electronic and tape-music, manipulated piano recordings with Lubomyr Melnyk, and studies with Udo Kasemets at the Ontario College of Art. In addition to playing percussion, guitar and synthesizer, I have frequently used radio broadcasts and recordings from a wide variety of non-musical sources in my work with the CCMC, as well as collaborations with poets, dancers, and videographers. Currently I work with a digital sampler, which allows me to draw from an unlimited number of sound sources, using the keyboard to "play," for example, the tenor saxophone or a freight elevator.

In 1987, Robert Olver released a cassette of my compositions on his label Freedom In A Vacuum. The title of the album, *Kaiser Nietzsche* came to be the name of a group with Thomas Handy and David Scurr. The project spawned several other cassettes and an LP, *Heterology*, produced in Japan. There were also live radio performances, concerts, and an 80-minute sound track for Carl Brown's film *Re-Entry*. It would be difficult to summarize the diversity of methods and materials employed to create our collaborated works. Instead I will give two examples: in 1987 I composed a 29-minute tape piece called "Signal to Noise Ratio," which was exclusively comprised of forms of white noise derived from synthesizer, radio static, TV (dead channels), wind, rain, etc. These sounds were electronically treated and combined in loops and sequences. In 1991, Thomas Handy and I performed a piece called "Send," an improvisation for two microphone/speaker feedback "fields," digitally processed at the Electro-Acoustic Music Festival in Montreal.

```
CCMC TOURS and PERFORMANCES
1991    Electro-acoustic Music Festival,Montreal,Que.
1990    New Music America, Montreal, Que.
1990    The Du Maurier Jazz Festival, Toronto, Ontario
1988    Japan Tour - Tokyo, Osaka, Kyoto and Hamamatsu.
1986    Canadian Exposition, Vancouver, B.C.
1985    The Holland Festival, Amsterdam, Holland
1984    The Olympic Arts Festival, Los Angeles, Calif.
1984    West Coast Tour - Canada & U.S.
1983    O'Kanada Exhibition, Berlin, Germany
1983    Canadian Exhibition, Stuttgart, Germany
1983    Tour of Austria and Germany.
1982    Resident musicians for the Festival at La Chartreuse,
        Avignon, France.
1980    Canada/U.S. West Coast Tour.
1980    European Tour - England, France, Germany, Belgium,
                    Holland and Poland.
1979    Cross Canada Tour.
1979    European Tour - England, France, Belgium, Holland,
                    and Germany.
1978    Cross Canada Tour.
1978    European Tour - England, France, Belgium, Germany
                    and Poland.
1978    Pro Musica Nova Festival, Bremen.
1977    Cross Canada Tour.
```

CCMC, 1991 at the Music Gallery. Michael Snow—
piano, Al Mattes—guitar synthesizer, Paul Dutton—voice,
Jack Vorvis—drums, John Kamevaar—keyboard sampler.

Michael Snow: Discography

Commercially Issued Recordings:

Dixieland Jazz with Mike White's Imperial Jazz Band, 1959 (LP)
Raleigh Records (Hallmark, Toronto)
Mike White, cornet; Michael Snow, piano; Bud Hill, trombone; Ian Halliday, drums; Pete Bartram, bass; Ian Arnott, clarinet.

Theft/Sunset Time (45 rpm)
Astral Records, Toronto
Recorded 17 July 1962
"Theft" composed by Michael Snow
Mike White's Imperial Jazz Band: Mike White, cornet; Alf Jones, Trombone; Ian Arnott, clarinet; Michael Snow, piano; Terry Forster, bass; Larry Dubin, drums.

The Artists Jazz Band, 1973 (2 LPs)
The Isaacs Gallery, Toronto
Graham Coughtry, trombone; Harvey Cowan, violin; Terry Forster, bass; Jim Jones, electric bass; Nobuo Kubota, soprano/alto/baritone saxophone; Robert Markle, tenor saxophone, electric piano; Michael Snow, piano, celeste, flugelhorn, trumpet, whistling.

Michael Snow: Musics for Piano, Whistling, Microphone and Tape Recorder, 1975 (2 records)
Chatham Square Records, New York
Michael Snow, composer, performer.

Jazz and Hot Dance in Canada 1916–1949, Vol. 4, 1986
World Records, San Rafael, California
"Pallet on the Floor"
Recorded 1948
Lorna Dean, vocal; Ken Dean, trumpet; Bill Hicks, guitar; Michael Snow, piano.

CCMC, Vol. 1, 1976 (LP)
Music Gallery Editions, Toronto
Casey Sokol, piano; Michael Snow, trumpet; Bill Smith, soprano saxophone; Al Mattes, bass, guitar, theremin, euphonium; Nobuo Kubota, soprano/alto/baritone saxophone; Larry Dubin, drums; Graham Coughtry, trombone; Peter Anson, guitar.

CCMC, Vol. 2, 1976 (LP)
Music Gallery Editions, Toronto
Same personnel as Vol. 1 but Michael Snow also acoustic piano.

CCMC, Vol. 3, 1977 (LP)
Music Gallery Editions, Toronto
Nobuo Kubota, marimba, alto/tenor/soprano saxophone; Casey Sokol, acoustic and electric piano; Michael Snow, trumpet, piano, marimba; Al Mattes, bass, clarinet; Peter Anson, guitar; Larry Dubin, drums, marimba, various percussion.

Larry Dubin and CCMC, 1978 (3 LPs in box)
Music Gallery Editions, Toronto
Larry Dubin, Michael Snow, Peter Anson, Al Mattes, Nobuo Kubota, Casey Sokol; many changes of instrument.

Vic D'Or 33 1/3, 1978 (LP)
Music Gallery Editions 11, Toronto
Victor Coleman, voice; Larry Dubin, percussion; Allan Mattes, bass; Bill Smith, saxophone; Michael Snow, piano, trumpet; Casey Sokol, prepared piano.

Free Soap/CCMC, Vol. 4, 1980 (LP)
Music Gallery Editions, Toronto
Casey Sokol, piano and organ; Michael Snow, trumpet; Nobuo Kubota, alto saxophone; Peter Anson, synthesizer; Allan Mattes, bass.

Without A Song/CCMC, Vol. 5, 1980 (LP)
Same personnel as Vol. 4 but Michael Snow also piano.

CCMC Live At The Music Gallery(EP)
Recorded 16 and 19 November 1982

Nobuo Kubota, John Kamevaar, Allan Mattes, Casey Sokol, Michael Snow.

The Artisits Jazz Band Live At The Edge, 1976 (2 LPs)
Music Gallery Editions, Toronto
Robert Markle, tenor saxophone; Gordon Rayner, drums; Graham Coughtry, trombone; Gerry McAdam, guitar; Nobuo Kubota, soprano/baritone saxophone; Jimmy Jones, bass; Michael Snow, piano, trumpet, whistling; Denyse MacCormack, vocal.

The Last LP, 1987 (LP)
Art Metropole, Toronto
Michael Snow, drums, gongs, trumpets, voice, casio, invented instruments, recording.

Two Radio Solos, 1988 (cassette)
Freedom in a Vacuum, Toronto
Recorded 1982
Michael Snow, shortwave radio.

CCMC '90, Tapes 1 and 2 (2 90-minute cassettes)
Michael Snow, piano, trumpet; Al Mattes, guitar, synthesizer, bass; Nobuo Kubota, vocal; John Kamevaar, prerecorded sound; Paul Dutton, vocal.

Sinoms, 1989 (CD)
Art Metropole, Toronto
Michael Snow, vocal multi-track, composer.

Masterpieces From The Music Gallery, 1992 (CD)
"They Changed the Lights"
Recorded 6 May 1991
CCMC: Paul Dutton, John Kamevaar, Al Mattes, Michael Snow.

Musicworks Cassette and CD #54, 1992
"Somewhere Else"
Recorded 11 May 1992
CCMC3.

Work in Progress

Duets, 1992 (CD)
Michael Snow, piano; Jack Vorvis, drums.

Film, Videotapes, Radio Broadcasts

Mike White's Imperial Jazz Band, 1962
2 radio broadcasts (audiotaped)

Toronto Jazz, 1962
National Film Board of Canada, dir. Don Owen
Alf Jones, trombone; Terry Forster, bass; Larry Dubin, drums; Michael Snow, piano.

CCMC Concerts at Western Front, Vancouver (1977–80?)
3 videotapes

Around Blues, 1987
Two New Hours, CBC, 16 January 1987
Michael Snow, piano.

Music In My Life, 1987
CBC, 10 April 1987, 55 minutes

Duet Concert, Galerie Obscure, Quebec City, 1988
Videotape
Recorded March 1988
Nobuo Kubota, vocal, saxophone, electronics; Michael Snow, piano, trumpet, guitar.

Solo piano concert, Bibliothèque Gabrielle Roy, Quebec City, 1988
Videotape, 37 minutes
Recorded 24 March 1988

Condensation Of Sensation, 1989
Dir. Carl Brown, 90 minutes
Soundtrack by CCMC: Michael Snow, piano, trumpet; Nobuo Kubota, alto saxophone; Al Mattes, bass, guitar; John Kamevaar, drums, guitar.

Cloister, 1990
Dir. Carl Brown, 90 minutes
Soundtrack by Michael Snow, piano, casio, trumpet.

Two Pianos: Michael Snow and Bob Wiseman, 1992
Concert recorded at Music Gallery, Toronto, 14 December 1991
MuchMusic, CITY TV
Two New Hours, CBC, 23 February 1992

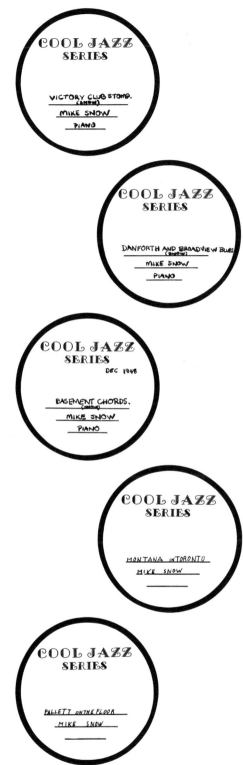

Labels from acetate records made by Eric Cuttiford of Michael Snow's piano solos, recorded November and December 1948.

Unissued Recordings

**Acetate Discs
(now transferred to cassette):**

"Careless Love" (1947)
The Cellar Boys: Lyle Glover, vocal, banjo; Art Schawlow, clarinet; Michael Snow, piano +?

**"Mamie's Blues"
"Victory Club Stomp" (Snow)
"Montana in Toronto" (Snow)
"Pallet on the Floor"
"Danforth and Broadview" (Snow)
"At the Jazz Band Ball"
"Basement Chords" (Snow)
"London Blues"**
Recorded November 1948
Michael Snow, piano.

**"Royal Garden Blues"
"MacDougall and Brown"
"Willie the Weeper"
"Lazy Sunday"
"Gin Mill Blues" (piano solo)**
Recorded autumn 1949
Ken Dean, trumpet; Michael Snow, piano.

"Ugly Child"
Recorded in concert at Centre Island or Polish Hall, Toronto
Ken Dean's Jazz Band: Ken Dean, cornet; Roy Glandfield, trombone; Don Priestman, clarinet; Michael Snow, piano.

"Ja Da"
Recorded in Chicago, 20 June 1950
Pee Wee Russell, clarinet; James Jones, trombone; Michael Snow, piano.

**"Dippermouth Blues" (May 1950)
"Sister Kate"**
Ken Dean, cornet; Don Priestman, clarinet; David Lancashire, trombone; Michael Snow, piano; Norm Grant, tuba.

**Unidentified
"Nobody Knows You When You're Down and Out"**
Michael Snow.

"Melancholy"
Ken Dean; Michael Snow.

**"It's Right Here For You" (May 1950)
"When the Saints Go Marching In"
"Georgia Grind"**

"Alexander's Ragtime Band"
"Blues in F"
"That Da Da Strain"
"Muskrat Ramble"
Ken Dean; Don Priestman; Roy Glandfield;
Michael Snow; Cy Ware, drums.

"Ja Da" (May 1950)
"How Long Blues "
Ken Dean; Don Priestman; David Lancashire;
Michael Snow; Norm Grant, tuba.

"Love Nest" (1950)
Ken Dean; Don Priestman; Roy Glandfield;
Michael Snow; Pete Jack or Cy Ware, drums.

"Pallet on the Floor #1"
"Walkin' the Dog "
"Pallet on the Floor #2"
"Royal Garden Blues "
Recorded in Chicago, 14 September 1949
Michael Snow; Don Priestman; Roy Glandfield;
Bud Jacobson, tenor saxophone; Harry McCall,
drums.

"Save It, Pretty Mama" (1950)
"Trouble in Mind"
Ken Dean; Roy Glandfield; Michael Snow;
(?) drums.

"Cherry"
"Save It, Pretty Mama" (1950)
"In a Quandary"
Michael Snow, piano.

"Red River Valley"
"When the Saints Go Marching In"
Lyle Glover, banjo; Michael Snow, piano +?

"How Long Blues"
Lyle Glover, banjo, vocal; Michael Snow, piano;
? female vocal.

"Louise"
Recorded in Chicago, 20 June 1950
Pee Wee Russell, clarinet; James Jones, trombone;
Michael Snow, piano.

"Muskrat Ramble" (1951?)
Michael Snow, piano.

"St. James Infirmary" (1951?)
"I Found a New Baby" (1951?)
Michael Snow, piano; Graham Coughtry, vocal.

Audiotapes

"Bruxelles/Brussels" (1953)
Hubert Kuzel, trumpet; Pierre Cordier, drums;
David Lancashire, trombone; Michael Snow, piano.

Artists Jazz Band (1962–80)
Tapes in collections of Gordon Rayner,
Nobuo Kubota, Michael Snow.

CCMC (1976–present)
Tapes in archive of The Music Gallery,
Toronto.
Tapes in collections of Allan Mattes,
Michael Snow.
All concerts by CCMC at the Music Gallery
(biweekly, then weekly) since 1976, many with
guests, including: Misha Mengelberg, Derek
Bailey, Evan Parker, Henry Kaiser, Toshinori
Kondo, Steve McCaffery, The Four Horsemen,
Barre Philips, John Oswald. Also, four tours of
Europe, one tour of Japan, many festivals:
Canada, USA, France, Germany. Personnel varies.

03-23-03 concert series
(*Parachute* magazine), Montreal,
6 March 1977 (1/4" tape)
Michael Snow, piano, trumpet.

Piano solos 1980–81 (home recording)
Piano solo concerts:
Around Blues, 1986 (Music Gallery, Toronto)
Paysages, 15 August 1987 (Matane, Quebec)
Lynx, 1985 (Holland Festival, Amsterdam)
Lynx, 1989 (Anthology Film A)

References

Jack Litchfield. *The Canadian Jazz Discography:
1916–1980.* Toronto: University of Toronto Press,
1982.

———. *Toronto Jazz 1948-1950.* Privately pub-
lished, 1992.

Mark Miller. *Jazz in Canada: Fourteen Lives.*
Toronto: University of Toronto Press 1982.

STEREO LP 1009/10
CHATHAM SQUARE

MICHAEL SNOW

MUSICS FOR PIANO, WHISTLING

MICROPHONE AND TAPE RECORDER

My first consideration in writing the text which you are now, I presume, reading ("presume": I guess that this text will still be here to read later even if you aren't reading it now) was to write something which when printed would cover all four faces of this album. Of several ideas for a design for this album cover or jacket this seemed at the time to be the best. Remains to be seen. Ruminations gradually clarified to this stage: I would write something that would fulfill several requirements, the basic one being that it function as a "design" or "image" that would be both decorative and "plastic". Another requirement that might better be approached now as an intention or ambition was the image

PRODUCED BY THE ISAACS GALLERY, 832 YONGE ST., TORONTO. MICHAEL SNOW and CHATHAM SQUARE

quality and the reading quality be unified and that it be "literature" that could be read with aesthetic prof
first, apart from the reader having any actual experience of the music which this will, in effect, enclose
consequently it should nevertheless have some connection, varying in strength, with the music, indeed, that s
of it would be so written that it would be interesting to read while half-listening to the music. Indeed, that s
your undivided attention to both reading this and listening to the music I'd be very s surprised. However, I sup
its possible. Before I attempt to amplify that I ought to say that because of the design of this album you can
this without owning the album which I assume is enclosed in plastic. Perhaps it's not. Anyway the text conti
on the two inside faces and concludes on the back. This is of course the beginning. It will get really interes
Now I should return to a discussion of how, when and if you should simultaneously read this text and listen to
music. You can ignore my instructions but you will soon see that certain parts of this text might be read again
with certain parts of the music and I plan to make it evident when such parts occur. For the moment please
put on one of the records. I don't want to give the impression that I intended the music contained herein t
mere background music for the reading of this text or any other activity. Obviously I have no control over th
you want to put one of the records on right now, you can go right ahead, What can I do about it? Maybe or
them is playing right now. Which one? A guess: "Left Right" right? . . . Perhaps for some people it woul
preferable to, at first, half-listen to the music and half-read this and later pay more attention separately to eith
hope that the music can be listened to often with or without this text. The music is more important than th
occasioned it. However, I would really like this to be as good as the music . . . I've been making music since a
1945. I've been writing about ten years longer but not generally with the same intent as that behind the maki
music, just casual writing, at first school stuff, some plays and skits at a summer camp, Camp Calumet. I
mostly letters, lots of letters, plus a couple of essays, one of which is somewhat close to this and most recentl
script, largely dialogue, for a 4½ hour film. I'm self-taught on piano, trumpet and typewriter. Whistling is natu
started out learning how to play blues-boogiewoogie piano because I liked it. No doubt there were other rea
too. I met some other problem children in high school who were playing other instruments, and gradually
were bands and then even gigs, especially after high school while I went to the Ontario College of
Subsequently for about 3 years I mostly made my living from music and played with many fine musicians su
Cootie Williams, Buck Clayton, Jimmy Rushing, George Lewis. In the summers of '48, '49, '50 for a week or t
some of my Toronto jazz friends went to Chicago where we jammed here and there, once with the grea
Wee Russell and went to some parties at the home of the equally great blues-boogie pianist Jimmy Yancey
Albert Ammons, Cripple Clarence Lofton, others and myself played at these parties and Yancey, very impre
proclaimed me his "pupil" and taught me some of his stuff. This may not impress you but it meant a lot to
then and now. Now back to the music sleeping on the discs between these sheets (unless it's already up and are
the room) or rather back to this text which, to repeat, is more or less connected to the music. . . I should mer
that since 1963 I have been especially interested in trying to compose, in my films, strong image and s
relationships. In 1964 I finished a film called "New York Eye and Ear Control". Shot and edited by myself, i
a sound track by a great (again!) group with Albert Ayler, Don Cherry, Roswell Rudd, Sonny Murray. This l
and white film was an attempt to set up a simultaneity of separate but equal picture and sound . . . Sound
aesthetics is a vast subject and perhaps this is not the time and place to discuss it. Perhaps it is. In my films I hop
modulate the spectator's consciousness by composing with varying emphasis on the nature of the sound in rel
to various means of indicating the fictional source of the sound within the range of image possibilities (
abstract pure color-light to "realistic" representation). "Rameau's Nephew by Diderot (thanx to Dennis Young
Wilma Schoen" made in '73-'74 is the most radical of these image-sound compositions and most closely relat
this . . . Language, spoken or written, can certainly be categorized as representational. If you were now to
record #1, side #1 (don't) and read this (to yourself) while listening you'd be experiencing something related t
hearing/seeing/thinking experience of certain parts of certain of my films . . . The "image quality" of this tex

examined: Read this then look at it. Those are very different activities. When looked at it is meaningless. No jokes now. Something that n be read cannot be meaningless. Stressing the "look" may tend print towards "visual art" forms but when it arrives it has become icture" not "sign". Nevertheless it is a peculiarity of language that it can claim that a picture can be "read". The reverse is difficult. dictionary of picture-meanings would have to be in print not in pictures, an inter-language dictionary, a translation, finally a rendering t of meaning but of possible language equivalents . . . The first side of the first record is the beginning of a piece called "Falling Starts". s a piano and tape recorder piece made in 1972 (first version 1970) and is dedicated to Baron Von Kayserling. It's arriving too late to p, he's been sleeping constantly for about 200 years. Lucky him, lucky Goldberg, lucky Bach and lucky us that this record wasn't ailable in 1792. Since we are lucky to have it hear and now lets finally hear it . . . It's on . . . Let's face the music and read! Those first ups of high sounds that you are hearing, have just heard or it you're just reading this and haven't as I suggested, put on the record, will ar when you do . . . do it now . . . are sped-up re-recordings of a piano phrase which at its "normal" speed should be heard soon, just has en heard, will be etc. This phrase was composed and played by myself for its use as a subject of tape recording compression and ngation. Tenses. Comprehension mention: Village Voice critic Tom Johnson wrote that this phrase (the musical phrase) is an "atonal" rase. It's not. It's not. It's built on an F minor scale and harmonically there are some open major sevenths. Flatted fifths and seconds. Several rases were tested out, this one seemed to have an internal fitness for its intended use. As you can hear, it starts very low, the right hand th slight acceleration rises and falls and rises and falls to the top of the keyboard while the accompanying bass figure revolves in the ne low tonal area. The right hand phrase covers almost the entire range of the keyboard and the bass provides a reference for this aural ce. The Chordal clusters and the requisite amount of resonance in performance generate new inner vibrations and re-reveal their original es when slowed down as you may be hearing right now. If one has understood the subject phrase structurally then the subsequent iations may be more than sensation though that can be a lot. Bathyspheric bubbles under ping ping ping ping ping, "Falling Starts" ntinues its descant descent on Side 2 with the final and lowest version which is a fundamental experience of sound generation and eption as tactile. Membrane to membrane to brain. I recommend that you stop reading this for a few minutes and listen closely to the e few minutes of Side 1 and then go on with Side 2, listen to it for awhile and then resume reading this . . . The 2 sides obviously can be ened to separately but the first time you should hear the whole piece all the way through and don't read or talk. Now, this sentence is thing very important, just something to read word by word while you're listening, a sentence that won't interfere much with your ening and since it doesn't say much (that's twice!), won't interpose other subjects between what you're doing (reading) and listening entively . . . flutter flutter . . . putt putt putt putt putt . . . cars in the rain on a dark street . . . the helicopter arrives with the motorboat . Ultramarine whale dreams . . . a snore at the shore . . . pat pat pat pat pat pat . . . morning running shoes . . . The time-space between tes can now be cavernous. Days of mixed metaphors can seem to go by between a certain two bass notes . . . Boom! . . . sh sh sh sh sh sh s s s s s s s s s s . . . Perhaps someone else could change the record so that you could go on reading this. Ask them to put on "W in the D". . wait! Reading this between records may put more emphasis on its quality than perhaps it can take. The style so far has been quite in hasn't it? It needs to be much more complex now. Là! L'Asie. Sol miré, phare d'haut, phalle ami docile à la femme, il l'adore, et dos dos là mille à mis! Phare effaré la femme y resolut d'odorer la cire et la fade eau. L'art est facile à dorer : fard raide aux mimis, domicile azzi. Dodo l'amie outrée! Surprise. That was less conversational, more musical but I didn't write it. I don't know who did. André eberge gave it to me . . . OK, before "W in the D" gets started (wait a minute) the following is some information about it. It's a ording of me whistling and breathing. There are no electronic alterations in the sound. It's documentary, real time. I held the rophone in my hand and moved it into and out of the airstream of the whistled phrase (sometimes it's just air, no notes). The air ake preceding each phrase brackets them all. The length of each phrase was determined by how long I could whistle on the amount of I'd stored. I tried to make each phrase a distinct event in itself although there are some repeats with slight variations of a dee dee dee dee dee dee dee repeated single air-note motif. Please don't read any of this aloud unless instructed to: You could however give notice a request that the record be started now and you'll hear the just described phrase first. It begins the piece and you'll note later that it ends lthough despite the fact that you've never heard it, if you trust this text you already know that that is how it ends. For my ear-mind the blowing on the microphone produces an aural picture plane . . . A concert playing of this tape (made in 1970) occurred (N.Y.U. 1972). ad all the lights turned off and the tape whistled in the dark. This is very effective. It can enhance the associational, imagistic effect of ne of the phrases and of course having seeing muted allows for a concentration on listening. If thinking doesn't take over one may ceive more of the subtleties that are in the music. If, as I suggested, you've already started the record you're probably at whooweedleyaduh ooweedleyaduh whooweedleyaduh whooweedleyaduh or if you are about to play the record why don't you leave off reading this for the ation of the piece, turn off the lights or just hold your hands over your eyes? . . . (I suppose that there are plenty of reasons why you ht not want to do this and evidently you are still reading). Well, darkness isn't absolutely necessary, in fact it's not necessary at all . . . rr tweet tweet tweet tweet tweet . . . The music is quite interesting with your eyes open looking at whatever you want to look at. Some ple turn on their T.V. set with the sound off while listening to records. With the T.V. sound on as well can be interesting but please 't try it with this record. You could put every damn thing on and keep on reading this till the phone rings but if you do I hope you'll your undivided attention to the music on some other occasion . . . By the way, marijuana and music, like Michael, microphone and , both begin with M. M m m m m m m . . . Why don't you smoke some now while you're still listening to "W in the D" and reading s? "W in the D" is about 23 minutes long and you can breathe along with it . . . puff puff puff puff puff peep peep sweeahoh . . . here

comes the ending now, sort of Beethovenesque in an airy way. The dee dee dee dee dee dee dee repeated note motif is repeated sans note, just air, and is followed by a long exhalation. That's it. Between records: One will perhaps note that the tapes used here date from '70-'72 and the record is being issued in '75. Perhaps you wondered why there aren't more recent pieces. No? Well, anyway for the last about three years apart from sound for my films, I have been very involved in playing freely improvised music with certain groups in Toronto (mostly The Artist's Jazz Band A.J.B.) and apart from a couple of other solo tapes (one for trumpet), I have been a contributing member in these groups and the music is collective composition. I had been wanting to make these "personal" tapes publicly available for sometime and it finally became possible which made possible the idea of wrapping these solos in this solo. The original tapes are "home" tapes and not studio quality recordings. There is more s s s s s s s s s s s certainly. However, I felt that I could not re-make them in a studio. They partake of a certain time and place. They have been expertly assisted to this stage by Kurt Muncacsi of Basement Recording Studio and by Klaus Kertess . . . Now do you feel like hearing the last side? Hungry? Oh come on let's give it a spin . . . It's possible that you may not like my music or my prose or both together but I certainly hope not. That would certainly be a drag, spending the money and then not liking the music and then reading this crap to top it all off! Still, if you don't like the music and you do like this at least you've got this! If the album was recommended to you maybe you should discuss it later with whoever it was. All I can say is that I've done and am doing my best and that maybe you'll like the music more on re-hearing and you'll never have to read this again. Maybe this is better as "image" than as literature! I'll keep working on it. You do your best too. It's not just up to me . . . The following should be read aloud or sung: except for the occasional onomatopoeia, yes, the occasional onomatopoeia is excepted, please don't read aloud or sing any of this text along with any of the music. Why, oh why? Because, then the text is liable to become a song-lyric stimulus for your own, choose one now, choice of notes and the music an accompaniment. This is my text and my music and if you want something that can be "interpreted" please look elsewhere. Autre part. That sounds pretty autocratic I suppose and I realize that if you have bought this it could as accurately be said said to be "yours". Also if I'd never mentioned reading aloud or singing you might not have even thought of it and there'd be no problem. Still singing? Should have indicated a stop after "accompaniment" . . . Back to the music and on to the back of the album: the last side of the 2nd record is titled "Left Right", was taped in '71 and is also a tape-piano piece because it was recorded in a way that made a part of the recording process a part of the music. In other words it wasn't only a "documentary" recording of the piano being played. The preceding text was "documentary", it has been other "modes" and meta-morphose again. If you would just put the record on now you would hear some qualities that are difficult for me to describe. (My limitations as a writer?). Maybe somebody else (maybe you) could describe them. "Distortion" has a moral tone, doesn't seem right but probably has to be. This piano music was recorded by laying, lying the microphone on its side on the top of my old upright piano with the recording volume way past its proper maximum. This was done to a nice tape recorder, a Uher which seems to have survived the strain. The percussive playing of the chords smack-rattled the microphone against the piano too. Other sounds you will hear, are hearing or have heard (not that again!) are a metronome tick tick tick ticking and a telephone bell ringing. Rrrrreading, matter. You can tell that I didn't answer the phone. I didn't answer it because I'd spent several hours getting the sound that I liked and the performance was going well and after my first dismay I hoped that the bell would sound well . . . rring, rrring, rring rring . . . it does, it fits, même famille. Who called? Later I coughed a bit, couldn't help it. Quite a slow tempo isn't it? Socialist and sinister. That tick tick tick tick tick sound which started the piece and continues throughout is the sound of the metropolitan gnome. Right now the music has just left being alternately a chord in the right hand and a single note on the left. It is essence of "oompah", a ragtime or "stride" left hand strain. I've played Jelly Roll Morton, Earl Hines, stride and ragtime influenced piano for many years so this piece comes out of that but also it is kin to a film I made in '68-'69 called ⇔ wherein the camera pans back and forth at different tempi in sync with a percussive machine sound which emphasizes the arrival of the picture at each left or right extreme with a thump thump thump thump thump . . . To return to the music, now it's changed to a single note in the treble alternating with bass chords. I played this piece with alternating right and left hands, a backhanded compliment to Paul Wittgenstein. barm barm. Those are alternating chords in both hands brark breek brarch breekeek bracque back to top single note bottom chord crash ping crash ping crash ping crash ping. It certainly is a slow tempo. One of the reasons for that is that it enables one to have time to hear all the music that is emanating from the sounding of each note or chord. Hear what I mean? See what I mean? Left right, left right left right left right two hands two ears two loudspeakers all marking time not marching time. I'll type this just with my right hand and this with my left hand and this with my right now left then right hen left then right then left then right then left . . . pause . . . electric typewriter. Typewriter and loudspeaker are interesting words, words that carry histories in their newness. A man in a bright blue windbreaker is running down the street. Words are inching across the page . . . Your eyes are what? Me, I'm veering. Sex. One's mind rebounds. Mine did, I can't know whether another mind does or did. Turning off the music my mind rebounded from the coldness of this page to the heat of our bodies enduto to a certain other body with my body in and on. A contributing member. Arrival at the station. Back to work. No, why don't you too think about fucking that someone who mutually. Deeper. Excuse me, I'll just get this out of your mind for a minute it's getting a bit too intimate in there . . . Sorry, but could you superimpose that warm wet picture on the sound? Now fade the picture out slowly till you're just listening. Now I'm just writing. You're listening and reading. Just one backward glance in the form of the reassurance that you'll very likely be able to think that over again just as you can play these records again or read this again. Perhaps this time you you you you're reading it it it it without the music but now this this this this time you're reading it with th th th th th the music on. Silent reading right? If so you'll note, perhaps, that the long slow tempo section is followed by a faster tempo coda . . . Mind keeps fading into her pants, into mine too. Could it be that the way the jacket was open to be read suggested "opened" legs? "Jacket" like legs! The "Album" might be a better word there, with another letter . . . Let's try that fading out/fading in system again. "Mixing" or "dissolving" it's called . . . "Left Right" gets pretty fast, racing ahead of the metronome beat very la fin. Lots of merging of the sustained "distortions" both there and here. Shaman. One presumes a lot if one presumes that one can direct another consciousness into varying states of attentiveness en face d'un construct made by one for that very purpose. Amplifying "varying states of attentiveness" I could say that I mean not only the intensity of the attention but its nature and focus. I presume that I can do that and that I do it to myself. Impossible subject, I can never be objective. I tend to believe, because of occasional exterior manifestations, that many of the states of mind I experience in preceiving my work are frequently enough experienced by others. A passage can push you back into yourself so that its benevolent force reinforces your integrity and you momentarily become a core of concentrated yourself. Such a passage might modulate into an arrangement of elements that might draw your self out into an edifying dialogue of equals and then transform into a constellation that might invoke analysis or criticism of itself only to become that more familiar but often welcome Svengalism which provokes total identification sans corps with the "reality" of the observed/recorded/recounted and tilts one off the edge of the bed of regular mind-time into an ancient and honorable lunacy, surfacing with real tears or laughter which were fathered by the ghosts of the artist's gesture. This particular passage, will, no, does appear on the back face of this album jacket and so it is very possible that you who are reading this have not read what appears before on the 2 inner faces. You may have bought the album and for your own reasons or no evident reasons have decided to read the back first. I must admit I sometimes do that with books. Adopting the pose of assuming that I am writing for one solo reader at a time, I say to you (a group reading seems unlikely but possible, of course someone may be reading over your shoulder) (No not yours, yours. Or is it you who are looking over my shoulder?) that I feel that I can address you somewhat intimately but also somewhat abstractly. Consider the class of obscene phone calls. Good thing I didn't answer the 'phone . . . Hello, this text is being written, was written by the composer-performer of the music which is awaiting transmission on the discs enclosed by the cardboard bed on which what was written has been printed. The text and the record are records both. Both of the records could be transmitting right now. Write now a manifestation. You, singular or all embraceable you are perhaps reading these notes because you're considering the purchase of some recorded music. These notes may help you to decide to purchase those notes. There is a lot of information about the music, names, dates, lengths, theories, etc. on the two inside faces of the legs of this jacket. What?! Sorry, that's explained there, too. A jacket has sleeves not faces. I know. The faceless author of this text is still also the composer-performer of the music which may be caused to emanate from the discs contained herein if united properly with the proper apparatus. Record player. So . . . let it suffice for me to say that I think highly of the mmmusic, a lot of living went into it and this and recommend it to you in the hope of contributing to your life a rich source of aural stimuli for years to come and getting paid for it (I know that's illegal grammar). A negligable amount of money will buy this. I myself have sometimes been so influenced by the notes on an album to purchase same. That consideration just emerged, at that last minute as it were as one of the reasons for writing this text (other considerations are faced in the beginning of the text, front face that is) and others may reveal themselves in other parts of the text. As a matter of facet, let's face it, on the face of it, because of my typefacing these facetious faces you (you) haven't come face to face with the face of the composer-performer-author anywhere on the four thighds of this bed-jacket. How do I look? Blue eyed . . . Most of the requirements of this text smiling on the front face have been put to bed satisfied I think (I'll check with them in the morning). So . . . I can see the end approaching. In temporal works this kind of perception is rare excepting that écriture is a creature whose beginnings and endings are apprehendable reversed. This must be qualified by noting that the beginning of a work of literature is new and now the first time it is read and the meaning states that may be evoked by it can be said to be relatively few. In other words, most readers of the first page of a text would be in quite close agreement concerning it's nature, qualities and meaning. However, it can without doubt be stated that someone who read only the last passage or only the first and last passage of a work of literature would be apprehending an "object" which would seem in an almost infinite number of respects radically different from that passage apprehended by someone who had read the entire text from beginning to end. Such is the modifying power of the prior experience in a temporal work that the significance of the ending can only be truly apprehended against the record of the voyage towards it. In isolation it is not an ending is it?

Michael Snow, April 1975.

Les Disques de Michael Snow
Partition 1 Music Snow

par Raymond Gervais

On peut distinguer deux grandes catégories dans l'œuvre musicale de Michael Snow, soit l'improvisation et la composition. Le jazz dixieland de ses débuts, sa période E.S.P. à New York, sa participation aux collectifs Artists Jazz Band et C.C.M.C., une œuvre pour piano comme *Around Blues* et, enfin, *2 Radio Solos* appartiennent au monde de l'improvisation.

Quant à ses disques solos, *Musics for Piano, Whistling, Microphone and Tape Recorder*, *The Last LP* et *Sinoms*, ils se rattachent à l'univers du compositeur. *Musics for Piano, Whistling, Microphone and Tape Recorder* est le premier de ces projets d'envergure à avoir été réalisé. C'est celui dont nous allons parler maintenant.

Il s'agit d'un album double paru sur étiquette Chatham Square, en 1975, et composé, conçu en privé, dans son studio, en solo. Michael Snow est devenu compositeur par le biais de sa pratique en cinéma. Il compose ses films, en planifie les concepts de jeu à l'avance, en structure la syntaxe, la rhétorique, au préalable. Cette pratique l'amena, entre autres, à réfléchir sur les rapports du son à l'image, de même qu'à transposer à la musique «pure» certaines de ses idées de cinéaste-compositeur, dans les trois œuvres que nous allons discuter ici : *W in the D, Falling Starts* et *Left Right*.

En dehors du cinéma, une autre référence importante pour aborder ces trois compositions serait l'art minimal des années soixante, tant au plan visuel qu'en musique répétitive, par exemple. Snow a connu et fréquenté les pionniers du genre aux États-Unis : Steve Reich, Philip Glass et d'autres. Il a fait, concrètement, l'expérience de

leurs œuvres. Ceci dit, Snow nous apparaît plus, cependant, comme étant une sorte de minimaliste «dissident». Son art ici, dans ces disques, est moins «beau» ou séduisant que la plupart des œuvres sonores minimales du temps. Snow s'affirme comme un minimaliste brut, cru, dissonant et radical. Les compositions que nous allons discuter plus loin échappent à toute possibilité de divertissement, de spectacle. Elles sont trop abruptes ou directes pour ça. C'est une question d'éthique aussi. Un choix moral. Snow, à cet égard, rejoint le «dernier puritain» que fut Glenn Gould. À sa manière[1].

Et il réalise mieux que quiconque, nous semble-t-il, une fusion tangible du free jazz dur, brutal, à vif, avec le minimalisme précaire et expérimental de son époque. Il en opère la symbiose parfaite avec un flair, une intuition d'une justesse implacable, dans les trois œuvres que nous allons commenter : *W in the D* (1970), *Falling Starts* (1971-72) et *Left Right* (1972). Ces deux dernières pièces faisant par ailleurs appel au piano soulignent, de manière autobiographique chez Snow, la continuité d'inter-rogation créative, tant au plan compositionnel qu'improvisé, via ce même instru-ment, le piano. Et puis, il y a d'autres objets qui pourraient être envisagés aussi comme des «claviers» chez lui, dans un autre ordre d'idées, la machine à écrire par exemple[2] ou même la radio à ondes courtes utilisée pour exécuter *Two Radio Solos*.

Ceci dit, en ce qui concerne l'album Chatham Square, il doit être abordé dans sa totalité, en tant qu'objet, c'est-à-dire en accordant une attention égale à l'aspect visuel de sa pochette, comme à son texte, essentiel, incontournable, avant même de s'attarder à la musique. De fait, le texte sert ici d'élément visuel. Il n'est pas dis-simulé dans la pochette. Il occupe au contraire les quatre faces extérieures de l'album double, imprimé dans un caractère qui, de très gros et très graphique sur la couverture de devant, va en diminuant systématiquement jusqu'à l'endos, mais demeurant toujours lisible.

On observe donc un processus visuel minimal à l'œuvre ici, le texte évoluant à partir de très grosses lettres vers de toutes petites en fin de parcours, selon un mode de fonctionnement qui recoupe, en contrepartie, conceptuellement celui-là même de la musique dans *Falling Starts*.

1 Glenn Gould, *Le Dernier Puritain*, Fayard, 1983.

2 « I'm self-taught on piano, trumpet and typewriter », Michael Snow, notes de pochette de l'album Chatham Square, LP1009-10.

Par ailleurs, le texte n'agit pas seulement comme texte. Il est visuel : image, graphisme, décor. Il illustre, ornemente la pochette. Sans divisions en paragraphes, en sections, il en occupe tout l'espace. On regarde ce texte bien avant de le lire. Et ça fonctionne! C'est intéressant, attrayant, intriguant. Il faut commencer par lire ce texte en tant qu'image, sous-entend Snow ici (suivant l'expression «lire une image»).

Plus tard, Snow réalisera un film intitulé *So Is This* avec seulement des mots ou signes de ponctuation en blanc ou légèrement teintés sur fond noir ou de couleurs foncées, lequel film entretient possiblement des liens avec la pochette-écran discutée ici.

Quoi qu'il en soit, après avoir regardé ce texte, il faut le lire bien entendu. Il est même indispensable de le lire. Snow suggère même une méthode pour le lire, soit tel quel sans avoir entendu la musique, sinon en écoutant la musique à demi, simultanément à la lecture d'un passage spécifique, et ainsi de suite. Il suggère même que cette activité ludique pourrait renvoyer, à la limite, au rôle que peuvent jouer certains personnages dans ses films (entre autres dans *Rameau's Nephew by Diderot (Thanx to Dennis Young) by Wilma Schœn*).

Comprise dans ce sens-là, la pochette devient une véritable «partition» pour le public. Snow transforme en quelque sorte ses lecteurs et lectrices en acteurs et actrices interprétant le scénario d'un de ses films imaginaires, immatériel ici, inachevé, ouvert puisque potentiellement ré-inventé à chaque nouvelle audition dans le temps, en fonction de circonstances, de lieux et de personnages différents, selon chaque écoute. La pochette ne joue donc pas un rôle d'emballage passif, comme on peut le constater, mais plutôt un rôle actif assez inhabituel. Elle incite aussi, de la sorte, son public à réfléchir sur les rapports divers et complexes que peuvent entretenir le son et l'image ou le texte au cinéma, comme dans d'autres disciplines (à s'interroger sur les notions d'accompagnement, de simultanéité, etc.). Et elle documente aussi, bien sûr. « The text and the record are records both », dit Snow. Des enregistrements.

Depuis toujours, Michael Snow écrit sur son travail en art, sur sa musique, et il le fait fort bien. Avec ce texte de pochette, il nous offre un commentaire fascinant,

jubilant, inventif, à la fois on ne peut plus précis et articulé sur chacune de ses pièces. Ce texte est une œuvre remarquable en soi, impossible à résumer en quelques mots. Il faut en faire l'expérience. Rien n'y est dissimulé. Snow dit tout sur chaque pièce. Tout est clair comme un processus minimaliste de Steve Reich, par exemple, qui se déroulerait limpide devant nous. Lire et comprendre de quoi il s'agit est donc relativement facile, au départ. Mais « la musique est plus importante », dit Snow (puisque c'est elle qui suscita ce texte, cette pochette et non l'inverse), et en faire l'écoute, la découverte, ne va pas sans exigences. À ceci s'ajoute la qualité technique des enregistrements qui n'est pas absolue (mais tout à fait acceptable, adéquate cependant). À ce sujet, Snow précise : « The original tapes are home tapes and not studio quality recordings (...). I felt that I could not re-make them in a studio. They partake of a certain time and place. »[3]

W in the D (1970)

Le titre signifie «Whistling in the Dark» et renvoie également au mot «Wind». On peut y déceler, en plus, toutes sortes d'autres significations possibles, plausibles ou farfelues même, selon sa grille de lecture. *In the Dark*, par exemple, est le titre d'une composition pour piano de Bix Beiderbecke, le souffleur-siffleur de la mythologie Dixie et *Whistling in the Dark* serait alors une sorte d'hommage déguisé d'un pianiste (jadis de dixieland) à un autre aujourd'hui disparu, «dans le noir» donc, désormais... (ou dans le brouillard, *In a Mist...*)[4].

Il y aurait aussi «We in the Dark», «Win the Dark», «Whistling in the D» (en laissant la lettre D ouverte à tous les sens possibles de tous les mots débutant en D, en anglais), et ainsi de suite. Il y a déjà un certain nombre d'interprétations possibles, à ce niveau.

L'œuvre, encore une fois, date de 1970. Or, cette année marque non seulement le début d'une nouvelle décennie, mais aussi l'avènement d'un second souffle pour Michael Snow. Cette année-là, avec le catalogue – format carré – d'exposition titré «A Survey»[5] (qu'on pourrait tout aussi bien adéquatement re-baptiser «A Record»), il fait comme le bilan de sa vie, de sa carrière d'artiste et de musicien en général,

3 Idem, notes de pochette. Concernant l'époque à laquelle Snow fait allusion ici et, relativement à l'enregistrement de ces trois œuvres, on pourrait ajouter qu'elles partagent aussi, naturellement, des affinités avec certaines idées ou réalisations d'autres artistes ou musiciens à la même période, approximativement. Qu'on pense par exemple à des compositions-processus comme *Slow Motion Sound* et *Pendulum Music* de Steve Reich, en rapport avec, respectivement, *Falling Starts* et *Left Right* (soit des œuvres proches parentes par l'intuition, conceptuellement, à certains égards, mais qui se traduisent très différemment, dans les faits, quant au résultat sonore, témoignant ainsi de deux identités autonomes).

D'autres associations du genre pourraient être discutées. La présente analyse en relève quelques unes mais n'épuise pas, loin de là, toutes les possibilités d'interprétation, toutes les pistes de lecture. On pourrait avoir recours à la science de l'acoustique par exemple (pour commenter *Falling Starts*), sinon à certains travaux de John Cage, Nam June Paik, Robert Ashley, Alvin Lucier, etc. (relativement au piano «dénaturé», aux disques à vitesses altérées, aux processus de répétition, aux techniques d'enregistrement, et ainsi de suite). Ce double album Chatham Square de Michael Snow suggère donc, potentiellement, des lectures multiples en ce sens, par comparaison, par analogie. Et on peut y lire aussi tout un milieu en synthèse, en écho au temps.

4 *In a Mist*, composition de Bix Beiderbecke (1903-1931).

5 *Michael Snow/A Survey*, Toronto, The Art Gallery of Ontario, 1970.

en un montage de documents visuels variés, de sa naissance à l'année 1970.

Significativement, *W in the D* est sa première œuvre sonore autonome conçue cette année-là, et qui n'est pas du jazz. En rupture, elle signale donc le début d'une nouvelle phase dans sa démarche de musicien, une nouvelle respiration dans son œuvre en cours. Avant de commenter cette pièce plus avant, voici ce que Michael Snow en dit lui-même :

> It's a recording of me whistling and breathing. There are no electronic alterations in the sound. It's documentary, real time. I held the microphone in my hand and moved it into and out of the air stream of the whistled phrase (sometimes it's just air, no notes). The air intake preceding each phrase brackets them all. The length of each phrase was determined by how long I could whistle on the amount of air I'd stored. I tried to make each phrase a distinct event in itself although there are some repeats with slight variations (...). For my ear-mind the air blowing on the microphone produces an aural picture plane (...). "W in the D" is about 23 minutes long and you can breathe along with it (...) here comes the ending now, sort of Beethovenesque in an airy way. The dee dee dee dee dee dee dee repeated note motif is repeated sans note, just air, and is followed by a long exhalation. That's it.

« Je pense toujours à faire une forme avec le temps »[6], a déjà dit Michael Snow. Dans ce cas-ci, la forme globale de l'œuvre est planifiée à l'avance, à l'intérieur de laquelle chaque intervention sifflée est improvisée. L'ensemble constitue presque une sorte de lexique du sifflement : legato, staccato, avec glissando, hululement, répétition et autres variations dans divers registres. Le corps en tant qu'instrument est, dans un premier temps, transposé ici en un clavier pour siffleur (et non persifleur!), un clavier qui respire, un clavier vivant. Puis, concernant cette respiration, on peut déjà relever que l'alternance de l'inspiration à l'expiration comme technique naturelle renvoie aussi, conceptuellement, à l'idée de mouvement alterné au piano dans *Left Right* (bien que ne s'appuyant pas ici sur un battement rythmique régulier, sur un «beat»), de même qu'au mouvement de caméra dans ←→ de Snow, au cinéma. Conceptuellement. À l'inverse, la distorsion dans *Left Right* fait écho au bruit de l'air soufflé volontairement dans le microphone, dans *W in the D*. Dans les

6 Michael Snow, Entretien avec Jean-Pierre Bastien, *Rétrospective Michael Snow*, Montréal, la Cinémathèque québécoise/Musée du cinéma, mars 1975, p. 12.

deux cas, on assiste à une même tentative de faire entendre la situation limite, critique, extrême, d'une mécanique (d'une esthétique aussi, par extension), via une proposition sonore minimale, et de faire réfléchir donc, par le biais des «défauts» et restrictions physiques des appareils, sur nos propres limites inscrites dans le corps, la pensée, la culture, l'identité.

Dans cette première composition solo comme dans les deux autres qui suivent, dans tout ce disque, Snow fait ce qui est interdit. L'interdit devient la norme ici (distorsion, vitesse faussée…), le prétexte et le sujet même de l'œuvre : confronter les limites permet une remise en question de l'identité.

D'habitude, on cherche à réduire au maximum les bruits accusant la présence des appareils d'enregistrement à l'audition d'un disque de sorte que l'illusion de la musique transcendant l'objet, la musique pure, libérée, soit la plus complète possible. La musique comme absolu, comme «dieu».

Or Snow remet tout ça en question. Il donne à entendre tout autant la machine que, simultanément, ce qu'elle enregistre. Il restitue le contexte technique avec l'œuvre, le factuel de l'appareil, si l'on veut, avec le magique de l'œuvre d'art. Le rationnel et l'irrationnel. Il ne cache rien. Il ne dissimule rien. Tout est audible et plus mystérieux d'autant. Evidence et Misterioso[7]. Du même coup, il démonte la musique et, par ricochet, désacralise le disque comme objet précieux chargé de la représenter. Il propose aussi d'autres pistes de réflexion.

Il insiste, entre autres, sur la notion d'inspiration, d'œuvre «inspirée». De fait, l'œuvre se joue physiquement, biologiquement, par inspiration et par expiration, en même temps qu'elle suggère, à un autre niveau, une «Inspiration» d'origine supérieure, venue d'ailleurs que du corps immédiat, et une «Expiration» à résonance tragique, en contrepartie, qui ferait écho à l'idée de la mort en représentation dans l'œuvre. Il faut donc lire, comprendre les mots inspiration comme expiration à divers degrés ici, corporel comme existentiel, et il en va toujours de même dans l'œuvre de Michael Snow. Il y a des fluctuations constantes du sens, des variantes du signifiant au signifié, des transferts d'identité.

Dans *W in the D* par exemple, parfois c'est un humain qu'on entend siffler,

7 Titres de deux compositions de Thelonious Monk, un adepte du «stride» à l'occasion et un musicien qui a beaucoup compté pour Michael Snow. Celui-ci jouait plusieurs de ses compositions, en trio, au début des années soixante.

à d'autres moments, on dirait un oiseau quelconque ou un loup ou un autre animal, comme des doubles cachés, dissimulés potentiellement dans chaque personne, et qu'on devinerait de manière troublante derrière le sifflement, l'activité de jeu, derrière la culture impliquée. Le corps connaît ainsi divers états de représentation, d'identité, le corps humain, le corps animal, le corps machinal (corps magnéto ou corps micro audible, lui aussi, via l'air qu'on y projette de manière plus ou moins directe). Projection d'air, de souffle, de sons, d'idées. Le corps-cinéma.

Il y a un parallèle à établir avec l'air qu'on respire comme matériau de base et l'«Air» que siffle l'exécutant, la mélodie, le chant, l'aria, bref l'air avec un petit «a» qui sert à faire entendre l'Air avec un grand «A» (tout comme il y a l'inspiration avec un petit «i» et avec un grand «I»). Idem aussi pour l'Expiration si l'on considère la «Grande Finale» de l'œuvre, c'est-à-dire le souffle entièrement expiré dans le micro, un bruit d'air, de vent, signifiant la fin, la mort de l'œuvre, le dernier souffle de l'appareil en contrepartie (par opposition à l'air expiré avec un petit «e», matériau invisible par définition, dont seule l'empreinte peut être capturée sur bande : l'identité du vent).

Il y a donc une seconde «nature» à l'œuvre dans *W in the D*, une nature manifestée dans le corps et procédant d'une opposition nature-culture, en un va-et-vient du sens, de l'une à l'autre, en alternance, suivant un swing mental, conceptuel, ludique, perceptible à l'audition. Snow donne à entendre la nature même de l'enregistrement ici. Et la nature de l'art. Et celle du corps. Plus tard, pour réaliser *The Last LP*, Snow retournera pointer son micro dans la nature. Mais ceci est une autre histoire. La même. Plus loin... Snow siffle aussi dans *The Last LP* ou avec l'Artists Jazz Band...

Respirer est la base de tout, de la vie même. De l'art aussi. Et siffler est la chose la plus naturelle qui soit, au départ. Et comme le précise déjà Snow, «Whistling alone (it affirms the self, blowing forth some company and thus de-alones). »[8] Siffler sans but précis, c'est comme dessiner un «doodle» sonore dans l'espace acoustique, un graffiti audible dans l'instant, sorte de sono-portrait spontané esquissé à partir de rien, ou presque. L'homme dit «primitif» devait siffler, à sa façon. En jazz, on se

8 Michael Snow, «Larry Dubin's Music», *Impulse* Magazine, vol. 7, no 1, 1978, p. 15.

souvient de Meade Lux Lewis par exemple, siffleur émérite qui jouait par ailleurs fort bien du céleste[9]. Siffler est céleste aussi... Certains en font même une profession à plein temps (comme Ron McCroby, par exemple, qui enregistre pour Concord Jazz aux USA)[10].

Michael Snow est le premier, cependant, à avoir fait du sifflement le matériau et le sujet d'une œuvre élaborée autonome. Recoupant parallèlement l'univers de ses films, elle fonctionne comme deux zooms en sens inverses, un zoom en soi avec l'inspiration et un zoom hors de soi avec l'expiration. En soi et hors de soi. La question de l'identité, encore une fois, et qui permet aussi de prendre la mesure des choses, la mesure de l'espace et du temps, la mesure de l'existence.

Siffler dans le noir, c'est siffler sans voir, c'est siffler pour voir. Pour faire la lumière. Chaque phrase sifflée, dit Michael Snow, « est une image différente. »[11] Siffler est à la fois ici l'image et l'activité qui rend visible. En même temps. Siffler dans la chambre noire permet donc à l'image de surgir, de se révéler, de s'imprimer. Une image du souffle, de l'identité. Selon un geste existentiel tout simple : Je siffle donc j'existe. *W in the D* est ainsi une réflexion sur la pratique photographique dans sa relation à l'enregistrement sonore, suivant cette problématique d'«Eye and Ear Control» amorcée par Snow auparavant.

Enfin, *W in the D* rend, en complément, l'espace tridimensionnel perceptible. On peut en mesurer, à l'oreille, une certaine profondeur, via les déplacements variés du microphone par rapport à l'air sifflé capté par l'appareil pour chaque intervention différente. On mesure l'espace par le temps ici, par le geste (cette action avec le micro trouvant certainement un équivalent dans certains mouvements de caméra au cinéma, chez Snow).

Par ailleurs, cette activité ludique de sifflement qui prend racine dans le corps n'est peut-être pas si éloignée que ça, par l'esprit, de la pratique des jeux de gorge des Inuit du Canada[12]. En effet, le va-et-vient minimaliste de ces voix qui se chevauchent durant l'exécution, se projettent l'une dans l'autre, se disent l'une par l'autre, de gauche à droite, et inversement, jusqu'à épuisement des participants, tient aussi d'un travail sur la respiration et la limite. Et ça ressemble au jazz en plus, aux

9 Meade «Lux» Lewis, grand spécialiste du boogie-woogie (1905-1964). On a réédité assez récemment un excellent disque où il joue du céleste : *The Blues Artistry of Meade Lux Lewis*, Fantasy/OJC 1759. Il s'était déjà produit au clavecin également, tout comme Jean-Philippe Rameau...

10 Ron McCroby, *Plays Puccolo*, Concord Jazz CJ-208. Ron McCroby, The Other Whistler, Concord Jazz CJ-257.

11 Michael Snow, *Autour de 30 œuvres de Michael Snow*, Center for Inter-American Relations, catalogue publié par la Galerie nationale du Canada, Ottawa, 1972, p. 31.

12 *Inuit Throat and Harp Songs*, Music Gallery Editions MGE28. *Inuit Games and Songs*, Unesco, Philips.

«batailles» en jazz, aux duels célèbres de souffleurs. Une «chase» et une «steeple-chase» de siffleurs serait à réaliser à cet égard, jusqu'aux confins extrêmes du souffle, de l'invention, de l'esprit manifesté[13].

Avec *W in the D* datant de 1970, nous pénétrons déjà, d'une certaine manière, dans l'univers du *Last LP* de 1986-1987 (titré préalablement, de façon provisoire, «The Last Gasp»). Un extrait de *W in the D* pourrait donc très bien être inclus dans *The Last LP* comme représentant une pratique traditionnelle de la région de Toronto... La boucle est bouclée. La respiration devient circulaire... comme un disque.

Avant de poursuivre avec la deuxième pièce, chronologiquement dans l'album, soit *Falling Starts*, il faut apporter quelques précisions sur les rapports du cinéma à la musique et au disque chez Michael Snow.

L'un des classiques du cinéma muet de Louis Lumière est *L'Arroseur arrosé*. Or, avec les trois œuvres enregistrées sur ces disques, on peut presque parler de «l'enregistreur enregistré»... une sorte de clin d'œil technopoétique peut-être, de la part de Snow, intentionnel ou pas, au cinéma rudimentaire d'origine et à ses appareils précaires du temps, ses projecteurs «perceptibles presque sur l'écran», visibles (dans leur mécanique déficiente, sautillante, turbulente), autant que les films projetés, que l'action filmée (tout comme les magnétos et micros dans le présent album Chatham Square).

Le cinéma, encore une fois, est l'art par lequel Michael Snow devint compositeur. Cette pratique l'amena à réfléchir précisément sur les caractéristiques propres au fonctionnement des appareils d'enregistrement du son et de l'image, sur les équivalences possibles entre le magnéto et la caméra, le tourne-disque et le projecteur, les formes musicales et le lexique cinématographique.

Il en vint à s'interroger sur la manière de transposer certains termes et certaines fonctions du cinéma en musique. Par exemple, que serait un zoom au plan sonore, sinon un panoramique sonore, un travelling sonore, etc.; on pourrait ainsi envisager tous les termes propres au cinéma dans une optique sonore ou musicale : le ralenti, l'accéléré, le champ-contre-champ, le plan fixe, le flou, le fondu, la plongée (dans le grave?), la contre-plongée (dans l'aigu?), et ainsi de suite.

13 *Steeple-chase*, thème associé à Charlie Parker qui l'enregistra pour Savoy en 1948. Surnommé «Bird», Parker nous rappelle ici que plusieurs musiciens de jazz portaient des surnoms, entre autres d'animaux («Rabbit», «Hawk», «the Lion», etc.), notion intéressante à considérer dans le cadre de ce texte sur l'identité en musique.

Concernant les «chase», véritables joutes confrontant deux ou plusieurs solistes (dont les populaires duels de saxos), les pianistes «stride» raffolaient eux aussi de ces «cutting contests» (le genre «stride» étant cité ici en rapport avec *Left Right)*.

Dans le même ordre d'idées, on pourrait aussi considérer le disque comme étant un film de sons... on projette un disque dans l'espace comme on projette un film, sauf qu'avec la musique, l'écran est en nous, invisible; on regarde par les oreilles. L'espace est intérieur. Et lorsque le film est aussi insolite, inhabituel que *Falling Starts*, on se frotte parfois les oreilles d'incrédulité, on est perplexe. Désorienté. De quoi s'agit-il au juste? Que regarde-t-on?

Snow a déjà dit, concernant ses films : « Ils veulent qu'on leur montre quelque chose dans le film et non le film. »[14] Or *Falling Starts* nous montre justement la musique et non pas quelque chose en représentation dans la musique. Ici encore, laissons, en premier lieu, à Michael Snow, le soin de décrire lui-même l'œuvre en détails.

Falling Starts (1971-72)

It's a piano and tape recorder piece made in 1972 (first version, 1970) and is dedicated to Baron Von Kayserling. (...) those first groups of high sounds that you are hearing (...) are sped-up re-recordings of a piano phrase which at its "normal" speed should be heard soon, just has been heard, will be etc. This phrase was composed by myself for its use as a subject of tape recording compression and elongation. (...) Several phrases were tested out, this one seemed to have an internal fitness for its intended use. As you can hear, it starts very low, the right hand with slight acceleration rises and falls and rises and falls to the top of the keyboard while the accompanying bass figure revolves in the same low tonal area. The right hand phrase covers almost the entire range of the keyboard and the bass provides a reference for this aural space. The Chordal clusters and the requisite amount of resonance in performance generate new inner vibrations and re-reveal their original ones when slowed down (...) Falling Starts continues its descant descent on Side 2 with the final and lowest version which is a fundamental experience of sound generation and reception as tactile. Membrane to membrane to brain.

Michael Snow nous convie donc à une expérience acoustique, sensorielle, peu commune ici via cette phrase écrite au piano puis étirée, compressée subséquemment, systématiquement, à la manière d'un processus graduel minimal.

14 Michael Snow, Entretien avec Jean-Pierre Bastien, *Rétrospective Michael Snow*, Montréal, la Cinémathèque québécoise/Musée du cinéma, mars 1975, p. 16.

Au départ, on remarque que cette pièce fait appel au piano, son instrument de prédilection. De fait, la plupart des minimalistes américains étaient pianistes, des précurseurs comme John Cage ou Morton Feldman, par exemple, à Philip Glass, Charlemagne Palestine, Steve Reich, Terry Riley et La Monte Young. Michael Snow est le pianiste nord-américain manquant dans cette nomenclature.

Le piano depuis la fin des années quarante recoupe toute son activité artistique. C'est son instrument le plus immédiat, le plus personnel. Ceci dit, Snow fait subir ici, au piano, un traitement singulier, peu orthodoxe. Ce n'est plus le «beau son» de piano qu'on entend, le piano culturel type. Snow nous entraîne plutôt entre les notes de l'instrument comme il faut lire «entre les lignes», parfois, pour saisir la dimension cachée des choses.

Au tout début, à l'audition, on ne peut identifier clairement la phrase musicale parce que reproduite en très accéléré. Vers sa sixième ré-exposition, on commence à reconnaître quelque chose. À la septième reprise (toujours un peu plus lentement), on dirait presque un clavecin. (Serait-ce Rameau qui joue dans une autre dimension?) À sa dixième exposition, la phrase musicale est en focus, à sa vitesse normale, initiale, d'exécution. C'est du piano standard, si on veut, qu'on perçoit.

Comme tout se mesure, s'évalue dans cette pièce en fonction de cette phrase d'origine exécutée à la vitesse normale, ce qui précède (autrement dit ce qu'on vient d'entendre en accéléré) relève de l'idée d'«ascension» mais diffusée en sens inverse, en rétrograde. Ce qui va suivre maintenant, au ralenti, venant après l'écoute de la phrase de base à la vitesse normale, participe de la notion de «chute». La pièce oscille conceptuellement entre ces deux pôles extrêmes, l'ascension et la chute, bien que, concrètement, l'expérience de l'œuvre met l'emphase sur la chute, la tombée progressive (le crépuscule du piano occidental?).

Cette descente graduelle du piano dans le grave, vers un ailleurs sonore à investir, s'effectue par étapes jusqu'à ce que la courte phrase initiale occupe, à elle seule, presque une face entière de disque, chaque note étant compressée, étirée au maximum, pour révéler un univers acoustique impossible à imaginer, à éprouver autrement.

Toute musique, toute action, ralentie à ce point devient étrange, insolite. Ce qui

est très lent contredit à son fondement même, le rythme nerveux, producteur, hyper-rapide et efficace de notre civilisation. C'est comme interdit, comme un acte rebelle, hérétique. Le lent terrorise presque, en ce sens. Et ça prend de notre temps, forcément, denrée rare, précieuse. Or Snow met en garde contre une écoute rapide ou partielle de la pièce :

> In other words, most readers of the first page of a text would be in quite close agreement concerning its nature, qualities and meaning. However, it can without doubt be stated that someone who read only the last passage or only the first and last passage of a work of literature would be apprehending an "object" which would seem in an almost infinite number of respects radically different from that passage apprehended by someone who had read the entire text from beginning to end. Such is the modifying power of the prior experience in a temporal work that the significance of the ending can only be truly apprehended against the record of the voyage towards it. In isolation it is not an ending is it? [15]

Falling Starts est donc un voyage dans le temps, au bout de l'inoui, une véritable aventure d'écoute, une odyssée acoustique sans pareil. On passe de l'autre côté du miroir ici comme on franchit le mur du son. On amorce la descente aux enfers, dans l'inconnu, dans les régions sombres, inexplorées de la psyché sonore, bref on descend dans la «mort de la musique», d'une certaine façon.

C'est comme si on assistait à un écrasement, à un effondrement graduel du sens de la musique au profit d'un *no man's land* sonore difficile à habiter, à décoder, et par conséquent à traduire en mots. Déjà il y a quelques décennies, Edgard Varèse, Darius Milhaud ou Pierre Schaeffer en Europe sinon John Cage aux États-Unis, avaient expérimenté diverses techniques, en studio, à partir des disques, en en modifiant la vitesse, la ralentissant ou l'accélérant, dans le cadre de multiples recherches en musique concrète ou pré-électronique. Mais ils n'avaient pas poussé plus loin leurs intuitions et leurs résultats. Leur équipement en studio était alors assez limité. Et puis leur point de vue, surtout, n'était pas le même que sera celui adopté par Snow beaucoup plus tard. Ce dernier, en étant systématique, avec une rigueur toute minimaliste, obtient des résultats fascinants que rien ne laissait présager auparavant

15 **Michael Snow, notes de pochette de l'album Chatham Square.**

dans l'histoire de la musique pour piano (ou tout autre instrument acoustique). D'ailleurs *Falling Starts* pourrait-elle être interprétée avec un ou d'autres instruments acoustiques que le piano? Quelle en serait l'issue? Quelle que soit la réponse à cette question, on se souvient que ce n'est pas de manière aléatoire que Michael Snow a choisi le piano pour réaliser cette pièce et qu'il a minutieusement travaillé à élaborer la structure sous-jacente à la phrase pour piano afin d'obtenir des points de repère, entre l'aigu et le grave, et produire des effets spécifiques permettant ainsi une lecture balisée, idéale de l'œuvre. Rien n'est laissé au hasard ici.

Encore une fois, comment dire, décrire ce qu'on entend? Mettre le doigt dessus alors que nous sommes comme à côté des notes, du sens, ailleurs. À cet égard, Snow interroge les limites de notre machine auditive, de nos mécanismes de perception. Il remet l'ouïe en question. Aurions-nous besoin d'un «Hearing Aid» ici pour mieux saisir de quoi il retourne?[16] Qu'est-ce que l'oreille perçoit et comprend vraiment de tout ça? Quel est son seuil de tolérance à partir duquel l'identité même du matériau sonore ainsi transformé n'est plus «récupérable»? Et que se passe-t-il alors? Quel est le point extrême de notre capacité à identifier ce matériau sonore en perte d'identité (en état de métamorphose), avant qu'on ne soit complètement désorienté, perdu, notre boussole culturelle mise K.-O., hors fonction, au profit de l'inconnu? Car la transformation du matériau sonore (timbre, hauteur, amplitude, durée, enveloppe), s'accompagne, en contrepartie, d'une remise en question de l'identité même de la personne à l'écoute de ce processus.

Falling Starts est ainsi une œuvre qui permet de se perdre soi-même, à l'audition. Où suis-je répond à Qui suis-je. L'identité bascule presque à partir d'un certain point de non-retour du matériau sonore évolutif. À partir de quand l'écouteur devient-il écouté, par ce processus même, sinon par l'appareil, par le magnéto? Et la mémoire auditive entravée, détournée, rendue perplexe, quasi inopérante par ricochet? Se souvient-on de *Falling Starts* dans tous ses paramètres après une ou deux auditions? Peut-on chanter la courte phrase initiale pour piano dans sa phase terminale d'exposition? Peut-on la siffler à ce stade ultime de son énoncé (face B)?

Ce qui est particulièrement étonnant ici (et on ne peut plus pertinent dans

16 *Hearing Aid*, installation de Michael Snow datant de 1976-77.

l'optique d'une pratique sonore ancrée simultanément dans le visuel), c'est qu'arrivé à son état limite de transformation, la phrase initiale pour piano, devenue grondements sourds et vertigineux (une infra-musique), commence à susciter ou suggérer des résonnances visibles, des images, des visions : un «hélicoptère» par exemple, ou un «bateau à moteur», de la «pluie», une «tempête», une «explosion» lointaine... et ainsi de suite. Ces images «tactiles», pour citer Snow, nous ramènent dans le monde réel, dans la nature (une nature rescapée par la mémoire, la mémoire qu'on a de ses bruits concrets, à partir d'une technologie qui contribue, selon toute apparence, en revanche, à en oblitérer les «bruits culturels», soit le piano ici et toute l'histoire qui s'y rattache automatiquement). Le son générant l'image recrée donc l'univers, la planète, l'environnement tangible (le disque sonore projetant un film visuel en nous). Comment peut-on être parti d'une simple phrase au piano, jouée dans un studio privé, pour aboutir là, sous la pluie, dans la nature, une face de disque plus loin... Pour bien dire ces images (tout comme pour bien raconter les sons), il faut des mots adéquats. Cette musique inusitée, dans son étrangeté, nous amène à chercher nos mots aussi. Elle suscite donc son propre texte, génère ses propres notes de pochette.

Encore une fois, les instruments acoustiques traditionnels (tout comme la voix humaine dans une autre catégorie, naturelle, organique), ne permettent pas de jouer, d'interpréter une musique semblable à celle de *Falling Starts*. Ce n'est donc pas un piano qui la joue mais un tout autre instrument, le magnétophone-interprète. Snow accorde au magnéto le premier rôle ici, supérieur au piano. Il lui confère le statut d'interprète. Il fait appel à la spécificité même de son mode de fonctionnement (le ruban magnétique opérant comme une partition qu'il étire et transforme à souhait, via un travail méthodique sur la vitesse et la compression).

Partie du piano pour aboutir dans un autre monde, *Falling Starts* témoigne d'un itinéraire, d'un cheminement inusuel. Et par ricochet, l'œuvre devient un peu la mesure de toute musique, l'étalon potentiel pour en évaluer le degré d'identité, quelle que soit sa catégorie. On n'écoute plus jamais la musique de la même façon après avoir écouté attentivement et au complet *Falling Starts*. Une ré-audition aide

aussi, à cet égard, et vaut amplement l'effort.

Falling Starts est une réflexion sur le changement, sur la mort, sur le transfert d'identité, sur le passage d'un état d'être à un autre. Est-ce le pianiste qui joue toujours ou un magnéto? Est-ce le public qui écoute ou un micro? Est-ce la musique qu'on entend ou un haut-parleur qui vibre? Est-ce notre imaginaire qui tourne ou un tourne-disque? Est-ce notre émotion qui enfle ou un amplificateur? Qui est qui ou quoi? Qui représente qui ou quoi? Qui joue qui ou quoi? Encore et toujours ici, comme dans toute l'œuvre de Michael Snow, l'identité est mise en question, la représentation en situation.

Parmi d'autres pistes fertiles à suivre concernant *Falling Starts*, il y aurait enfin le rapport plausible de cette musique avec l'univers du Land Art. Nous en parlerons plus loin. L'une des œuvres-clés dans la production cinématographique de Michael Snow, qui interroge le lieu, l'environnement, c'est, bien sûr, *La Région centrale* où la caméra tourne 360 degrés autour d'un axe et dans toutes les directions possibles, à l'intérieur d'une sphère. Elle tourne donc à l'horizontale aussi, comme un tourne-disque, captant le visuel ambiant dans le sillon circulaire de son déplacement (cette tranche ou coupe d'environnement sur pellicule correspondant peut-être, après coup, à un «disque»). Tout comme pour le magnéto dans *Falling Starts*, la caméra est l'interprète ici et son dispositif, son mode de fonctionnement, devient tout autant le matériau et le sujet de l'œuvre que le paysage sauvage filmé dans sa trajectoire.

Le lieu choisi, éloigné, sauvage, inhabité, est signifiant aussi. « Je veux communiquer l'impression de la solitude absolue, cette espèce d'Adieu à la terre que, je crois, nous vivons actuellement », disait Michael Snow, de manière presque visionnaire, en mars 1969, concernant *La Région centrale*[17]. Comment ne pas faire le lien ici avec Glenn Gould et son œuvre pour la radio (sur le thème de l'isolement) The *Idea of North*[18], de même qu'avec sa propre vie d'ermite, de solitaire, à s'inventer des personnages, des voix (tout comme Michael Snow le fera d'ailleurs, différemment, plus tard, dans son deuxième disque solo intitulé *The Last LP*). Il y a, à distance, comme un dialogue secret entre ces deux pianistes singuliers, tous les deux de Toronto, que sont Glenn Gould et Michael Snow. Une parenté d'esprit, d'attitude,

17 Michael Snow, *Autour de 30 œuvres de Michael Snow*, catalogue publié par la Galerie nationale du Canada, Ottawa, 1972, p. 35.

18 Glenn Gould, *The Idea of North*, œuvre radiophonique de 1967, premier documentaire de Gould dans le cadre de sa *Solitude Trilogy*. Une version télévisée a été réalisée en 1970.

malgré les apparences. Car il y a du «jazzman» aussi chez Gould qui grognait souvent de manière audible en jouant (comme le font beaucoup de pianistes de jazz tels Bud Powell, Oscar Peterson, Keith Jarrett, etc.), et qui savait fort bien improviser aussi, au moment opportun, malgré ses réticences avouées face à l'improvisation). Et en contrepartie, il y a de l'interprète au sens presque classique du terme chez Snow qui traduit assez fidèlement, à ses débuts, les modèles américains de piano jazz (Jelly Roll Morton, Earl Hines, Jimmy Yancey...), avant de s'émanciper complètement comme soliste autonome par la suite. Incidemment, Snow cite Bach et Goldberg en relation avec *Falling Starts* dans ses notes de pochette... Et puis il y a les techniques et les objets de l'enregistrement pour lesquels les deux pianistes manifestent une fascination considérable et d'autres aspects communs aussi qui seraient à di\cuter en parallèle.

Quoi qu'il en soit de leur intérêt mutuel pour la notion de solitude (traduite au cinéma ou à la radio), on se retrouve seul, nous aussi, autour du tourne-disque, à l'audition de *Falling Starts*, véritable périple en slow motion, pas agressif pour autant mais une sorte de quête spirituelle plutôt, un pèlerinage aux sources de l'entendement.

Concernant enfin *Falling Starts* dans son rapport au Land Art mentionné très brièvement plus haut, on pourrait suggérer ici que l'œuvre de Snow, à la manière de Robert Smithson avec *The Spiral Jetty*[19], trace sur deux faces de vinyl un immense sillon spiralé à même la culture, la culture comme environnement. On circule dans cet immense disque, à l'audition, comme on se promènerait dans l'œuvre de Smithson, en contrepartie, confronté à sa propre histoire, à sa mémoire comme disque ouvert, à sa vie comme processus et continuum. *Falling Starts*, à cet égard, est une œuvre existentielle, révélatrice de soi et qui redéfinit, différemment à la fois pour chacun(e), l'espace et le temps. Une œuvre inachevée aussi, qui pourrait théoriquement se prolonger après la fin du disque parce que sa structure et son déroulement contredisent l'idée même de fin, d'arrêt fixe (tout comme l'oreille en forme de spirale organique inscrite dans la peau dément, symboliquement, l'idée de mort définitive au profit du changement).

19 Robert Smithson, *Writings*, édité par Nancy Holt, New York University Press, 1979, incluant une section sur *The Spiral Jetty*, p. 109-116.

Si l'on transposait le temps mis en scène dans *Falling Starts* en termes d'espace, on pourrait voir comme une immense coupure circulaire dans l'environnement, en forme de courbe spiralée, une sorte de «Spiral Jetty» en négatif, en creux si on veut (une blessure ou cassure aussi, par analogie, dans la culture musicale occidentale, la culture du piano noble et des formes sublimes). À cet égard, le piano se voit beaucoup plus dénaturé et métamorphosé avec *Falling Starts* qu'avec les œuvres pour piano préparé de John Cage par exemple, bien que pour chacun les enjeux soient différents et les objectifs autres. Les prodigieuses *Sonates et interludes* pour piano préparé de John Cage[20] prennent ainsi presque l'allure d'un divertissement à côté de l'austérité grave et prenante de *Falling Starts*, également pour piano. Avec Snow, ce n'est pas l'instrument qui est préparé mais plutôt le dispositif d'enregistrement qui est comme détourné de son mode usuel d'utilisation à partir d'un «concept préparé», composé à l'avance et audible, en cours d'exécution, d'audition (la machine «s'écoutant» elle-même, aussi).

Les œuvres de Land Art comme *The Spiral Jetty* furent souvent réalisées dans des lieux isolés, loin des centres urbains et de l'activité turbulente des villes. Dans leur sillage, *Falling Starts* nous entraîne au désert à son tour. L'idée du désert hante toute notre culture technologique à sa façon, par besoin, par manque, par fantasme. Et en musique, le désert est toujours là pour exprimer l'essentiel. On vient au désert pour écouter, une écoute de type mystique, c'est-à-dire plus proche de la prière que de l'«entertainment». Au 20e siècle, d'Edgard Varèse à Steve Reich via Arnold Schœnberg, Olivier Messiaen et d'autres, le désert affirme déjà une présence forte en musique. Et, par son temps indicible, son espace impossible, *Falling Starts* nous emmène, elle aussi, au désert, lieu synthèse d'un questionnement de l'existence, de l'identité. Avec *Falling Starts* nous redevenons nomades, des nomades de l'écoute en chute libre dans l'univers.

Left Right (1972)

C'est, chronologiquement, la dernière des trois œuvres réalisées par Michael Snow sur ce disque. Avant de la commenter plus avant, laissons au compositeur le soin

20 John Cage, *Sonates et interludes* pour piano préparé, 1946-48. (Plusieurs enregistrements réalisés.) Dans cette œuvre, le piano endosse parfois une double identité. On croirait entendre un gamelan par exemple, à l'occasion. Enfin, 1946-48 correspond aussi à la période de formation en jazz classique pour Snow et d'enregistrement de ses premiers 78 tours de jazz traditionnel au piano, en solo (des pièces comme *Mamie's Blues, Pallet on the Floor, At the Jazz Band Ball, Gin Mill Blues*, etc.). Ces disques fascinants mais précaires quant à l'enregistrement sont parfois traversés de tels parasites sonores qu'on croirait du piano-jazz «préparé» par le bruit ambiant, le bruit concret du vinyl qui gratte. Ces premières altérations (non voulues) du son «pur» du piano annoncent, peut-être déjà, à distance, les œuvres beaucoup plus expérimentales à venir, réalisées toujours à partir du piano (comme *Left Right*). Et ce, avec un humour involontaire, à la manière d'un clin d'œil à travers le temps et l'histoire adressé par le Snow de 1948 à son double de 1971 (le Snow de *Left Right* et du piano détourné).

de nous la présenter. Snow dit, à nouveau, tout dans ses notes concernant les matéri-aux, le mode de fonctionnement, une interprétation possible de l'œuvre et sa portée critique. Il mentionne tout dans son texte de pochette. Et la musique est suffisam-ment forte, originale, pour ne diminuer en rien l'expérience qu'on peut en avoir, de même que notre capacité d'en faire une lecture autre, personnalisée. Ça n'épuise pas la pièce. Ça n'atténue pas son impact, au contraire. Voici ce qu'en dit Michael Snow :

> Left Right was taped in '71 and is also a tape-piano piece because it was recorded in a way that made a part of the recording process a part of the music. In other words it wasn't only a "documentary" recording of the piano being played. (...) The piano music was recorded by laying, lying the microphone on its side on the top of my old upright piano with the recording volume way past its proper maximum. This was done to a nice tape recorder, a Uher which seems to have survived the strain. The percussive playing of the chords smackrattled the microphone against the piano top. Other sounds you will hear (...) are a metronome tick tick tick ticking and a tele-phone bell ringing. (...) I didn't answer it because I'd spent several hours getting the sound that I liked and the performance was going well and after my first dismay I hoped that the bell would sound well... rring, rrring, rring rring... it does, it fits, même famille. Who called? (...) Right now the music has just left being alternately a chord in the right hand and a single note on the left. It is essence of "oompah", a rag-time or "stride" left hand strain. I've played Jelly Roll Morton, Earl Hines, stride and ragtime influenced piano for many years so this piece comes out of that but also it is kin to a film I made in '68-'69 called ←—→ wherein the camera pans back and forth at different tempi in sync with a percussive machine sound which emphasizes the arrival of the picture at each left or right extreme with a thump thump thump thump thump... to return to the music, now it's changed to a single note in the treble alter-nating with bass chords. I played this piece with alternating right and left hands, a backhanded compliment to Paul Wittgenstein. barm barm. Those are alternating chords in both hands brark breek brarch breekeek bracque back to top single note bottom chord crash ping crash ping crash ping crash ping. It certainly is a slow tempo. One of the reasons for that is that it enables one to have time to hear all the

music that is emanating from the sounding of each note or chord. (...) The long slow tempo section is followed by a faster tempo coda... (...) "Left Right" gets pretty fast racing ahead of the metronome beat vers la fin. Lots of merging of the sustained "distortions" both here and there.

D'entrée de jeu, dans *Left Right*, on entend le métronome (le temps avant la musique), tout comme on retrouvera ce même métronome en solo, à la toute fin (le temps après la musique) comme une parenthèse qui se ferme, mais au point d'arrivée. Et non de clôture. Car, d'une certaine manière, la pièce commence vraiment pour l'auditeur, pour l'auditrice, après qu'elle se soit terminée sur le disque. Son impact commence alors à se faire sentir graduellement, via la mémoire, la mémoire d'un «choc», celui de la distorsion, la distorsion agissant comme une «musique», une musique autre, interdite, hors la loi, clandestine presque et dont les échos provocants peuplent désormais nos souvenirs.

Et puis cette musique trafiquée passe par le piano, traverse le piano pour nous parvenir, pour nous atteindre, le piano-filtre, le piano-médium, le piano voyant aussi, vu. Le piano en crise d'identité, en représentation. C'est comme si le piano servait de «micro» ici à la distorsion pour se manifester, pour se projeter (par micro interposé). Comme s'il y avait un premier transfert d'identités à ce plan-là. Le piano révélant la distorsion et l'inverse aussi, paradoxalement. Piano-écrin, piano-écran, toile de fond pour la mise en scène de cette distorsion. Et piano-miroir enfin, piano-lentille déformant le son et le sens en même temps, d'un même accord.

Au départ, encore une fois, tout ce qui concerne le piano possède avec Snow une signification particulière puisque c'est le tremplin même de son aventure artistique depuis 1945. Snow réfléchit au piano, moyen d'expression individuel mais aussi, dans un autre registre, symbole culturel collectif en occident (via les réalisations de Bach, Beethoven ou Paul Wittgenstein, par exemple, trois noms que cite l'artiste dans ses notes de pochette). Il y a donc, d'emblée, une sorte de «Left Right» de l'individuel au collectif dans cette pièce. À l'inverse, il y a comme une sorte d'antinomie, de rejet «naturel», culturel, de la distorsion par le piano et son contraire aussi. Un va-et-vient complexe donc, à plusieurs niveaux.

Et puis bien sûr, il y a le style «stride» choisi à bon escient par Snow ici et qui rappelle ses débuts en jazz. Or, Snow ne se contente pas de paraphraser ou de rejouer l'histoire, de citer le modèle d'origine dans *Left Right*. Il le transcende et propulse ainsi le piano «stride» afro-américain au rang de forme musicale universelle, d'archétype.

Pour ce faire, l'œuvre offre diverses pistes de lecture, d'écoute, en commençant par les liens qu'entretiennent l'instrument (le piano) et le style choisi (le «stride») avec le métronome. Snow semble associer ici le mouvement de balancier propre au «stride», (la main gauche qui pompe le rythme, la main-tempo, en alternance avec la main droite qui brode selon sa fantaisie virtuose), au mode de fonctionnement même du métronome. Le métronome est, par définition, par nature, «stride» de comportement, de personnalité (bien que mécanique et plus rigide, donc moins poétique en soi). Le stride est un style de jeu ouvert, pas un objet. Mais le métronome n'est pas n'importe quel objet. Il recèle un mouvement de pendule générant une activité de découpage rythmique, régulier du temps, qui l'apparente de loin aux battements du cœur humain. Il est anthropomorphique (ou plutôt «anthropo-rythmique»). Le jumelage du style «stride» donc et du métronome dans le contexte du piano transforme l'instrument en un gigantesque métronome hybride (l'hybridité faisant figure de première «distorsion» ici, distorsion de sens et de fonction).

Ce piano-métronome, piano-cœur, piano-corps aussi, nous rappelle, dans un autre ordre d'idées, le métronome avec un œil en photo fixé au pendule par Man Ray, le fameux *Objet à détruire* de 1923 suivi de son double, *Objet indestructible* de 1958[21] (selon une oscillation «Left Right» de la destruction à l'indestructibilité et inversement, mimant donc le fonctionnement du métronome en question).

Dans cette œuvre étrange, surréelle, Man Ray suggère, lui aussi, une sorte de mécanisme d'«Eye and Ear Control»[22], de pulsation régulière de l'œil à l'oreille et inversement, de va-et-vient complice entre ces deux sens indissociables. La première version de cette œuvre de Man Ray date de 1923, période qui correspond exactement à l'invention du style «stride» déjà évoqué. En contrepoint, en ce qui concerne *Left Right*, on peut presque parler de «musique à détruire» (pour paraphraser le

21 Giuliano Martano, *Man Ray Clin d'Œil*, livre d'artiste édité par les galeries Il Fauno et Martano de Turin, 1971. (Incluant des photos des œuvres citées ici de même que d'une nouvelle pièce pour deux métronomes titrée *Perpetual Motive*, de 1970.)

22 L'expression «Eye and Ear Control» renvoie à la fois au film de Michael Snow titré *New York Eye and Ear Control* et au disque aussi qu'on a tiré de sa trame sonore (un album édité à l'époque sur étiquette E.S.P. et réédité tout récemment). Incidemment, Michael Snow avait réalisé le graphisme original de la pochette de ce disque légendaire.

titre de l'œuvre de Man Ray), d'habitudes ou de routines d'écoute à détruire aussi, à repenser, à réviser, via la distorsion.

Et puis il y a ce téléphone qui surgit inopinément dans la musique (tel un clin d'œil de John Cage), avec tout ce que cet appel insistant suggère de mystérieux, d'intrigant, en deçà du quotidien de la chose[23]. Car cette sonnerie téléphonique n'était pas voulue, désirée à l'origine par Snow (en tant qu'élément figuratif, littéraire, narratif, greffé à même la trame musicale). Il s'agit donc d'un imprévu, d'un appel réel qui n'en finit plus de sonner désormais, après coup, et pour toujours, à la manière d'une «Unanswered Question»[24] insérée dans la musique même, pour la postérité.

D'une certaine manière, lorsqu'on écoute cette pièce, on répond automatiquement au téléphone, nous, le public auditeur, parce qu'on répond déjà à l'appel de la musique, à l'appel de l'artiste dans sa musique, en écoutant le disque. Écouter pour vrai, attentivement, activement, c'est toujours s'engager, prendre un risque, sous-entend Snow dans son texte de pochette.

> A passage can push you back into yourself so that its benevolent force reinforces your integrity and you momentarily become a core of concentrated yourself. Such a passage might modulate into an arrangement of elements that might draw your self out into an edifying dialogue of equals and then transform into a constellation that might invoke analysis or criticism of itself only to become that more familiar but often welcome Svengalism which provokes total identification sans corps with the "reality" of the observed/recorded/recounted and tilts one off the edge of the bed of regular mind-time into an ancient and honorable lunacy, surfacing with real tears or laughter which were fathered by the ghosts of the artist's gesture.

Ce geste de l'artiste, il vise également le dispositif d'enregistrement dans *Left Right* (tout comme dans *W in the D* et *Falling Starts*, précédemment), soit le micro déposé à plat sur le piano, directement, avec le volume faussé et la distorsion qui en résulte. C'est le micro qu'on entend tout autant que le piano ici, l'appareil et le procédé d'enregistrement tout autant que ce qui est effectivement enregistré : un piano, un métronome et de la distorsion.

23 Cette présence inopinée du téléphone dans *Left Right* nous rappelle qu'Alexander Graham Bell, l'inventeur du téléphone, est le dédicataire du film *Rameau's Nephew by Diderot (Thanx to Dennis Young) by Wilma Schœn*, 1972-74, (*Left Right* datant de 1971). De souche écossaise et mort au Canada en 1922 (après y avoir inventé le téléphone à Brantford, en Ontario, en 1874), Bell, par le biais de ses recherches pour parvenir à «faire entendre les sourds» recoupe, d'une certaine façon, l'approche de Snow dans le présent disque Chatham Square.

24 *The Unanswered Question*, une œuvre de Charles Ives datant de 1906 dans laquelle la trompette (un instrument dont joue Michael Snow), pose la «question de l'existence» à plusieurs reprises.

Quant à cette distorsion, Snow lui attribue, avec beaucoup de justesse, une teneur morale. « Distortion has a moral tone », dit-il, « dœsn't seem right but probably has to be used. »[25] En effet, on ne peut vraiment utiliser *Left Right* pour se distraire ou se divertir au sens habituel du terme. La distorsion n'est pas qu'une simple curiosité acoustique ici, un ajout ou un «agrément» quelconque. Elle est une prise de position aussi. Elle vise à rendre moins «sourd», sourd à nous-mêmes et aux autres, à l'univers. Trop de musiques ne servent que de toiles de fond agréables pour faire oublier. *Left Right* au contraire cherche à nous rendre plus présent. On ne peut pas l'ignorer, y être indifférent, au choix. Cette musique «à côté de la musique», qui dérange avec ses sonorités parasites, ses défauts voulus, ses «déchets» auditifs et son échec à «faire beau», joli, plaisant, c'est une forme d'éthique en musique qui répond avec urgence à un besoin d'éveil, cette même urgence qui habitait le free jazz d'antan et qui nous interpelle encore tout autant aujourd'hui (vingt ans plus tard).

La distorsion donne donc à voir ici, à entendre mieux, paradoxalement. Inspiré du jazz, du ragtime comme du «stride», *Left Right* nous rappelle aussi que tout grand jazz novateur a été une remise en question souvent radicale de la société américaine de même qu'une célébration, une affirmation, une fête, en contrechant. Dans cette optique, *Left Right*, qui n'est pas tout à fait du jazz, participe du même esprit, malgré tout, avec force et conviction. Snow rejoint ici de manière autonome, pour la première fois sur disque, la confrérie des grands pianistes free (dont Cecil Taylor), dans un registre qui est le sien et sans mimétisme aucun, sans concession.

C'est qu'avec *Left Right*, la distorsion entraîne ou fait glisser le «stride» historique vers le «free» critique. *Left Right* fait habilement la jonction entre ces deux mondes. Le «stride» bascule donc dans le «free» quant au son, tout en maintenant intacte sa forme type pour l'essentiel (effectuant de la sorte, en raccourci, une bizarre synthèse de l'histoire du piano jazz). *Left Right* n'est pas du free jazz organique, bien sûr, au sens habituel, collectif et largement ou totalement improvisé du terme. Et pas du stride orthodoxe non plus. Mais lorsque le «stride» se fait strident et excessif presque, comme ici, traversé de distorsions crues, brutes, il débouche sur le cri, sur le «free».

25 Michael Snow, notes de pochette de l'album Chatham Square.

Un autre parallèle pourrait être esquissé aussi entre *Left Right* et certaines musiques d'artistes signées Annea Lockwood ou Ben et La Monte Young (de Fluxus), pour ne citer que ces noms-là, où le piano est «maltraité» de différentes manières, brûlé, cloué, poussé contre un mur, etc[26]. D'autres cas seraient à citer où le piano se voit comme agressé dans sa représentation... *Left Right* pousse ainsi la musique à sa limite, à l'extrême, du grave à l'aigu et inversement (musique minimale par la forme et «free» par la sonorité, et ce, tout comme *Falling Starts* et *W in the D* à leur façon, bien que ces deux œuvres soient non explicitement reliées au jazz comme celle-ci). Il y a une unité saisissante de conception, de point de vue, dans ce double album Chatham Square de Michael Snow avec ce métronome qui vient clore, à la toute fin, pour un très bref instant, en solo, toute l'aventure. Il faut dire qu'un peu avant, cependant, Snow au piano avait accéléré le tempo pour exécuter une coda presque caricaturale, signalant la fin imminente du disque, de l'histoire, du «film», jouant cette idée même de «la fin» au piano avec une frénésie, une jovialité, une détermination qui s'entendent (ainsi qu'un taux de distorsion accrue, en fonction du rythme), et ce, jusqu'au fil d'arrivée, jusqu'au dernier sillon, ou presque (le piano ralentissant alors et le métronome prenant la relève seul, pour terminer).

Originalité, rigueur, humour, virtuosité d'exécution, tout concourt à faire de *Musics for Piano, Whistling Microphone and Tape Recorder* une réussite majeure, incontournable, dans l'histoire des musiques d'artiste au 20e siècle.

Deux autres disques solos entièrement composés suivront une dizaine d'années plus tard soit *The Last LP* en 1987[27] (une réalisation magistrale en tout point, conceptuellement, musicalement, au plan du texte aussi et de l'objet-pochette, une œuvre-phare de cette modernité fin-de-siècle), et *Sinoms*[28] datant de 1989 (également une grande réussite artistique avec un tout autre matériau et fonctionnement mais des préoccupations similaires, quand même, quant aux notions d'identité et de représentation). Dans ces deux derniers disques, la voix, entre autres, occupe une place très importante, la voix au pluriel, féminine comme masculine, parlée comme chantée et dans plusieurs langues ou cultures et traditions (inventées ou non).

De l'œil à l'oreille, de l'image au son, du cinéma à la musique (instrumentale ou

26 Annea Lockwood, *Piano Transplants* (1968-82), cf. Sound by Artists, Toronto-Banff, Art Metropole et Walter Phillips Gallery, 1990, p. 217-18 (incluant *Piano Burning* et *Piano Drowning*).

27 Comme son titre l'indique déjà, *The Last LP* est un disque de "longue durée", en vinyle (édité par Art Metropole, à Toronto, en 1987). L'album contient, nous dit-on, "unique last recordings of the music of ancient cultures, assembled by Michael Snow".

La pochette double nous donne à voir, par devant, une illustration montrant deux moines-musiciens jouant de la trompette auprès d'un feu de camp. Dans le coin droit inférieur, une photographie couleur, superposée au dessin, nous montre le Dr Misha Cemep (alias Michael Snow), debout, dans un champ, un micro à la main et en train d'enregistrer (sinon dans l'attente, aux aguets, tel un chasseur de sons en safari acoustique).

À l'endos de cette même pochette, on trouve deux textes de Michael Snow. Le premier intitulé *An Introduction* porte sur l'histoire de l'enregistrement sonore et son impact sur les musiques traditionnelles. Le deuxième titré *Re: the Cover* explique l'origine et la signification du dessin, supposé "authentique", reproduit en couverture frontale.

À l'intérieur de cette pochette double, on peut lire des notes détaillées sur chacune des onze pièces musicales qu'on retrouve sur l'album (soit six sur la face a et cinq sur la face b). En guise de complément, à la toute fin, on découvre un plus court texte, toujours de Michael Snow, mais

vocale, composée ou improvisée, collective ou solo, acoustique ou électronique...), tout s'équilibre chez Snow avec une rectitude et une nécessité sans pareil, sans négliger la dimension poétique pour autant. Ses musiques à la fois concentrées comme éclatées témoignent d'identités multiples réconciliées à l'intérieur d'un seul et même individu : Dixie Snow, Classic Snow, Folk Snow, Free Snow, Solo Snow, Music Snow.

imprimé à l'envers. Son titre révélateur est: *Further Reflections*. Il faut le placer face à un miroir pour pouvoir le lire. C'est alors que se confirme ce qu'un certain nombre d'indices, dans les notes, nous avaient déjà laissé soupçonner, à savoir que toute cette musique présentée, au départ, comme provenant de diverses cultures disséminées partout à travers les continents, est, en réalité, complètement inventée, jouée et chantée par Michael Snow lui-même (via la technique de l'enregistrement multipiste). Encore une fois, Michael Snow ne cache rien. Il dit tout et préserve le mystère malgré tout.*

*Editor's Note: The "interior" texts of *The Last LP* referred to here are reproduced in their entirety in *Collected Writings*, one of the books in The Michael Snow Project series.

À chaque pièce correspond une mise en scène spécifique, un scénario sonore, un narratif. Il faudrait pouvoir résumer chacune de ces histoires ici, en provenance d'URSS, de Chine, du Canada, d'Inde, d'Afrique, de Finlance... Chaque pièce est un petit "film sonore", Snow créant l'illusion du plus vrai que vrai en utilisant des sons d'environnement, en intégrant des "sound effects" repiqués de disques et en manipulant les plans sonores aussi, la perspective acoustique (chaque intervenant étant placé stratégiquement dans un espace imaginaire différent, selon chaque pièce). Michael Snow, encore une fois, joue de tous les instruments, inventés ou pas. Il fait toutes les voix aussi. Le résultat est étonnant.

Il y aurait un livre à écrire sur ce disque étrange, singulier, unique, à la fois plein d'humour,

de vitalité et d'invention. Michael Snow y pose la question du vrai et du faux en art, de ce qui est devant comme derrière le miroir (un autre jeu subtil avec la notion d'identité). *The Last LP* est une réflexion sur la mort aussi, sur la disparition, la fin, "the last song, the last sound".

Déjà en 1973, dans les notes de l'album double de l'Artists Jazz Band, Michael Snow parlait de son intérêt pour Ravi Shankar, pour le Gagaku et pour le folklore d'ici. Près de quinze ans plus tard, sa curiosité pour les musiques d'ailleurs se transpose dans une forme originale qui nous interpelle pour ce que nous, les auditeurs-auditrices, sommes vraiment: des êtres humains en voie de disparition. Sans résoudre pour autant ce dilemne existentiel, *The Last LP* propose une réflexion qui dépasse l'enjeu "local versus international" (pour rejoindre Greg Curnoe sur son propre terrain). La dimension locale est aussi internationale.

A cet égard, on pourrait discuter ce disque, dans un premier temps, en le plaçant dans le contexte de l'histoire de l'enregistrement sonore au Canada, depuis Emile Berliner, au début du vingtième siècle, jusqu'à aujourd'hui. On pourrait rappeler, par exemple, que c'est de Toronto que nous vient le plus ancien document sonore au pays (soit une allocution du Baron Stanley M. Preston, gravée sur un cylindre, à l'occasion de l'ouverture de l'exposition industrielle de Toronto, le 11 septembre 1888). On pourrait signaler aussi que c'est en 1904 qu'un premier interprète canadien fut capté au Canada (soit le baryton Joseph Saucier chantant *L'improvisateur*). On pourrait évoquer enfin les 78 tours réalisés par le chef Mohawk Os-Ke-Non-Ton en 1920. Et ainsi de suite. (Ces informations sont compilées dans l'ouvrage d'Edward B. Moogk, *En remontant les années*, "l'histoire et l'héritage de l'enregistrement sonore au Canada, des débuts à 1930", publié par la bibliothèque nationale du Canada, à Ottawa, en 1975).

Il y aurait un dialogue intéressant à amorcer entre *The Last LP* et cette histoire. Et beaucoup d'autres choses encore à dire sur ce disque surprenant. Michael Snow résume bien ses intentions lorsqu'il affirme avoir créé une "new music in memory of the old", une musique authentique malgré les apparences et qu'il faut absolument "écouter pour vrai". Ici la fabulation rejoint la vie et confère un "second souffle" à celui/celle qui écoute (the last listener?).

28 Créée en 1990, l'oeuvre *Sinoms* constitue le "first CD" de Michael Snow, un disque sans pochette celui-là, sans illustration, sans texte (à moins que le texte ne soit "sur le disque"...). Le compact dure une cinquantaine de minutes environ. *Sinoms* ne fait appel à aucun autre instrument que la voix parlée. On y entend vingt-deux récitants, des voix de femmes et des voix d'hommes, anglophones comme francophones, captées à Toronto ou à Québec et prononçant les noms de tous les maires de l'histoire de la ville de Québec (34 au total, de 1833 à 1989). Sous forme d'énumération, en alternance ou suivant diverses combinaisons, permutations, ces voix harmonisées par Snow oscillent du masculin au féminin, de l'accent anglais au français, du solo au collectif, à la masse, au choeur ("chorus" dirait-on en anglais, Michael Snow le "jazzman" prenant comme une série de "chorus" à partir de tous ces noms-tremplins...). Ceci dit, *Sinoms* est, avant tout, une oeuvre composée en studio (autour de la question de l'identité à nouveau). Aux variations de l'identité correspondent diverses sonorités de voix.

L'espace manque ici pour analyser, en détails, cette oeuvre austère et un peu à part dans la production de Michael Snow. *Sinoms* met en vis-à-vis la voix humaine et le nom, le corps et sa dénomination. La voix est-elle synonyme du nom qu'elle prononce? qui appartient cette voix? qui appartient ce nom? Ici encore, tout comme pour *The Last LP*, Michael Snow pose la question du vrai et du faux. Le nom nomade voyage en tout sens. Le nom-nombre multiplie ses identités, établit la nomenclature de ses doubles potentiels.

Avec *Sinoms*, dans le même esprit qu'avec *2 Radio Solos* et *The Last LP*, on circule entre les langues, les accents, les timbres de voix, les cultures, les époques. On passe les frontières. *Sinoms* est une musique ethnique à sa façon. Chaque voix, chaque langue est une "musique" potentiellement menacée, soumise au changement, susceptible de disparaître donc, à plus ou moins long terme. La dernière langue? La dernière voix? Comme on peut le constater ici, *Sinoms* est une suite logique à *The Last LP* (on pourrait déjà lui donner, comme sous-titre, par anticipation, "The Last CD"). Cette oeuvre a été réalisée spécialement pour le musée du Québec dans le cadre de l'exposition "Territoires d'artistes: Paysages verticaux".

Ces notes concernant *The Last LP* et *Sinoms* sont succintes et ne rendent pas compte de toute la richesse de ces deux oeuvres. Il faudrait les analyser beaucoup plus en détails, dans de longs textes appropriés. L'espace manque ici. On constate une grande cohérence derrière tout ce travail, une unité de propos dans une multiplicité d'expressions.

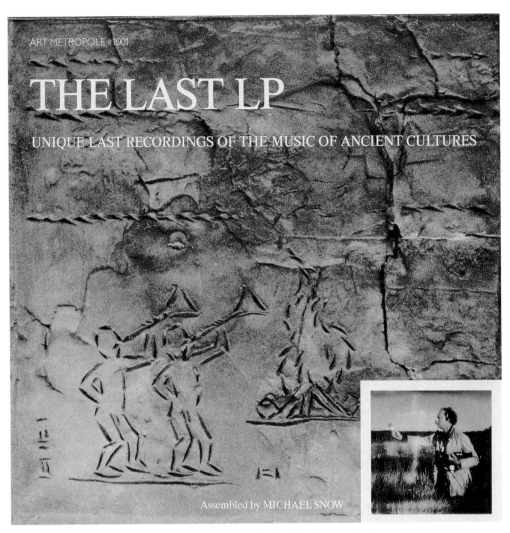

ART METROPOLE #1001

THE LAST LP

UNIQUE LAST RECORDINGS OF THE MUSIC OF ANCIENT CULTURES

Assembled by MICHAEL SNOW

The Last LP a two-record album, designed, performed and recorded by Michael Snow, issued by Art Metropole, Toronto, in 1987. Texts by Snow describing all the compositions, which were printed on the inside two faces of the original album are also published in *Collected Writings* in the series to which this volume belongs.

SIDE A

1. Wu Ting Dee Lin Chao Cheu 6:09
 (Announcing the Arrival of the Emperor Wu Ting)
 The Orchestra of the National Music Institute, Seoul Korea
2. Si Nopo Da 3:42
 (By What Signs Will I Come to Understand?)
 Women of the Bo-sa-so-sho tribe, Niger, S.E. Africa
3. Ohwachira 9:34
 Water ceremony performed by Miantonomi and Cree
 tribespeople, Quebec, Canada .
4. I Ching Dee Yen Tzen 3:41
 (The Strings of Love)
 Tam Wing Lun on the Hui Tra, Ontario, Canada
5. Póhl'novyessnikh
 (Full to the Brim) 0:29
 Performed by a 16-member male choir, Varda, Carpathia,
 USSR
6. Speech in Klögen 2:12
 by Okash, Northern Finland

SIDE B

1. Mbowunsa Mpahiya 7:59
 (Battle Song of Bowunsa)
 Performed by male members of the Kpam Kpam tribe, Angola,
 West Africa
2. Quuiasukpuq Quai Gami 2:14
 (He is Happy Because He Came)
 Performed by Ani'ksa'tuk of the Tornarssuk tribe, Siberia USSR
3. Amitābha Chenden Kālā 6:32
 (The Simultaneous Welcome of Amitābha)
 Performed by the 12 monks of the Kagyupa Sect, Bhutan.
4. Roiakuriluo 9:36
 (Dawn Ceremony)
 Performed by Sabané, Elahe, Brazil
5. Raga Lalat 2:53
 Performed by Palak Chawal, Benares, India

RE: THE COVER

Our cover photo shows the priceless artefact in the possession of the
KAGYUPA sect of TIBETAN Buddhist monks, now in Nepal. This artefact
indicates the possibility of an astonishing antiquity for the AMITĀBHA
ceremony (The Simultaneous Welcome of Amitabha), the music for which
is included in this album.

It is a fire ceremony performed by 12 monks/musicians, each playing a
different horn or trumpet as they slowly walk around the wood fire.

The object is a clay tablet (12¾" square) incised in a method resembling
that of certain cuneiform tablets from Mesopotamia, 12th century B.C.
Cuneiform (stylus inscription on clay originating in Babylon) could be
considered the first LP technique. While only two musicians are shown on
the clay tablet, the cuneiform characters have been translated as "multiply
by six".

The object contains many puzzling aspects, and amongst its historical
curiosities are: the drawing of the figures playing trumpets and the fire and
the cuneiform are all done with the same stylus which was used for the
"letters". In all the known related examples of Babylonian, Chaldean,
Assyrian and Sumerian clay objects the "writing" is done with different
instruments than the relief drawing. The style of the figures is also odd,
definitely not Babylonian etc (but not thoroughly distant), less hieratic,
more informal. It may be that what we have here is a secret but casual cult
sketch by an Assyrian scribe. The tablet could also have been done much
later, being a (perhaps cult) survival of cuneiform into the era of Persian
dominance of the Middle East (5th - 3rd century B.C.). This is possible

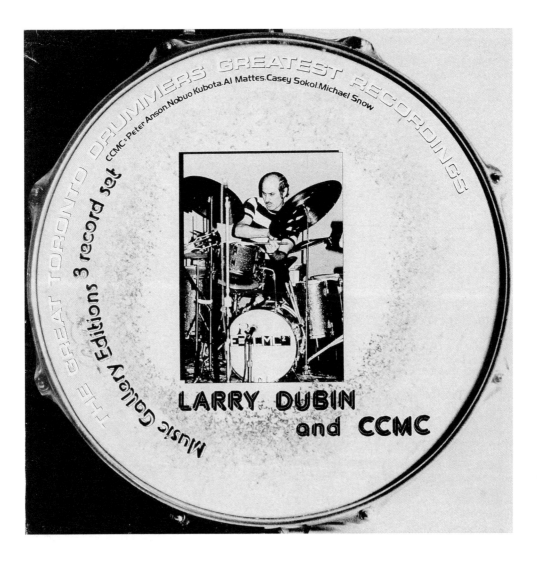

THE GREAT TORONTO DRUMMERS GREATEST RECORDINGS

CCMC: Peter Anson, Nobuo Kubota, Al Mattes, Casey Sokol, Michael Snow

Music Gallery Editions 3 record set

LARRY DUBIN and CCMC

Les Disques de Michael Snow
Partition 2 Free Snow (Michael Snow et le CCMC)
par Raymond Gervais

Après avoir vécu les débuts du free Jazz à New York et après avoir fait partie, pendant plusieurs années, d'un premier collectif free, l'Artist's Jazz Band, Michael Snow allait former avec quelques amis musiciens, en 1974-75, un nouveau collectif d'improvisation libre, fort différent cependant et qui allait bouleverser la conjoncture du jazz à Toronto, soit le CCMC, le Canadian Creative Music Collective (un groupe à part dans le réseau du jazz expérimental à Toronto, et ce encore aujourd'hui).

Affilié à la Music Gallery dès janvier 1976, le CCMC allait contribuer à la mise en place de son propre réseau facilitant la création et la diffusion d'une nouvelle musique d'improvisation qui se voulait spécifiquement canadienne à l'origine, c'est-à-dire émancipée des modèles américains comme européens dominants à l'époque (des réalisations des membres de l'A.A.C.M. aux U.S.A. par exemple, à ces productions éditées par Incus, F.M.P., I.C.P. et compagnie en Europe). Donc, en premier lieu, un engagement précis et une esthétique définie sous-tendaient le projet du CCMC : toute la musique devait être improvisée, totalement improvisée. Pas de composition donc, de thème préconçu, de structure établie au préalable. Tout devait être spontané, inventé dans l'instant, dans l'immédiateté du geste sonore collectif. Cette activité alors enregistrée, documentée systématiquement sur bande magnétique, était réécoutée par la suite, suivi d'une autocritique des musiciens participants, relançant ainsi, après chaque session de jeu et d'écoute subséquente, la musique libérée vers de nouvelles avenues.

Cette autre musique nouvelle, encore une fois, se voulait, au début, enracinée dans la réalité et la culture locale, torontoise, canadienne, tout en gardant une ouverture sur l'univers, en contrepartie. C'est à cette quête d'identité en musique improvisée que le CCMC nous convie, à l'audition de ses enregistrements édités depuis 1976. On peut déceler diverses phases dans l'évolution du collectif à l'écoute de ces quelques disques officiels. (Cependant, puisque le CCMC enregistre toutes ses séances depuis quinze ans, nous ne connaissons, de fait, qu'une infime partie de ses réalisations passées, via ces quelques témoignages disponibles sur disques).

De façon plus ou moins arbitraire, discutable, nous diviserons cette évolution en trois phases. 1) La première, plus acoustique, s'échelonnerait de 1974 à 1978, alors que Larry Dubin était le batteur attitré du collectif. Cette période correspond à trois disques vinyle parus de même qu'à un coffret triple en hommage au batteur. Six disques donc, au total, où la batterie règne.

2) La deuxième phase se situerait, approximativement, entre la mort de Larry Dubin, survenue en 1978, et la fin des années quatre vingt, alors que sans batteur régulier, le collectif chemine dans d'autres directions, où l'électronique occupe désormais de plus en plus de place. Le langage improvisé s'éloigne alors d'autant du jazz, devient plus abstrait, plus difficile à classer, à situer quant au vocabulaire, au style, à la forme sonore en cours. À cette période correspondent les volumes quatre et cinq du CCMC.

3) Enfin, la troisième phase couvrirait la fin des années quatre-vingt jusqu'à aujourd'hui, entamant une nouvelle décennie. Parmi les nouveaux territoires sonores inventoriés par le collectif, la voix humaine, dans tous ses états, occupe ici une place singulière et tend à imposer sa loi, la voix viscérale, désormais omniprésente. Deux cassettes, en particulier, documentent bien cette période, éditées sous le titre *CCMC '90* (auxquelles il faudrait ajouter une autre cassette qui correspond au numéro 54 de la revue MusicWorks, soit le CCMC, version 1992). Dans tous ces enregistrements, la voix occupe une place centrale, les voix de Paul Dutton ou de Nobuo Kubota, entendues séparément ou ensemble, selon le cas.

Encore une fois, cette division de l'art du CCMC en trois phases successives reste

une tentative approximative de cerner une musique qui change tout le temps. Ça n'a donc rien d'immuable, de rigide, au contraire. C'est un essai de synthèse précaire, éphémère, fluctuante d'une certaine manière (puisque l'aspect électronique, par exemple, associé à la deuxième phase du CCMC était déjà un peu présent au tout début, de même que la voix aussi, à l'occasion, alors que la batterie d'origine refait, quant à elle, surface aujourd'hui avec Jack Vorvis, et ainsi de suite). Bref, pas de catégorisation étroite ici, mais une division souple et ouverte à la contradiction.

Phase 1

Cette phase, à nouveau, correspond au passage du météore Larry Dubin au sein du CCMC. Comme le confiait le batteur au critique Mark Miller dans une entrevue, c'est Michael Snow qui l'entraîna du côté de la musique libre, qui l'encouragea à jouer sa musique avant tout, sans restriction, sans concession[1]. C'est d'ailleurs avec le CCMC que l'un comme l'autre allaient pouvoir donner sa pleine mesure en tant qu'improvisateur, Snow devenir un pianiste plus mature (il était déjà un compositeur accompli), et Dubin un batteur original, personnel. On ne racontera pas ici l'histoire et la carrière de Larry Dubin. Michael Snow le fait déjà fort bien dans deux beaux textes écrits en hommage à son ami-batteur[2]. Rappelons simplement que Larry Dubin était un «natural», un batteur-né, un rythmicien dans l'âme et un improvisateur forcené, passionné. On peut l'entendre à souhait dans les six premiers disques édités par le CCMC.

CCMC volumes 1 et 2 sont des enregistrements particuliers en ce qu'ils réunissent trois milieux de l'improvisation sonore en un seul. On y retrouve Graham Coughtry de l'Artist's Jazz Band (lequel ne reviendra pas dans les disques subséquents), de même que Bill Smith (musicien-critique-promoteur associé à la revue Coda), ainsi que les membres réguliers du CCMC, soient Michael Snow et Nobuo Kubota (également affiliés à l'Artist's Jazz Band), de même que Peter Anson, Al Mattes et Casey Sokol. À ses débuts sur disques donc, en 1976, le CCMC et l'Artist's Jazz Band se recoupent, les deux seuls collectifs free de Toronto, à l'époque. Puis, avec le temps, le CCMC, à vocation plus publique, prendra ses distances d'avec

1 Mark Miller, *Jazz in Canada – Fourteen Lives*, University of Toronto Press, 1982, pp. 139-140.

2 a) Michael Snow, *Larry Dubin's Music*, Impulse Magazine, volume 7, no. 1, 1978.

b) Michael Snow, *Larry Dubin and CCMC*, notes de pochette accompagnant le coffret produit par Music Gallery Editions, Toronto, 1979.

l'Artist's Jazz Band. On le constate déjà avec la parution du *volume 3* du CCMC, en 1977, où l'on ne retrouve que le nucleus de base du collectif : Anson-Dubin-Kubota-Mattes-Snow-Sokol. La musique y est toujours totalement improvisée et la pochette, plutôt qu'une simple illustration, se lit comme son équivalent textuel. Elle ne donne à voir, à lire donc que du texte, dans une mise en forme ou graphisme de Michael Snow. Ce texte est constitué d'autant d'alliages de quatre mots différents correspondant aux quatre lettres du sigle CCMC, le tout formant une longue énumération qui recouvre toute la face un et le tiers de la face deux de cette pochette. (L'autre 2/3 est confié à des notes de Peter Anson sur le CCMC et sa musique).

Tous les membres du CCMC ont participé à ces collages de mots dont voici quelques exemples : Cross Canada Musical Cruise, Careless Crew Misses Craft, Chansons Cris Mélange Constamment, Cries Crashes Murmurs Clanks, Canadian Composition Making Continuum, Completely Canadian Monster Circus, Clever Crescendos Mundane Chords, Celeri Champignons Mayonnaise Cornichons, Chapeau Chemise Mouchoir Cravate, Canadian Cool Music College, Coherent Chaos Manifest Creation, Computer Caught Memorizing Chords, Canadians Collect Mistakes Casually, Crazy Cosmopolitan Music Cult, Courage Courage Musique Cessera, et ainsi de suite. Au total, plus de deux cents de ces amalgames textuels insolites ont été ainsi fabriqués et sont reproduits en un long poème verbal, a saveur dadaïste, redéfinissant en tous sens le CCMC. À nouveau se pose ici, très clairement (et comme dans toute l'oeuvre de Snow), la question de l'identité en musique, en art, au Canada. Michael Snow rejoint donc encore ses préoccupations et réflexions de base, avec humour toujours, mais avec une acuité accrue aussi, du fait que le collectif entier (et non pas un seul individu), participe à l'entreprise et endosse concrètement cette problématique. Ces voix qui se joignent en une seule expression, énonçant diverses combinaisons à partir d'un matériau de base (les quatre lettres du CCMC), elles sont comme ces autres voix qui s'uniront en choeur, plus tard, pour la réalisation de l'oeuvre *Sinoms*. Il y a une grande continuité et rigueur dans l'art de Snow à cet égard. La lecture systématique de toutes ces définitions du CCMC publiées ici constitue un commentaire pertinent, en contrepoint, sur la musique même

du collectif, sur son ouverture à tous les possibles du discours improvisé. La pochette dit bien la musique, la représente bien.

En 1978 mourrait Larry Dubin. Pour lui rendre hommage, le CCMC faisait paraître, en 1979, un coffret anthologique de trois disques incluant, en plus, des textes émouvants de Michael Snow et de Paul Haines (soit *Larry Dubin and CCMC*, Music Gallery Editions, MGE15). La pochette du coffret, réalisée par Michael Snow, reproduit en photo la caisse claire de la batterie de Larry Dubin, laquelle, circulaire et vue à plat, évoque aussitôt un disque (ce qui se trouve donc, de fait, derrière cette photo et dans le coffret). La photographie de pochette représente ainsi la batterie, représentant elle même un disque, représentant Larry Dubin à son tour, en fin de parcours. Ce coffret contient, selon nous, les meilleurs moments du CCMC sur disques, dans sa première phase, soit une sélection de treize improvisations de durées différentes et de personnels variés, du duo au sextuor. Tous les titres pour identifier chacune des pièces (captées entre 1976 et 1978), sont tirés du texte d'un poème de Paul Haines, *Larry's Listening*, rédigé spécialement pour accompagner ce projet. Ces titres d'une étrange justesse poétique sont les suivants : *Larry's Listening*, *Upon Arriving*, *A postponement*, *Circuitry*, *Down the Street*, *Yourself Elsewhere*, *Radio in a Stolen Car*, *Uncalledforness*, *Silky times*, *Back to Timmons*, *Leaves Shed their Trees*, *One of your Lips* et *Qui ne sert qu'à nous faire trembler*.

La musique, à nouveau, dans ce coffret est excellente, emblématique du CCMC à

LARRY DUBIN and C C M C

Larry Dubin and CCMC
Music Gallery Editions MGE 15

Larry Dubin, percussion, drums; Allan Mattes, bass, percussion; Michael Snow, synthesizer, percussion, trumpet, piano; Casey Sokol, piano, percussion; Peter Anson, guitar, kettle harp piano, vegematic; Nobuo Kubota, saxophones, percussion.

Larry's Listening/Upon Arriving/A Postponement/Circuitry/Down the Street/Yourself Elsewhere/Radio in a Stolen Car/Uncalledforness/Silky Times/Back to Timmons/Leaves Shed Their Trees/One of Your Lips/Qui ne sert qu'à nous faire trembler.

This three record set is packaged as a memorial tribute to the late Canadian drummer Larry Dubin, who died on April 24, 1978 (one month to the day after *Silky Times* was recorded).

Dubin was one of the founders of CCMC, and it is a gallant gesture on his friends' part to dedicate this set of performances to him. However, it would be a serious mistake to consider this a showcase for Dubin, or indeed, *any* individual, since that would be absolutely contrary to everything the CCMC stands for. Theirs is a thoroughly ensemble conception, playing a freely improvised music in totally spontaneous situations, and as the extremely varied musical statements on this album show, they are remarkably and often stunningly successful at creating a music which can be experienced strictly as a group sensibility.

The single exception to this rule is the three minute cut called *Upon Arriving*, which is basically a solo example of Dubin's drumming (though it may be an edited excerpt from a longer group performance). *Upon Arriving* is a superb illustration of Dubin's approach to drumming; his highly tuned, tight drums were capable of a great deal of melodic variance, and as this piece shows he was adept at constructing episodes that are not only rhythmically engaging, but equally concerned with melody (pitches and intervals) and timbre in a way that

favorably calls to mind Max Roach — not necessarily as an influence, but as a drummer who has traversed a similar path.

The remaining cuts, documenting performances from 1976-78, are full of a fresh, invigorating spirit. These people have played together for years, and their familiarity and single-mindedness of purpose — completely spontaneous improvisation — allows them a control of their materials, a subtlety of interaction, and a flexibility of moods resulting in a wide palette of colors, textures, and effects. You won't hear any solos here; even at their most conventional sounding — that is, when you hear faint echoes of something you think you might have heard before — they never fall into a dangerous "lead voice plus accompaniment" because each of the instruments is an equal voice, in precisely the way each card is an equally supportive, decorative, and self-defining component of a house built of playing cards.

This is not a band in which one can hear imitations of other bands, or one which wears its influences (and, consciously or subconsciously, they have influences, though they might not necessarily be of a musical nature) on its collective sleeve. Like all aspects of life, CCMC's music has low and high points (and I certainly hope they don't misunderstand what I'm about to say), but at its most successful the music has an inevitability and drama which seems composed, beyond the wonderfully tense edge of invention one feels in improvised music at its best. For me, this quality is especially evident in the last two pieces — *One of Your Lips* and *Qui ne sert qu'à nous faire trembler* — which do for me what such composers as Feldman and Dlugoszewski do. But everywhere in their music, for better or worse, one can hear what poet Philip Whalen and critic Whitney Balliett call "the sound of surprise."

— *Art Lange*

(Available from The Music Gallery, 30 Saint Patrick Street, Toronto, Ontario M5T 1V1 Canada).

son plus créatif et de sa quête d'un jazz enraciné, essentiellement torontois. Chaque pièce mériterait un commentaire détaillé. Du début à la toute fin, Larry Dubin y installe un swing continu. Il dynamise et accouche la musique à sa façon, la propulse à terme. Tous les musiciens jouent de plusieurs instruments ici. Michael Snow, par exemple, joue du piano acoustique comme électrique, de la trompette, du synthétiseur, des percussions et, enfin, du copper tubophone. Ceci dit, quel que soit l'instrument utilisé, son jeu s'intègre avant tout au collectif, à l'ensemble, au jazz organique en cours. « On y entend des systèmes nerveux », dit Snow de cette musique électrisante. « Quand elle est bonne, elle est au-delà de toute composition; on ne pourrait la concevoir autrement. »[3]

Dans *Larry's Listening* (la première pièce du coffret), on peut déjà «entendre l'écoute» entre les musiciens, à l'intérieur d'une forme énergétique en devenir. *Upon Arriving* (la pièce qui suit), est une sorte de court sonoportrait du batteur, en solo, à son maximum. *Circuitry* est un duo avec Michael Snow, pour synthétiseur et batterie, capté à la Music Gallery, le 14 juin 1977. Ici, Snow utilise le synthétiseur comme une machine, un moteur qui tournerait à différentes vitesses. Et avec ce moteur dialogue la dynamo humaine (l'autre «moteur»), qu'est Larry Dubin, à la batterie. Ce face-à-face de l'instrumentiste avec la machine, en tant que double potentiel, est tout à fait fascinant et suscite une réponse inventive de la part du batteur. Mêlant presque le jazz à l'art conceptuel, cette oeuvre fonctionne comme si Larry Dubin improvisait à partir d'une installation de Michael Snow. L'aspect fluide et acoustique de son jeu opposé au côté plus rigide comme électronique et répétitif de l'appareil, crée une situation d'écoute insolite, provocante. Au départ, ce son de synthé n'est pas beau en soi, mais plutôt dérangeant et à la limite même du musical. Encore une fois, Snow installe comme un dispositif dans la musique qui amène l'exécutant à définir ou révéler son identité par confrontation, via un dialogue dans l'instant, en temps réel, avec la machine. (Ce même type de situation se retrouve dans *Left Right* de 1972, d'une certaine façon, où le piano confronte un métronome.) Quoi qu'il en soit, il ne s'agit pas de faire «beau» ici mais d'être vrai, authentique, comme à la limite de soi, «on the edge», là où on «existe pour jouer» (pour citer Michael Snow)[4].

3 Pierre Théberge, *Conversation avec Michael Snow*, Centre Georges Pompidou, Musée National d'Art Moderne, 1978, p. 45,

4 Michael Snow, *Larry Dubin and CCMC*, Coffret MGE15, 1979 (« He existed to play » y écrit Michael Snow à propos de Larry Dubin).

Et partout dans ce coffret, Larry Dubin joue justement à fond et se donne complètement dans la musique. (Chaque musicien mériterait son crédit ici en ce qui concerne cette aventure collective improvisée). Quant à Larry Dubin, tour à tour effervescent, fébrile, enjoué, nuancé, emporté, il manifeste dans son jeu tous les états de la possession. Son «transe-jazz» ou trans-free, collectif comme solitaire et au bord du cri, serein aussi, ludique, c'était la signature même du CCMC.

Phase 2

Le drumming intense, polyrythmique, pulsionnel de Larry Dubin maintenait un lien fort du CCMC avec le jazz de souche afro-américaine. Le CCMC cependant faisait son propre jazz, un jazz torontois personnalisé, mais du jazz quand même.

Avec la disparition de Dubin, la musique du collectif (sans batteur pour les trois prochaines années), va changer considérablement. Elle va devenir de la nouvelle musique d'improvisation torontoise qui prend d'autant ses distances avec le jazz historique et ses rythmes insistants, pour aller voir ailleurs et trouver autre chose (se perdre si on veut, pour mieux se retrouver, se redéfinir une identité). C'est ce que documente, en partie, les volumes 4 et 5 du CCMC. Le volume 4 est particulièrement éloquent quant à cette nouvelle orientation du collectif sans Larry Dubin. L'expérience du temps surtout n'est plus la même dans la musique ici recueillie. Le rythme est plus discontinu, plus abstrait. Les sonorités, les textures, les harmonies et le vocabulaire sont en partie différents. Les instruments électroniques utilisés (entre autres, le Buchla synthesizer), suscitent, par ailleurs, de nouveaux modes de jeux, de nouveaux mélanges électro-organiques inédits.

Ce volume 4 du CCMC est titré *Free Soap*. Il signale un réel changement, une transition importante pour ce «group in progress», au laboratoire. L'album comme tel comprend trois pièces exécutées par trois quatuors à l'instrumentation distincte, et enregistrées à trois moments différents, entre février et novembre 1979. Chaque musicien participant joue de plusieurs instruments, à la manière d'un «Art Ensemble of Toronto», constituant ainsi un mini-orchestre post-free, électro-acoustique, électro-bruitiste, travaillant à inventer un nouveau langage improvisé, à investir un

nouveau territoire audible, un nouveau «pays de sons». Et ce d'instinct, dans l'instant, dans l'intuition du moment.

À cet égard, une oeuvre comme *A.K.A. February 13th* (enregistrée le 13 février 1979 et d'une durée de 24'33"), est exemplaire de cette démarche exigeante et sans compromis du CCMC. On y entend Casey Sokol au piano et au steel drum; Al Mattes au marimba, à la contrebasse, à la basse électrique, à la batterie, aux cloches et au steel drum; Michael Snow au marimba, à la trompette (avec ou sans sourdines), à la sirène, au piano électrique et à la tôle d'aluminium; et enfin Nobuo Kubota à la sirène, aux sifflets, au strange horn, au saxophone alto, au tambour basse, au crackle box et au marimba. Une foule d'instruments donc pour quatre musiciens seulement, à partir desquels s'effectuera un jeu sur les sonorités, les couleurs, les timbres, les alliages inédits, inouïs, dans un style communal qui maintient ses distances toujours avec le jazz américain ou international en vogue. On décèle des subtilités nouvelles dans cette musique où les pauses sont fréquentes, comme des îlots de réflexion, traduisant un espace intérieur autre et une écoute en conséquence aussi. Ça oscille entre un free intense occasionnel, renouvelé, et un jeu plus épars autour du silence (incluant cette sirène magnétique que Snow utilise parfois, comme un clin d'oeil à Varèse, et qui polarise un court moment la musique). Pas de solos ici, d'envolées virtuoses au sens classique du terme, mais un jeu collectif complexe, à quatre voix, foisonnant, captivant, avec des «trous» aussi dans la musique, des oasis d'écoute, des vides nécessaires, des temps d'arrêt qui créent l'attraction, maintiennent le désir et relancent la musique. Cet *A.K.A. February 13th* s'inscrit, symboliquement, sous l'égide du chiffre treize, le nombre du changement, numérologiquement, un terme on ne peut plus approprié pour définir le CCMC à cette étape-ci de son évolution.

Le volume 5 du collectif (plus électronique encore que le précédent et comme plus éclaté), s'intitule *Without a Song*. Il comprend quatre pièces réunissant Michael Snow à Casey Sokol, Nobuo Kubota et Al Mattes, dont une composition titrée justement *Without a Song*, enregistrée le 18 janvier 1980. On y entend une très courte citation de cette chanson fort connue, *Without a Song* (un titre qui correspond très

bien, d'ailleurs, au credo de base du CCMC). En effet, le collectif ne joue jamais de standards, de classiques du jazz ou des mélodies populaires à partir desquels il improviserait. Il se lance toujours dans l'improvisation à cru, à vif, sans filet et «Without a Song» comme tremplin initial obligé. À chaque fois sur la corde raide, selon l'inspiration, les moyens et les participants du moment. Le CCMC ne cite ainsi que très rarement l'histoire de la musique et ne paraphrase pas concrètement les cultures sonores d'ailleurs. Il cherche à imposer sa voix propre en évitant les références faciles, les clichés, et ce par choix critique, par volonté d'authenticité, par souci de naturel aussi, de véracité. À cet égard, le CCMC parvient à transcender l'aspect hybride de certaines autres productions improvisées. C'est sa façon de respecter la culture d'autrui en ne la copiant pas, en ne la piégeant pas sans considération.

Parfois cependant, dans ses interventions plus récentes, Michael Snow cite le vieux jazz américain pour piano, le stride et le blues d'origine. C'est sa propre histoire qu'il cite alors, son passé de jazzman tout autant que l'histoire du jazz américain. C'est une citation autobiographique, si on veut, dans une citation culturelle, au deuxième degré. C'est ce qui se produit, par exemple, dans *Interpretation of Dreams* enregistrée en duo, avec Al Mattes, en décembre 1989 (une oeuvre éditée sur la cassette jaune dite *CCMC '90*, tape I). Avec cette musique, nous pénétrons, de fait, dans la troisième phase de l'évolution du CCMC.

Phase 3

Cette étape est documentée par deux cassettes passionnantes distribuées commercialement, soit *CCMC '90*, tape I (cassette jaune), et tape 2 (cassette bleue). La cassette numéro un contient, sur le côté A, trois duos magiques entre Michael Snow au piano et Al Mattes à la guitare-synthétiseur, soit *Interpretation of Dreams* (déjà cité), *Time of the Essence* et *Chips and Hammers*, enregistrés, tous trois, le six décembre 1989. Michael Snow et Allan Mattes sont de vieux copains qui travaillent ensemble depuis une quinzaine d'années environ, et cette complicité s'entend très bien ici. En duo, il y a moins de voix instrumentales simultanées. L'interaction est

modifiée et le format réduit permet de suivre chaque ligne improvisée plus facilement, chaque voix acoustique comme électrique, en vis-à-vis. Michael Snow évoque ici, dans son jeu, le blues et le stride d'origine, mais un blues surréel presque, dans son traitement, repris ensuite par la guitare futuriste de Al Mattes, laquelle décolle graduellement, comme dans un rêve éveillé, étrange, bizarre, caricatural, pour clore à point cet *Interpretation of Dreams* bien nommé. *Time of the Essence*, à son tour, se construit lentement, sans se presser. L'écoute étant différente à deux, le jeu s'en trouve moins précipité, peut-être, ou chargé qu'en collectif. Tout tombe en place ici comme si c'était mystérieusement planifié d'avance, dans une autre dimension, avec encore des relents ou des bribes de piano-jazz, de piano virtuose. Et la guitare agile, en parallèle, y répond tel un écho, prolonge, commente, ponctue la conversation. En bref, la quintessence du duo free, un free lunaire et sanguin, paradoxal. Cette entente parfaite à deux (où l'humour occupe une place aussi), se poursuit de manière concluante avec *Chips and Hammers*. Ce dernier duo donne lieu à un jeu nerveux, alerte, rapide, changeant, la guitare-synthétiseur sonnant parfois même comme un orgue. Elle adopte alors une nouvelle identité (suivant un thème déjà familier à Michael Snow comme au CCMC).

Ceci dit, ce sont cependant les trois pièces inscrites sur la face B de cette même cassette jaune qui indiquent possiblement, pour nous, une nouvelle orientation du CCMC. Nobuo Kubota vient s'y joindre comme vocaliste ou chanteur, à nos deux acolytes.

Enregistrées le onze octobre 1989, elles ont pour titre : *Chants Meeting, Wonzentoozenthreez* et *Kohe Dances*. La voix humaine est au coeur de ces trois improvisations fascinantes, la voix sonore, hors texte, irréductible (une nouvelle voie pour le CCMC).

Chants Meeting donne à entendre, d'entrée de jeu, la voix comme un théâtre énigmatique, un théâtre free à trois personnages, voix versus instruments, mais où la voix domine souvent. Snow ramène discrètement sa sirène dans le paysage (la sirène-muse?), et son piano surtout. Mais la voix plaintive, japonisante, qui parle comme une langue inventée et murmure aussi, gesticule à sa façon, grogne, éructe,

interpelle, soupire, s'emballe, bref cette voix ramène tout dans son giron tel un aimant. (Il s'agit d'une voix sous influence ici, celle de l'opéra japonais par exemple, ou de la musique de cour, mais une voix qui transcende aussi ces données.)

Wonzentoozenthreez offre, en introduction, un beau duo pour contrebasse et la trompette de Snow (la trompette comme étranglée du souffleur se rapprochant étrangement plus de la voix que le piano acoustique). Puis la voix de Nobuo Kubota s'amène, comme venue d'ailleurs, d'une autre planète, des zones interdites de la psyché, la voix impossible, libérée du corps, du sens, initiant son propre scat démentiel, sans fausse pudeur, son «space bop» incisif, en réaction au piano terrien de Snow (le «piano-groove»), et à la guitare martienne, «out of this world», de Mattes, en complément. Cette musique imaginée à trois nous échappe tout le temps, fugace, fuyante, pour glisser lentement vers le cri, dans un appel pressant de la voix, tel un signal urgent auquel répondent Snow et Mattes en fin de parcours, dans un grand geste romantique terminal.

Kohe Dances, comme son titre l'indique déjà, est une chorégraphie pour la voix. La voix se fait rythme ici, danse, geste et entraîne les instruments dans son sillage, résultant en une musique abrupte, excessive, extrême et qui se réinvente constamment, musique insaisissable dans son flux et reflux constant, son mouvement perpétuel, évacuant toute mémoire à la limite. Or la voix entretient déjà un rapport trouble à la mémoire étant liée au corps, inséparable du corps et donc éphémère, mortelle, elle aussi. Elle rend donc tragique, à sa façon, la musique fin-de-siècle du CCMC et pose en des termes encore plus existentiels, si possible, la question de l'identité, à savoir : Quelles voix? Quelles musiques? De quel espace? Vers quel temps?

On imagine bien que toutes ces voix inventées auparavant, en 1986, par Michael Snow pour *The Last LP*, pourraient en perspective, entretenir des liens, elles aussi, ou des affinités avec ce que Nobuo Kubota fait brillamment ici, sinon Paul Dutton dans une autre musique apparentée dont nous allons parler maintenant. Il s'agit de la cassette bleue du *CCMC '90*, la deuxième bande avec voix éditée commercialement et qui réunit Michael Snow à Paul Dutton, Nobuo Kubota, Al Mattes et John Kamevaar.

Membre pendant près de vingt ans du groupe The Four Horsemen, Paul Dutton est un spécialiste de la poésie sonore, de l'improvisation vocale. Son approche est très différente de celle de Nobuo Kubota cependant. Pour comparer, on peut apprécier nos deux vocalistes free dans trois longues pièces où ils sont par ailleurs réunis, soit : *Sounding the River* (enregistrée le vingt juin 1990), *Things Go* et *Memory Bank* (captées, celles-ci, le dix octobre 1990). On a donc deux voix en présence ici, deux voix qui assurent la liaison avec les instruments et menacent d'avaler toute la musique aussi, parfois. Ceci dit, même s'il y a toujours plus d'irrationnel dans la voix qui transgresse les codes, ça ne relègue pas pour autant les instruments à un rôle de subalternes ou d'accompagnateurs. Il est difficile, encore une fois, d'isoler les contributions individuelles dans cette musique fulgurante, soudaine, complexe, chargée émotionnellement et où la forme se recompose constamment.

Ce qui est particulier à Paul Dutton cependant, c'est qu'il introduit le texte, le langage parlé, les mots dans la musique (bref un propos ludique en installation dans la matière sonore). Il énergise la musique par le biais de la parole. Cet aspect singulier permet d'établir un lien entre le CCMC et certaines productions d'Ambiances Magnétiques à Montréal, par exemple (où le texte compte pour beaucoup : cf Michel F. Côté, *Les Granules* ...), sinon avec le collectif Bruit TTV à Québec, et autres aventuriers du verbe éclaté à travers la planète (dont tout le mouvement de poésie sonore à l'échelle internationale).

Ce qui est unique cependant au CCMC, il faut le rappeler ici, c'est que tout s'improvise en direct, sans partitions, sans rien de préconçu à l'avance. Il n'y a donc pas de montage après coup, en studio, pas de re-composition ultérieure de la musique en différé, de collage multipistes, de manipulation des bandes. Le CCMC assume tous les risques de la musique spontanée, instantanée. C'est une option difficile, courageuse, exigeante, pas meilleure qu'une autre en soi mais garante d'une certaine «vérité» de la musique, et fidèle, en fin de compte, à ce free intégral dont rêvait déjà Michael Snow au début des années soixante, aux États-Unis.

En dehors de la poésie sonore de souche européenne, il y a toute une tradition de «jazz poetry» de racine plus américaine à laquelle s'apparente enfin le CCMC vocal

et dont font partie les Beat Poets des années cinquante, les Last Poets des années soixante, les free poets subséquents (incluant, pour nous une figure comme John Cage, par extension, en tant que récitant). Paul Dutton et Nobuo Kubota participent, eux aussi, de ce mouvement libérateur de la voix, auquel répond à son tour, avec pertinence, le piano dixie-free de Michael Snow.

Enfin, dans une pièce titrée *Things Go*, Paul Dutton et Nobuo Kubota traduisent, dans plusieurs registres, divers états d'âme de la voix para-littéraire, du chuchotement à la déclamation. C'est la voix au bord des mots, entre les lignes, heurtée, voilée, cassée, fêlée, erratique, râleuse, moqueuse, provocante, délirante, balbutiante, la voix fragmentée, éparpillée, en rupture et qui génère ses propres bruits, ses bruits de voix, sa rumeur audible, ses humeurs multiples, comme autant de personnages à l'oeuvre, d'identités en présence. Ces marginaux lunatiques ou nomades trans-modernes qu'incarnent à merveille Dutton et Kubota ici, affiliés à la «tribu» du CCMC, jouent leur propre destin sous la forme d'un sonodrame poly-free au déroulement imprévisible. Et toujours derrière, et tout autour d'eux, la musique cru, le piano blues, le jazz sublimé, quelques accords autobiographiques et de petites citations insolites aussi, emmagasinées en mémoire par John Kamevaar et relâchées dans la musique au moment opportun (des cloches, une sonnerie de téléphone, une chanteuse de blues, le thème fétiche de la cinquième de Beethoven...), bref autant d'éléments sonores disparates cherchant à faire sens dans l'imaginaire du public, à s'intégrer à sa propre «Memory Bank», en contrepartie. *Things go. Words go. Sounds Go. Memory goes... on.*

En 1993 par conséquent, le CCMC poursuit toujours sa quête de mondes sonores inédits via l'improvisation totale et n'a pas dit son dernier mot encore, son dernier «son», loin de là. À suivre de près donc, ce Canadian Creative Music Continuum : CCMC.

Imaginary record labels for imaginary recordings of imaginary ensembles. Only a fellow "Early Jazz" expert could imagine the interesting musical possibilities expressed here. Imagined in chemistry class at Upper Canada College, probably in 1948, by Michael Snow.

Les Disques de Michael Snow
Partition 3 Jazz Snow

par Raymond Gervais

En 1948, Michael Snow gravait ses premiers disques 78 tours en solo, en privé. Le jazz américain était alors sa principale source d'inspiration, son influence et sa passion première, totale (« the only thing in my life », dira-t-il, plus tard). D'une certaine manière, c'est un peu l'esprit du jazz, l'attitude libertine et expérimentale propre au jazz qui habite toute son oeuvre multiforme, et ce encore aujourd'hui.

Sous le titre de *Early Michael Snow*, l'artiste a édité trois cassettes comprenant une sélection de ses plus anciens enregistrements réalisés en solo, en duo et en petites formations, de 1948 à 1950. L'écoute de ces disques est fascinante lorsqu'envisagée dans la perspective globale de l'oeuvre de Snow, jusqu'à aujourd'hui. Ils marquent, de fait, le début de toute son aventure comme artiste. Le sonore précède donc le visuel chez lui. La cassette numéro un comprend des solos de piano de 1948, des pièces en duo pour piano et trompette de 1949, de même qu'une mélodie gravée avec le légendaire clarinettiste Pee Wee Russell à Chicago, en 1950. On se souvient que c'est en 1948 que le microsillon fut inventé («the first LP»), au moment même ou Michael Snow réalisait ses premières acétates 78 tours («the last 78's?»). Ses sources d'inspiration étaient alors, sur disques, les grands pianistes associés au jazz afro-américain de la Nouvelle-Orléans, de Chicago et de New York, les grands interprètes de ragtime, de blues, de stride et de boogie (de Jelly Roll Morton à Earl Hines, Jimmy Yancey, Meade Lux Lewis et compagnie).[1] À ces noms viendront s'ajouter, avec les années, une foule de pianistes de renom en jazz (dont Thelonious Monk), et en

1 Les premiers enregistrements de piano-jazz ont été réalisé sur des rouleaux (piano rolls), joués par des pianos mécaniques. Jelly Roll Morton (endisqué déjà par Michael Snow), James P. Johnson, Fats Waller et d'autres ont enregistré de tels documents.

Le piano mécanique agit un peu, ici, comme un phonographe et le rouleau de papier perforé comme un cylindre. En rejouant la musique, le piano mécanique se substitue aussi à l'interprète, un peu comme le magnétophone prend la place de l'exécutant dans *Falling Starts*, jusqu'à un certain point. Mais le fait que ce soit l'instrument lui-même, c'est-à-dire le piano, qui se substitue au pianiste plutôt qu'un appareil plus distancié comme un magnétophone, rend d'autant plus troublant ce jeu de substitution, de transfert, par où le piano représente le pianiste, adopte son identité (et prolonge ainsi, à sa limite, l'illusion propre au théâtre et son double).

Bien sûr, le piano mécanique n'est pas apte à faire tout ce que fait le magnétophone dans *Falling Starts*, bien que, avec les travaux d'un compositeur comme Conlon Nancarrow aux États-Unis, intervenant sur le débit, la vitesse, le toucher ou divers paramètres des sons produits par un ou plusieurs pianos mécaniques, on en vienne à s'interroger en ce sens. Conlon Nancarrow fait éclater les limites admises du piano mécanique tout comme Michael Snow repousse celle du piano acoustique, chacun à sa manière. Envisagé dans cette optique, on peut déjà entrevoir une parenté d'esprit entre Snow et Nancarrow, que la pratique du jazz réunit également. Une écoute des *Studies for Player Piano* le confirme (certaines de ces études s'inspirant directement du jazz

musique classique aussi (Dinu Lipatti, Wanda Landowska, Glenn Gould, Bela Bartok, Paul Wittgenstein et ainsi de suite).

Les disques ont donc joué un rôle important dans la vie de Michael Snow. Ils lui ont permis de découvrir, d'étudier et d'approfondir le jazz historique, en premier lieu, et auront suscité, de la sorte, son implication dans le champ artistique, via la pratique musicale. Sa passion pour les disques était si grande même, à ses débuts, qu'elle l'amena, alors qu'il était encore au collège, à l'adolescence, à inventer ses propres 78 tours imaginaires. Édités sur étiquette Classic Jazz, ces disques fictifs (à cinquante sous la copie, deux pour soixante sous), proposaient diverses formations inventées par Snow: Sidney Bechet and his Reedtet, The New Orleans Veterans Association, the dixieland Classicists, Mutt Carey and his Bobby Soxers, Don Ewell and his White Bottom Stompers, et d'autres encore.

En tant que pianiste autodidacte, à la fin des années quarante, Michael Snow se voulait être l'interprète d'un jazz s'inspirant prioritairement des modèles américains en place.[2] Avec les années, l'interprète allait devenir, par étapes, un improvisateur et un compositeur autonome, à part entière. L'impulsion initiale cependant, l'étincelle de départ, pour lui, restera toujours le jazz traditionnel. On se souvient que les années quarante correspondent à la période du New Orleans Revival en Amérique, simultanément à l'émergence du bop plus avant-gardiste. Au Canada, Toronto fut un haut lieu de cette renaissance dixie, dont Michael Snow comptait parmi les interprètes les plus en vue.[3] En 1948, sur disques, on peut donc l'entendre interpréter, avec beaucoup de ferveur et d'émotion, des classiques du jazz comme *Mamies Blues* de Jelly Roll Morton, *Pallet on the Floor* associé à Jimmy Yancey ou *Gin Mill Blues* de Joe Sullivan. Il compose également quelques pièces de facture assez orthodoxe, dans l'esprit et d'après les modèles américains. Composer ici demeure encore une forme d'interprétation quant au style, à la manière, au référent audible. Les titres de ces pièces, un peu typés, pointent d'ailleurs en ce sens: *Victory Club Stomp, Basement Chords, Montana in Toronto.* (La musique n'en reste pas moins touchante, malgré tout, et fort agréable à écouter). Il faudra attendre cependant les années soixante et dix, sur disques, pour découvrir, avec une oeuvre comme *Left Right,*

et du blues, dont la *Boogie Woogie Suite*). Incidemment, c'est en 1948 que Conlon Nancarrow composait sa première Étude du genre, l'année même où Michael Snow enregistrait ses premiers disques.

Tout comme Michael Snow, Conlon Nancarrow fut aussi un trompettiste de jazz (durant les années trente, en ce qui le concerne), avant de s'intéresser au piano mécanique, d'un point de vue plus expérimental. Si le piano mécanique évoque, à distance, par son mode de fonctionnement, le phonographe à cylindre, le pavillon de la trompette, en contrepartie, renvoie quelque peu, visuellement, aux pavillons des gramophones d'antan (souvent appelés "cornets" de gramophone). Mais ceci est une autre histoire...

c.f.:Conlon Nancarrow, *Complete Studies for Player Piano*, 1750 Arch records.

2 Au moment où Michael Snow grave, à Toronto, en 1948, ses premiers 78 tours, le pianiste Paul Bley se produit dans les boîtes de jazz à Montréal. Il va bientôt remplacer Oscar Peterson, en 1949, à l'Alberta Lounge.

Il y a un parallèle intéressant à établir entre Michael Snow et Paul Bley à partir de cette date, en tenant compte de leur cheminement respectif vers le free jazz et après, via la tradition. En 1949-50, par exemple, on retrouve Michael Snow à Chicago alors que Paul Bley est à New York, les deux pianistes en quête, pourtant, du jazz le plus authentique à sa source même (Snow en pourchassant les racines auprès de Jimmy Yancey et Pee Wee Russell alors que Bley interroge

à quel point Michael Snow saura être un compositeur original, personnel, sans renoncer pour autant à la tradition du jazz comme tremplin.

Mais revenons-en à ces disques de 1948. Au départ, ces acétates se présentent comme des enregistrements assez pauvres, voire même primitifs quant à la qualité technique de captation initiale et de reproduction sur vinyle. Ça gratte beaucoup. Au travers les parasites sonores, les bruits de fonds très présents, émerge une musique fort belle, d'autant plus belle, peut-être, qu'elle est ainsi un peu lointaine, mystérieuse, involontairement trafiquée. On assiste presque à la naissance de la musique concrète avec ces disques de 1948![4]

Voyons voir, à nouveau, ce que joue Michael Snow cette année-là, en le considérant dans l'optique d'un questionnement portant sur la représentation. Il interprète *Mamie's Blues* de Jelly Roll Morton, par exemple. Or, Morton n'était-il pas préoccupé, lui aussi, par la question de l'identité, se réclamant d'une famille de souche française et affirmant même sa paternité sur le jazz. Jelly Roll Morton avait gravé ses premiers solos en 1923. Vingt-cinq ans plus tard, Michael Snow relit son histoire à sa manière, une histoire qui n'est donc pas la sienne, au départ, mais qu'il va s'approprier et faire sienne par le biais de l'improvisation. Ce jeu de miroirs à identités multiples, par où Snow joue Morton et Snow simultanément, l'un par l'autre réinventé, se prolonge ainsi avec d'autres lectures de classiques du jazz à son répertoire, dont *At the Jazz Band Ball*. Ce dernier thème associé, pour beaucoup, à l'Original Dixieland Jazz Band (le premier orchestre de jazz à avoir enregistré en 1917), pose à nouveau, par extension, la question de l'origine, de la paternité du jazz et de l'identité de ses géniteurs, blancs versus noirs (Snow reprenant, en 1948, cette problématique à sa façon, au piano, en solo, à partir de Toronto).

C'est en 1949 qu'il enregistre une série de duos chaleureux avec le trompettiste émérite Ken Dean (dont le célèbre thème *Royal Garden Blues*). Certains duos du genre, pour trompette et piano, sont d'ailleurs célèbres dans l'histoire du jazz, réunissant King Oliver à Jelly Roll Morton ou Louis Armstrong à Earl Hines (incluant, de ce dernier tandem, la fameuse version de *Weather Bird*). On a dit souvent d'Earl Hines qu'il jouait du piano comme d'une trompette. Michael Snow, pianiste

les boppeurs modernes autour de lui). Quel que soit leur point d'ancrage, le dixieland pour Snow et le bop pour Bley, les deux pianistes vont éventuellement déboucher sur le free. Leur chemin va d'ailleurs se croiser, à New York, au début des années soixante.

3 Concernant le jazz dixieland à Toronto et son interprète Michael Snow, il faut consulter l'ouvrage de Jack Litchfield, *Toronto Jazz 1948-1950*, 130 p., 1992, publié à compte d'auteur.

4 De fait, la musique concrète est apparue en France vers 1948-49, et déjà elle faisait appel, elle aussi, à l'improvisation ... Clin d'oeil à part, la fin des années quarante (alors que Michael Snow endisquait pour la première fois), constitue une période importante de l'histoire du jazz, annonçant même, par certaines réalisations, le free jazz à venir.

Le jazz dit «cool» émergeait alors. Un pianiste originaire de Toronto, Gil Evans, travaillait à New York en 1948-49, en compagnie de Miles Davis, à l'élaboration d'un concept orchestral nouveau devant mener à l'enregistrement des célèbres sessions éditées par Capitol sous le titre: *Birth of the Cool*.

Parallèlement, en 1949, Lennie Tristano (qu'on associe au jazz cool lui aussi), réalisait les premières expériences de jazz libre, en collectif, avec des oeuvres comme *Intuition* et *Digression*, documentées sur disques. En tant que pianiste, en solo, Lennie Tristano allait verser dans le free, dès 1953, avec une oeuvre comme *Descent Into the Maelstrom*.

Des musiciens associés au dixieland comme Bud Freeman et Bob Wilber ont, curieusement,

lui aussi, ne mettra que peu de temps, pour sa part, à maîtriser concrètement la trompette, l'ajoutant même régulièrement, à partir des années cinquante, à sa panoplie instrumentale (et effectuant, par la suite, une recherche originale sur les sonorités, à l'aide de diverses sourdines utilisées, entre autres, comme des filtres). Piano ou trompette, chaque instrument permet désormais à l'artiste d'exprimer une facette différente de son identité, de se dédoubler, en quelque sorte, tout en restant lui-même.[5]

C'est à Chicago qu'on retrouve Michael Snow en 1950 pour l'enregistrement d'une session en trio, réalisée avec le légendaire clarinettiste Pee Wee Russell. (James Jones au trombone complète la formation). Tout comme Michael Snow, Pee Wee Russell a un profil de carrière pour le moins inusité. Ce styliste inclassable, unique en son genre, affilié au milieu du dixieland, à Chicago, dès les années vingt, devait enregistrer avec Thelonious Monk en 1963 et inscrire même quelques thèmes d'Ornette Coleman à son répertoire. Il fut peintre également, à la fin de sa vie (tout

Ken Dean, cornet,
Toronto 1950

étudié avec Lennie Tristano. Il y a, encore une fois, une filiation certaine entre le dixieland et la modernité (ce que Pee Wee Russell et Michael Snow viendront, à leur tour, confirmer plus tard).

Pee Wee Russell, incidemment, joua en duo, en 1957, avec le clarinettiste Jimmy Giuffre, (l'un des pionniers, lui aussi, du free jazz, dont le trio de 1961-62 comptait un certain Paul Bley, parmi ses membres). Les musiciens, les écoles, les styles, les tendances se recoupent mystérieusement dans l'histoire du jazz: Toronto, Montréal, New York, dixie, cool, free et ainsi de suite.

c.f.:a)Lennie Tristano, *Live in Toronto* 1952, Jazz Records.

b)Robert Hilbert, *Pee Wee Russell: The Life of a Jazzman*, Oxford, New York, 300 pp., 1993.

5 Les pianistes qui, tout comme Michael Snow, jouent aussi de la trompette sont plutôt rares en jazz. À l'inverse, certains trompettistes ont, à l'occasion, joué du piano. On pense à Bix Beiderbecke ici, ou à Roy Eldridge, Dizzy Gillespie, Don Cherry, Bill Dixon et d'autres.

Michael Snow fait un peu la synthèse de ces deux pratiques, à sa façon. Non seulement joue-t-il de ces deux instruments, mais il a aussi accompagné, au piano, autrefois, plusieurs grands trompettistes dont Clifford Brown, Rex Stewart, Wingy Manone, Cootie Williams, Buck Clayton et d'autres.

comme son camarade de jadis, le batteur George Wettling). Personnage attachant, musicien incomparable, insituable, Pee Wee Russell est le premier artiste free de la clarinette en jazz, et un interlocuteur de premier plan, pour Michael Snow, en 1950. Il faut les entendre jouer *Ja Da*, par exemple, véritable rencontre privilégiée entre deux peintres de sonorités.

C'est huit ans plus tard, en 1958, que Michael Snow devait enregistrer son premier disque professionnel, en studio, un 33 tours avec le Mike White Jazz Band intitulé : *Dixieland Jazz with Mike White's Imperial Jazz Band*. L'album, édité sur Raleigh Records, réunit Mike White au cornet à Bud Hill au trombone, Ian Arnott à la clarinette, Michael Snow au piano, Peter Bartram à la contrebasse et Ian Halliday à la batterie. Le sextuor joue onze pièces au total, des classiques du dixieland, des standards, des pièces originales, soit un répertoire qui va de Louis Armstrong à Duke Ellington et du New Orleans Jazz au swing via le blues (incluant même le *I Love Paris* de Cole Porter, avec une petite citation de *La Marseillaise* au passage).[6] Côté interprétation, l'orchestre nous donne à entendre un jazz collectif vigoureux et vibrant, une vraie musique d'exultation et de swing débridé. Tout le monde joue bien ici, dans l'esprit festif comme emporté du style d'origine. Et Michael Snow

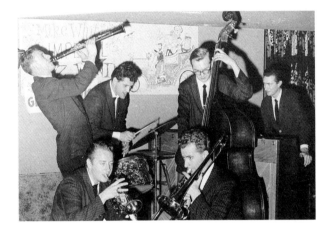

Mike White's Imperial Jazz Band at Basin Street, Westover Hotel, 212 Dundas Street East, Toronto, 1958. Ian Arnott–clarinet, Mike White–cornet, Ian Halliday–drums, Bud Hill–trombone, Peter Bartram–base, Michael Snow–piano.

6 C'est Art Hodes, pianiste réputé de Chicago, qui signe les notes de pochette de ce premier album de l'Imperial Jazz Band de Mike White, avec Michael Snow, en 1958. Art Hodes était lui-même un grand spécialiste du blues et du jazz de la Nouvelle-Orléans et de Chicago. Il a, par ailleurs, enregistré deux disques à Toronto, en solo, en 1983 et 1985, pour l'étiquette Sackville, de même qu'un album gravé en duo, au Café des Copains, en compagnie du saxophoniste Jim Galloway, pour la marque Music and Arts. Art Hodes est mort tout récemment, en 1993. Sa biographie venait tout juste de paraître sous le titre *Hot Man*, aux éditions Bayou Books.

Concernant la présence de Michael Snow dans l'orchestre de Mike White en 1958, Art Hodes écrivait ceci dans les notes de pochette: « And something new has been added ... we have a pianist instead of the banjo ... and that makes me smile; you see, I'm prejudiced. »

Art Hodes qui garda, pour l'essentiel, le même style de jeu toute sa vie, n'aurait jamais pu imaginer, cependant, en 1958, la trajectoire inusitée qu'allait suivre la carrière de Michael Snow par la suite, du dixieland au free jazz subséquent.

Mike White's band with Edmond Hall, an extraordinary
New Orleans clarinetist, who for many years played
with Louis Armstrong. Westover Hotel, Toronto, 1958.

Mike White's band with Vic Dickenson, one of the
great trombone stylists, 1958.

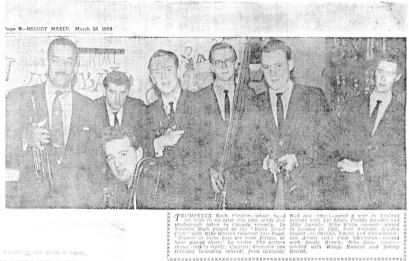

Page 8—MELODY MAKER, March 28, 1959

TRUMPETER Buck Clayton, whose band we hope to see later this year, sends this photograph taken in Canada recently. In Toronto, Buck played at the "Basin Street Club" with Mike White's Imperial Jazz Band. Several of these boys are from Britain, or have played there," he writes. The picture shows (left to right): Clayton; drummer Ian Holliday (standing behind), from Glasgow; Bud Hill (tmb.)—spent a year in England jobbing with Vic Lewis, Freddy Randall and Mike Daniels; Mike White (cornet)—played in London in 1955; Pete Bertram London bassist—ex-Daniels, Laurie and Fairweather; Ian Arnott (clt.) from Edinburgh—worked with Sandy Brown; Mike Snow (pno.)—worked with Wingy Manone and Sidney Bechet.

Mike White's band with Buck Clayton. Photo taken January 20, 1959.

The reproduction of it appeared in *Melody Maker*, at the time the most widely read English Jazz and Pop magazine, the English equivalent of the American *Down Beat* magazine.

The flyer, typical of those put out to advertise the appearances of American stars with the Mike White Band, gives a good short bio of Clayton, a wonderful musician.

197

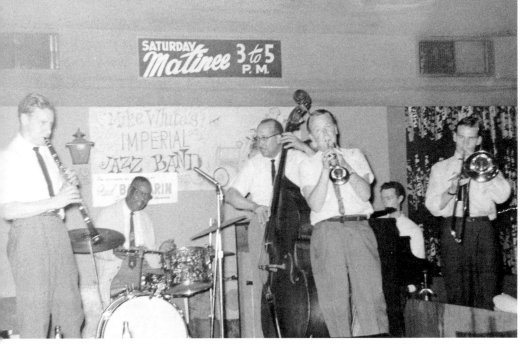

Another New Orleans musician who never left his home city, Paul Barbarin, was the Mike White Band's guest on drums for one week in 1959. Toronto bassist Harold Holmes had by then replaced Peter Bartram on bass and Alf Jones was the new trombonist.

Trombonist Dicky Wells with the Mike White Band, May 3, 1959. Wells, like Clayton, was an alumnus of the great early Kansas City Count Basie bands. Vocalist with those early Basie bands, Jimmy Rushing was also a guest performer with the Mike White Band. Other fine, often legendary first generation Jazz musicians who were guest artists: Chicago pianist Art Hodes, New Yorker Willie "the Lion" Smith, one of the originators of the Harlem "stride" piano style and two great trumpet players, who had been stars of the incomparable Duke Ellington Orchestra, Rex Stewart and Cootie Williams. Thanks to Peter Bartram for saving and supplying these rare photos. Unfortunately, it appears that no performances by these great guest musicians with the Mike White Band were ever recorded.

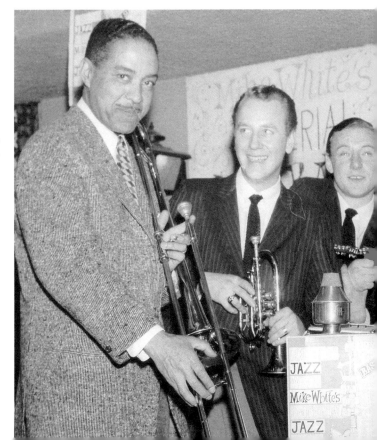

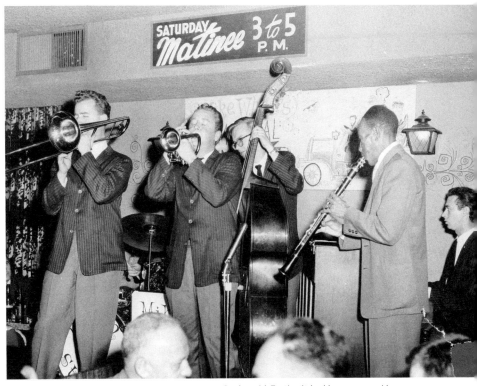

In the mid-Forties it had been assumed by many Jazz aficionados in North America and Europe that all the best musicians had left New Orleans for Chicago, New York, etcetera in the Twenties and Thirties, and that there were no interesting musicians left there. Led by an American composer William Russell, a small number of musicologists decided to look and listen in New Orleans. Some of the inventors of Jazz were indeed still playing and playing very well. Trumpeter Bunk Johnson, said to have been an influence on the young Louis Armstrong, had stopped playing but was urged to resume. Russell recorded and issued x(on his label American Music) the band that Johnson assembled. The unflashy pure ensemble style of this music had a radical effect on listeners and young musicians. George Lewis who was a member of the Johnson band and one of the first generation creators of Jazz who had never left New Orleans, finally and rightfully entered the history of the music. The Mike White Band had the honour of having Lewis play with them for one week as one of their series of distinguished visiting artists. Photo taken December 3, 1958.

199

The Mike White Band also had the thrill of performing on the same stage with some of their heroes at the First Canadian Jazz Festival.

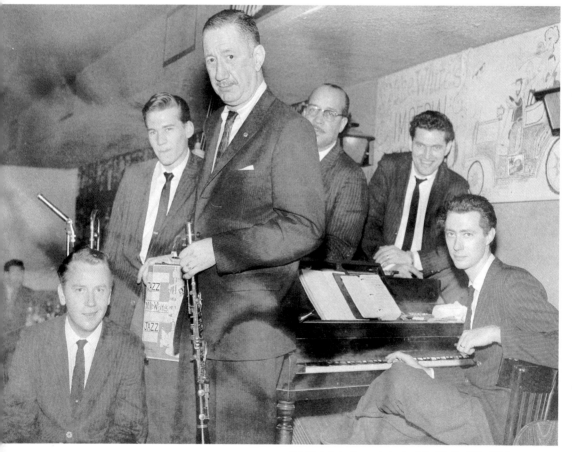

Pee Wee Russell, guest clarinetist with the Mike White Band. Photo April 6, 1959, courtesy of Peter Bartram.

B^b | | | | ∕. | B^bmaj 7 | | | | B^b | | | | ∕. | B dim | | |

F^7 | | | | ∕. | ∕. | ∕. | C^7 | | | F^7 | | | | ∕. | F^{7+} | | | B^b | | | F^7 | | | ⑯

B^b | | | | ∕. | F^m | | | G^7 | | | C^{m7} | | | G^7 | | | C^{m7} | | | | ∕. | ∕.

C dim | | | B^b | A^7 A^{b7} | G^7 | | | C^7 | | | F^7 | | | B^b | | | | ∕. ㉜

Cherry 16

E^b | | | D^7 | | | B^{bm7} | | | C^7 | | | F^7 | | | B^{b7} | | |

E^b | C^{m} | F^{m7} | B^{b7} | | E^b | | | ∕. ⑯ BRIDGE G^7 | | | ∕. | C^7 | | | ∕. | F^7 | | | ∕.

B^{b7} | | | ∕. | E^b | | | D^7 | | | ㉘ C^7 | | | F^7 | | | B^{b7} | |

E^b | | | ∕. ㉜

$Bbm7$

F | | | | ∕. | ∕. | ∕. | ∕. | ∕. | D^7 | | | ∕. | G^7 | | | ∕.

G^7 | | | ∕. | G^{m7} | | | B^{bm7} | | | F | | | F/E^{b7} | ⑯ BRIDGE A^b | | | E^{b7} | | |

A^b | | | ∕. | ∕. | E^{b7} | | | A^b | | | C^7 | | | ㉘ F | | | ∕. | A^b dim | | | ∕.

F | | | C^7 | | | F | | | ∕. ㉜

C | | | | ∕. | ∕. | ∕. | ∕. | ∕. | G^7 | | | ∕. | ∕. | ∕. | C | | |

C | | | D^7 | | | ∕. | G^7 | | | ∕. ⑯ C | | | ∕. | ∕. | ∕. | C^7 | | | ∕.

F | | | ∕. | ∕. | $F^{\#}$ dim | | | C | | | A^7 | | | D^7 | | | G^7 | | | C | | | ∕. ㉜

19

G | | | D^{7+} | | | G | | | E^7 | | | A^7 | | | D^7 | | | G | | |

D^7 | | | G | | | B | $F^{\#7}$ | B | | | B | $F^{\#7}$ | B | | | D | A^7 |

D | | | A^7 | | | D^7 | | | G | | | D^{7+} | | | G | | | E^7 | | | A^7 | | |

D^7 | | | G | | | ∕. ㉜

⑦

Mike White's IMPERIAL JAZZ BAND

"What's gonna happen when you guys go?" How often have I heard this question voiced. The answer? Its simple; nothin' . . . nothin's going to happen that hasn't been happening right along. Look at it this way; what happened when King Oliver left the scene? Along came Louis Armstrong, and in time carried the tradition forward a bit. Ah yes, there will be some to argue that Louie had changed the 'sound' of jazz . . . he had injected his own personality into the music. But hasn't this always been true? That something new is added to the old?

Nope; the future didn't concern me as did the present. For one thing, I was bothered by a tendency I seemed to note in fresh, young bands to group together . . . that is; the personnel seemed to be of one age level. The interplay was missing . . . the jam session with the oldster; youth learning from age, sittin' in . . . I was concerned; you see, when we who are now being called 'old timers', were first coming up, we did a lot of running here and there; to listen, to 'sit-in', to jam . . . Sure, its true we grouped together . . . there was the Austin High gang, the Wingy Mannone group, the Red McKenzie bunch . . . We stuck together . . . we worked together . . . but we learned apart . . . drummers searched out Baby Dodds, pianists dug Earl Hines . . . the horn men followed Louie . . . Yes, I was a bit concerned about this tradition . . . 'passing on' . . . Yet I needn't have been, I had only to look around; it was still a part of the musical scene.

All of which brings me to my subject . . . this recording, and Mike White and the Imperial Jazz Band. I believe it was sometime in April of '58 that I was invited to a session in Toronto. Joe Taylor, the 'at the time' manager of the Imperial Jazz Band, arranged for me to appear in 'joint' concert with the Imperials, at Hart House. I well remember meeting the band 'on Stage' for rehearsal. Most of the guys were in their 20's; definitely a young band. My first impression was a band tryin' to play in the Oliver tradition. Certainly, the tunes dated back to the 'authentic'. It was quite a kick for me. I like to be around people who are tryin' and doin' . . . I don't believe I missed a night of Bunk's New York stay (Stuyvesant Casino) . . . I was part of the New York scene during the Jazz Information-Commodore-H.R.S. days . . . a time of 'Jazz rebirth' . . . And at the rehearsal, and later, when we relaxed at Mike White's apartment, I was getting a feeling of the excitement these chaps felt . . . nor did anything that happened in the two dates we were together dispel this . . . Way before the concert, they sat and talked music and musicians 'at me' . . . The record player was there . . . and in action. I heard Dodds, Oliver,

Bunk; I heard 'blues'. It was a good session; the two dates went fast. One of the things that impressed me most was, 'these guys aren't afraid to try'; and they blew two; three opening chorus's . . . and the ensembles 'swung' . . . Bud Hill, the trombonist, seemed to be the musical mind; the fellow who had put in years of hard study. Pete Bartram carried a good bass beat. Mike White played the 'lead' and the band tended to business. I felt these guys were on the right track.

In August of '58 I again journeyed to Toronto; this time, I was to play a six-day week gig with the Imperials; their first guest. A hotel owner had become interested; enough so that he had converted the bar-room into a 'Basin Street' . . . The place was jumpin' . . . it was the bands first 'steady type' engagement. I was in for a surprise. Boy, this band had improved. The biggest improvement was in Mike White. He had added punch and assurance; having to carry the lead alone seemed to have helped. But it was more than 'just one man' . . . it was a whole band that had 'grown up' . . . they were swingin' 'much more' . . . a wider selection of tunes . . . Not only was I impressed, I thoroughly enjoyed the 'whole bit'.

Since then, the Imperial Jazz Band has had two other guest artists . . . Vic Dickenson, trombone . . . Edmond Hall, clarinet . . . You see what I mean; any time young talent exposes itself to such music men as Vic and Ed, somethings bound to rub off. The mere fact that this is the type of jazzmen the Imperials want to learn from . . . jam with . . . hear . . . be around . . . this talks worlds to me. You couldn't make a healthier move . . . knowledge is being handed down . . . you're witnessing circulation . . . and thats good.

And now comes word that Hallmark has recorded the Imperial Jazz Band. Gee, I'm glad. I'm glad for all concerned. I feel like I was part of their growing up . . . of their coming of age . . . And believe me, they didn't rush the bit. They didn't record when they were deep in early experimentation . . . We've had a rash of experiments marketed as 'truth' . . . I'm glad they waited to record. I believe 'young bands' should tape their early efforts and 'give a listen' to themselves. Learn from tapes; don't issue them. The Imperial Jazz Band had a long 'school' period. Also, I note a few changes: Syl (that's Mrs. White) has become quite active in band business . . . now the fellows don't have to worry about that. And, the I.J.B. has changed drummers; that happens to bands. And something new has been added . . . we have a pianist instead of the banjo . . . and that makes me smile; you see, I'm prejudiced.

There you have it; not one word of who did what to whom; no description of what took place during the second chorus; i've left your thinking uncluttered. Let the music speak for itself. I did this for two reasons: one is, I believe in this style . . . the other is, I am now about to hear the music for the first time. That's it.
 art hodes . . . nov. 17th . . . 1958.

P.S. After hearing the record, I changed my mind! The band is 200% improved— Everyone on the date makes sense to any one with an open set of ears— YIP! Send me a record! Now!

New Orleans, Sweet Georgia Brown, Anything Goes, Yellow Dog Blues, The Preacher, I Love Paris, Basin Street, Steam Boat, I Found A New Baby, Savoy Blues, Things Ain't What They Used To Be.

Mike White, cornet; Michael Snow, piano; Bud Hill, trombone; Ian Halliday, drums; Peter Bartram, bass; Ian Arnott, clarinet.

Produced for **RALEIGH RECORDS**
 by *Hallmark* RECORDINGS

R.I.A.A. Recording Characteristic Recording Producer - Joseph Brook

PRINTED IN CANADA

démontre qu'il a parfaitement maîtrisé l'idiome traditionnel, tout en y ajoutant une touche moderne ou des accents plus audacieux lors de ses interventions solistes. Snow met déjà du bop dans son dixie (tout comme il mettra, graduellement, du free dans son dixie-bop, à partir des années soixante).[7]

Le dixieland entretient d'ailleurs des liens avec le free jazz.[8] Albert Ayler, par exemple (filmé par Michael Snow en 1964), croyait que sa musique partageait plus d'affinités avec le jazz collectif des débuts, à la Nouvelle-Orléans, qu'avec le bop individualiste plus récent. D'autres avant-gardistes comme Steve Lacy ou Roswell Rudd, pour leur part, furent d'ardents praticiens d'un dixieland convivial avant même de se recycler complètement en musique free. (À l'inverse, des traditionalistes comme Kenny Davern ou Pee Wee Russell n'ont, qu'à l'occasion seulement, lorgné du côté du free). Par ailleurs, Lacy et Rudd se sont avéré être, en plus, de fervents adeptes de l'oeuvre de Thelonious Monk.

Michael Snow a, lui aussi, beaucoup joué Monk, en trio, à Toronto, au début des années soixante, avec Larry Dubin à la batterie. (Une de ses oeuvres d'art, réalisée en 1960, s'intitule précisément *Blue Monk*).[9]

C'est en 1962 que l'artiste choisissait de quitter Toronto pour s'installer indéfiniment à New York. Un petit disque 45 tours gravé cette année-là (le 17 juillet), vient en quelque sorte sceller cette période de sa vie de façon exemplaire. Il nous donne à entendre un Michael Snow plus moderne encore, capté en phase de transition, en voie d'émancipation, sous l'influence avouée du jazz modal de Miles Davis et de John Coltrane. On y retrouve donc deux pièces originales, *Theft* (de Michael Snow), et *Sunset Time*, interprétées par Mike White, Alf Jones, Ian Arnott et un trio constitué de Michael Snow au piano, Terry Forster à la contrebasse et Larry Dubin à la batterie. Deux points de vue s'affrontent ici, au sein de cette formation, celui de Mike White, partisan d'un dixieland authentique, et celui de Michael Snow, ouvert aux nouvelles harmonies post-bop en cours. Malgré cette propension au changement, le pianiste était sans doute bien loin de s'imaginer que, peu de temps après, vers 1962-63, il serait propulsé, à New York, au coeur même du mouvement le plus libertaire et le plus radical de toute l'histoire du jazz, le free jazz.[10]

7 Les compositions qu'on retrouve, en 1958, sur ce disque de l'Imperial Jazz Band de Mike White (avec Michael Snow au piano), sont les suivantes: *Down in New Orleans, Sweet Georgia Brown, Anything Goes, Yellow Dog Blues, The Preacher, I love Paris, Basin Street Blues, Steam Boat Stomp, I Found a New Baby, Savoy Blues* et *Things ain't What They Used to Be*.

Qu'il s'agisse du jeu costaud de Bud Hill au trombone ou du phrasé plus sinueux et fluide de Ian Arnott à la clarinette, il faut souligner, à la fois les qualités de soliste et la cohésion d'ensemble des six membres de cet excellent orchestre dixieland, à Toronto, en 1958.

Au même moment, en Californie, en 1958, Paul Bley se produisait avec le trompettiste canadien Herbie Spanier (actif, quant à lui, auparavant, à Chicago en 1949-50 et, à Toronto, de 1950 à 1954). Puis, toujours en 1958, à Los Angeles, Paul Bley allait s'adjoindre, pour son quintette, Ornette Coleman et Don Cherry (ce trompettiste free que Michael Snow devait filmer, plus tard, pour *New York Eye and Ear Control*).

8 Jelly Roll Morton est un compositeur traditionnel qu'affectionne beaucoup les musiciens d'avant-garde. Il a été célébré, sur disques, par Charles Mingus, Sun Ra, le groupe AIR, Alexandre von Schlippenbach et d'autres.

9 Outre *Blue Monk*, d'autres oeuvres visuelles de Michael Snow portent des titres qui font explicitement référence à la musique, comme par exemple *Woman with a Clarinet* (1954), *Piano* (1956), *Downbeat* (1959), *Trane* (1959), *Carla Bley* (1965), et d'autres encore. Le rapport des

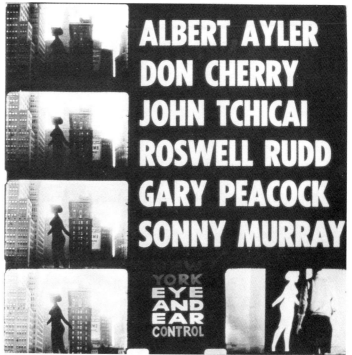

arts visuels au jazz, au vingtième siècle, est un sujet vaste et passionnant qu'on ne peut discuter ici. De Picasso à Mondrian, Matisse, Pollock, David Stone Martin et une foule d'autres, il y en aurait très long à dire sur ce thème. Michael Snow fait aussi partie de cette histoire.

10 Concernant le séjour de Michael Snow à New York, d'une dizaine d'années environ (à partir de 1962), il y aurait lieu de décrire sommairement, ici, le contexte musical d'alors, à l'intérieur duquel s'inscrit son propre travail d'artiste (et ce, en tenant compte d'un milieu plus global qui inclue aussi d'autres pratiques parallèles en art, en littérature ou en danse, par exemple, dont nous ne pouvons pas parler dans ces notes).

En musique d'ailleurs, nous ne nous intéresserons qu'à deux secteurs bien définis, celui du nouveau jazz (appelé free ou New Thing), et celui de la nouvelle musique dite minimale, en complément.

a) New Jazz

Lorsque le torontois Michael Snow s'installe à New York en 1962, le montréalais Paul Bley vient d'y enregistrer un album important, en trio, pour la marque Savoy (où il joue, entre autres, des compositions d'Ornette Coleman et de Carla Bley). Michael Snow lui-même vient tout juste de laisser derrière, à Toronto, un fascinant trio avec Terry Foster à la contrebasse et Larry Dubin à la batterie. Cet énigmatique trio (qu'on aurait bien aimé voir endisquer lui aussi), jouait des compositions de Thelonious Monk, Charlie Parker, Miles Davis et d'autres.

C'est ainsi que la trame sonore d'un de ses films, *New York Eye and Ear Control*, allait être éditée, à New York, sur étiquette ESP (la compagnie de disques emblématique de l'avant-garde et du free jazz à l'époque).[11] L'album comme tel, enregistré par Michael Snow le 17 juillet 1964, comprend trois improvisations, soit *Don's Dawn* (très courte, d'une durée d'une minute seulement), et surtout, *Ay* et *ITT* (deux longues pièces d'une vingtaine de minutes chacune). Pour les interpréter, on retrouve le nec plus ultra du free jazz d'alors : Albert Ayler au saxophone ténor, Don Cherry au cornet et à la trompette, John Tchicai au saxophone alto, Roswell Rudd au trombone, Gary Peacock à la contrebasse et Sunny Murray à la batterie.

Ce qu'il y a de particulier ici, c'est qu'à la demande expresse de Michael Snow, la musique est totalement improvisée, en mettant l'accent, entièrement, sur l'aspect collectif du jeu, sans solos donc et sans thèmes préconçus, fabriqués à l'avance. C'est la même attitude qui sous-tend, encore aujourd'hui, la pratique musicale du CCMC, à Toronto. L'improvisation totale comme discipline donc, comme mode de composition de groupe, dans l'instant. Dix ans même avant la formation du CCMC, Michael Snow avait eu, à New York, l'intuition de cette musique, du potentiel illimité de cette approche libertaire, extrême, et de ses exigences aussi (ce qu'une autocritique régulière permet au CCMC d'assumer). Bien qu'il n'ait pas participé à l'enregistrement de cette session ESP, en 1964, en tant que musicien, en tant que pianiste (c'est lui qui enregistre), ce disque occupe quand même une place cruciale dans la discographie de Michael Snow. On y entend son concept de jeu libre tel qu'exécuté par les plus grands musiciens free d'alors. Il a par ailleurs, en guise de signature, réalisé le graphisme de la pochette de ce disque ESP, en y introduisant sa célèbre figure de la *Walking Woman*. Ce disque mythique de l'histoire du free jazz a enfin été réédité en compact, tout récemment, avec la pochette d'origine reproduite en miniature. Quant à la musique, rauque, viscérale, volcanique presque, par moments, elle n'a rien perdu de sa puissance d'expression et de sa force d'impact, encore aujourd'hui.

Un autre album ESP a suscité une participation de Michael Snow. Il s'agit du disque de Paul Bley titré *Barrage* (sa session la plus free), pour lequel Snow réalisa

Ceci dit, les notes de pochette accompagnant l'album Savoy de Paul Bley sont signées Paul Haines (un écrivain et ami de Michael Snow, son voisin immédiat alors, à New York). Ces notes «iconoclastes», inclassables, uniques en leur genre, mériteraient à elles seules un commentaire adéquat. Elles occupent une place à part dans l'histoire des notes de pochette. Elles n'expliquent pas la musique de Paul Bley. Elles fonctionnent sur un autre plan, à côté, comme une sorte de poème free, avant la lettre. Elles anticipent, à cet égard, sur la musique encore plus libre à venir. C'est ce même Paul Haines qui signa le livret de l'opéra *Escalator Over the Hill* de Carla Bley (dans lequel apparaît succinctement Michael Snow, sur disque).

À New York, à l'époque, Michael Snow habitait un loft avec piano. Beaucoup de musiciens d'avant-garde se sont produits dans ce loft (dont Paul Bley, Archie Shepp, Giuseppi Logan, Milford Graves, etc.). C'est aussi dans ce studio d'artiste que devait répéter l'un des groupes les plus importants de l'histoire du free jazz, le New York Art Quartet (dont faisait alors partie le tromboniste Roswell Rudd, un camarade de Michael Snow qu'on retrouvera également dans le film *Wavelength*). C'est enfin dans ce même loft de Michael Snow que le Jazz Composer's Orchestra devait se réunir, à ses tout débuts, pour déchiffrer les premières partitions orchestrales ambitieuses de l'histoire du free jazz.

Très engagé en art visuel à l'époque, Michael Snow écoutait plus souvent qu'il ne jouait dans ce contexte, de son propre aveu. Cependant, il s'impliquait parfois, accompagnant Pharoah

le graphisme de pochette, en y insérant, à nouveau, la silhouette de sa *Walking Woman*. (Ce personnage découpé en profil suscita, par ailleurs, une composition de Carla Bley portant ce même titre, *Walking Woman*, interprétée par Paul Bley sur cet album). Avec les années, pour beaucoup de collectionneurs de disques, la *Walking Woman* est ainsi devenue une véritable icône du free jazz. Elle marche encore et toujours dans leur imaginaire un tant soit peu fétichiste.

New York Eye and Ear Control, incidemment, est le seul film de Michael Snow dont la trame sonore ait fait l'objet d'un disque subséquent. Si le free jazz qu'on y entend était, en 1964, une musique particulièrement intense, urgente (comme un lent zoom à l'intérieur d'un cri), la musique collective que va pratiquer Snow, plus tard, avec le Artist's Jazz Band, puis le CCMC, sera peut-être plus ludique, ou moins farouchement existentielle, mais tout aussi créative et vitale, cependant, à sa façon.

Quant au pianiste soliste, il faudra attendre les années quatre-vingt, surtout, avant de pouvoir réentendre Michael Snow au piano, en solo, dans des bandes inédites réalisées en public.[12] On se souvient qu'une trentaine d'années auparavant, Michael Snow avait endisqué ses premiers 78 tours en solo, avec un équipement technique rudimentaire, à l'époque. Le temps alloué pour chaque interprétation était limité, alors, aux capacités du format 78 tours, et le répertoire était modelé, pour l'essentiel, sur les archétypes américains en place. Chaque solo était donc très court, très concis.

Plus de trente ans après, la situation a complètement changé. Il n'y a désormais plus de limite de durée à une improvisation captée sur bande. La qualité d'enregistrement n'est évidemment pas comparable, non plus, à ce qu'elle était auparavant. On découvre enfin le «sound» Snow au piano, un toucher dur, franc, percutant. En dehors des limites matérielles liées au médium lui-même, au fonctionnement des appareils, ce sont surtout les limites humaines et créatives, si on veut, qui ont été considérablement repoussées avec le temps. D'interprète qu'il était à l'origine, Michael Snow est devenu, entre-temps, un improvisateur autonome, indépendant. Il s'est transformé tout en gardant certaines attaches avec son passé. Une oeuvre comme *Around Blues*, exécutée en direct, en 1986, le prouve amplement. (Elle devrait

Sanders en concert, par exemple, ou d'autres.

b) New Music

En parallèle à toute cette activité en jazz, il faut préciser l'implication de Michael Snow dans le milieu de la musique nouvelle d'alors (dite New Music ou Minimal Music). Les musiciens dits minimalistes entretenaient, eux-aussi, des liens étroits avec le milieu des arts visuels comme avec celui du jazz progressif en cours. Michael Snow, artiste et jazzman, jouera donc en duo, en privé, avec Philip Glass, par exemple. Il participera aussi à l'exécution de l'oeuvre-processus, *Pendulum Music*, de Steve Reich. (Une photo tirée de son film *Wavelength* illustrera même, plus tard, la pochette d'un album de Steve Reich paru en France, sur étiquette Shandar, et incluant Four Organs et Phase Patterns).

11 Le catalogue novateur des disques ESP a été en partie réédité, récemment, en format compact, en Europe, incluant l'album de Paul Bley titré *Barrage*. Ce disque ne comprend que des compositions de Carla Bley, six au total (dont *Walking Woman*). Carla Bley est d'ailleurs le personnage féminin dominant dans cette saga du free jazz, à New York, durant les années soixante.

Fondé en 1964, la compagnie ESP incarna, tel un microcosme, l'esprit du temps et du lieu propre aux années soixante (aux États-Unis comme ailleurs). Le New York Art Quartet (mentionné auparavant), et Albert Ayler ont gravé de très grands disques pour ESP. Plusieurs pianistes free ont également débuté sur ESP: Lowell Davidson, Don Pullen, Call Cobbs, Ran Blake, Burton

faire l'objet d'une édition sur disque, éventuellement.)[13]

Au départ, il faut souligner la réticence de Michael Snow à enregistrer en solo. À ce sujet, il confiait à Pierre Théberge ce qui suit : « Peut-être que je suis extrémiste mais pour moi, les miracles de l'improvisation sont produits par la rencontre des personnes et des événements sur lesquels personne n'a de contrôle. Ils ne peuvent être répétés. En solo, il n'y a pas nécessairement de différence entre l'improvisation et la composition puisque on est entièrement responsable de ce qui se produit, même le hasard. (...) Quand j'improvise chez moi, je joue des morceaux qui sont individuellement liés à un matériel spécifique et cela n'est vraiment pas assez radical, je ne peux jamais me surprendre autant que d'autres lignes de pensée traversant la mienne ».[14]

On pourrait suggérer cependant, ici, que lorsque Michael Snow joue en solo devant un public, c'est ce public présent qui constitue peut-être, alors, ces «lignes de pensée» recoupant la sienne, sa seule présence et sa qualité d'écoute suscitant, potentiellement, une énergie, une concentration, un climat de tension, d'éveil très particulier chez le pianiste.

Quoi qu'il en soit, une oeuvre comme *Around Blues* témoigne avec éloquence de la maturité acquise par Snow, avec les années, comme soliste. Il s'agit d'une longue improvisation de quarante cinq minutes environ, exécutée d'un seul trait, sans arrêt, un long et magnifique solo autobiographique qui résume, à lui seul, le cheminement de Michael Snow face à son instrument, à l'histoire du jazz et à l'improvisation (en tant que méthode de jeu renouvelée, actualisée). Comme son titre le laisse déjà deviner, *Around Blues* est une réflexion à voix haute autour du blues sous-jacent à toute pratique du jazz, avec, en cours de route, quelques citations amalgamées au discours (*Sophisticated Lady, Honky Tonk Train Blues, Easy Living*), et très bien intégrées.[15]

Via le piano (sa palette acoustique), Michael Snow déconstruit le blues vers l'abstraction. Avec un souffle, un tonus, une énergie considérable, il fait ici le bilan, en quelque sorte, de toute une vie comme jazzman, comme improvisateur.[16] Si on compare ses premiers solos de 1948 (plus candides), à cet immense envolée d'un

Greene, Bob James et d'autres. Le free jazz européen a aussi fait son apparition, en Amérique, sur ESP avec des parutions de Gunther Hampel, Peter Lemer, Karel Velebny et d'autres.

ESP était une abréviation pour Esperanto, cette langue universelle (faisant déjà écho, peut-être, à l'idée de la «World Music» actuelle), et à laquelle un album ESP avait été consacré sous le titre: *Let's Sing in Esperanto*. Le rock alternatif était présent aussi sur ESP avec les Fugs, le psychédélisme avec Timothy Leary, la poésie beat avec William Burroughs et, encore une fois, le nouveau jazz à son plus radical avec Ornette Coleman, Steve Lacy, Henry Grimes, Sunny Murray, Giuseppi Logan et d'autres.

Ce bref survol du catalogue ESP nous permet beaucoup mieux de situer l'album *New York Eye and Ear Control* (avec Albert Ayler) dans sa juste perspective, à savoir l'une des sessions clés, capitales, de l'histoire de la free music créative des années soixante.

12 Le premier concert solo de Michael Snow eut lieu à Montréal, en mars 1977, dans le cadre de l'événement multidisciplinaire nommé *032303*. Michael Snow y joua alors du piano et de la trompette en solo. Cette performance semble marquer un tournant pour lui, dans sa démarche d'artiste-musicien-soliste.

13 *Around Blues* fut exécutée en public par Michael Snow, à la Music Gallery, à Toronto, en 1987, et diffusée par la CBC dans le cadre de son émission «Two New Hours». Concernant la Music Gallery, une anthologie, sur disque compact, a été édité, en 1992, sous le titre *Masterpieces*

lyrisme choc, «filmée» une quarantaine d'années plus tard, on est confondu, stupéfait devant l'ampleur du chemin parcouru par l'artiste depuis. Du dixieland à la free music et après, Michael Snow a vécu diverses phases de l'évolution de cet art du jazz au premier degré, i.e. en tant que participant. Il fait un peu la synthèse de tout cet acquis ici, dans cet autoportrait tracé à l'emporte pièce, Around Jazz, Around Blues, Around Snow.

from the Music Gallery. Elle comprend quatorze pièces interprétées par autant de formations différentes, captées entre 1989 et 1991 (dont le CCMC). On y trouve aussi une improvisation en trio faisant appel au pianiste Bob Fenton, un autre «monkien» invétéré.

14 Pierre Théberge, *Conversation avec Michael Snow*, Centre Georges Pompidou, Musée national d'art moderne, 1978, p. 45.

15 Dans *Around Blues*, parmi des échos lointains de Thelonious Monk ou des réminiscences distantes de l'année 1948, émergent quelques citations précises: *Sophisticated Lady* (de Duke Ellington), *Honky Tonk Train Blues* (de Meade Lux Lewis) et *Easy Livin* (un standard).

On peut déjà inventer tout un narratif, tout un programme dans l'imaginaire, à partir de ces trois titres.

16 De Thelonious Monk à Cecil Taylor, il y a un certain nombre de pianistes singuliers dans l'histoire du jazz, des insituables, des originaux. Call Cobbs, par exemple, qui accompagna Albert Ayler est de ceux-là. Au Canada, les noms de Michael Snow à Toronto, de Paul Bley à Montréal et d'Al Neil à Vancouver sont des exemples qui nous viennent spontanément à l'esprit, de ces pianistes qui ont débordé, en quelque sorte, leur esthétique de départ, pour aboutir à une musique improvisée plus expérimentale, plus libre.

Ceci dit, peu de pianistes ayant de fait, tout comme Michael Snow, pratiqué le dixieland à fond au début de leur carrière, se sont, par la suite, orienté vers le jazz d'avant-garde ou des musiques

plus abstraites, plus complexes. C'est le cas du pianiste Mel Powell, notamment, qui, du dixieland au swing initial, a évolué, avec les années, vers la musique contemporaine de composition, acoustique comme électronique, à laquelle on l'associe surtout aujourd'hui. Le pianiste-improvisateur cependant, à la différence de Michael Snow, semble être resté plus traditionnel (comme en témoigne un album «mainstream», *The Return of Mel Powell*, enregistré en 1987, pour Chiaroscuro, avec Benny Carter et Milt Hinton). Un tel «retour en jazz» semble peu probable, ou plausible, en ce qui concerne Michael Snow.

D'autres cas apparentés à celui de Mel Powell pourraient être Herbie Nichols (un spécialiste de Monk qui jouait du dixieland avec Roswell Rudd pour composer, en parallèle, sa propre musique avant-gardiste), ou Mary Lou Williams (qui du stride au boogie se tourna vers le free, à la fin de sa vie, endisquant avec Cecil Taylor et signant des oeuvres élaborées pour choeur ou orchestre).

Enfin, un certain nombre de pianistes non affiliés, initialement, au dixieland, ont cependant renoué, ces dernières années, avec divers aspects de la tradition afro-américaine, intégrant des éléments de ragtime, stride ou boogie à un jeu plus libre, quasi free, en complément. C'est le cas, aux États-Unis, d'artistes comme Jaki Byard (qui endisqua même en duo avec Earl Hines), et Richard Abrams (qui se passionne toujours autant pour le ragtime que pour le free), sinon de Sun Ra (qui fut un pionnier de ce jazz éclaté fondé sur Jelly Roll Morton ou Fletcher Henderson), de même que de Dave Burrell, Horace Tapscott, Don Pullen et d'autres.

En Europe, une telle attitude se retrouve chez Misha Mengelberg, Friedrich Gulda, Georgio Gaslini, Stan Tracey et quelques autres encore.

Michael Snow s'inscrit très bien dans ce contexte du piano-synthèse en jazz actuel international. Tout comme Richard Abrams avec l'A.A.C.M. à Chicago, il aura été, jusqu'à maintenant, à Toronto, une sorte de catalyseur pour le CCMC. En tant que soliste, son jeu reste singulier au sens où il n'est pas prévisible, jamais banal ou routinier mais plutôt en constante redéfinition, en quête toujours d'une identité propre et d'autant plus affirmé qu'elle demeure, paradoxalement, ouverte à l'expérimentation continue. Sa musique ne ressemble donc pas vraiment à celle des autres pianistes cités ici, mais il appartient, tout comme eux, à cette famille à part des novateurs singuliers du clavier jazz. *Around Blues* le démontre bien de même qu'une série de duos récents exécutés avec brio, panache, mordant, en compagnie du batteur Jack Vorvis, à la Music Gallery, en 1992.

Dans le contexte du microsillon, Russ Freeman avec Shelly Manne en 1954 ou John Mehegan avec Kenny Clarke en 1955 sont, sans doute, les pionniers de ce genre de duo pour piano et batterie. C'est le batteur Milford Graves cependant (qui se produisait autrefois dans le loft de Michael Snow à New York), et le pianiste Don Pullen qui, les tous premiers, probablement, ont réalisé, dès 1966, en concert et sur disque, un duo du genre véritablement free (c'est-à-dire où la batterie ne fait pas qu'accompagner le piano). Des pianistes comme Cecil Taylor, Borah Bergman, Irène Schweizer, Alexandre von Schlippenbach, Misha Mengelberg, Paul Bley et d'autres ont participé, depuis la fin des années soixante et dix environ, à de telles expériences en duo, avec des batteurs. Michael Snow s'inscrit dans cette lignée. En tandem avec Jack Vorvis, il révèle le côté «batterie» du piano, son aspect percussif occulté avant le vingtième siècle.

Énergie, lyrisme, invention, «sports et divertissements» dirait Erik Satie de cette formidable gymnastique improvisée à deux, en vis-à-vis, pour piano et batterie. Ce duo prolonge ainsi, dans l'actualité, le dialogue Snow-Dubin de jadis. Jadis maintenant, différemment. (Un album de cette musique en duo de Michael Snow et Jack Vorvis devrait paraître à Toronto, éventuellement).

Addenda (The Last Notes)

En révisant avec l'artiste les notes accompagnant le présent texte, de nombreux détails intéressants ont surgi qui n'étaient pas inclus initialement. Nous avons donc voulu ajouter ces dernières notes, en complément, ce qui rend, par la même occasion, très bien compte du processus de composition de tout ce livre-collage.

Voici donc, à la suite, ces notes additionnelles dans la partition de *Jazz Snow*.

Un groupe qui a joué un rôle très important en musique d'improvisation à Toronto est l'Artists Jazz Band. Ses quelques enregistrements déjà édités, sont mentionnés dans la discographie de Michael Snow.

Il faut discuter l'apport de l'Artists Jazz Band en fonction de l'histoire des musiques d'artistes au vingtième siècle, de l'histoire du jazz, et enfin, de l'histoire des collectifs d'improvisation.

Concernant les musiques d'artistes, un lien très intéressant pourrait être fait entre la démarche de l'Artists Jazz Band et celle de Jean Dubuffet dans ses *Expériences musicales* improvisées de 1961. Concernant le jazz, un premier rapprochement, parmi d'autres, pourrait être effectué entre Ornette Coleman et l'Artists Jazz Band via l'album Atlantic de 1960 titré *Free Jazz* (lequel associait, par la pochette, l'art de Coleman à celui de Jackson Pollock).

Enfin, en ce qui a trait aux collectifs d'improvisation des années soixante, on pourrait dresser un parallèle entre l'Artists Jazz Band et des regroupements ouverts, en Europe, comme AMM ou le Scratch Orchestra (avec Cornelius Cardew), Il Gruppo di Improvisazione Nuova Consonanza, le New Phonic Art, Musica Elettronica Viva, le Globe Unity Orchestra, Music Improvisation Company et d'autres.

Au Canada, à la même époque, dans le contexte de la musique free, des affinités existent, probablement, entre l'Artists Jazz Band et le Toronto New Music Ensemble (avec lequel Michael Snow jouait parfois, en 1966-67), sinon avec le quatuor de jazz libre du Québec à Montréal, ou la formation d'Al Neil à Vancouver (pour ne nommer que ces groupes là). Un enregistrement du Toronto New Music Ensemble a été réalisé à Toronto, en décembre 1966, avec la participation de Jim Falconbridge au saxophone ténor et de Ron Sullivan aux percussions (deux ex-musiciens dixieland qui ont aussi participé à l'exécution de l'oeuvre *Sense Solo* de Michael Snow, à Expo 67, à Montréal).

Ayant débuté vers 1962, l'Artists Jazz Band a su inventer, avec les années, sans complexe aucun, sa propre version d'une musique libre, totale, communautaire, instantanée, une musique ayant la verve du dadaïsme contestataire, la truculence du pop art, le lyrisme d'une certaine gestuelle abstraite et le ludique des happenings ou des performances du moment.

Tel que mentionné déjà, Pee Wee Russel était un peintre merveilleux (ami d'un autre peintre américain, Stuart Davis). Une peinture du clarinettiste est reproduite sur la pochette d'un album Impulse qu'il a réalisé en compagnie d'Oliver Nelson, en 1967. On peut lire dans les notes de pochette de Georges Hoefer accompagnant ce disque, les renseignements suivants: « Russell implicitly agrees with the Canadian painter Mike Snow who after admiring some of the musician's work, advised him against taking art lessons ».

Michael Snow qui avait déjà enregistré avec Pee Wee Russell, à Chicago, en 1950, devait le retrouver à Toronto, en 1959, alors que le clarinettiste se produisit durant une semaine en tant qu'invité spécial du Mike White's Jazz Band (avec Michael Snow au piano). Malheureusement, aucun enregistrement ne subsiste de ces sessions ad lib. (C'est un ami de Pee Wee Russell, Kenny Davern « qui a rencontré la femme de Mike White à Toronto, raconte Michael Snow, et elle est devenue Sylvia Davern, à New York ».)

Le saxophoniste Jim Galloway qui endisqua avec Art Hodes, fit également appel au cornettiste Ken Dean, à l'occasion. C'est ainsi qu'on retrouve Ken Dean avec les Metro Stompers (sa première session commercialement éditée), dans un album Sackville paru à Toronto, en 1977. Par ailleurs, en 1980, Ken Dean a eu l'insigne honneur d'incarner Buddy Bolden au cornet, dans le cadre de la pièce de théâtre *Coming Through Slaughter* de Michael Ondaatje, en référence donc à celui qu'on nomme "le premier homme du jazz". Il y a un jeu fertile à l'oeuvre ici, en ce qui concerne la question de l'identité, de la représentation.

Le blues occupe une place appréciable dans la musique de Michael Snow. *Around Blues*, daté 1987, en est l'exemple type (cette oeuvre utilisant, parmi d'autres références, les accords du *Bemsha Swing* de Thelonious Monk, précise l'artiste, mais non la mélodie).

Au plan visuel, le blues est aussi présent dans certaines des oeuvres de Snow. En témoigne *Blues* (1959), *Blues in Place* (1960) et *Light Blues* (1978).

Le trio Snow/Forster/Dubin, augmenté du tromboniste Alf Jones, a souvent joué à Toronto, en 1960-61, sous le nom du Michael Snow Quartet ou du Alf Jones Quartet. C'est ce même quatuor qu'on retrouve dans le film *Toronto Jazz* réalisé par Don Owen pour l'O.N.F., en 1962. Quelques photos tirées de ce film sont d'ailleurs reproduites dans les premières pages de ce livre, *Mmusic/Ssound*.

Concernant le trio, il est fascinant de constater que chacun de ses membres s'est orienté vers le jazz libre, totalement improvisé, par la suite, Snow à New York (auprès de Milford Graves, Steve Lacy, Roswell Rudd ou d'autres), Forster à Toronto (au sein de l'Artists Jazz Band), et Dubin, également à Toronto, soit par lui-même, sinon, plus tard, avec l'Artists Jazz Band, le CCMC, Fred Stone, Don Pullen... Larry Dubin, incidemment, était un ami du peintre-batteur George Wettling. Les arts visuels et la musique se recoupent donc étroitement pour chacun des membres de ce trio unique en son genre, à Toronto, au début des années soixante.

Michael Snow tient à préciser que Paul Haines fut le technicien qui enregistra la musique de *New York Eye and Ear Control*. Il a également rédigé un poème pour le film. Paul Haines est un jazzomane averti et un éclaireur. Dès 1953, par exemple, il enregistrait Tony Fruscella et Brew Moore dans une boîte (ces documents sonores ayant été édités, depuis, sur Spotlite). Paul Haines a également signé les textes de pochettes de certains disques de Derek Bailey et Evan Parker (deux musiciens parmi les plus originaux qui soient en nouvelle musique européenne d'improvisation). Derek Bailey et Evan Parker se sont, par ailleurs, déjà produits en concert avec le CCMC, à Toronto comme à Amsterdam. Leur vision de l'improvisation à vif, sans répétition, sans montage, est proche parente de celle du CCMC. Signalons enfin qu'un poème de Paul Haines à propos de Derek Bailey, *Off the Bribed Path*, a été publié autrefois par la revue Parachute, à Montréal (no 5, p. 31).

Michael Snow se souvient d'avoir acheté le piano, pour son loft de New York, de son voisin Roswell Rudd, pour la somme de $50.00. C'est ce même piano qui a servi à l'exécution de son oeuvre titrée *Left Right*. On peut entendre Roswell Rudd au piano, dans un disque paru sur étiquette Horo, en Italie, et intitulé: *The Definitive Roswell Rudd*. Enregistré à Rome en 1979, on y retrouve Rudd au piano, trombone, contrebasse ou batterie, et utilisant sa voix aussi (s'accompagnant lui-même par le truchement du multipiste).

Concernant Michael Snow et l'histoire du free jazz, on trouve des renseignements intéressants dans les ouvrages suivants:
1) Denis Levaillant, *L'improvisation musicale*, Jean-Claude Lattès, Paris, 1981, pp. 80-81.
2) Valerie Wilmer, *As Serious as Your Life*, (The Story of the New Jazz), Lawrence Hill and Company, Westport, Connecticut, 1980, p. 165.

Parmi les musiciens avec lesquels Michael Snow a joué à New York durant les années soixante, il y a le clarinettiste-saxophoniste Kenny Davern. Ami de Pee Wee Russel et de Roswell Rudd, Kenny Davern est habituellement associé au jazz dixieland et swing (bien qu'il ait aussi enregistré un album expérimental en compagnie de Steve Lacy et de Steve Swallow, en 1978). Michael Snow se souvient avoir joué en quatuor avec Kenny Davern, Ahmed Abdul Malik à la contrebasse et un batteur inconnu, dans une boîte de Greenwich Village, autrefois.
Ahmed Abdul Malik est l'un des personnages énigmatiques et fascinants de l'histoire du jazz, un véritable précurseur du "world jazz" actuel. Né à Brooklyn en 1927, il apprit à jouer du oud (sa spécialité), du qanun, du violoncelle, du tuba, du piano et de la contrebasse. En 1957-58, il accompagnait Thelonious Monk en concert et sur disque. Il a gravé plusieurs albums exotiques pour RCA, Riverside ou Prestige, mêlant les musiques d'Afrique, d'Asie ou des Caraïbes au jazz afro-américain, et ce plusieurs années avant que ça ne devienne une pratique courante. Ahmed Abdul Malik est un mystérieux personnage qui pourrait donc très bien figurer dans *The Last LP*. C'est un pionnier un peu oublié aujourd'hui et dont l'art phonographique, en voie de disparition, mérite d'être rescapé et célébré.

À propos de Carla Bley, Michael Snow signale qu'il a déjà fait une oeuvre photographique, *Walking Woman*, qui contient l'image même de Carla Bley. La pianiste est d'ailleurs visible dans le film *New York Eye and Ear Control*.
Carla Bley collabore régulièrement, aujourd'hui, avec le bassiste Steve Swallow. C'est le loft de ce dernier que Michael Snow loua, jadis, à New York. Steve Swallow, on s'en souvient, avait joué auparavant avec Paul Bley et Jimmy Giuffre au sein d'un des premiers trios free des années soixante. Les compositions de Carla Bley occupaient une place importante au répertoire de cette formation.

Dans le cadre d'une réflexion sur les appareils d'enregistrement et de reproduction du son en rapport avec la pratique artistique de Michael Snow, il y aurait peut-être lieu d'établir un parallèle entre la *Walking Woman* des années soixante et le «walkman» actuel, le balladeur fin-de-siècle de la post-modernité. Isolé par ses écouteurs, traversé «ear to ear» par la musique, le «walkman» n'en continue pas moins de marcher en quête de son identité.

On pourrait aussi écouter 2 Radio Solos de Michael Snow en marchant, à l'aide d'un walkman.

La cassette titrée *2 Radio Solos* contient deux oeuvres: *Short Wavelength* et *The Papaya Plantations*. Elle documente (à la manière d'une performance), une action sonore, un jeu avec la radio (l'appareil étant ici l'instrument, au premier degré).

Ces *2 Radio Solos* ne sont donc pas des oeuvres conçues, à priori, pour être diffusées à la radio après coup (elles pourraient l'être, bien sûr), mais des compositions spontanées, improvisées «non stop», à même le poste de radio, en temps réel, à partir d'une matière sonore variée, disponible à un moment précis et en provenance de partout à travers la planète. La radio à ondes courtes ici utilisée est une «World Band Radio», un nom qui suggère déjà l'idée d'un «orchestre mondial» en interaction avec une radio. C'est Michael Snow qui, à lui seul, incarne ce «World Band» ici.

L'artiste réalise, en privé, en solo, une sorte de média-jazz improvisé de l'intérieur du médium (tout comme Christian Marclay joue du tourne-disque, par exemple). La radio joue son propre personnage ici. Elle ne représente personne d'autre. Elle est à la fois émetteur et récepteur, dans un même temps, simultanément. Une boîte à sons, à mots, à bruits constamment renouvelables, dans laquelle Snow puise à volonté. Ce type d'activité, à même les sons, potentiellement, de tout l'univers, interroge forcément, avec beaucoup d'intensité, la notion d'identité, tant pour notre joueur-globetrotter (qu'est Michael Snow), que pour l'écouteur-public que nous sommes.

Cet appareil radio fonctionne aussi comme une sorte de «clavier à ondes courtes» pour Michael Snow, ce dernier se jouant des stations, des longueurs d'ondes, des volumes, des tonalités, des sonorités multiples, à sa guise, et sans limite. Il n'y a pas eu de montage, de mixage ou de manipulations électroniques après coup, précise-t-il. Tout est donc une question d'attitude, d'éveil, de présence aux sons, de disponibilité d'esprit pour créer. D'écoute. Ce qui remet ainsi en question la notion traditionnelle de virtuosité, de technicité acquise au préalable, en ce qui concerne l'exécutant. Cette musique change tout le temps. Elle passe les frontières, échappe aux interdits, défie les écoles, les académies, les idées reçues. Il faut une autre "technique" pour la jouer, un autre point de vue, un autre regard (une autre oreille pour l'entendre, pour l'accepter, une oreille qui glisse volontiers entre les catégories, les genres, les cultures).

Cette musique, malgré ses apparences multiculturelles, n'a rien à voir avec l'esthétique du «nouvel âge». Il s'agit d'une proposition radicale ici qui ne génère pas une expérience d'écoute confortable ou relaxante, divertissante (au sens habituel du terme). Thérapeutique peut-être (sans le revendiquer pour autant), *2 Radio Solos* surprend, provoque, déride.

Il y a une histoire quasi mythique de l'avènement de la radio au Canada depuis le début du vingtième siècle (avec des figures légendaires comme Reginald Aubrey Fessenden ou Guglielmo Marconi), qui pourrait très bien servir d'introduction pour une mise en contexte préliminaire de *2 Radio Solos*. Puis, du point de vue conceptuel, certaines affinités pourraient être discutées entre 2 Radio Solos et des oeuvres de John Cage (*Imaginary Landscape no. 4*, par exemple), de Karlheinz Stockhausen (*Telemusik, Kurzwellen*), et d'autres. Michael Snow, cependant, fait tout autre chose qu'eux, du fait, sans doute, de sa pratique du jazz, de l'improvisation. Par comparaison, enfin, à l'*Idea of North* de Glenn Gould, Michael Snow nous propose une «Idea of earth» qui se transforme aussitôt en une "Idea of Snow".

« Les bandes furent réalisées la nuit (précise-t-il, dans un texte d'accompagnement aux nombreuses interférences visuelles significatives...), dans un chalet retiré, dans le nord canadien, éclairé par une lampe de kérosène ». On croirait lire ici la description d'une mise en scène sous-jacente à une pièce tirée du *Last LP*. Ce commentaire de l'artiste ne manque pas d'humour non plus. Ainsi donc, ce dialogue électrisant avec l'univers (activité éminemment moderne), s'effectue sous l'éclairage d'une lampe de pionnier! Il existe sûrement un rapport ici entre l'action de manipuler la radio et celle qui consiste à «faire la lumière». Michael Snow joue dans le noir pour voir. «Bien entendre» signifie «mieux voir» ici. L'un implique l'autre. C'est une question d'éthique que traduit un choix esthétique.

Sans doute qu'en voyageant un peu plus longtemps sur ces mêmes ondes, à partir de ce même

poste radio, «circa 1982», Michael Snow pourrait y entendre, un jour, les voix de Gould, Fessenden, Marconi, Bell, Edison ou McLuhan, sinon sa propre musique (en provenance du Tibet par exemple, ou d'ailleurs), laquelle pourrait, à son tour, servir à l'invention d'une nouvelle musique, à l'infini.*

*See "Playing the Radio" in *Collected Writings*, one of the books in *The Michael Snow Project* series.

Biographie

Raymond Gervais (Montréal, 1946-) est un artiste qui travaille en art visuel à partir de la musique, du son. Il a réalisé depuis 1973 plusieurs installations et performances de même qu'organisé des concerts de nouvelle musique (dont celui de l'Artist's Jazz Band à Montréal, en 1974, pour l'Institut d'art contemporain de Normand Thériault). Il a publié des entretiens et divers textes critiques dans plusieurs revues depuis 1971, dont *MusicWorks* et *Parachute*. (Son premier texte sur la musique de Michael Snow est paru dans *Parachute* no. 3, en 1976). Il collabore aussi aux émissions de jazz, au réseau français de Radio Canada. Parallèlement à ses travaux en cours, il rédige un essai sur la musique de l'artiste-écrivain Robert Racine.

LARRY DUBIN and CCMC

By Michael Snow

Larry Dubin died of Chronic Aplastic Anemia in Wellesley Hospital in Toronto on April 24, 1978, two days before the CCMC left for Europe. He was 47 years young. He was a great friend and a great musician. I first met him in 1961. I was playing piano with a Toronto dixieland band led by trumpeter Mike White. I played with this band off and on for about 3 years. It was quite popular in Toronto during that period. There was a change of drummers and Larry who came from Cochrane, a remote Northern Ontario town, and had been playing drums in Toronto for about 4 years happened on the job. He'd never played dixieland before and never really listened to it but he felt his way through all the parts of High Society etc. and was hired. It turned out that he, like Terry Forster, a new bassist, and myself were more 'modern' in our orientation than we should have been for the job and we had a wonderful time together. I also had jobs leading my own trios and quartets and I always used Larry and Terry if they were available. We played BeBop tunes (Parker and Miles, etc.) but also many/most Thelonius Monk compositions. We were really interested especially in the 'playing' and we made our first attempts at evading chord changes then, first by playing blues in whole tone scales. I lived in New York from Dec. '63 to 1970 where I, through Roswell Rudd a neighbour, met most of the interesting 'new' musicians, Roswell, Archie Shepp, Paul Bley, Milford Graves, first version of JCOA all played at my loft. I made the film 'New York Eye and Ear Control' with sound by Albert Ayler, Don Cherry, John Tchicai, etc. then (64). I heard some literally stunning music. I played occasionally but I knew my place, they were way ahead of me! As I started to 'understand' the various things that were going on I started to have ideas of my own about the implications of it. Meanwhile back in Toronto the Artists Jazz Band started in '61, '62 and I played with them once or twice. I was a professional musician and I thought then that what they were doing was pretty silly but I changed my mind. They were (the original core) all painters and started to play just for fun which is a good reason. They still play for fun and it's still a good reason. What I couldn't understand then was that they didn't try to play tunes or learn anything about harmony, they just had a good time. About 5 years later I understood and enjoyed. In my own defence I have to say that of course it wasn't so good when it started anyway. So, . . later on fairly frequent trips back to Toronto I occasionally played with the AJB and it really knocked me out. Terry Forster who was an all round professional bassist had come across them and realised that it was the most adventurous music being played in Toronto, despite their being 'amateur' and started playing with them. He plays acoustic and Jimmy Jones also a pro electric bassist (with mostly a rock background) joined them and Gerry McAdam a guitarist/painter. (Nobbi Kubota who is the marvelous saxophonist with the CCMC of course, was one of the original players in the AJB). Back to Larry: during this period he jobbed around playing all kinds of music, mostly 'cocktail' jazz and sometimes Dixieland, sometimes BeBop. His most important music had become of necessity private. He used to play several hours a day alone either on a practice pad in his apartment or on anything in his apartment or on his full set if there was somewhere he could get away with it. His public playing was good but conventional but alone he developed his own attitude. He didn't practice the way he had to play on jobs. He used to play with any sound at all, anything on the radio or TV including the news. He would play for hours with traffic sound, with rain storms and he told me that he often played with clouds in the sky. He was a totally obsessed player, carrying his sticks with him everywhere. On long bus or car trips he would practice on his folded knee. He wasn't 'sophisticated', he didn't 'learn' from John Cage, he just started listening to everything and relating to it by playing with it. His conception is his own but paralleled that of Sonny Murray and Milford Graves in some ways. It didn't at all come from them and I know it seems corny to stress it, but Larry's playing and personality became so pure and solitary that I want it to be realised in print that he, white Canadian, away from history, found himself. He used directions from everywhere around him. His personality and music was local. His own music developed painfully and until the last 5 years in total isolation. It's a tragedy of the provinces that it takes gifted people a longer time to be able to recognise that doing something 'wrong' can become 'right' and is 'creative' and 'original' if properly understood and developed. When there is no one to listen to your 'mistakes' and say 'hey that sounds interesting', 'what's wrong with that?' it's harder to develop. Larry was stuck with doing things 'wrong' as he was emphatically told if he lapsed into being himself on any of his jobs. Several jobs were lost with violent arguments because of this. He kept it to himself as much as he could and apart from playing privately with a couple of other goofy friends he couldn't play publicly his own way until the CCMC cohered in 1975. Before that he played 2 or 3 times with the AJB (with Gord Rayner on drums as well). When I moved to Toronto in 70/71 I started to play regularly with the AJB and re-met Larry but didn't play with him until '74.

He was always totally and absolutely for improvisation and disagreed tenaciously with any attempts at scored or verbal pre-arrangement. He wanted of course to finally play his own music and that was playing in spontaneously developing relations with whatever else was happening. In discussions about the music and especially about some local musicians who were starting to use 'tunes' followed by 'free' playing he often said and quite rightly I think: 'They haven't stuck with free improvisation long enough.' Prior composition seemed to him a kind of 'packaging', a 'commercialisation' or a distortion of the ego possibilities of playing freely. In the CCMC we all agreed with him and still do. In the first years that I heard the great musicians who opened up this new territory for exploration (especially Cecil and Ornette) I gradually found myself surprised at the constant emphasis on leadership and tunes. Some of these leaders and some of these 'tunes' were of course marvellous but it seemed to me then and now that the implications in the music were that a group could come together and organically through the interaction of the individual musics of the members develop a group music. We 'conversationally' developed in the music. I'm interested in composition and I think that the CCMC composes inconceivable music. I don't state Larry's or my conviction in opposition to any other music.

Larry's playing centred on a conventional jazz drum kit but with many smaller drums, etc. added. He of course played marimba (especially beautiful on 'Oct. 4th' CCMC Vol. 3, Music Gallery Edition), gongs, etc. He tuned his drums unusually tight and high. His touch was exquisite and his playing extraordinarily refined. His conception centred on snare drum rolls (or rolls on any surface). At the highest speed possible these sensitive vibrations provided a kind of equivalent to the speed of light in his musical universe. He based all on this ultimate 'tempo' and in playing selected from this close-to-infinite pulse, constantly changing sub-tempos. He rarely played purely 'rhythmic' repeated figures yet his playing had a thrilling impetus and propulsion. When the CCMC have been very affected by this sense of multiple pulses that was uniquely his. His playing was movingly sensitive, he never 'hit' or 'beat', every tap was lived through, every tap even of the swiftest snare drum rolls was an individualised vibration. His total 'palette' of sound was breathtakingly unified. Cymbals which he had gradually decided on over many years of playing produced splashes, sprays, roars of great subtlety and kinship to the sounds of his other instruments. He always preferred to play with something, somebody and he could add to any other sound in such a way as to of course modify that sound but also to make it more itself, to clarify its nature but also to clarify himself in relationships. His playing was often a kind of commentary on what else was happening which could become a dialgoue and also a 'speech' by him with accompaniment by whatever else. After so many years of being himself musically only in private the existence of the Music Gallery in Toronto was a paradise for him. The CCMC was the best music bar none for him and he said he could hardly bear to listen to any other music any more. The 2 or 3 more hours of playing that he used to do privately became public at the Music Gallery and he played there everyday. He'd play alone or with a tiny portable radio turned on anywhere or with anybody that felt like playing. He existed to play.

Reprinted from *Musics* magazine, no. 18, July, 1978. London, England.

SIDE 1
Larry's Listening (Nov. 4, 1977) 18:10
Larry Dubin: percussion, drums
Allan Mattes: bass, percussion
Casey Sokol: piano
Michael Snow: synthesizer, trumpet
Peter Anson: guitar
Nobuo Kubota: percussion, alto saxophone
Upon Arriving (July 26, 1977) 3:25
Larry Dubin: drums
Peter Anson: guitar

SIDE 2
A Postponement (June 8, 1976) 6:25
Larry Dubin: drums
Allan Mattes: electric bass
Peter Anson: guitar
Casey Sokol: percussion
Michael Snow: piano
Circoitry (June 14, 1977) 4:51
Larry Dubin: drums
Down the Street (Dec. 23, 1977) 12:00
Larry Dubin: drums
Allan Mattes: electric bass
Michael Snow: electric piano, trumpet
Nobuo Kubota: alto saxophone

SIDE 3
Yourself Elsewhere (June 14, 1977) 13:40
Larry Dubin: drums
Allan Mattes: bass
Casey Sokol: electric and acoustic pianos
Radio in a Stolen Car (Jan. 24, 1978) 10:55
Larry Dubin: percussion
Allan Mattes: guitar, bass
Casey Sokol: piano
Michael Snow: trumpet
Nobuo Kubota: kettle harp

SIDE 4
Uncalledforness (Feb. 21, 1978) 22:00
Larry Dubin: drums, marimba
Allan Mattes: bass
Michael Snow: trumpet, acoustic and electric pianos
Peter Anson: guitar
Nobuo Kubota: electric and acoustic pianos
Nobuo Kubota: alto and tenor saxophones

SIDE 5
Silky Times (Mar. 24, 1978) 8:20
Larry Dubin: drums
Allan Mattes: bass
Peter Anson: guitar
Michael Snow: piano
Casey Sokol: piano
Back to Timmons (Mar. 14, 1978) 15:30
Larry Dubin: marimba, drums
Michael Snow: trumpet
Allan Mattes: bass
Nobuo Kubota: alto saxophone
Casey Sokol: piano
Peter Anson: electric piano

SIDE 6
Leaves Shed Their Trees (Oct. 14, 1976) 5:30
Larry Dubin: drums
Allan Mattes: bass
Casey Sokol: electric piano
Peter Anson: guitar
One of Your Lips (Mar. 21, 1978) 11:15
Larry Dubin: drums, pipe drums
Allan Mattes: bass, percussion
Nobuo Kubota: alto saxophone, percussion
Casey Sokol: acoustic piano
Michael Snow: electric piano, percussion
Qui ne sert qu'a nous faire trembler (Nov. 6, 1977) 7:50
Larry Dubin: percussion, marimba
Casey Sokol: piano
Michael Snow: copper tubophone, trumpet
Allan Mattes: bass
Peter Anson: guitar, vegematic

Recorded at The Music Gallery, Toronto by Peter Anson and John Oswald except for Leaves Shed Their Trees which was recorded at Convocation Hall, Toronto. Album Production and Cover by Michael Snow. Titles of Pieces extracted from writings by Paul Haines. Larry Dubin can also be heard on CCMC volumes I, II and III — Music Gallery Editions 1, 2, and 6, 33/3 by Vic d'Or, Music Gallery Editions 11. Larry Dubin and the Big Muddys — Capitol T-6074. Contains insert of writing by Paul Haines. Music Gallery Editions, 30 St. Patrick Street, Toronto, Ontario, Canada, M5T 1V1. MGE 15.

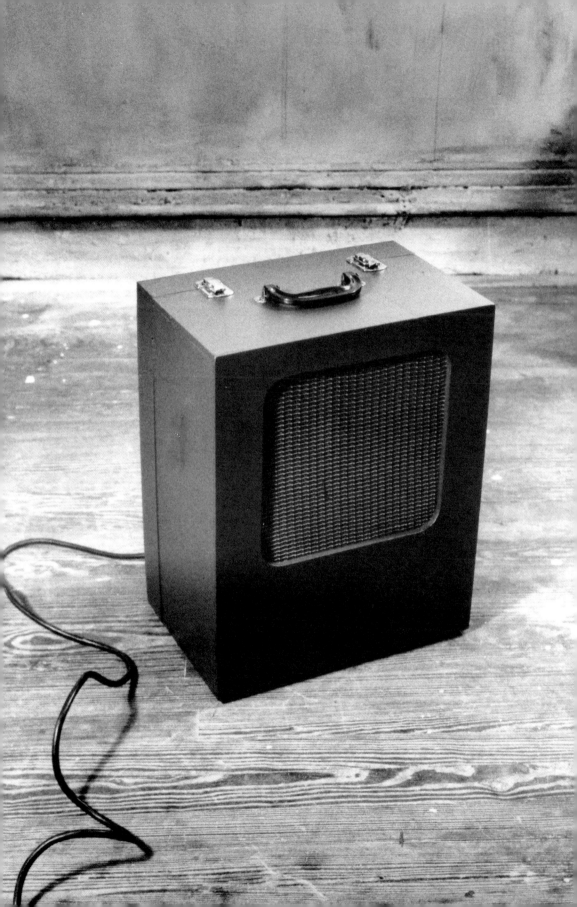

On Sound, Sound Recording, Making Music of Recorded Sound, The Duality of Consciousness and its Alienation from Language, Paradoxes Arising from These and Related Matters

A dialogue between Bruce Elder and Michael Snow

Introduction

In their Summer/Fall 1982 issue (#7), a now unfortunately defunct Montreal magazine called *Ciné-Tracts*, published "Bruce Elder and Michael Snow in Conversation." This was in fact a written exchange where Bruce first wrote comments and questions addressed to me and I responded in writing.

I still feel that this "interview" was/is one of the best general discussions of what I've been trying to do in my film and photo-based work. The main reason for this success was that my interviewer's questions and comments were so knowledgeable and pertinent that they stimulated responses from me that another person might not have provoked.

Bruce Elder is an extraordinary film-maker whose monumental work has been one of the most important parts of the continued growth and strength of "experimental" film in the last twenty years (despite misinformed obituaries). In his capacity as professor of film (at Ryerson Polytechnical Institute in Toronto) he has had a profound effect on many students, again contributing to the continuity of the important concerns which have developed in the ninety-year history of "avant-garde" cinema. He has seen "everything" in film and this experience is grounded in a deep and continuing experience of philosophy, poetry, literature, aesthetics in general, electronics, computers and wine. He is a writer and critic, author of many important articles and reviews that also contribute mightily to the ongoing dialogue of the arts where in many cases there would, without him, unfortunately be silence for the representation of informed and deeply based opinion. He is the author of *Image and Identity: Reflections on Canadian Film and Culture*

(Wilfrid Laurier University Press, 1989), a unique book that discusses Canadian "avant-garde" film in a context of related American work, and Canadian philosophy. A major contribution to the literature on film.

One of the aspects of his own film work I admire is his "polyphonic" use of several simultaneous manifestations in sound and image (several sounds plus spoken and written text plus "picture"), often part of a cyclical recurrence, which is in total, very "musical." In planning this volume I decided to ask Bruce if he would be interested in repeating the form of written interview that (we both agreed) had been so successful previously, but this time centring it around my work with sound. As you will see, I found his text extremely impressive and challenging.

Michael Snow
January 1993

Elder: To begin with, a distinction is required — i.e. you have produced quite a number of recordings and works other than film that make use of replayed sound. These recordings can be sorted into two or three types.

First, there is the music that you have produced, initially with various Jazz groups, and later with the CCMC, a group which produces music by collective improvisation. The concerns of the ensemble resemble your own in important ways. One similarity is that the recordings incorporate quite a spectrum of forms: from those resembling the atonal, "free jazz" of the Art Ensemble of Chicago, or Albert Mangelsdorf, for example, through more tonal forms, though they still avoid the theme and variations structure of traditional Jazz, through passages that allude to recognizable themes (sometimes appearing as quotations) to the actual incorporation of familiar material from tapes, AM radios, etcetera. (This is not unlike the range from abstract

to representational that your visual artworks feature; your recent (1991) show of paintings at the Isaacs Gallery, for example, divided this span into a structuring opposition, which the paintings attempted to balance.) Furthermore, the music often incorporates a diversity of material, from the sounds of a grand piano or double-bass down to sounds produced with party novelties, plastic tubing, noise, hiss and snatches of pop music from cheap radio receivers, etcetera. Your films and constructions also sometimes use a range of material, and the effect of these distinctions is attenuated by the forms you construct, which often demonstrate that there are similarities among the forms we commonly conceive of as radically different. Yet another similarity to your visual art is that the adventurousness of your work excites many of us because it at once conveys and invokes the thrill of discovery. In your visual art, you have made extensive use of systematic (or quasi-systematic) structures that determine the range of some of the variables within the work. Having planned the system, you allow it to vary the "parameterized" features of the artwork. This permits unforeseen occurrences. There is a three point relationship between system, medium and artist. Even as the system relates to the medium, and the artist both problematizes the medium and invents the system, all three points exert a pressure on the final form. This creative method acknowledges that the artist is not the only force that gives shape to the work, nor is the artist claimed to be an omniscient creator whose conscious skill and unconscious canniness afford him or her complete and perfect knowledge about the character of the work being created. Rather, things are permitted to happen which the artist could not have foreseen.

Your improvised music also relies on strategies that open you up to unforeseen occurrences, perhaps in an even more radical fashion. The music is open form, obviously, and the relation from part to part is such that there is a spectrum of possibilities for what event might follow its predecessor. (Hence, the classical canon based on the conception that the unity of a work is inviolable, and that the relationship of one part to another could not be other than it is — without reducing the quality of the work — is repudiated. It seems to me that this repudiation goes hand-in-hand with surrendering the conception of the omniscient artist who is the sole point of origin of the work of art.) Because you work with an ensemble, the spectrum of possibilities is expanded, insofar as sensibilities and ways of thinking other than your own come into play.

A second group of your sound compositions are of another kind. These are even more strongly related to your visual art work. These works fit into two categories, site installations that include replayed sounds, and sound recordings that are autonomous objects. In the former category are **A Casing Shelved**, **Tap**, and **Hearing Aid**, and, extending the point somewhat, we could say your films, and especially **Rameau's Nephew by Diderot (Thanx to Dennis Young) by Wilma Schoen** and **See You Later (Au revoir)**; in the latter, **Michael Snow: Musics for Piano, Whistling, Microphone and Tape Recorder**, **The Last LP**, **Two Radio Solos** and **Sinoms**. While your recordings with the CCMC do not foreground (to borrow that useful term from Mukarovsky) the recording medium, all of the aforementioned works do. In fact, **The Last LP** takes those techniques that were developed for recording, such as multi-tracking and mixing, in fact, primarily for producing accurate sonic "images" of large ensembles, and puts them to creative ends, to make something new, not a likeness of some already existing thing.

Do these distinctions make any sense to you, or do you see your work in sound as all of piece, indeed, all of a piece with your visual artwork?

Snow: Yes, I think the sound distinctions you've made are sound. More than that, on first reading I was surprised/grateful/flattered by the extent of your experience of my work in its various forms and impressed and excited by your consequent reflections and insight. The taxonomy is illuminating (to me).

So, I've never been conscious of an overall program or commitment in respect to all the work I've done in various media, and though of course I've given some thought to the reception of the work, I've given up caring about whether it's inconsistent or not.

So, I've never considered my work with sound to be "all of a piece," just kept on doing the different things that I've done because I thought they should exist (for me to learn from too). Your mapping is the first that's been inclusive and made me realize that: it has, for a long time, seemed to me that a hypothetical observer/auditor of all the work with sound might find it to be … what? Promiscuous, perhaps because (and here we invent a persona) as a philosophical point those who are involved with Composition (even Cagean) might be unable to stomach the unpredictability, danger and lack of overall control that must be a feature of a completely improvised music … and this hypothetical estimation would find Composition clearly discernible (even strict) in some of my other work and one might wonder why the same artist could espouse antitheticals, in favour of fixity on some

occasions but seemingly in favour of flux on others.

The nature of the physical manipulation that the work is has something to do with this but more about that later.

You are the first real estimator of this area of my work. I find your taxonomy isn't like the one I (my hypothetical evaluator) had (un-repressed, as a result of reading yours).

I have known Steve Reich since 1969. (My studio on Canal Street in New York, where I shot **Wavelength**, was around the corner from Steve's on Broadway.) We talked often and I was at several of his rehearsals. I think he's a great composer. He leaves little to chance in the planning and execution of his work. We have had some discussion on this matter and while he professes to be an admirer of my films, my impression is that he doesn't understand how someone who could make those films could make that music.

However, I shouldn't oversimplify his reception. I sent him a tape of **Around Blues**, a forty-two minute solo piano piece I played in concert in 1986, and he said he liked it a lot, that it should be commercially available.

The piece was "improvised" but the areas of musical investigation were decided on beforehand. I practised a great deal and had a list of the "areas" I wanted to work on, but didn't have a plan as to when they might turn up or how I would get from one to the other. So it was "composed" in some respects and "improvised" in others. Your saying that the range of sound sources and forms CCMC has used is "...not unlike the range from abstract to representational which your visual art sometimes features..." really hit me. I never noticed that, perhaps because CCMC isn't "my" work, it's "ours" — something you also mention. There is lot of difference between solo and ensemble improvisation; no one person has any total control whereas when you play alone what tells whether it's "improvised" or "composed"? Yes, in the work over which I assume "directorship" I have often (always?) conceived of a "system" or "structure" and worked with how that plays itself out in action as opposed to thought. It is in "character" to have a "system" go wrong. I don't want the work to look like a "demonstration" of a compositional principle or principles but to be felt as an existence, a phenomenon whose manifestation couldn't be what it is without a "mode" or "modes." I've been working from "ideas" since I started thinking I was an artist, but I've always been conscious that the "idea" is just the beginning and the "principle" also has a life of its own, which will manifest itself in unimaginable ways by being set in motion. I hope that the "system" can be applied with some unforeseen variation or "accident" and still retain its structural strength, perhaps be stronger by any minor "slips" in contrast. Major "errors" would cause another system, perhaps interesting too.

Though I didn't have an academic training in music, my "world-view" of music in terms of its components, harmony, rhythm etcetera was conservative, I think, while I was playing Jazz. However, it was easy for me to extend my aural attention to all sound-sources without the conscious influence of John Cage's extraordinary consciousness.

Within Jazz, the first time I encountered uses of other-than-the-conventional instruments such as piano, saxophone etcetera (which of course have their own evolution, aren't constant, but years ago seemed immutable) was with the Artists Jazz Band (Toronto), probably in '64 or '65. Nobi Kubota had made some strange percussion instruments, and some toy instruments were being used too.

Every "shock of the new" merges into the "known" soon enough but these AJB instruments and the artists really "free" attitude (to say the least) to their instruments and "study" were surprising and influential. You mentioned the Art Ensemble of Chicago, who for some reason are often credited with bringing "small instruments" into Jazz. Others did too, and the AJB was one of the first. Incidentally, I've never heard the Art Ensemble and had stopped buying records by about 1970, so they were not an influence on me or anybody else in the original CCMC, despite the implications of the original name of the group (long form) – which is never uttered.

Elder: Since the time of Cézanne, and even more insistently, since the era of Cubism, artists have announced repeatedly and made artworks that bear out the conviction, that art's proper business concerns the mechanics of perception. One statement of that belief, my own favourite, appears in Joseph Conrad's preface to **The Nigger of the Narcissus** as "a single-minded attempt to render the highest kind of justice to the visible universe."

My fondness for Conrad's comment can be explained by the fact that it expresses a deep reverence for the phenomenological world — a lesson that artists have tried to teach again and again, from the first days of art right down to the present, as the kind words that Stan Brakhage recently offered in homage to my work, indicate that it had a way of pointing him towards appreciating the beauty of the phenomenal world. Cherishing the gifts of the given result in revelations, as the rewards that issue from attending to the manner in which the given comes into presence are epiphanies. We return the gifts of presence their favours by cherishing them and holding them fast.

Of course, recording is cherishing, and serves to hold fast something that is disappearing. This purpose is commonly served by ethnographic recordings. The conceit in the making of one of your own "recordings," **The Last LP** is that it is an ethnographic recording of just this sort. But **The Last LP** doesn't just pretend to be a recording of vanishing cultures; it pretends to be the last example of its form. And there is a certain tragic dimension to this, in attempting to preserve the dying cultures, though the examples that are supposed to be saved for us are not really the work of the cultures from which they are said to be drawn, but rather your inventions. There is no such thing as authentic preservation, for every representation is invention instead of accurate recording.

Anyway, the media of representation, especially in our time, are no more universal, and hardly any more enduring than what they represent. What are purported to be reproductions are not reproductions but creations (as always). So they never grasp what is in the process of disappearing. And even if they were reproductions, they would still not conquer time, for even the medium in which they are reproduced is disappearing. Comments about this tragedy?

Snow: "This tragedy" is also (I agree it has its tragic aspects) an amazing process of constant metamorphosis that means that everything is always new at each perception. "Keep it going" is the only cosmic order. The living want to live. For thousands of years our conscious species seems to have yearned for a fixity, an Unchanging, to oppose our vulnerability, puzzlement and brief life-span.

The arts have always been involved in this desire. The image is eternal while the audience decays and dies: Egypt, Vermeer. From the standpoint of evolutionary biology, I don't think we are much different from our ancestors of one million years ago. An infinity of cultures have been produced by the same animal, but this stage of (let's say) the last one hundred and fifty years has had the most incredible accelerating techno-logical change, and the poor animals have simply had to try to adapt to it.

With **The Last LP** I wanted to make a work for what I was certain would soon be an obsolete technology (and **The Last LP** was one of the last LP records) and the idea of "representing" dying cultures seemed to promise a rich (but "tragic," as you say) cross-current. However, another side of it is that I wanted to work as a solo artist (like a painter) with multi-channel recording so that the entire project would be a "solo" (like a painting).

The Last LP has been called a "hoax." When I first heard this, I was a bit defensive because I didn't want the work's motivation to be reduced to that. But I guess it's true. Or was it *trompe-l'oreille*?

A friend of mine was with a visitor one afternoon. While they chatted over coffee she had **The Last LP** on. The visitor said she really liked the music and where could she buy it. A week later the visitor phoned and angrily said to her, "Why didn't you tell me?!!" I would have asked "But do you still like the music?" If you consider the music to be a constant this is an interesting experience of contextual shifting changing an appraisal. Isn't the music the same? Isn't it still "good?"

Yes, but what's involved is "documentary" and very "pictorial" when one believes the history and description of the recording circumstances in the texts. It is much more like a fiction film than any film I've made. A suspension of disbelief is involved. In listening, one sees images of the dusty plain of "Si Nopo Da," the heavy stone building of "Amithaba Chenden Kala" and the monks rotating around the fire. When you know it's all done by one person you listen "critically" in respect to to the "deconstructed" context, but ideally one hears the music as more "independent," "concrete," and sounded by recording as an instrument.

Elder: Michael, please excuse a rather lengthy preamble regarding language. Conrad is, along with Louis Zukofsky, one of two great contributors to modernism in English literature whose native tongue was a language other than English. Their relationship to the language wherein they created works of art was profoundly different from the one that most English authors have to the English language — a relation, I venture, not entirely different from your relationship to the artistic media in which you have worked. I hasten to point out I am constructing something that really is a fantasy

about the qualities, the experiences of someone who, like Zukofsky or Conrad, writes in a language different from that of his childhood. In this fantasy, such a person would always experience the world as sundered, and the self as being adrift.

Heidegger suggests that language is a home wherein our being dwells. We discover ourselves through its agency. We humans identify ourselves both in and with the flow of language. In its rhythms, assonances, alliterations, rhymes and cadences, we discover our inwardness, our "soul." Our identification with language is the source of much of the emotional power that language has over us. It explains why, when of an evening we sit silently reading to ourselves, this power is revealed so much more strongly than it is when read aloud, to a group. When the text describes a misfortune or injustice, we feel ourselves broken in the rhythm and flow of the language.

In my fantasy, Conrad or Zukofsky's experience of language is significantly different. For them, the subject is partly held back from, rather than invested in, language. Only a part of the subject emerges from within language, while another identifies with the ebb and flux of more or less raw experience. In fact, I think that there is a continuum of types of experience here, from the extreme of identification with the objects represented within language, to that of withholding the self from language (with most of us somewhere in the middle). Representative of the latter extreme is the extraordinary film work of the protean American avantgarde filmmaker Stan Brakhage, whom I consider to be more knowledgeable than anyone else as to just how this process operates and what it feels like. Such experience has an almost hallucinatory quality, for it has not been sorted according to the categories of real and unreal, inner and outer, self and non-self Its spatial features are not fixed. It undergoes perpetual change. There is no object constancy. This type of perception occurs before perceptual gestalts are formulated; and so there is no separation of figure from ground, or object from environment.

As the psychoanalyst Marion Milner points out in her neglected book **On Not Being Able to Paint**, on this way of seeing, the boundary of a vase set against a wall does not separate the vase from wall; rather, it is the curve where the wall and the vase fuse together. The scanning, all-over character of this mode of perception operates along with an as yet unachieved object constancy to produce the impression of objects coming into and going out of being, and of their shapes being continually altered, as they reveal themselves, then are eclipsed by other objects, or interact with them. For this mode of perception, an object's identity is changed when they fall into the shadow of other objects, which not only create new shapes on its surface, but also occultate parts of its form; when this happens the two objects merge their identities. In short, such perceptions have all the characteristics that the cognitive scientist David Marr attributed to primal sketches (and more besides).

This is what experience *before* the word is like. It is, I think, precisely because Brakhage accords such importance to this mode of perception that he is so famously hostile to the use of the perspectival system that the Renaissance mathematics of projective geometry and science of geometric optics left us as its legacy. The type of experience that I have been attempting to describe (and really, there are no words for it, for it is a kind of perception that exists before the individual acquires language) is of a realm where nothing has a stable identity or any sort of constancy — where, really, nothing has any being. That is to say, only a very small margin separates this form of perception from the confrontation with nothing. When talking about such experiences, one feels disposed to say that it is the experience of being "*sous rature*" — under erasure, of disappearing, overcome by its opposite. Hence, this mode of perception is associated with the feeling of the negative, and with all nihilating forces, and so with time and death. So Brakhage, who is so insightful about this mode of perception, has created a body of work, most of which is given to us under the sign of death. For the subject of such experience identifies strongly with every change in the course of the experience, that this pre-linguistic subject dies and is reborn with every shift in experience. This subject is more than just labile; it is a subject strung between life and death.

There are both similarities and differences regarding your ideas about (and attitude towards) recording here, it seems to me. One clear difference is that your films seem to work with, and at the same time to contest, the notion that photographic images capture fleeting moments. This, I believe, is something that Brakhage is not concerned with, as the forms of his work indicate. His films are concerned with the musical attributes of film. His columns in the Toronto music magazine, **Musicworks** (published by the Music Gallery, an institution which you yourself have been associated with) reveals that his concerns with poetry are similar, for they are in the purely sounding properties of verse. He seems to believe what half a dozen of the great early modernists famously stated: all of the arts aspire to the condition of music. His reasons for believing this, like theirs, are rooted in a reluctance to engage with representation — something his works make increasingly evident.

Your own works have incorporated representation as one of the legitimate potentials of medium, and

one of its appeals. Thus, in many of your sound "recordings" you seem as interested in what I shall say are the photographic or cinematic aspects of the recording as with the medium of the reproduction. Ironically, Brakhage is devoted to purely musical properties of cinematography. However, like Brakhage's, your work seems haunted by the idea of death and the nihilating force of time. What seems fundamentally different is your emphasis on the mediating role of medium. Acknowledgement of the mediating role of medium prevents one from completely identifying with the object of the representation. Thus, paradoxically, while Brakhage evinces hostility towards representation, his work engages identificatory mechanisms. Your work, on the other hand, acknowledges, even if somewhat skeptically at times, the value of representation, yet it also grants importance to the medium, to the constructive, as opposed to reproductive aspects of the medium.

Snow: As you know, I'm a great admirer of Stan Brakhage's work. Its depth and strength have often moved me and also have helped me to clarify myself. Your writing on both our films in **Image and Identity**, and that of William Wees in **Light Moving in Time** (Berkeley and Los Angeles, 1992) have edifyingly tackled discussing the non-verbal aspects of our work in ways I'm grateful for. Perhaps the "musical" aspect of visual art is taken care of in my life/work as music. The last half of your last paragraph is especially important here ("like Brakhage's, your work seems haunted by the idea of death and the nihilating force of time ...") to "... to the constructive aspects of the medium as opposed to the reproductive aspects of the medium" It's not only that any human being is at least CONCERNED with death, but that any thoughtful use of any representational medium will recognize that whatever is depicted is not there. You say, "the mediating role of medium prevents one from completely identifying with the object of representation." In my view this is the essential possibility left for art. It connects with the recognition of the *absence* of the object being represented and its replacement by a "fiction" that has its biological place in the human organism: language is its first manifestation. I've been thinking about the "reality" of mimesis for a long time, and each work I've made is a summation of some thematic concentrations on our shared "hallucination." I've been assisted by reading, of course, and some of the most powerful reinforcements for what I've come to almost

"on my own" have come from my gradual reading over a period of about thirty years of the works of Plato, Aristotle, the tragedies and comedies of Aeschylus, Euripedes, Aristophanes, etcetera and many commentaries thereon. An important point for current jargon is that this is not "modernism." The arrival of the tragedy in fifth century BC Athens is a decisive moment in man's conscious apprehension of "fiction" in the strictest sense of the term. By elaborating a theory of "mimesis" or imitation which was closely linked with the new experience afforded by the tragic spectacle, Plato and Aristotle set out to determine the status, place and function of what we refer to today as art or "the imaginary." The precise meaning of "mimeisthar" (to imitate) is to simulate the presence of one who is absent. Plato's and Aristotle's thinking is completely related to cinema; they realized the superiority of the distancing, the transposition, which made it possible for the feelings of pity and terror to be displaced into a different register, no longer experienced in the same way as real life but immediately apprehended and understood as *fiction*. The great tragedies carry in their formal organization a knowledge of the illogical logic that governs human activities and can produce in their spectators an inspired realization of the irreplaceable value of their existence and its extreme vanity. Representations can be powerful ghosts. I don't consider music to be "representational," though.

There are some wonderfully "accurate" descriptions of some ineffable experiences in your foregoing paragraph.

I can disappear into **Star Trek** as well as the next person but in my own films I want (mostly, often) an objective experience of representation. All representations are for me abstractions from some existing-in-the-world subject but since they are obviously not the thing they represent, what are they? They have their own reality which can flow away from and back to the source.

I don't think that Stan Brakhage has had any particular interest in Jazz, but for me what he's done/is doing with the movie camera is close to what the best Jazz musicians have done with their instruments. Classical music has norms of phrasing, vibrato, etcetera that are involved with ensemble integration and only a certain amount of individuality could/can be allowed without threatening cohesiveness. Expression has

structural limits. Personal expressivity, an individual style, has been the goal and achievement of the greatest Jazz musicians. Tonal qualities alone have an amazing range in the best Jazz trumpet players, for example Louis Armstrong, Bix Beiderbecke, Rex Stewart, Cootie Williams, Buck Clayton, Roy Eldridge, Dizzy Gillespie and Clifford Brown.

I think Brakhage has done something similar with the camera, an instrumental "style" that has its own vibrato, phrasing, rhythm and harmonic conception. Interestingly, his camera playing can as usefully be compared to musical instrument playing as to other utilizations of the camera. The source of his "style" is his still-radical view of the range of "seeing."

Obviously, "life" is the context for "art." The living that's done by the artist in making art can be a subsidiary aspect of the work, but it's important.

The diversity of my work has something to do with that (with wanting to live a "creative" life). There's also a certain purism or essentialism, which has its paradoxical aspects. All played, performed, "live" music is an indisputably social occasion. Ashkenazy playing Mozart has its theatrical, acting, interpretative side but playing improvised music is *living* the music; it's the music that's being created for and out of that never-to-be-repeated moment.

I'm trying to approach another experience of the "pre-linguistic" perception which you have just discussed in relation to visual art, particularly Brakhage's films: in playing totally improvised music one is in a present which is metamorphosing against the wake of the music's recent past, which one is simultaneously trying to categorize while moving into a future over which no one person has total control. There is definitely not a "language" of visual art but it seems closer to actual language than does music. This idea is certainly debatable, set against the emotional expressiveness of music. The experience I'm trying to describe is totally non-verbal.

In the first ten years or so of the CCMC we had many discussions about the forms that were the results of what we did. We talked about striving for "chaos," that what was totally new would at first be difficult to identify and would be the most demanding ideal for the process of creation/perception we were involved in. The education/experience that one has of other music becomes an

important part of how one behaves musically, reflexes based on feeling (from experience) that following *this* with *this* would sound "good." I remember arguing that the only pure or successful improvisation would be by a baby because nothing he/she could play would come from memory. Casey Sokol, a marvellous pianist then with the group, countered this assertion by saying "You can't make music at all if you don't have a memory." You can see that an improvising ensemble performs a politics, and the music is a result of an acceptance of a social principle. It's Kropotkin's ideal music, or perhaps it's "democratic," with elections every few seconds.

Now "painting" is a solitary act. For me – and I think for most painters – it involves as much looking at what you've done and considering the next move, as it does action. Even fast-looking paintings like the great DeKoonings of the '50s and '60s are solo acts which are distillations of *years* of hours and hours of looking. Improvised music is very "Abstract Expressionist" in psychology, gestural too but the result – the painting – is a static object of contemplation.

But when the CCMC records its music-of-the-moment it produces an "artifact." Our recordings are "documentary" as you've said. Our "gestures" become examinable as a past, an echo of a never-to-be-repeated event.

Elder: I want to return soon to my fantasy about the mode in which Conrad and Zukofsky experience; it may be helpful to explain why. I think there is a prevalent misconception about the purpose of self-reflexive constructions. According to this misconception, artworks offer metalinguistic statements about artistic media. It was the philosopher Bertrand Russell who produced the first extensive analysis of a distinction that has become central to our notion of how language operates. In a famous note written to the logician Gottlob Frege, Russell revealed how any formal system that allowed classes to be members of themselves — tantamount to allowing self-reference — would inevitably produce paradoxes. To prevent this, he drew a distinction which has become central to the thought of our age, despite being philosophically quite shaky. The distinction is known as the ramified theory of types and it proposes a strong distinction between statements made within a language and statements made about a language. Statements that are made about a language are part of a meta-language, not part of the language itself.

When Russell proposed it, the distinction was greeted as radical, and probably wrong. But it has

been one of the major topics of philosophical analysis for nearly seventy-five years, and has degenerated into something of a commonplace. Hence it has entered academic discussion of film, particularly amongst semioticians and cultural theorists. The conceptually reduced version they trade in serves at least one of the functions that Russell's daring version did — it fends off paradox and so tidies up our mental universe. However, it does this at the cost of suggesting that artworks embody self-reflexive devices so that artists can make statements about the medium in which the artworks are realized, and in fact, that the significance of the self-reflexive devices can be exhaustively unfolded into a set of mediumistic assertions. In this interpretation of their importance, self-reflexive works of art can both illustrate and analyze aspects of medium, just as English words can be used or mentioned, or just as Kurt Gödel uses numbers both to calculate the value of formulae and to refer to formulae which involve numbers.

This model can surely be applied to a few works of art. Dziga Vertov's masterpiece **Man with a Movie Camera** for example, is, in part a theory of film written on film that both illustrates and analyzes the medium's abilities and inabilities to convey truths; and it does demonstrate the problem when a film makes statements about itself, the truth of the assertions it makes fall prey to paradox. For the most part however, I believe the interpretation to be quite wrong. Its basic failing is that it treats works of art as though they were discursive objects — objects that offer statements about whatnot. Artworks rarely do this, I think. More commonly, they offer forms that suggest or elicit feelings about being undecided about something — feeling the tensions that surround some activity, or idea, or person. Thus one great failing of this view of the purposes for using self-reflexive forms of construction is that it tends to tidy up "confusions," forcing them into resolved views.

Another difficulty with this view is that it makes a too clear distinction between use and mention (or between language and metalanguage.) I think the sharpness with which that distinction is commonly drawn is philosophically unjustified. But that really is not an issue that I wish to consider here; rather I want to point out an unfortunate consequence of making the distinction so very clear-cut and then applying it to artistic forms. When critics and analysts think that it is always quite clear whether a device belongs to the object language or the metalanguage, they misrepresent the effect of using self-reference by diminishing the tensions that result from it. They make it seem that we always know whether a device is employed for its own sake, or whether it is put under scrutiny. Applied to a

work such as **The Last LP**, for example, it proposes that we can easily sort out those devices which are used constructively, and those that are used critically. This seems to me utterly wrongheaded — and characteristic of a sort of wrongheadedness of the age. Any comments?

Snow: I agree with you that in the last twenty years (!) more weight has been put on the discursive properties of artworks than on their object-like status ... or on the discourses *implied* by the nature and structure of art objects. It then seems to have become reasonable to consider artworks as comprising a kind of speech and they then enter dialogues where they are facts spoken for rather than "speech."

Although the phantom of the problems exemplified in Wittgenstein's wonderfully tragi-comic **On Certainty** are always lurking around the corner for me, it would be impossible to function if I didn't believe that I, first, made a concrete, finite object (this carpenter point of living-making is a factor of sound or light as much as wood). That shaped "something" is a provocation for engagement within areas understood by myself to be indicated (to any other interested biped) by the object itself.

The object's function will be to direct and concentrate attention of a kind uncommon in daily life. Artworks themselves are the concretions of the artist's concentrated attention. The intensity of this concentration will make it possible for the work to survive the gradual removal of some of its referents (from the social situation in which it was made). I think that this "definition" is still useful when applied to "executive" art (symphonies, opera, "Hollywood" films etcetera) as well as "solo" art (paintings etcetera).

However, a good artwork deserves a good spectator.

There has been a truly paranoiac ad hominem misuse of artworks. The critical "vision" involved, sees only the already-recognized and is contemptuous of play, thus of creativity. Often the supposed intention and real creative danger of some aspect of a work is given a surprising power which can only be likened to a belief in voodoo.

I did a class at the Nova Scotia College of Art and Design once in which a student said "the social context of art is the most important thing," which I countered by asking, "The social context of *what*?". No answers.

The extraordinary collective achievement – a great moment in the history of Art – of Pollock, DeKooning, Rothko, Newman, is reduced in some recent criticism to poker chips of politics, the artists are deprived of dignity and reduced to puppets, their struggles simply part of the Cold War. The work itself is not looked at, just its (mis)use. Of course, art and artists have had to deal with the rich and powerful and the works have often been forced into the role of servant.

I often see TV advertising that has interesting effects, which from the point of view of pleasure in human creativity in any manifestation are admirable. However, since their raison d'etre is to make you want to buy some product they remain a minor art. A lot of the art shown in the "fine art" milieu done from "political" social-cause motivation is also advertising. The reduction to a single point, not a field of points, means the work has no staying power, and while its iconic power might make it last longer than the moment the message was meant for, often such works (like advertising) become quaint a few hours after they've been encountered. But then everything dates.

A wonderful book that might be falsely "Readers' Digested" as a vindication of the power of "form" over "content" is **Antigones** by George Steiner.

Ever since Sophocles' play was first performed in Athens in 442 BC it has been admired. Steiner's book traces analysis and description of the play through many centuries. The amazing thing is that against the often-expressed consensus that it is a great work, there are authoritative but surprising and often entirely contradictory accounts of what the play *means*!

Elder: I should like to return to my fantasy about the mode in which Conrad or Zukofsky experience language and how that effects their experience as a whole and to consider this issue of self-reflexivity in terms of viewer/listener response: in terms of the qualities of the experience the artworks elicit and the implications of those qualities. The subject I described above, a subject, one partly within and partly withheld from language, is exactly in the position described in an oneiric fantasy by a great artist of more recent times, Hollis Frampton (a former colleague of yours until his unfortunate death by cancer in 1984). Forgive me, please, for introducing another filmmaker here, but those relations between sonography and cinematography are just what might legitimate the efforts of a film theorist to speak to you about your sound recordings.

Snow: "Self-reflexivity" in art is one of the strategies that can contribute to the being of a work and its continuation as a present-tense *now* experience for the spectator. No doubt it will seem disagreeable to some, but I think that art can have *some* value in itself (and please understand I don't exclude *any* kind of representation, subject or cause) not only for its ability to cause one to think seriously of "non-art" issues perhaps referred to by the work.

Inclusions of an attempt to direct the viewer's attention to what is in front of him/her seems a fairly easily defendable idea. Directing the viewer's attention to the nature of the material or medium in which the work is composed can make for a more "critical" level of experience than the shade of hallucination involved in our belief in representation which (unless it has a "self-reflexive" possibility) must refer to an elsewhere at another time, not *now*, and in my opinion such a work won't have the strength to survive the gradual removal of the period importance of the referent. My film **So Is This** (which is silent) is an example of how I've tried to deal with this (!). The film (all text) deals with various references that are consciously "dated" (the most remote in time being a quotation from Plato's **Phaedrus**. I was aware that the references that were "now" when the film was made would soon be "then." These references metamorphose out of, or are parts of continual returns, to "this," which in every case has a different present-tense subject (the screen, the word, the light, the sentence etcetera), all seen in a particular way by particular people, in a particular place each time the film is projected.

"Self-referentiality" and "materiality" are related.

An odd understanding of this concept was manifested in an article published several years ago, concerning works by Robin Collyer, Tom Sherman and myself.[1] **Authorization**, a work in which I sequentially photographed the camera and some of my face in a mirror, and mounted the series of Polaroids as they were made on the mirror, was described as "self-referential" because it referred to the self that made the work. Hence it is "autobiographical," a self-portrait. I disagree with this reading and misuse of the term. My image in this work is a photographic equivalent of the "thumb-print," brush

stroke, a personal quality possible in painting. Somebody made the work and that person is recorded in-the-making of it. It says no more than that about the person. Perhaps it could be thought the artist was self-effacing! Photographing the face obviously wasn't the point of the piece, so it's not a "portrait" and thus no more "biographical" than any other work. Everybody's work is "autobiographical" in some sense.

Of works by myself in sound that have a self-referential aspect, **Hearing** and **Tap** are good gallery examples.

Elder: In the work I just alluded to, "A Pentagram for Conjuring the Narrative," Frampton presents the fantasy of a person who spends his life, from the moment of his birth, through infancy, boyhood, and young adulthood, until his death, watching films of another person's life — films that have been taken from the moment of *her* birth, through every moment of infancy, childhood and young adulthood, through marriages and a successful career in science, up to her death. The piece is one of Frampton's extravagantly successful philosophical fictions, one of a series of writings in which, rather like one of his literary masters, Jorge Luis Borges, Frampton proposes ideas about the most profound issues that the human mind has grappled with — time, being, illusion, identity, history, truth and, of course, aesthetic experience — in a witty, even playful, tone. A crucial moment in the essay alluded to above concerns the period of the boy's adolescence, when, of course, he watches movies of the girl's life across the same span of years. Frampton remarks upon the boys' total identification with events he beholds there, so he feels that:

> young men fumble through the confusion of her clothing to caress his own unimaginable breasts.
> (**Circles of Confusion** p. 60)

Frampton thought deeply about the relations between perception, expression and biology. His best-known remark on the topic, perhaps because it was his pithiest, concerned the range of purposes served by birdsong. It appears in the same essay, for it is devoted to the aforementioned relations, where he proposes the fiction that one fine morning he awoke to discover the language of birds.

> I have listened to them ever since. They say: 'Look at me!' or: 'Get out of here!' or: 'Let's fuck!' or: 'Help!' or: 'Hurray!' or: 'I found a worm!' and that's all they say. And that, when you boil it down, is about all we say.
> (**Circles of Confusion**, p. 66)

His interest in the work of the (appropriately named) Ray Birdwhistle — which I have never really understood, is another manifestation of the appeal the topic held for him. Those who had the pleasure

of hearing him deliver his paper on erotic fascination at Ryerson ("Erotic Predicaments for Camera," published in **October**'s special Hollis Frampton issue, no. 32) is the culmination of these interests, for it draws together his interests in the archaeology of photography, scoptophilia and the obscene pleasures of the mathematical imagination. His remarks about the period in the boy's life when he feels male lovers caressing his unimaginable breasts evince the same interest. Frampton recognized, acutely, that our relation to erotic images invokes just such a subject as I have been describing; a fractured subject, one part of which identifies with the objects represented within language, and another part which is withheld from language. After all, erotic images place us in the position of the voyeur, that person who consummately articulates these two modes of experience. For the voyeur is the person at the keyhole, shut out from the experience he or she observes. At the same time, the voyeur is aroused by the experience, since he or she identifies with its participants — in fact, typically (and assuming the voyeur is watching the statistically more likely, i.e. heterosexual scene), with both the male and female participants. One of the factors which is involved in the voyeur's behaviour is that he (the more likely gender) observes the couple and takes both their roles. To make the point about identification, we could say that in imagination, every voyeur is a human androgyne, and since there are no real human androgynes, voyeurs usually consummate their activity in the imagination, and can never give themselves sufficiently to the real. Any response to this?

Snow: Frampton's text constructs the experience of a supra "suspension of disbelief" and a hyper-identification with the girl-image by his boy protagonist. It's a wonderful piece of writing. Such deep identification is perhaps possible and I see how it opens to the subject of "voyeurism" in an interesting way. Of course it's a text, not "images", or a real-life experience narrated.

The last (Hotel) section of **Rameau's Nephew ...** (1975) contains a similar idea introduced as sync-sound speech: "It is said that everything that happens in one's life is recorded in the brain. After death one can see all or any of this life-film and we can see others' life-movies too."

Images and sounds in this part of the film are often presented out of their filmed order — a wonderful capacity of film being that, for example, the end of an action can be shown before what in real-life preceded it (effect precedes cause; the destruction of the green table has the "life-movie" talk sound "over" it,

and the green table soon reappears with the sound of its hammer destruction "over" it).

Hollis Frampton was a close friend. I had the honour of giving a talk about him at a "wake" in Buffalo after his death in 1984 (the text of this talk appears in my **Collected Writings**). He was a wonderful person whose films and writings are of great importance. I was present at the talk you refer to and it was very moving. Even more moving was his visit to our home later that night, where he told me of his lung cancer (I had known nothing about it) and that it seemed he had little time to live.

I think we must attempt here to distinguish a pathological voyeur and a normal voyeur. The pleasure aroused by erotic representation and by erotic sights seems to me to be entirely normal and positive. But if the individual in question is, as you've described, stopped at seeing, seeing alone could be a false non-physical consummation and could be pathological. There are such people, no doubt. I think the pressure built up by voyeuristic desire for out-of-your-reach women is a factor in rape.

"Every voyeur is a human androgyne ..." this goes too far. There are too great a number of possible identifications that could be made by a possible "voyeur" of possible male/female situations as "image" or real for this to be a discussable proposition.

All images place us in the position of "voyeur." Desire aroused by the image can be "satisfied" in a vicarious way by the image. Your "voyeur is the person at the keyhole" describes a man or woman with a movie camera and a cinema spectator quite well. It even works in reference to a listener of recorded music. While we're at it, I enjoy and am stimulated by women on the street in spring and by some "pornography," which (talk about suspension of disbelief!) can stimulate me to the point (ha ha) of erection and masturbation. I like images of beautiful nude women without men. I don't identify with the women, I'd like to fuck them.

The impossibility of consummation is a factor in the desire aroused by the images. I've tried to work with the provocations of eroticism in **Rameau's Nephew ...**, which after all depicts intercourse and *is* an experience of "intercourse," and also (especially) in **Presents** in a different way. **Wavelength** is as easily read as coitus as any other way. The remarkable amount of advertising for "phone sex" and on-line computer "sex"

seems to indicate its popularity and brings in a strange new media masturbation. In the case of phone sex we have an "écouteur" rather than a "voyeur". I've never made such a phone call, so I don't know what I'm talking about but the "realism" of the phoned voice and the fantasy arousal involved are very peculiar and new.

"There are no real human androgynes" but the Freud-based claim for a normal but socially repressed "bisexuality" might do in a pinch. Since there are two sexes and that's that, I think the term "bisexuality" is not as apt as one might hope. Surgery has been enlisted to make "she-males" and the number of medically-assisted castrations called sex-change operations is impressive. (Here it seems that women get the short end of the stick. Alas, it's easier to make a hole than orgasmic erectile tissue.)

In relation to that, a history of the eunuch is an interestingly appalling thing, as horrible as that of foot-binding. There have been long periods in the administration of the Christian Church (especially in Byzantium) where being a castratee was highly regarded, to the extent that parents with several sons often had one or two of them castrated in the hopes of a good career in the Church.[2]

I'm puzzled by the textual and verbal silences about shaving! I've only found *one* evolutionarily-based discussion of it, in **The Body Book** by Desmond Morris. Why do men do it? Isn't it (shaving) a "feminization?"

The replacement of the vagina by the anus in male homosexuality is argued by some men to be a "feminity" (strangely defended by "feminists") but maybe here is your "human androgyne."

But we – men and women – are sharers of a species, not "opposites," so "empathy" shouldn't be too surprising. Also, someone else's pleasure provoked by one's own, is a shared pleasure.

I think homosexuality is inevitable, not "natural," in our big-dicked permanent-estrus species. In a way it's an affirmation of our range and freedom compared to the other mammals where there is no such constant. It might also be a birth control device. Quoted in Derrick de Kerckhove's interesting book **Brainframes**[3] is the following statement by Jean-Marie Pradier:

Social life, sexuality and aggression are mainly ruled by visual components. This is perhaps why gazing is so severely con-

trolled by precise codes and display rules. It is also why most human cultures have created freely viewed objects (paintings, sculptures, photographs, films) and freely viewed individuals (sportsmen and women, dancers, actors and actresses, but also prostitutes, priests and public figures) along with free-viewing spaces and events (theatre, carnival, hot urban districts) where it's possible to be a voyeur. De Kerckhove goes on to discuss how TV is such a "free-viewing area."

One of the wonderful things about sex and the nature of language is that sex is so primal, obviously pre-linguistic. Regarding Freud's school: I wonder whether the mind doesn't present a new picture of itself at different periods to the strongest explorer who is motivated to look (at that particular period) and is consummately a product of the currents of the time. As said before, anyone's work is autobiographical in some sense, including Freud's. Freud was inspired by Darwin, of course, but I don't think it's as big an opening in human knowledge.

Neuro-scientists speak of our having *three* brains (which could be described as three basic mentalities, never of course functioning totally separately). To our first "reptilian" brain was added an old "mammalian" (paleomammalian) brain and then with evolutionary time came the third or "neo-mammalian" brain. The important thing about our evolutionary growth here seems to be that the brain was successively "added onto" rather than being internally modified over the millenia involved. I recommend a reading of Paul D. MacLean on this incredibly complex matter which combines growing physiological knowledge with new speculation on evolution. It practically pictures "repression."

Elder: The fault in consciousness that I have been attempting to describe between the prelinguistic subject and the subject engendered-by-and-dwelling-within language is really split between those agencies that Lacanians would refer to as the *imaginary* and the *symbolic*. Lacanian theory, whatever its excesses, and however monstrous its underestimation of the somatic basis of psychic life, has done us a great service in mapping certain psychic conflicts to this split between the I-that-speaks and the I-that's-represented-within-language. Lacanians show that the latter never coincides with the former. Thus the self is always misrepresented within language. I would go on to suggest that the self withheld from

language must be a prelinguistic self and I believe this self must always be threatened with nonexistence. (Lacanians have said less about the latter point, but I think it may be implicit in the concept of the *corps morcelé*).

Thus the structure of our situation with relation to language is a tragic one, for it consists in choices, either one of which condemns us to being perpetually dissatisfied and unhappy. We can choose a terrifying, but perhaps more authentic mode of being, or we can choose to falsify our self. On the one hand we can withhold ourselves from language, in which case we are threatened perpetually with nonexistence. On the other hand, we can surrender ourselves to language and make a home for the self there. While this affords some shelter from the terrors of non-being, it also falsifies the self. Neither choice is satisfactory, yet they are the only options.

The reasons for my interest in the fractured subject are many; those that are primarily philosophical must remain unspoken of here. However, some of the others are germane to aesthetic discussion. Over the past one hundred years, artists have often made works that rely on the artistic analogue of a metalinguistic statement, for they make us aware of the texture and qualities of the materials of which they are made. As I remarked above, this is a feature of your visual art, of your performances with the CCMC, and of your sound recordings. The distinction between the subject that is within language and the subject that is withheld from language mirrors, I believe, that relation between object language and metalanguage that is so crucial in the art of the last one hundred years. The subject is fissured and on the one hand, finds a stable, but inauthentic being within langage, and on the other hand, in acquiring language (and his or her being in language) becomes alienated and in the extreme instances, develops feelings of being alienated and looking in upon the place where one's being resides.

As I am sure you are aware, numerous works of your visual art embody tensions that arise from taking a hard look at a scene which we are distanced from (we gaze at it, but are excluded from it) or (the more common of the two sources) from a rupture between the vantage point implied in the scene and the vantage point from which we view it — examples of the former are **Scope** and **Atlantic**, of the latter, **Of a ladder**, **Crouch**, **Leap**, **Land**, **Side Seat Paintings Slides Sound Film**, and **To Lavoisier, Who Died in the Reign of Terror**. We could view this matter psychoanalytically, in terms of *l'autre scène*, that primal scene that is the site of origin and being, and so truth. There would be validity in doing so, I suggest, but it is not this line of questioning I wish to pursue. Rather, I want to consider again your relation to language and medium. It seems to me to

put at stake the conception that the artist does not create meaning, but rather that meaning resides, in part or whole, in some material or some system independent of the artist. This conviction seems crucial to understanding your creative methods, which so often seem to involve chance operations. It is entirely contrary to convictions of, say, Stan Brakhage for whom the artist brings truth out of his or her own being. It is closer to that claim of Steve Reich's I so cherish, that when you are listening to his music, it is not him (the composer) or yourself (the listener), but *it* (do I detect a replacement for the tetragrammaton?) to which you attend.

There are a few issues here I invite you to comment upon, but particularly the chilling alienation (exhilaratingly so) that some of your works evince, visual and audio alike … particularly **Two Radio Solos**.

Snow: Perhaps (probably) out of fear of un-repressing a repressed, I've avoided intending or discovering a psychological self-analysis in my work. I've especially — at least thirty years ago — thought of being an artist as self-creative more than self-expressive. Perhaps that self has been created (by experiencing its emanations) and I'm finally me and too relaxed. I had a lot of problems too and I don't think they are or should be of more or less interest than anyone else's.

There's a linguistic aspect to my psycho-sexual history. I don't think I'm (technically speaking) schizophrenic but in my childhood cultural-linguistic-sexual "opposites" (they aren't) were very symmetrically embodied in my father and mother, provoking a desire for a more unified psyche from their son. What did he say?

I expect my psychology to be a part of what I make, even when avoiding it, so it's a given of any work – all work of *any kind* being "self-expressive" to some extent. In some ways I agree with your quote from Steve Reich, it's beautifully put. I think an artist should make *something*. It should enter the world and be self-reliant and meeting it should be an Event or Experience different from others, by its provocation to meaning, not only by its carrying of a meaning.

Play is more and more underestimated in favour of service (despite Marxism's failure it's still very influential). Related to that I think is a pre-linguistic reservoir, perhaps not only of conflicts, that's a source and raison d'etre for artists. But that might hold for financiers too.

Perhaps the "alienation" you mention in the experience of some of my work, especially **Two Radio Solos**, comes from my desire to not make work that is personally expressive. I first "played" the radio for the sound-track of **Standard Time** (an eight-minute film made in 1968) perhaps as a result of experiencing Ken Jacobs' in-person use of a radio for the sound to accompany his film **Blonde Cobra** (see "Playing the Radio" in my **Collected Writings**).

Since then I've made several uses of playing and taping a short-wave radio. The section of **Rameau's Nephew…** called "Dub" has a lot (I think) of amazing short wave stuff.

Two Radio Solos is two recorded unaltered "playings" of a short-wave radio, each about forty minutes long. They are "improvisations," which were developed as discovered, shifting between bands, stations, volume, bass and treble, etcetera. The batteries in the tape recorder I used (the tapes were made in a remote northern cabin, no electricity) were gradually dying during the playing and recording of one of them, something I didn't know until I played it back later, changed batteries, and heard the wonderful gradually-speeding-up result. "Short Wavelength" and "The Papaya Plantations" are very pure electronic music, which included "speech" and "music" — that once had a "natural" source but in the final tapes has gone through many modifications (including the simple one of becoming sound on a particular short-wave radio) before being heard via your tape player loud-speakers. Perhaps this distance from the human sources (which in these works includes constant metamorphosis) is the source of the "chilling, exhilarating alienation" you feel from these pieces.

I don't feel those feelings. I felt "alienated," especially as a teenager; maybe it *is* autobiographical. It may be that my "gaze," here and elsewhere, is related to my viewing of the Primal Scene which I believe I saw when I was about fourteen, too late for it to have any effect according to psychoanalysis.

"*Corps morcelé*" is an intellectual hors d'œuvre. Some early perception will be "fragmentary" but surely it will consist first of sensations of continuous surfaces that "flow" from one to the other and "feel" different, hot becomes cold, dry becomes wet, bright becomes dark. "Fragmentation" will be differentiation and as it arrives will thus be the beginning of indentification, of classification, of language.

That psychoanalysis is linguistic is its problematic. Freud's writing is wonderful but art-world reference is always to it (or Lacan), not to the *field* of psychoanalysis and its testing of its hypotheses for ninety-odd years. I'm not disputing their eminence because I also have nothing else to work with. But a *lot* has been written by other analysts and *many* psychologists find the psychoanalytic anatomy of little use in their work.

Not boasting, but I was in analysis with a Freudian for a year ("not enough," he said when I quit) and I see in art-critical writing by and large a literate academic use of psychoanalysis with little evidence of actual experience in practice, as either doctor or patient. I think that's a "lack" too.

I'll go further. The "fault" of Lacan's work is that it's linguistic/textual/verbal. I can know nothing of his practice as a doctor; I'm referring to his published writings. His use of "mystic" diagrams and invented signs is an arrow towards the visual. The more sophisticated (and "adult") the literate taxonomy the further the distance from the "facts" which we are all supposed to have experienced (more or less). Representation of the pre-verbal might better be visual. In Lacan the distance between description and object is almost as extreme as in physics (likewise an "invisible" theoretical but one with slightly more material evidence than psychoanalysis). "There is no means of knowing whether the unconscious exists outside of psychoanalysis." (Lacan) Brakhage's great **Scenes From Under Childhood** comes to mind.

In discussing *corps morcelé* – pre-Oedipal image categories as "images of the fragmented body" – Lacan wrote: "images of castration, mutilation, dismemberment, dislocation, evisceration, devouring, bursting open of the body." These are all adult impositions, all more or less impossible for an infant experience, especially "images of castration." The only one on the list with any relevance is "devouring." Infants are greatly involved with sucking, licking, swallowing, tasting (and puking). Later, in the course of normal development, these activities become tearing, ripping, crushing, grinding, cracking, crunching, mashing – which is called "eating" and which for some reason is never attacked for being so violent.

I'm not questioning the existence of infant fear, horror, pain, but its description. I'm not denying that pathological oaks come from tiny acorns, but the psychological botany is worth examining.

The voice of the "pre-linguistic subject" is that of the linguistic subject. We can never hear that original voice; we can hear a conceptual translation, not from one language to another but from chaos to order. This kind of out-of-context quoting is suspect because it's so fragmentary (!) but Freud himself wrote (in **Screen Memories**, 1899) "It may indeed be questioned whether we have any memories at all from our childhood: memories *relating* to our childhood may be all that we possess."

Psychoanalysis contains propositions interestingly similar to the undemonstrables in theology (the angels-on-heads-of-pins type). The Christian "Original Sin" of the childhood of the human race has been Darwinized (Freud's ambition) to the pre-linguistic childhood of each individual human being. The unconscious may also be likened to a divinity. The Greek pantheon is internalized, the unconscious always present but revealing itself only obliquely at privileged moments, within every being but inaccessible unless it "chooses" to manifest itself.

I know that the use of psychoanalysis in art criticism can be illuminating. It's strange that this text is the occasion for me to express publicly some of my negative feelings about such use – strange because I know from past conversations that you share my sense of the extreme questionability of many uses of psychoanalysis in film criticism and that your own infrequent uses have been the exception that prove the rule! Your texts on my film **Presents** in **Words and Images**[4] and in **Image and Identity**[5] use psychoanalysis fittingly and in an enlightening way. I recommend a "psycho-biography" of Lou Salomé by a certain Freudian author[6] as another example. But since in psychoanalysis everything stands for something else this "constant deferral" can take people into text and away from multi-sensual multi-meaning experience. The work is ignorant, unconscious, and psychoanalysis "knows." Psychoanalysis has its vision of the meaning which will always lie in wait, the truth which lies covered by the "rest," but the "real" is in art, the work itself.

More questionable rhetoric. Freud wrote, "The use of analysis as a weapon of controversy can clearly lead to no decision"

– isn't that beautiful? And there's the wonderful anecdote about Freud's comment upon being reminded that smoking a cigar is obviously a phallic activity: "Sometimes a good cigar is just a cigar."

The summer 1992 issue of **Clitoral Inquiry** has an interesting article by Diana Fuss, "Fashion and the Homospectoral Look," about the fact that women's magzines – like men's magazines – always have photos of women on their covers and contain many extremely sexy photos of women. The article uses Lacan to attempt to analyse this fact and the qualities of particular examples. This, it happens, is one of the things I tried to discuss "pictorially" in **Presents** (1982), where the term "presents" in its zoological usage is especially useful to this analysis. That film is also deliberately "psychoanalytical." **Screen** magazine (Laura Mulvey) posited that the spectatorial look produced by the classic film is masculine, heterosexual and pre-Oedipal; yes, and film *is* those things.

Elder: A number of interpreters of Lacan, most significantly Stuart Schneiderman, have suggested a different interpretation of *l'autre scène* and of the voice of the analyst, which, because the analyst is heard but not seen (for the analysand must not face the analyst as he or she attempts to engage in free association) feels to the analysand as though it comes from the other side. That "other side," Schneiderman suggests, is the other side of life, the side of death. I note that in your liner notes for **The Last LP** you mention the music recorded on a gramophone disk comes from "some Other Room" — set out in capitals. You then cite two instances that you prize of the "re-presenting" of sounds from the past — the first, of Louis Armstrong's Hot Five and Seven recordings, made in Chicago in 1929, the second, "the exquisite last recordings (1950) of the great classical pianist Dinu Lipatti [made] at Bésançon" — a pianist who, as you note, "died shortly after making them." I suggest your capitalizing the "Other Room," your reference to departed musicians and your explicit comment that Dinu Lipatti died shortly after making the recording you cherish all point toward that "other place," the other side of language that is the place of the dead.

The illusory being of a record, either of an object or of a sound, is phantasmal, rather like that of a revenant that returns to a time and place and populates it with ghostly traces from another time and place. These images are then like memory, and the very notion of memory brings in its wake the idea of death.

Snow: The CCMC music is precisely "free-association" and the audience is the analysand. We've had a joke for a long time about having cots (to rest on) on the stand when we play, but hadn't thought about playing while lying down. Might try.

Sound recording and film/video recording are more spookily "live" than still photographs. The "ghost" is more active (obviously because they exist in time but *still* photographs remain"still"), with Dinu Lipati now as a kind of poltergeist tapping not on a table or piano but on the diaphragm of a loudspeaker. The "suspension of disbelief" in listening to sound recording is as astounding and common as that same mental operation in relation to moving visual images.

Sound recording "works." I heard Louis Armstrong once in person but I know the music emanating from his recordings from the '20s to the '60s very very well, and have always been extremely moved by it. It *is* music, not only the ghost of music.

I've tried to use the "realism" of sound and picture recording but I've always also (not necessarily simultaneously, but within individual pieces) tried to arouse a consciousness of, a tasting of, the sound/picture as, as you say, "phantasmal." This need not thin or diminish the "realism" effect, it adds a saddening, ennobling, funny (whatever) sense of mortality to the "concrete." In several writings starting in the '60s I have referred to recording mechanisms as "memory devices" which concretize, externalize, make public, embalm. Yes, your last sentence is very apropos.

Elder: A number of your site installations that make use of replayed sound involve dispersed forms. **Tap*** is an outstanding work in this regard, consisting of five elements, "a sound, an image, a text, an object, and a line." One point of interest is that the object **Tap** is made up of five varieties of objects that could be considered to present varying degrees of

concreteness that lessen as the object becomes one of a type we commonly consider more as an information bearer than as a thing in itself. Thus a sound isn't usually considered to be an object; a line of wire is — though less an object than a more compact speaker. Certainly, you do use various devices that foreground the objecthood, to borrow Fried's term, of the objects that constitute the piece.

The objects that make up the object named **Tap** could themselves be referred to by "tap." Its sound is that of a finger tapping on a microphone. The picture is one of a person, yourself, tapping on a microphone — or more precisely, since it is a still photograph, making a single tap. The self-reflexive text that describes how the materials for the piece were assembled, is shown in typewritten form, presumably to acknowledge the manner in which the text was produced (just as the content of the text does), to foreground the medium — the paper and ink, and the actual shape of the marks on the page — and so to the objecthood of the text, but also because a text is tapped out on a typewriter.

The word "tap" invokes many ideas and the work **Tap** makes many references to tapping — some deliberate, some perhaps not, I suppose — that use ideas and experiences we associate with the word. One taps (on a lectern, a desk, a podium or a microphone) to draw attention to oneself. We can think first about the phenomenon of drawing someone's attention to something. Artworks are devices for focusing attention; and the sound of tapping here serves the work in its reflection on the character of experience. (While engaging with the work, we ask ourselves such questions as: "What is there about a tap that draws our attention?" "What is there about this tapping sound that draws our attention?" "What sets this tapping sound, as a component of a work of art, apart from tapping sounds I have heard on occasions when someone wanted my attention?" "How does the fact that my attention is attracted by the tapping sound change my perception of the non-aural components of the work, and how does my interest in the work change as my attention becomes more purely aesthetic?" "How does drawing attention to something make it seem "more of a thing," more "there?")

We can think too about drawing attention to *oneself*. **Tap** involves an elaborate play of revelation and concealment, and the delight we take in that play, as children's play shows, relates to the self. Thus, the picture of the person making the tap, is framed in such a way that it is recognizably you, and so it is revealed that you are behind all that we hear or see, though, of course, you are not really there as an actual object. (In a sense, you are not there because the objects you have made stand in for you.) Thus concerns with objecthood, so evident in this work,

are linked to the concepts of presence and absence. Considering merely the historical affiliations drawn out by this is completely engaging.

Another secondary reference involves a pun on the word "tap." For "tap" refers not only to sounds, but also to physical objects, to spigots from which liquids pour. Another remarkable sound/image construction you produced involved taps (of the aural variety) on the side of a sink, with water pouring from its tap. Punning seems a characteristic way of thinking for you, and so one wonders if there was in the back of your mind the recognition that a speaker is a kind of tap for sound, a source from which sound emerges, carried by a pipe-like wire, and allowing itself to be turned on and off. (The idea that sound, at least in its form as fluctuating electrical current, is like a liquid that flows through channels, and is shaped by the channels through which it flows appears in **Rameau's Nephew...**, an extended and brilliant film devoted to questions similar to some we are giving consideration to here.)**

I hinted above that skeptical strategies are pandemic in your work; and **Tap** is not without its skeptical ironies. Some of the work's structures foreground the objecthood of its individual components and others allude to the dense, totally presented unity which was, until the recent past, normative. The "integrating" repetition of the colour of the speaker is an example: the same colour is used to frame the written text, the photograph. In fact, the work insists, through repetition, on the importance of the frame — traditionally a device for isolating an image from its surroundings and making it more of a "thing." Thus, a temporal frame contains the sound, for it is a loop, and this frame rhymes with the frame of the speaker, and this with the frames around the text and the photograph. The work makes use of such devices presumably to suggest the objecthood of the individual components and, by extension, the object that comprises them. Despite this, objects that the title **Tap** refers to as an integrated group are remarkably dispersed. Indeed, the overall unity seems almost as dispersed as that of some "ensembles" that appear within it, some of which we can refer to with the plural noun "taps," for they are presented not as individual objects but

*Photographs of Tap appear in *Around Wavelength* by Philip Monk, one of the books in The Michael Snow Project.

**This film is discussed specifically in another text by Bruce Elder which appears in *Presence and Absence: The Films of Michael Snow from 1956 to 1991*, edited by Jim Shedden, one of the books in The Michael Snow Project.

in a series or group, just as the object **Tap** is made up of other "tap" objects.

The objects that constitute the piece are dispersed through space. The work, despite the many allusions to framing which it makes, opens outward toward the environment wherein it is situated. We could take the cord that connects the tape player speaker as a figure for the dispersal which as a formal principle is central to the construction of the work.

Snow: A water theme flows through **Rameau's Nephew**.... The wonderful natural cycle of seas, lakes, rivers, evaporation, clouds, rain, seas (etcetera) moves through the strata of reference in recorded speech, representational sound and image in the film.

All except two shots in **Rameau's Nephew...** are interiors, enclosures which are and do represent man-made culture or civilization. Nature is "outside." "Cultural" reference to it is made, for example, by the attempts at singing Bob Dylan's "A Hard Rain's Gonna Fall" made by Nam June Paik and his instructress Helene Kaplan in the "Embassy" section of the film.

Later, in one of the two exterior shots: a woman in the window of a log cabin (a "primitive" stage of enclosure construction contrasting with the other exterior shot of a huge jet plane) a "hard rain" does indeed fall visibly and it falls more and more on the lens of the camera itself. The sound is "documentary" realism = rain.

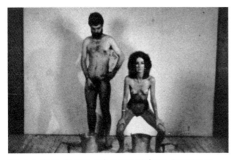

Pissing Duet. Frame enlargement from *Rameau's Nephew by Diderot (Thanx to Dennis Young) by Wilma Schoen* by Michael Snow, 16 mm film, colour, sound, 1972-74, 4 hours.

Then there's the human "civilization" of water that you mention, where it's forced to flow through a faucet, is "tapped," which happens in the "sink/sync" sound scene, where my hands "tap" in sync in the sink and I control the flow. Another human shaping of water is the animal/physiological one of our expulsion of urine. Water passes

through us to rejoin the cycle: the "Piss Duet" scene where a nude man and woman pee into two buckets simultaneously and make sync sound water music.

Your description of **Tap** is a pleasure to read; you've really experienced it.

I first made what I then called (at least to myself) "dispersed" compositions in the **Walking Woman** series (1961-67). I'm not sure now which pieces came first but **Sending and Receiving Crosswalk (and After)** (a colour painting/part on one wall, facing another different colour painting/part directly opposite it, and a third much smaller painting in greys on a third wall) was one of the earliest. **Sleeve** is one of the more complex, including a sculptural element, as is **Morningside Heights**. The many "lost" **Walking Woman Works** were also "dispersed," sometimes with parts in different cities; they were also the first "site-specific" works that I know of before the term entered art jargon. To my knowledge no one had done or was doing visual work in a way which included memory, the spectator's motion and the nature of the site, before these manifestations. Now everybody does them ("installations").

In the 1970 AGO retrospective for which I produced the book **Michael Snow/A Survey** I did a site-specific installation using thread, where a single white "line" went from wall to wall and room to room. It was called **Piano**. Also in that show was a work using electrical wire called **Short Circuit**; it plugged into a wall outlet but was not electric (wired). It has since disappeared.

Elder: There is another aspect to this dispersal, for **Tap** spans not only different places but different times. The cord that connects the player and the speaker runs between two "times" as much as between two "places," between the immediate present in which the tap is heard (and a tapping sound does draw our attention to the present moment) and the time when the recording of the tap was made. Thus, the sound in this work, like the objects presented in a photograph, are dispersed through time. This is intrinsic to the phenomenon of recording. Recording seems to promise the ability to preserve things in time and to reach across time — indeed, to obliterate time — and render the object recorded "present" once again. But here, too, there is a twist for the object that was "recorded," in image *or* sound, is not ontologically identical with the object; at best (or worst) only an illusion of the object is presented, in a manner that, willy-nilly, conforms wholly to that nature of the media rendering the illusion.

Thus, **The Last LP** pretends to be a recording, a device that will keep alive the memory of departed cultures. This is a conceit — and not one that we are really invited to believe. That enterprise of keeping alive (in memory at least) all cultures, many of which are on the verge of extinction, you refer to with irony and skepticism. That same irony and skepticism seem to characterize your thoughts about stopping time and preserving memory. This is probably as it should be, for the idea of preserving memory is odd. For memory is in thrall to time, it must disappear as the span of time that separates us from a particular event surpasses the span of a human life. We do not remember the events we have seen only in photographs from before the time we were born; we only imagine, on the basis of flimsy record, what life must have been like then. We are too removed from the site where those photographed, originated. I suppose we all, sometimes, wish to believe that the span of time separating us from that origin could disappear — that the photograph, because it preserves something of the essence of the object, could annihilate time. But time, as we all admit, however reluctantly, really is inexorable.

In your liner notes for **The Last LP** you comment on the effect of the illusion that the recording of aural phenomena invokes, an effect that rivals the one solicited by images conforming to the system of Renaissance perspective, to wit, the suspension of that disbelief and the credal acceptance that the various objects "depicted" in the composition (in the case of a musical recording, the instruments recorded, in the case of paintings, the catalogue of items that constitutes the subject matter of the painting) were co-present in a real space and, at the extreme, co-present with the act of observation.

Snow: Yes, one aspect of **The Last LP** (and here it resembles **So Is This**) is that via the guidance of the text it purports to present music that is "ancient." Since sound recording did not exist in ancient times the music couldn't have been recorded then, so it has to be a survival into contemporary times — which of course must involve the continuity of a culture's memory.

There's a lot of "time-keeping" in the work, as you say. In the text, specific period/dates are given if a score is said to exist or a span of time for its existence if the work is said to be "traditional" and passed on by example. A specific time and narrative context is also given for the "actual" recording (note: the reversed mirror-printing paragraph gives the true time and method of recording and composition). Then there's the time of the assembly of the material to become **The Last LP** and your playing/hearing of it. Now (1992) there are no more LPs being made and **The Last LP** is out of print. I might make a **Last LP** CD!

Elder: A certain philosopher whose work I find remarkably close to your own in many respects, Jacques Derrida, has written incisively about our desire to surmount any medium of signification to establish an unmediated relation with the signified. (Philosophers traditionally have written as though they believed that thinking possesses this wonderful power. The potent alliance forged between linguistics and psychoanalysis at the beginning of this century has pretty much eliminated all but the vestigial remnants of the once commonplace conception that consciousness is transparent to itself in as much as it affords unmediated contact with its noematic objects.)

Like Derrida, you suggest that we can never reach outside representing media and make unmediated contact with the object, that there are no points where language reaches outside itself and anchors itself in an ultimate act of reference in the world itself. Like Derrida, and like Nietzsche before him, you seem to believe that no phenomenality ever reduces the sign so that the referent comes to actual presence within it, in the fullness of its objective being. The thinking your works imply accords with his claim that meaning is endlessly deferred, for all signs mean only by making reference to other signs which make reference to other signs; this, I take it, is one of the purposes of the puns and plays on words that are so common in your work.

Derrida's work has a long and venerable — even if far too infrequently recognized — genealogy. At the head of the lineage leading to his work is negative theology, which has its origins in the writings of the Pseudo-Areopagite, though I would conjecture that Derrida would be most familiar with the forms in which it appears in writings of Avicenna and, especially, Maimonides. We could summarize this aspect of Derrida's thought by saying that language would be true only if its truth were Divinely guaranteed (consider in this regard Derrida's comments about the Transcendental Signifier). However, language has no such warrant, for language is a self-enclosed system — a system, one would be inclined to say, that "refers to items presented in experience." But the issue is more complex than this formulation of the problem acknowledges, for a language system actually shapes experiences and gives form to the items presented within experience. (Here I refer back to the fantasy with which our conversation began, but of course this is also the famous Sapir/Whorf thesis you refer to in **Rameau's Nephew....**) Derrida's debt to Nietzsche is again clear, for Nietzsche announced decades ago, in **The**

Will to Power that "Knowledge is possible only on the basis of belief in Being." For Nietzsche, the death of God is the passing away of all truth and the vanishing of all certainty. Even the being of the beings of nature became ungrounded with the passing of Being, and so knowledge as it had been traditionally understood — the conformity of thought to being — also lost its ground. Thinking that is not rooted in Being can know no certainities, for its questioning plunges into the downward spiral of infinite regress; only the concept of Being can account for any non-tautological, non-contingent truth. Derrida notes that we cannot know Being, for our language is based on our experience of beings. Hence he finds thinking caught up in the movement of endless deferral and endless intralinguistic reference. This aspect of his view of language seems to me to be, for precisely the reasons Nietzsche gave, the consequence of the negative theology that I believe is the germinal kernel of his work.

But your own work seems to mourn a similar lack of relation. This, I suggest, is amongst the ideas implied by your frequent emphasis of perspectival character of perception — that what we know is always partial and often, seemingly, ungrounded. A basis for your work's skeptical quality is the belief that thinking is a form of interpretation and ineluctably affected by the perspective of the interpreter, that there is no knowledge founded in direct apprehension of the thing as it is itself, unaffected by the conditions under which it is apprehended.

Snow: Puns, precisely, satisfy me in the way you describe. I realize they're dangerous but they involve the structural "Lego set" quality of the basic elements of printed words, the alphabet and how our communication creates a membrane over chaos: laughter so easily becomes slaughter, but only in writing. When spoken, puns bring in the musical aspect of speech. The late bpNichol's work is outstanding in its use of all the modes of text starting with our alphabet and its development. The CCMC played several concerts with the Four Horsemen (bpNichol, Steve McCaffery, Paul Dutton and Raphael Barreto-Rivera), a truly wonderful sound poetry group which did not continue after bp's death in 1988. We did a spectacular concert with them at the Holland Festival in 1985, at which Derek Bailey — the great English guitarist — joined us. Another Horseman, Steve McCaffery, an extraordinary poet and vocal improvisor and an interesting essayist, whose collection of critical writings **North of Intention**[7] contained an analysis of bp's work — and in

particular the problematics of puns. Steve McCaffery, Raphael Barreto-Rivera and Paul Dutton have also performed solo and together with the CCMC, until finally Paul Dutton became a permanent member of the group in 1990, making verbal/vocal improvisation an important part of our material.

Derrida, yes I've read much and feel/felt close to lots of it, particularly **Disseminations** and **Éperons/Spurs, Nietzsche's Styles**. About his work, I've always felt a Mallarmé/Hegel reduction might be relevant; unfortunately, I've read all his work in English translation. I can read French but after attempting one of his books in the original I came to the conclusion that I was missing more than I was gaining. I think "the original" really matters in his case, because there are so many *jeux de mots* and hybrid words in the French that the translated look, sound and sense becomes a second work. Of course his English is good enough that he can collaborate with his translators. The "endless deferral" in his work can bring on a great fatigue when the musical/creative contribution of the prose cannot rescue itself from the weight of the return of the same, as you say, "pessimistic" signified. "Thinking is really a form of interpretation." It is also a form of play.

One of the things history teaches us is that people will believe anything, and I don't see why "now" should be any different than "then. "

While I think your reading of the meaning field of my work is apropos and I agree with your digest of Derrida/Nietzsche on the endless linguistic reference, the endless deferral, there's an implied solipsism which is refuted by the fact that we *are* bodies and there is a physical world. It's true that it is *very* entwined or modified or "given form" as you say, by language. As the maker of artworks (while I'm making them, living their construction) I've always worked with *materials* which can be shaped, then apprehended as a sign and/or signifier (which is interpretive). In fact I would like my audience to have as much "unmediated" contact as possible from which to derive meaning and significance. That's important. Otherwise the work is just another reflection in a vast hall of mirrors.

Working with vibrations directed to the ear or eye (in time) is certainly more fugitive than making objects (especially with music) and the significance/meaning aspect

becomes even less graspable. Despite this (and the seemingly contradictory evidence of the CCMC) I think that formal principles are objective in the making, though not necessarily in the apprehending, and they make an object-in-the-world.

In **Rameau's Nephew...** I had the Toronto artist Dennis Burton modify a text I gave him in a manner he'd devised, which involved maintaining all original syntax but joining the ends of phonemes to adjacent beginnings and exaggerating chosen sounds (for example, O CANADA becomes OAK AND DADA). He read his version of the text on camera as a "talking head" lecturer. The text I gave him to read was stolen from a very interesting book published in 1943, called **The Nature of Explanation** by Kenneth Craik, who was brilliant but had a tragically brief life. The pre-Burtonification text is:

'A PRIORISM' AND SCEPTICISM 27

...ts are so in- ...on shadows ...ive a definite ...her, I do not ...tances, with ...if I make a ...datum when ...except con- ...my own at ...omenalist— ...all? How, ...r moment, ...lish? How ...nt the same ...know that ...nces, or to ...moment? ...must lead ...of his own ...is seeing ...s inability ...t things, ...moment ...at words ...ve in any ...y read his ...ly to the ...cepticism ...ght at all, ...hing; he ...to. His ...me par- ...ght and

language and action, and to utter emptiness. As Northrop (1931) says: 'The consequence of Hume's analysis is neither probable nor pragmatic science, but no science.'

Having reduced the sceptic to silence can we not now begin to say something? We can make a noise when a certain event occurs and find that this naming of events does work[1] on the whole. Now and again we may be misled, but this does not drive ordinary men or physicists to disbelieve altogether in the possibility of knowledge of the external world. As a result of making noises in conjunction with things we build up language, and in using language we make the discovery that this symbolical representation of events does in fact work just as when somebody tells us that there is a train to London at a certain time we do usually find that the rest of our experiences conform with this prediction. This language is based on the assumption of external objects behaving in a certain way. The primary fact is that we have discovered something by observation and experiment—we have discovered that symbols can work and can predict our future experience. Even our use of words to express this discovery is based on the same discovery. If symbolism did not work we could never express the fact that it failed to work; but as it does work we can express the fundamental fact that it does, and can say a great deal more besides. Thus we can surely silence the complete sceptic or the phenomenalist by pointing out that as soon as he opens his mouth to argue he is assuming that words can symbolise events, and that he is no better able to justify this assumption than the assumption he rejects—that words are able to represent external objects and events. Thus the use of language itself is based on the principle that any symbolism which works has objective validity; and it is illegitimate to use words to contradict this principle. Such

[1] See Chapter V for discussion of this concept.

As well, I think a totally "cultural" view of language is mistaken. It's a physiological aspect of this species. We are a symbiotic product of millions of years of evolution with other forms of life. This is definitely a nature/nurture criss-cross but the necessity

for speech is in our DNA. As a bee's or dog's apprehension of the world is theirs, ours is ours and it involves our genetic structure. It's difficult to know whether to laugh or cry about this.

We land organisms derive from aquatic ancestors and retain many aspects of these water relatives. The concentration of salts in both sea water and blood are, for all practical purposes, identical. These salts are compounds which sea animals took with them as they, over the millenia, made the perilous voyage onto land. Sweat and tears are basically sea water.

The first tiny animal brains appeared six hundred and twenty million years ago. Human consciousness has recently arrived at tinkering with DNA, a participation in the ancient process of bacterial genetic transfer which was primordial life for billions of years before animals developed. In one of life's giant self-referential loops, changing DNA has led to consciousness which enables us to change DNA. Our curiosity and its linguistic codification are the evolutionary avant-garde of life's strategies for expansion that began three and a half billion years ago.

I don't think language is "foreign" to the rest of the universe, as Derrida does, consciousness being the result of the activities of millions of microbes evolving symbiotically to become the human brain.

My "skepticism" is more of a directing-attention to the experience of "belief" and an attempt at maintaining the signifier in the experience, rather than have it vanish when its work of meaning is done.

I realize there is a difference between Craik's and my attesting that language "works," and your proposition that "subjectivity has no immediate access to things." But I think there are things outside "the text" and perhaps some of the anxiety that you comment on as experienced with my work is the strain of recognizing an attempt to be momentarily as free of "language" as possible.

Elder: The philosophers Locke, Berkeley and Hume have argued that consciousness does not acquaint us immediately with the objects that constitute the furniture of the external world. Our immediate acquaintance is with impressions and ideas, the stuff of our mental life. "We are locked within the circle of ideas," is a common means of asserting this claim. Immanuel Kant, though in the end he argued against Hume's radical attacks on

our claims to apprehend the spatial, temporal and causal principles that order the world as we know it, accepted the empiricists' claims that we have no knowledge of the noumenal world, the world of things-in-themselves. Kant's thought looms over the works of the French structuralists; and even Derrida, for all his anti-structuralist tendencies, has not escaped his influence.

While reading Derrida, I often get the feeling that I am reading something that a contemporary Kant might have written if he felt his "Transcendental Deduction of the Categories" was breaking down and he was being cast back, abjectly, into the realm of Hume. For Derrida attributes to language something of the power that Kant does to the forms of intuition and the categories of understanding, for Derrida depicts language as shaping subjectivity — in fact, he proposes that subjectivity is simply an effect of language. According to Derrida, subjectivity never has unmediated access to things; its awareness is an effect of signs, and the meaning we apprehend through signs to not disclose their meaning in a pure act of self-revelation, but only by our discerning their relation with other signs. The relations amongst these constitute the system which gives each sign that belongs to it, its meaning. This aspect of Derrida's work might be paraphrased by saying that consciousness is an affair of meanings that depend on signs, that meaning is not a matter of a sign's presenting its material referent — that a sign's only reference is to other signs within the system to which it belongs. Hence meaning, and so consciousness, is locked within a circle of intra-linguistic reference. This is not so remote from saying that consciousness does not acquaint us with the noumenal realm, but only with things insofar as they have been conformed to the categories that the mind imposes on them. "*Il n'y a pas d'hors texte.*" We know nothing outside of language.

Derrida's thought shows affinities with Nietzsche's in this regard also. For Nietzsche had pointed out, in **The Will to Power**, that "We *think* only in the form of language ... We cease to think when we refuse to do so under the constraint of language." The claim this statement stakes is not so different from that we make by saying that consciousness knows nothing that is not given within consciousness — nothing beyond itself, or beyond what we presume are the effects of objects on the sensory system and mind.

But many of your own works offer formal analogues to the structures of consciousness; **Wavelength** is the work most frequently cited in this connection, but it does seem a recurrent concern in your work. Your interest in recording derives from an interest in the faculty of memory, surely. Your efforts to foreground the medium of representation in the artistic works that you have made, develop from a desire to reflect on consciousness itself and more importantly, on the distance that separates those objects in consciousness from the objects they represent.

Hence I add to the list I have enumerated thus far (of ways our desires to merge with the objects are thwarted) another: consciousness' self-reference makes it impossible for us to make contact with the noumenal objects that support and condition its phenomenal contents.

Snow: These claims for the primacy of language in human perception (you mention Kant, Nietzsche, Derrida) are true but not all-encompassing. "We think only in the form of language. We cease to think when we refuse to do so under the constraints of language" is a general truth but surely it is the special pain of philosophers, not so much of musicians or painters. I know I often think in images or in visualizing processes. Creative thought is often "formal" not "linguistic." I came across an interesting statement by Albert Einstein ... in explaining his thought process in a letter to Jacques Hadamard, he wrote that to explore the physical world he used non-verbal symbols, an abstract language of "reproducible elements." Explaining how he came to his spectacular discoveries, Einstein said:

> The words or the language as they are written or spoken do not seem to play any role in my mechanism of thought. The psychical entities which seem to serve as elements in thought are certain signs and more or less clear images which can be 'voluntarily' reproduced and combined.

He went on with the assumption that to him there was no essential difference between the "mere associating or combining of reproducible elements and understanding itself." He believed that his thought processes proceeded by a "rather vague play with the above mentioned elements" and

> this combinatory play seems to be the essential feature in productive thought — before there is any connection with logical construction in words or other kinds of signs which can be communicated to others.

In relation to that, the first statement I ever published about my work (reproduced in **Collected Writings**) was in 1959: "I make up the rules of a game and I play it, if I seem to be losing I change the rules." I still feel that's "right."

Sound/image being separately manipulable elements in cinema, provides an historic possibility for inner/outer sensory constructs that deal precisely with the guidance of the spectator to varying states of consciousness.

I'd like to quote a couple of paragraphs which seem relevant – from our previously printed discussion in **Ciné-Tracts**:

Speaking of religion, I've always wanted to hear everything said at once but while I'm waiting I must say I'm always embarassed by what I say. I doubt if it's sillier than what other people say, it's just that so much has to be left out! Naming that list of artists (from all artists!) saying that that historical line "exists," concentrating on the "modernist" attitude neglects so unfairly so much! But that's obvious isn't it? Just be interested.

I am very grateful for your [Bruce Elder's] insightful description of the temporal states sometimes generated from my work. I've never been able to systematically and objectively understand how it's done. I've always hoped that I and the spectator might benefit from my own attempt to apprehend and invoke a participation mystique with the nature of the "reality" being presented by the little things I do and be led to extrapolate (emotionally or intellectually) that situation to the larger situation to which it belongs. My own fairly obsessive attempts at resolving existential problems have always started from an attempt at realizing a specific concrete/materialist base. Successive seeming clarifications in my philosophy as in many others always head to a Mystery. I'm not a "literary" philosopher but, if we are here to name everything, it all has to build to a Transcendental Signifier. Out of facetious humility, I'm "religious." The paragraph above means that I'.m resigned to begging for revelation and thus probably don't deserve it. But who's to say?"

"Deferral" seems to mean that finally only "God" could give all the possible meanings of an utterance. But "He/she/it" won't, can't. Deferral is also a reference to the living power of language in all its usages: poetry, prose and "practical" and "technical" forms.

The relative constancy of language comprehension ("proved" by action taken) in a given location and time period is amazing. The constant metamorphosis of English language terms, accents and dialects all over the world is a fantastic example of the organic resilience of speech (Australia, Louisiana, Brooklyn, Newfoundland etcetera).

A "Transcendental Signifier" can be evoked in "religious" minds by **Wavelength**.

Derrida's discussion/defence of Paul DeMan after the publication of accusations that he had collaborated with the Nazis in war-time Belgium was a fascinating and sad attempt. I was reminded as much of Kierkegaard's * as of Derrida's work. Reading his consideration of the tragically ironic secrecy of someone he knew well was to experience a poignant "impracticality" in Derrida's thought. "Deconstruction" is no addition to the rhetoric of litigation.

I think I should pass the ball here to Derrick de Kerckhove and Marshall McLuhan. It seems as if people in general (because of TV) are becoming more visually involved and *less* literate, so that perhaps "language: is in fact less restricting than it was." Of course general literacy is very recent (but obviously not language).

A mirror relationship might be found in the fact that pop music has always – and especially in the now-twenty-year-old Rock era – been *songs*. "Instrumentals" are almost hopeless commercially. Electronic magic and the revolution of amplification, to please the kids *must* be only grounds to a single verbally emoting singer.

People apparently find the words of a song important. This no doubt colours the meaning of the accompanying music but the persistence of *words* is interesting. This (and TV) are part of a resurgence of the oral over the written which McLuhan correctly predicted.

Elder: I have commented elsewhere on some striking similarities between your artistic ideals and those of another great Canadian artist, Glenn Gould. (His name even appears in your notes on the **The Last LP**.)

One of the principal influences on Gould was the profound thinker Jean LeMoyne, whose work is too little read. LeMoyne expounded his (vaguely Kantian conviction) that technology has, in its total, systematic character, become a "second nature," one machine that encompasses the whole earth, so that we can only understand nature as it is presented through the mediation of technology. Technology has come to constitute an epistemology. A considerable portion of your *oeuvre* has been made using the implements of nineteenth and twentieth century technologies — those which enfold

our being. You have made photographs, films and holographs and you conceived and designed the elaborate, radio-controlled camera mount that you used to make **La Région Centrale**, a great film on a landscape unaffected by industry and technology — except insofar as the images are shaped by that machine that inherited from the Renaissance pictorial codes deriving from geometric optics.

As George Grant pointed out, technology is not something external to us — not an array of implements lying outside us and available for our use. *Our* being is enfolded within that of technology, and so technology has entered into our inner recesses. We are the implements of the one machine that by now has come to encompass all of nature. It is our way of hearing and seeing and thinking and feeling. Thus even nature itself remains something that is beyond us, inaccessible even at the level of our being, for we are not simply creatures of flesh any longer. We too are becoming objects of metal. (If you think this is hyperbole, you might take a look at the writings of Hans Moravec, Marvin Minsky, and the performance artist Stelarc.) **La Région Centrale** is awesome, and as tragic in its relation to nature as that of our own being. **The Last LP** shares this feeling.

Snow: What you've said here so movingly has pushed to the surface two areas of thought. The first is that my work, since it became mine, has been involved in an oscillation, which is no doubt that of a lapsed Cartesian, between Mind and Body. I'm still oscillating, which might account (slightly) for my work's variety and its frequent dualities, twinning, doubling, comparing, schizophrenia, sex. On the one hand, there is the body-made (and/or real-time) made-by-an-individual shaping (here painting is to me still the ideal, solitary, totally tactile and capable of unforseen nuance). On the other hand, there is twice-removed projection, as much mental as physical, even if originating with myself still passing through a technology (photo-works, films, video installations, holograms, bookworks). The hand and mark of the maker is distant.

I was one of the first artists to work with photography and now in the art scene it is prevalent in such frequently superficial (and endorsed) ways that I see its acceptance as being in some ways corrosive of the continuity of art values. People in the visual-art world seem increasingly reliant on twice-removed experience (e.g. photos whose subject matter is affective but unrelated to its physical manifestation) to the extent that first-hand experience (something tactile or hand-made) can disgust them. Involved in this "taste" tendency is the cultural constant of television.

I'm interested in human creativity in all its manifestations so I'm continually astonished (and sometimes frightened) by growing technology. I think any filmmaker should be interested in any moving-image technology. So-called Virtual Reality is part of the human representational desire that produced photography, cinema and television. My fears are somewhat tempered by my feeling that the Electronic Revolution is more benign for the earth and its life forms than the Industrial Revolution was/is. But despite my occasional use of "new" technology (I'm frequently asked to submit work to "Tech" art shows) I'm constantly recoiling from it … and back to "it."

Computer Music is developing an extraordinary range. CCMC played at the Electro-Acoustic Music Festival in Montreal in 1991, where we had the opportunity to hear many state-of-the-art works. One of the most beautiful was a performance by computer/synthesizer of a process/program composition by Jean Piché which has defined parameters of pitch and all other music variables but has so much range that each performance is different and of a different length. The composer himself is constantly surprised. We discussed how strangely similar it was to the CCMC's principles.

The electronic arts contain many magical possibilities and far more positive pleasures than negative. While Murray Schafer doesn't agree, I think they're "eco-sensitive" and could be a model for our escaping some of the disasters that industrialization and the population explosion have caused.

As you've said, **La Région Centrale** is a film "on a landscape unaffected by industry and technology … unaffected except that the images are made by an elaborate machine." I think your own films share in this contradiction or paradox, that a tragic loss caused in part by technology can be described especially well by technology.

But that's where I put my hope that the "art" uses of technology may help to swerve us from its destructive uses.

Your point about technology making "nature" something more and more inaccessible seems true. It is building a house of mirrors in some ways.

We mentioned the following text in our **Ciné-Tracts** discussion but I think it's perti-

nent to reproduce it here in two versions.
The first is a scrap of paper with the text
composed in toto. I was in Cambridge,
Massachusetts showing films sometime in
1974. The other version is the film script
I typed (badly) for its use in the film
Rameau's Nephew.... The way I finally did it
in the film was with a male voice that lisped,
rather than being "electronically altered"
and instead of superimposing "spray-
painted dots" on the scene I made actual lit-
tle pin pricks in the film.

To continue the body-made/non-body
issue above … In the CCMC I went through
a number of estimations and re-estimations,
which are still going on in the world of jazz
and improvised music.

Open or "free" improvisation entered jazz
through an extension of the close-to-the-
breath or lips or hand achievements of jazz's
personal expressive style. Just think:
Coleman Hawkins, Lester Young, Sonny
Rollins, John Coltrane, then Albert Ayler.
All tenor sax! In the early '60s I knew and
loved this music but I was involved in other
kinds of music that moved me too (Lamont
Young, Steve Reich, Phil Glass, Bach,
Schoenberg) and with **New York Eye and
Ear Control** (1964) was starting to think
seriously of the nature of recorded sound
and image relations, arriving at my sense

that recording and representation could
or should become conscious objects for art-
works.

Loudspeaker sound from pre-recorded
or pre-systematized sound sources (like
film sound, or working with radio itself)
seemed/seem to me to be a particular area
of sound production. Despite much studio
playing with tape recorders (I made feed-
back tapes and loops in 1963), including
the macro/"enlargement" use of the sound
of **Dripping Water** (a film made in collabora-
tion with Joyce Wieland in 1965), I was
resolving my understanding of electronic
played sound in my first few years with
the CCMC, which from its beginning used
synthesizers, electric pianos, electric bass
and guitar and amplification for the horns
and piano. One of our premises was that
"orchestration" and "sound qualities" were
important parts of our process of discovery,
hence *any* possible sound source was usable.
The distance from "expression" of purely
synthesized electronic sound and the limited
touch control on electric pianos were impor-
tant problems. Around 1975 Nobuo Kubota
started using pre-recorded cassette tapes in
the music. These were and are exciting
things to work with and were/are all part
of the wonderful openness of the group.
An aspect of that is, for about fifteen years
there were two pianos, myself and Casey
Sokol who came to free improvisation from a
complete classical training; he had no jazz
experience. We always used two grand
pianos and two electric pianos; since every-
one else played some piano sometimes there
were four keyboards. Playing out of my jazz
background with Casey was a wonderful
experience which affected us both. (See
"CCMC History" in this volume.)

The dialogue desired by the CCMC and
the skill of the players made me recognize
sounds more and more for themselves and
not to ask for the wrong quality from the
wrong source. Electronics introduced
another layer to the "quoting" that we'd
started to recognize in the music.

The CCMC has been largely disregarded
by the jazz scene in Toronto, perhaps
because it doesn't fit the right categories.
In my opinion originality has been one of
its problems here. Our use of electronics has
been described disparagingly as "sound
effects" by Bill Smith (musician/writer for
Coda magazine, who was part of CCMC in
its first year). Yes, there are sometimes what

could be called "sound effects" – part of the incredible range of sounds available with electronics – but they are *musical* materials. In fact John Kamevaar used modifications of material from a "sound effects" record as almost his sole source of sounds in a wonderful CCMC piece called "Things Go" for Tape 2 of the **CCMC '90** set of cassettes. There's a terrific "car starting" sound after a beautiful blues section, then later, behind a vocal soliloquy by Paul Dutton, a telephone rings. It's "narrative," "atmosphere," and very musical.

Technologies are human projections and they have evolutionary sources, and may enter evolution. We may be a plague to the biosphere, and unless we reverse our trend (which is in our power) we may be the cause of the next global catastrophe (*we* managed to survive through and be transformed by the last Ice Age). Worrying about whether we are "becoming objects of metal" already seems dated because current paranoia should be more legitimately focused on "biotechnology." Recombinant DNA genetic engineering is producing new species of organisms combined with continually accelerating computer capacity (intelligent machines already aid in the molecular design of new drugs) and robotics seem almost a companion species, not a metallizing of us.

But think of the breathtaking success of the four robot spacecraft designed to study our outer planets, all launched in the 1970s. From 1976 to 1980 the Viking orbiters and landers periodically surveyed the lonely stillness of the Martian landscape and sent those images back to earth. NASA funding shortages stopped this – but what an amazing work of art/science. **Voyager 2** has visited Jupiter, Saturn, Uranus and Neptune. All four spacecraft have passed the orbit of Pluto but despite the enormous distances are still (1992) making observations and transmitting the data back to Earth. **Voyager 2** is going out of our solar system into the area provisionally known as the heliopause, about which little is known. Bravo. Cosmology, astrophysics, paleontology, microbiology are fields of special interest today.

Elder: Another site installation, **Hearing Aid** works with the theme of memory — as do **Tap** and, for that matter, **Wavelength**. **Hearing Aid** consists of a metronome, which is sounding into a gallery space. The sound of the metronome (and the space through which it spreads) is recorded, and that recording is played back on a small cassette

recorder in another space; the output from that tape recorder is recorded, then played back on another more distant recorder, and the same process is repeated on another. (When I saw it, at the Musée des Beaux Arts in Montréal, it was installed in a long corridor at the top of a staircase and the large, adjoining gallery space.) Like many of your works, its form derives partly from the aesthetics of mini-

malist and conceptual art; this explains, I think, the similarity that it bears to Alvin Lucier's **I am sitting in a room.** Those material concerns are important, for the work does foreground the effects of the medium of representation and does deal with the representation as a material reality in itself by raising to the level of significance features intrinsic to the processes of recording and re-playing sound and always perceptible but commonly disregarded. But, I dare say, the concerns of the piece are not solely, or even principally, constructivist concerns of the sort that we generally associate with minimalist and conceptual art. For we recognize in **Hearing Aid** issues with which your visual artworks have made us familiar: memory, movement and space. In fact, we recognize that it is a site installation, like a sculptural work whose spatial organization is of its essence, though less solid and more dispersed than that of a sculpture. A mark of this dispersal is that

the work opens to the environment, as the acoustical properties of the environment are incorporated into the work. Another feature of the work's spatial organization is similar to a characteristic of your films: the work spatializes time, to use Panofsky's idiom — it uses a spatial form as an analogue for the structures of time and memory. Thus as we move through space, we leave one event behind and

observe itself. To separate the viewer from the participant, to attain a state of objectivity that only a visitor from another planet might have.

In a parallel way consider the evolution of machines, which though not based on models so evidently as in representation do attempt to objectify activity, for example flight and thinking. It seems as if we are in the crude stages of creating new forms. These new species are at present enjoined by their fondness. Eventually they may be self-sufficient and self-reproducing, like us in those respects but unlike us in many others. Perhaps a similar superimposed growth towards independence accrues from our existence. The future may present at some stage: the line of the species we have created living with us and our absolute mirror-image, other wise indistinguishable representation.

* CAMERA and EYE?

approach another. When we approach the source of one sound, the other sound fades away, just as movement is movement through time, as we approach the next moment, its predecessors vanish into the past. We move through space as "the now" moves through time and our moving in space suggests the manner of event receding through time.

Furthermore, as we walk away from one tape recorder towards another, we hear a more echoey, and therefore muffled, version of the same sound we heard before. Its clarity and distinctness diminish, suggesting what happens to events as they recede in time and fade in our memories. What we hear, transformed through the effects of space, is the sound of a metronome, a device for keeping time. This layering of new features onto a core that comes closer and closer to vanishing resembles the work of memory.

Furthermore, even the stress on the reality of representation serves to reveal that every representa-

tion is a distortion, for there is no system of representation that preserves the thing represented in all its purity and individuality. As Derrida points out, there can be no language made up only of proper names.

Snow: Your preceding paragraph is indeed a very sensitive reading of **Hearing Aid**.

To me, "every representation is a distortion" is not a meaningful proposition. Representations are *derived*, they're not even mirrors. While "no system of representation preserves the thing represented" seems true (I can think of some possible non-linguistic exceptions) it also seems a misunderstanding of the "stand-for" aspect of language. A representation can "distort" sensory perception and thought but it can't distort the signified itself. Words are parts of a code or system of substitutions. Representations *are* "abstractions." We abstract *from*. Nothing is "Abstract."

The exceptions I thought of may not be contained within your categories but mass production is a "system of representation that preserves the thing represented" as is the making of casts of sculpture from molds. "Mass production" of course includes films and tapes! But is "it" representation? (I think yes.)

"Proper names" — well, there is a work of mine **Sinoms**, which is not a language but it is an isolating of names for their sonic/social/political/psychological significance.

Elder: **Tap** uses a sound that draws attention to itself, to the present and to its presence. Ironically, though, the original tapping sound comes from another time — firstly from the time and place where you tapped and recorded the sound, then from the other place and time where the tape plays. However, the tapping sound, is present in the room, in a sense. Its presence and its absence have an extremely intimate and convoluted relationship with one another (as they do with any strongly illusionistic work). Yet, as powerful as the illusion of presence is in this work, it makes the impression of absence stronger.

In **Tap**, as in many of your visual artworks, you seem to raise the hope of using representation to re-present (literally) the object recorded. At the same time, you bring into evidence the medium that intercedes between the object recorded and the viewer. I suggest that the strong feelings your work elicits depend upon our desire to make a connection with the object in its full, luminous presence, to transcend all categories and all intermediaries to reach the thing itself. Then, time and again, you point out that the object is never known in itself, but only through the agency of a medium.

I venture to suggest that these strong feelings relate to a desire we harbour to transcend language, to tear away the screen that language puts between consciousness and things, and to form unmediated relationships with things. We long for a means whereby we could tack down the relation between words and the world, that would fix our understanding of objects. But a word never fully presents the world; language does not acquire significance through reaching outside language and serving up to us the world in the immediacy of full presence. Language acquires meaning only by making reference to other items within the language, by the differential play of signs among themselves, not by making reference to some external thing.

We secure meaning only at the price of entering into a system which then mediates all our relations with things and fixes our understanding — and to all intents and purposes, makes us conscious, for outside the realm these systems disclose there is only the nothingness of random, chaotic impressions. (This is the chaotic realm that most of us learn to forget, in which I proposed earlier in my fantasy tale, a part of Conrad and Zukofsky's being was invested in. The portion of their being that was being-in-language was smaller than it is with most people.) Language is the condition of meaning, and to purchase meaning, we buy into language. The cost of this acquisition is that, once we have acquired language, language mediates all our relations with things. To think, we need a language, but the acquisition of language prevents thinking from making direct contact with things. The feeling that language has no outside, that we cannot reach beyond representations to things, is one that you expose again and again.

Snow: One of the hopes for visual art is that it will direct and teach eyes (which are after all buds of the brain) to see particulars in the condition of "random and chaotic impressions" which the dominance of language trains people to receive. But seeing "formally" (that is seeing "order") is also a biological projection of our cellular, bilateral symmetry and sex, which again language has had a hand in suppressing or modifying.

It's true that the feeling "that we cannot reach beyond representation to things" is something my work sometimes "exposes" but I hope that contact with the work leads one to see the "things" in a sensory, sensual way in an emanation of meaning-areas.

Actually, in contemporary society people's time is increasingly lived in a world of representations and this seems in some ways dangerous.

I have seen marvellously-made nature programs on television (a particularly impressive one was about a giant salamander that exists only on the coast of Japan) but have sometimes felt with horror that because of the privileged view one has of impossible-to-see-in-person animals and events, and because they are now recorded, *this* is really the end of nature. It is documentation and castration of "nature" for the couch-potato. When it's all recorded it can all die because we'll have its representation in a convenient easy-to-play cassette form.

Many technological variations of this kind of artificial life are being worked on.

Retaining experience of the pre-verbal in the full range from traumatic terror to amorphous ecstasy, as subconscious pressure to conscious nurturing, is probably the defining psychological factor in all areas.

Being an artist is infantile and we know very well that the therapeutic coping with early impressions is part of it. I have a personal experience of language that I think has affected me. More about that later.

The characteristics of Art and Artists are astoundingly present in Shamans and Shamanism. I have read a lot about this and the frequency in many tribal societies (Siberia, Mongolia, Tibet, North and South America) where the Shaman is a psychological "misfit," and very often homosexual, is remarkable. The Shaman heals him/herself by inventing medicine/theatre/music/narrative for the rest of the tribe and thus becomes an operative, contributing member of the tribe, not just a problem! Art for the audience thus may be *also* a momentary return to a pre-verbal freedom and have the social function of "reminding" those gripped by the dictatorship of language that it is possible to "uselessly" see, hear, move. (Though I tend not to feel the need for "entertainment" it is nearly impossible to remove "Art" from the general field of "entertainment.") The "reminding" can restore awe, since it is psychologically primal; its themes are the fundamental Mysteries, thus "religious."

I think solitary play — asociality — is an aspect of the childhood of artists, so the accusation that Art is masturbatory is also true. The solitary play of more and more children is television, rather than imagining. TV is an artificial imagining. It remains to be seen how this will affect the ancient continuity of Shamanism.

Elder: To return to the considerations I introduced early in this conversation; these feelings derive from a revelation that would only occur to someone who felt him or herself at the margins of language and meaning, both inside and outside language and seeking for the unoccupiable position of alterity to language.

Another sound-image installation piece, a film installation in fact, raises related issues in an affectively compelling manner. I refer to **Two Sides to Every Story**. The title suggests duality and dialogue, a tension between two things both like and unlike — a tension operative in several of your pieces. As with a number of your visual art pieces, this one re-enchants a dead metaphor by literalising it.

This installation consists of a thin, white screen, suspended diagonally in the middle of the room, and projectors in opposite corners of the room projecting onto either side of the screen. Sound accompanies the images, in the form of directions that you apparently gave to the performers during the shooting. The films we see were shot from two synchronized cameras, mounted on tripods set up facing each other at opposite ends of the room. You sit on one side of the room next to one of the camera operators, back nearly against a white wall. On the opposite wall, a second camera operator films, back against a dark window through which we see the lights of automobiles moving in the dark, and is filmed as he films, as you are filmed looking through the director's viewfinder or reading from a list of instructions, the script, which you hold in your hand and use to direct a walking woman who is seen from two sides (unlike the camera operators and yourself, who is seen only from one.) Many of her movements are along the imaginary line between the two cameras and so are recorded by one camera as approach towards it and simultaneously by the other as retreat. Throughout, we hear rain.

Recto-verso construction such as one finds here has an impressively long history, and you had made use of it previously, in an extended form, in your photographic book **Cover To Cover**. Especially notable in **Two Sides to Every Story** is the way it uses recto-verso construction to make reference to the moment when the performers were recorded. For the spatial organization of the installation appears to be isomorphic with the set-up that was used to make the piece: The projectors are situated approximately where the cameras were, and the events unfold on the screen in real time, so the camera saw them approximately, but not exactly, the same way that they are shown on the screen. There are other self-reflexive devices. For example, an instruction appears, its immediacy reinforced by the imperative mood and we see, if we are positioned appropriately, a performer respond.

To emphasize the isomorphism between the shooting and projection situation, a thin screen was hung in the centre of the room where you filmed; at one point you instruct the woman to go to the centre of the room and, when she puts her hands forward we notice that they press against a thin transparent sheet; she is then handed an aerosol can and, moving her arm around in circles, she sprays part of the sheet green. A man then splits the screen and she steps through it, rather as we feel when watching the recto-verso projection that the performers are walking through the suspended screen. Furthermore, after the sprayed sheet has been cut, the woman returns to the centre of the room where she gestures as though making a screen with her arms. She is later given a matte board, which is blue on one side and yellow (blue's complement) on the other and the camera operators are given blue and yellow filters. There then develops a dialogue between the cameras and the screen, as we see on one side of the screen a solid colour, for example, and on the other the woman, viewed from behind, with only an edge of the matte board visible, or one side of the screen tinted, then the other, etcetera.

This isomorphism of the shooting and projection situations suggest that the situation we view recreates the situation just as it was filmed. Even the rain seems to act similarly to the way the taps do in the piece entitled **Tap**, as they seem to make the ambience of the projection situation the same as that of the filming; this is especially true since the piece, as a film installation, must be shown in a darkened room, without windows. However, the viewing situation is not really isomorphic with the filming situation. There are significant differences. The event we see on screen is projected onto a two-dimensional surface, while the event the camera recorded took place in three-dimensional space. This means that if one had been present when the film had been made, one could have walked into the space of the performance, or one could have walked around and taken in different aspects of the objects in the space. If we situate ourselves in different positions in relation to the film screen, however, we do not see different aspects of the event but simply see the same flat surface from different angles. Furthermore, the event that takes place on the screens is in Ektachrome, Kodachrome, Fujichrome, Gaevertchrome or whatever, while the event that took place in front of the camera was in living colour. The isomorphism thus suggests the identity but insists on the difference between the two circumstances.

Crucial to the experience that **Two Sides to Every Story** elicits is that we cannot see everything we want to see. We hear you issue an instruction, but it might be carried out on the other side of the screen. We need to, but cannot, be on both sides of

the screen simultaneously to see everything that is going on. This points to the inevitably perspectival character of perception, a notion you have worked with in other pieces. It is this emphasis on the perspectival character of perception, knowledge and understanding that I want to consider. Something is always happening on the other side of the screen, in a scene we imagine (for though we can often guess, we cannot know for certain, because of the variations described above), that what we see would be as it would appear if viewed from behind the scene. The half-imagined, half-unreal scene we are describing has many of the characteristics of *l'autre scene* that psychoanalysts deal with, that scene that we long to merge with, but cannot. We want to see everything, but only a being whose nature was not subject to the vicissitudes of spatio-temporal location could have such knowledge. So this piece also awakens feelings of longing for a wholeness we cannot apprehend and, I would argue, we can never be, since we cannot be whole if we do not know the Whole, the All-in-One. This integrity is what we long for, even as we are excluded from it.

Snow: I can add nothing to such a superb description and investigation of my **Two Sides to Every Story**.

In the first stages of planning the retrospective at the Power Plant, Louise Dompierre and I included **Two Sides To Every Story** but finally we decided against it, partly in order to have more numerous smaller works and thus a wider range. **Two Sides ...** takes a lot of space and nothing else can be shown in the same room with it.

Your "feelings of longing for a wholeness we can never apprehend" and "only a being whose nature was not subject to the vicissitudes of a spatio-temporal location could have such knowledge" and "...if we do not know the Whole, the All-in-One ..." are all statements of religious yearning, the sources of which (in the Freudian view) can be found in psychology, in the pre-verbal.

Your mention of "*l'autre scène*" as perhaps the Ur-scene instigation of **Two Sides ...** in the artist and reflex in the spectator's psyche, is interesting and (but Who knows?) relevant.

Naturally my father and mother are involved in my psychological formation! My childhood traumas (probably) are set in or against a particular linguistic/social background and might partly account for the frequent presence of dualities in my work. A Canadian autobio.

Two Sides to Every Story by Michael Snow, 1974, film installation, 16 mm, colour, sound, two projectors, aluminum screen painted white. National Gallery of Canada, Ottawa.

I find I cannot accept certain aspects of the codification of childhood experience and its effects in Freud/Lacan. While there will be many cases where this analysis seems to be true, the effect is to reduce the possible contributors to one's psychological growth to a few pre-verbal crises. These may be the first "recordings" of certain perceptions (or perhaps mis-perceptions from the adult point of view) but there are far too many other factors to be considered for them to be generally the major part of character formation. Psychoses may be traceable to some infant experience but they can't be reduced to those causes because they happen to *someone* and much more happens later.

As a parent (apparent?) with some awareness of Freudianism it's been interesting to be so frequently baffled, watching for the Mirror Stage, etcetera.

First of all, a real person is born, an

individual organism with his/her own tendencies. These tendencies are unknown to everyone but may be twisted or assisted whether inadvertently or not. Which flavour or tone of an event will be retained? The idiosyncracies of the new individual involve personal interpretation right from the beginning, which the parent has to learn, too.

To perhaps overemphasize the genetic: the results of many years' research on identical twins – separated at birth and reared in different circumstances – have now been published (1992). One might expect personality resemblances but the extent of the quantifiable similarities is incredible (professions, tastes, politics etcetera). In one of the classic cases (apparently four thousand have been studied) two men reared separately with no contact both became firemen!

Elder: If Tap is premised on a radical use of dispersion, some of your discs have been built on a much more stringent idea of unity than most "records" are, for yours integrate sound, album cover design and text. The Chatham Square album, **Michael Snow: Musics for Piano, Whistling, a Tape Recorder and Microphone** is an example. The longest piece on the disc-set, "Falling Starts," is based on a recorded piano figure that goes from the lowest note on the piano and works its way up

to the highest. The overall architecture of the piece is similarly simple: it begins with the recording played very fast, and slows down little by little, until it is played very, very slowly. The form itself (or the process that it mobilizes) has results analogous to the fruits of attention, for it discovers many unexpected features in the original recording.

There are, I suggest, two main tendencies in contemporary art. One stresses speed, movement and change as analogous to the whirl of images and ideas in consciousness. Artists belonging to this group tend to be committed to imagination and to disparage those products of the mind that do not find a pure visual form; many therefore are skeptical of the work of the intellect. The other attempts to engage prolonged attention so as to reveal ordinarily passed-over richnesses; the contemplative response their work elicits resembles that which prolonged philosophical meditation evokes; so artists belonging to this group are generally open to forms that have a conceptual basis. The former line descends from Ezra Pound, the latter from Marcel Duchamp. All in all, though, your work seems somewhat more closely allied with the latter, for as I noted when comparing your interests with Glenn Gould's, your work, like his, delights in the revelations that result from taking a long, hard look at something. But since I covered some of that ground previously, perhaps we should let those concerns be for now.

The text printed on the cover is highly self-referential, as "Falling Starts" itself is. Moreover, the text's graphic design (and the text really is made graphic through its design) has an overall shape that is isomorphic with that of "Falling Starts": it starts out large and gradually becomes very tiny. Further, the text, while partly informational (about the musical pieces "inside the jacket"), has a conceptual density and ironical richness that makes it an object worthy of attention in its own right — that is to say, as a piece of literary art.

The cover design of **The Last LP** is similarly integral to the work; **The Last LP** is a text/sound/ image construction, not a sound recording covered in a decorative sleeve. The notes on its jacket suggest that the album comprises recordings of a number of musical groups; the array of instruments that appear on it, and the relations between the different "instruments" on a single "cut" also suggest that we are hearing the coordinated product of several instruments playing simultaenously. However, the ironical use of jokes, inconsistencies, and lexical exaggeration (especially with regard to the "factual data", the names of the performers and composers, the locations where the recording was done) exposes the deception that we are hearing ensembles, for what it is. Thus the liner notes create and deconstruct an illusion of ensemble just as the music does.

Furthermore, the commentary on virtually every "cut" contains statements about the impact the modern world is having on the cultures these works pretend to be drawn from — or to put it otherwise, it contains statements about the impact the culture that produced recording technology is having on the the cultures that supposedly produce the sounds we hear on the gramophone disc. The commentary is aware then of an almost paradoxical relation between "primitive" culture and technology — for while our technological civilisation is destroying theirs, it also helps preserve something (if only a simulacrum) of it.

There is a not completely dissimilar paradox inherent in the status of both recording technology and representation: both seem to be secondary realities, that depend on another reality that they derive from and supposedly represent (and whose place they sometimes seem to usurp), but in fact they are primary, actually creating what they only appear to represent. The illusion of the ensemble also has a similar status — what seems only a secondary presence is actually a productive device. It is a common strategy of Derrida's, too, to demonstrate that a phenomenon or object we usually consider to have primacy is actually a secondary or derived reality, and a corresponding phenomenon or object we are accustomed to regard as secondary, as a derived reality, actually creates the reality from which it appears to derive. Derrida too propounds the idea of the primacy of the signifier and the notion is crucial to his arguments concerning the impossiblity of extralinguistic reference. **The Last LP** thus suggests, in its conjoining of issues concerning primitive cultures and issues of representation, and in its efforts to show the creative primacy of that which we are accustomed to think of as representational, ideas that are strikingly similar to ideas Derrida proposed in his discussion of Rousseau — an area of Derrida's writing that is especially dear to me.

But to return to remarks on the integrity of text/image/sound in **The Last LP**. The notes on the album jacket include remarks on the history of vinyl-microgroove recording technology. The album jacket also incorporates a photo of a drawing on clay of a mock-antique character, which the notes tell is a priceless artifact in the possession of the Kagyupa sect of Tibetan Buddhist monks, indicating the possibility of astonishing antiquity for the Amitabha ceremony, music for which appears on the album. But the drawing is clearly not antique. Moreover, the dimensions of this object of supposedly great antiquity are given as 12 ¾ square inches — the exact size of a record jacket (making us recognize that the object described is in fact none other than the cover illustration). What passes itself off as a derived reality, a representation, is actually

an original object. The originary and creative character of the supposedly secondary illusion is thus evidenced, as is the non-hierarchical relation between image, text and sound. Anti-hierarchical thinking is also characteristic of Derrida.

Finally, much is made of the fact that the entire illustration was done with a stylus, while at another point in the notes it is pointed out that gramophone recordings are made and played back using a stylus. The relation between these assertions posits a connection between the visual "recording" on the jacket and the audio recording on the disc inside. Another sort of recording is included on the front cover, a photo of yourself, though the figure is identified in the liner notes as a Soviet ethnomusicologist — an inclusion which indicates the relation between photography and sonography.

The various components of these albums — the sound constructions themselves, the liner text and pictures used (and their layout) maintain a similar relation to one another as do the various components of **Tap**. This is fascinating, because it radicalizes and formalizes aspects of the object we purchase when we buy a gramophone recording. For these are frequently text/image/sound constructions and there is generally extensive inter-reference between the text component and the sound, especially in that part of the text which sets out the factual data about where and when the tracks were recorded and the names of the musicians constituting the various ensembles, etcetera; while the images, and often some portion of the liner text discuss the process by which the music was made, or provide some background information about the ideas of the composers or performers that played a role in shaping the music we are about to hear. You have taken these aspects of object that we purchase in record stores and extended them. But once again, in a way that your previous work has made us familiar with, there is a twist here.

I remarked earlier that the liner notes on virtually all the pieces include some remark about the impact of the modern world of technology on the music, the culture — even the health — of peoples not enfolded within technology's embrace. The album, as a complete object, plays with the myth that there are pristine cultures and that they are closer to truth than we are. While **The Last LP** seems to mourn the loss of cultural diversity to the homogenizing imperatives of technocracy, it exposes the illusion behind such beliefs. But Derrida too has exposed our culture's illusory belief that the primitive is closer to the origins than we are, and so closer to the truth, and more generally the illusion that there is something more natural, because it is outside systems of representation, and because it is more natural, is more authentic and more truthful.

The Casio synthesizer is taking over the world, you say. Yet, **The Last LP** is a work that also revels in the creative potential of the new technologies and suggests that we cannot ever return to these more Edenic sites anyway — just as Derrida suggests that we cannot get a paradisical site outside language and representation. There is a psychological aspect of this I wish to stress: here too you are at work with our feelings about being expelled from an originary site, from a source of wholeness from which, perhaps, we are farther removed than we have ever been. But it is not the cultural or social aspects of these feelings I wish to emphasize. I wish to point out that these feelings arise from memory; they are the result of memories that most people cannot even identify.

Snow: I think you are right that, not only in **The Last LP** but often, I am "playing with feelings we all have about a lost origin, a source of wholeness from which perhaps we are farther removed than we ever have been." This statement can be interpreted from a religious, psychological, social and species point of view. I've never been able to sympathize totally with any organized religion so my "religion" is nebulous, perhaps it's just a sentimentality because I admit to wanting to know the "why" of existence but am convinced I can't.

Our mortality and our flowing in the river of Time are of course sources of both joy and sadness. Artworks can give the illusion of stopping time, which is one of their refreshments. Attempting to Be actively in the "present" is one of the reasons why I'm involved in improvised music and why I used to be a womanizer (I'm still horny). This is all "religious" too.

The "memories" you refer to may be the drives and effects, endocrine system, musculature, finally DNA, which were formed millenia ago and can't have changed in historic time (they will over long periods of time if we are allowed or allow ourselves the time). Our evolved physical structure and our artificial environment seem in many ways to be at odds with each other. For me, a "lost origin" can also have a childhood resonance, memories of a far-from-perfect but energizing doubling.

I've often thought that the arrival of agriculture in the Neolithic period is the beginning of the end for the human race. I've read a lot of ethnography and am convinced that at its best the "hunter, gatherer" way of life was the most satisfying possible. This attitude is ridiculously romantic but

it has been reinforced by some amateur living-off-the-land which I will now admit has been a kind of secret life of mine for many years.

What you said here comes back to your remark that we are "becoming creatures of metal." More serious consequences may come from the fact that the success of technology has made the human body "vestigial." In the West, the body has become an ornament for ... what? Feminism wants the female body to equal the obsolescence of the male body. Once the human body was the operative instrumental factor in living (eating, keeping warm and procreating). I think the "fitness" movement (a failure if the numbers of unhealthy people one sees are any indication) is an expression of the present uselessness of the body and of its becoming "decorative." Equalization of sexual signs is an aspect of this just-arriving "absence"-of-the-body dialogue and evolutionarily may be part of a species "birth control" effort.

What I've just said is dependent upon the continued world growth of technology and its wasteful destruction of "primitive" values. Ecological collapse might change it. Or the effort to control and direct technology for new environmental and social goals might change it. Efforts are being made. And body-work is still done in a few remaining social situations where it "fits" and is necessary, experienced, valued.

Elder: In a similar vein to that of **The Last LP**, the compact disc that the Musée de Québec released as part of the catalogue for the **Paysages Verticaux** exhibition of 1989 (now distributed by Art Metropole) also suggests the themes of dispersion and separation from origin. That work consists of twenty-two voices reading out the names of the thirty-four mayors of Québec City since the first was elected in 1833. The readers are at first presented in sequence reading out all the names on the list. Later the voices are mixed with one another. Different voices reading the same, or nearly the same parts of the text are sometimes juxtaposed. At other times, the different voices juxtaposed read out different names.

Most significantly, the voices were recorded with the readers at a variety of distances from the microphone. Thus the space that sound occupies becomes an issue here, or a quality to be modulated, as it does in **Tap** and and the "Record Player" section in **Rameau's Nephew. . . .** Sometimes the ambience of the room in which the voices were recorded has more presence than it does at others.

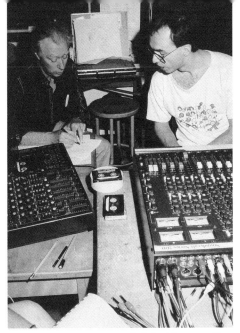

Jocelyn Robert, technician, and Michael Snow working on *Sinoms* at the studio of Obscure, Quebec City, July 24, 1989.

Tous les voix des femmes, section of score for *Sinoms*, July 1989, Quebec City.

The variety of voices reading out names, female and male, Anglophone and Francophone, the differences between the textures, speed, and intonational patterns make for a remarkably varied palette of impressions. One charming feature of the recording is the generic difference between the various manners in which Anglophones and Fracophones read out the list. By and large, the Anglophones read with greater hesitancy. This has two effects. Firstly, as the Anglophones (by and large) stumble over the French names, we become aware, in broad terms, of language itself, but more specifically of the distance that separates the written text, which we imagine them as struggling with, and spoken language. As another work of yours, the film **So is this** suggests, this distinction maps onto one between representations and presence. Just as importantly, it suggests that for the Francophones the names have meaning, but for the Anglophones, they are only material sounds. To return to the fantasy that was the starting-point of this conversation, they are *outside* language and cannot, through an imaginary act, identify with the meanings of the text.

Probably more importantly, the play of differences among the aural spaces of the recording again provides a spatial figure for time; we hear the speakers at various virtual distances, just as we are removed in time from the various mayors.

The alternations of Anglophone and Francophone, male and female, near and far, assertive and hesitant elicit feelings of irreconcilable division: in other words, feelings of the lost whole.

We have a text that is composed of nothing but names. As I remarked above, the dream of a language that is composed exclusively of proper nouns is the dream of a language foregoing abstraction and generalization, therefore one through whose agency objects could emerge into full presence. But the recitation of the names does not, in this work, evoke such feelings at all. On the contrary, the work evokes feelings of separation, division and loss. The dream of a full nominalism in which name and object would be identical is in vain. We must live with division, separation and loss.

Snow: To elaborate on your very astute listening to **Sinoms**: the work contains degrees of "authenticity" with respect to pronunciation. At one extreme there are Anglophones who simply don't speak/read French but who kindly agreed to give it a try. Then there are others whose grasp is better in relation to Quebec French (which of course has its local styles). Amongst the Francophones there is a man from Bordeaux and a woman from Haut-Provence; the others include a Franco-Ontarian, two Montrealers and several from Quebec City.

Obviously the linguistic background of a listener to **Sinoms** will be an important factor in their listening to the work.

The list of mayors that triggered the work contains some of the implications for my selection of the voices. There are many Irish, English and Scots names as well as archaic French names, like Télésphore.

Many originally Irish or Scots settlers quickly became Québecois; there are many MacLeans and Blackburns now totally francophone. In **Sinoms** the different ways francophones and anglophones pronounce these "English" names provides an interesting criss-cross.

Sinoms is an historico-political opera, one made possible through the medium of multi-track tape recording. Technology speaking again. It has its personal sides which finally call for more psycho-biography and less formalism (ha ha).

Quebec City is poignant in my memories, more so than Montreal where I lived from one to six years of age. My mother, my sister and I (not my father, he was working) saw Quebec City every summer for many years. My mother used to drive us from Montreal (then after 1936 from Toronto) to Chicoutimi. It was a lot further away (in every way) than it is now. I was always moved by our surprising arrival at Quebec City, first the beautiful old bridge then the ancient town itself. We sometimes stayed a day or two visiting family friends, then continued on mostly hilly gravel roads. We had children's books from France with beautiful illustrations of medieval towns and castles (Sur le pont d'Avignon). I guess I felt the city that way.

We spent the summers on my grandfather's island cottage at Lac Clair near Chicoutimi, but also spent one year living with my grandparents in town. This was the first horrible year I went to school. My grandfather Elzéar Levesque was mayor of Chicoutimi for several years. Elzéar Bédard was the first mayor of Quebec City.

We never spoke French at home in Toronto but all of a sudden each summer we were surrounded by French speakers. There was never any real effort to have us speak French, relatives in Chicoutimi seemed to prefer to practise their English on us.

My relation with French Culture (not only that implied in "personal" ads) has its incestuous side. That's going too far, but amongst the many other things it's "about," my **Rameau's Nephew...** is about my father and mother. My mother was and is a fine classical pianist. Her Debussy floats in my memories.

The Snows, originally English, were United Empire Loyalists who came to Upper Canada from Massachusetts in the 1780s. They were a classic Anglo-Toronto family. My great-grandfather James Beaty, a mayor of Toronto, also started the newspaper **The Mail and Empire**, which later joined with **The Globe**. My father's culturally nurtured reticence was tragically coloured by the death of "all his friends" and a brother in two battles in France in 1917. He was not "optimistic." He was a civil engineer, his most visible above-ground work is the Glen Road Bridge in Toronto. His "underground" work was water mains and sewers. He lost one eye in an explosion in Montreal in 1934 and in the fifties lost the use of the other.

So your "dispersion and separation from origins" relates somewhat to my "Métis" origins (sort of a joke), perhaps particularly to those of my mother. She didn't leave Chicoutimi reluctantly; she was/is rather anglomane and never regretted leaving Quebec. The "lost whole" here in a way refers to the "two solitudes" of Canada, which I suppose I contain.

"We must live with division, separation and loss" but we can also use the cause of one aspect of our "loss" – language – to attest to and testify for the value of the sensory and intellectual object/experience we call "art."

Your writing in this text does that.

You've ended with a discussion of a work composed of names. Paul Valéry wrote "The subject of a painting is foreign to it and as important, as his name is to a man."

———————

1 Philip Monk, "Colony, Commodity, Copyright: Reference and Self-Reference in Canadian Art," *Vanguard*, 12 (Summer 1983): 14-17.

2 Reay Tannahill, *Sex in History* (New York: Stein and Day, 1980).

3 Derrick de Kerckhove, *Brainframes* (Utrecht: BSO/Origin, 1991).

4 Bruce Elder, "Presents", *Words and Images*, (Canadian Film Studies, 1984).

5 Bruce Elder, *Image and Identity: Reflections on Canadian Film and Culture* (Waterloo: Wilfrid Laurier University Press, 1989).

6 Rudolph Binion, *Frau Lou, Nietzsche's Wayward Disciple* (Princeton University Press, 1968).

7 Steve McCaffery, *North of Intention* (New York: Roof Books and Toronto: Nightwood Editions, 1986).

Bruce Elder and Michael Snow in the De Chirico at Mowatt and Liberty. Photo by Derrick de Kerckhove (author of the text on the holographic work of Michael Snow in Louise Dompierre's catalogue, *Embodied Vision,* a volume in the series to which this book belongs).

Following Spread:
1 and 2 Michael Snow's first completely solo concert on both piano and trumpet was in Montreal on March 6, 1977. It was one of a series of performances called "03 23 03". Other performers/participants were Giuseppe Chiari, Simone Forti, Charlemagne Palestine, Raymond Gervais, Germano Celant, General Idea, Klaus Rinke ... An extensive catalogue was published. The following is from its introduction: "03 23 03 est une manifestation organisé par la revue d'art contemporain PARACHUTE et par L'INSTITUT D'ART CONTEMPORAIN de MONTREAL. Cette manifestation donnera lieu à une série de performances et de débats sur l'art contemporain qu'elle réunire les travaux d'artistes européens, canadiens et americains". Photos by Pierre Boogaerts.

3 Michael Snow, piano solo, in the garden of the Hara Museum of Contemporary Art, Tokyo, during the opening reception of his retrospective exhibition. October 22, 1988.

4 Michael Snow, piano solo in concert, sponsored by "Obscure", Quebec City. September 1988.

5 Michael Snow and English guitarist Derek Bailey at the Music Gallery, Toronto, 1987. Photo by Benny Thomson. Starting in the Sixties, English musicians made strong contributions to the new musical area of Jazz-derived free improvisation. Bailey is one of the greatest of these, an original and uncompromising improviser. Another equally profound English innovator is saxophonist Evan Parker. Both have played on several occasions with the CCMC.

6 Michael Snow and Bob Wiseman, piano duet concert at the Art Gallery of Ontario, January 21, 1993. Photos by Hans Bock.

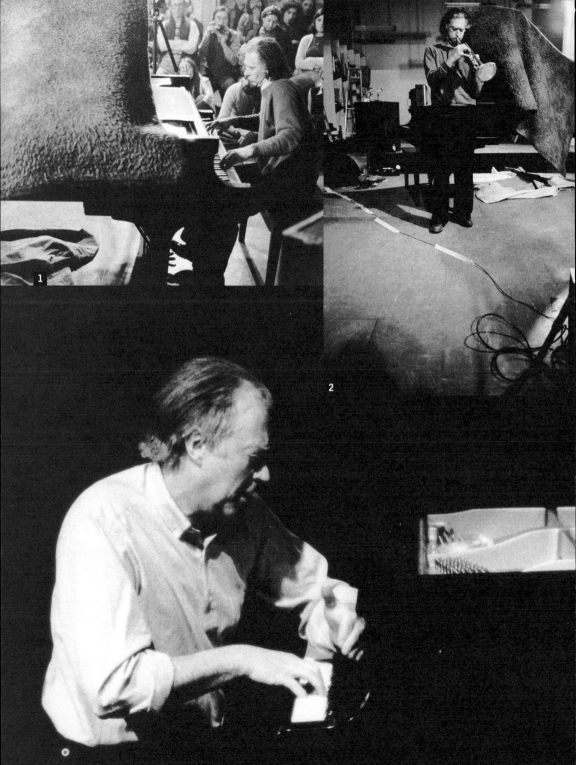

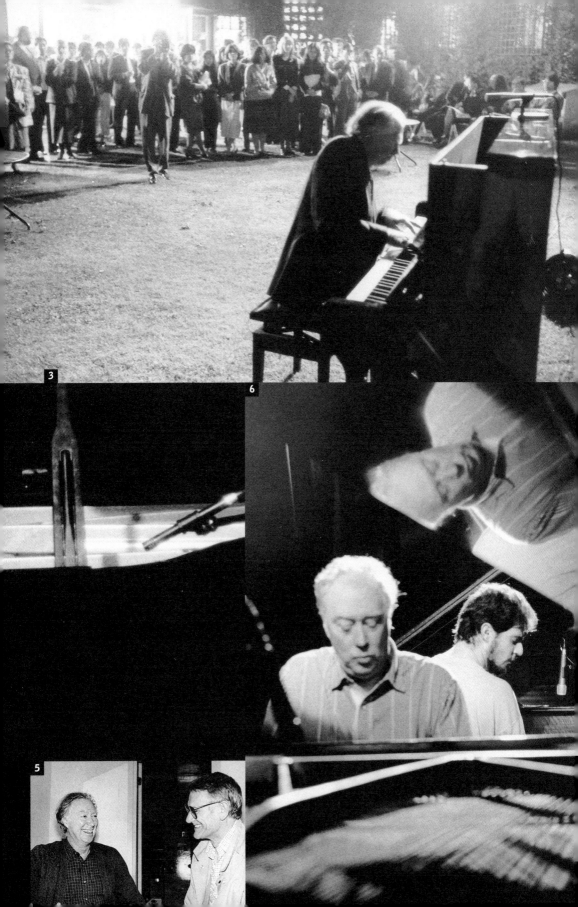

Reproduced here is a photo of a work of mine titled
Nineteen Nights. It is made of nineteen, by now very
yellowed, little pieces of folded paper mounted on a
very dark red watercolour painted corrugated card-
board ground. It measures 20 x 64 cm.

I played the piano with the Mike White Band at
the Park Plaza in Toronto for several weeks in 1961.
Sometimes I bought myself a beer during intermission
and with the little piece of paper, the receipt one used
to get from a cash register, I would make one of these
little abstract folded sheet compositions. During the
day, in my studio I was working on what I called
"foldages" in various materials. I was unaware of
origami at the time.

Perhaps the work is not the product of exactly
"nineteen nights," but the little paper constructions
were all nocturnally made, joining the site of one of my
activities (playing music) to my (studio-made) visual
art objects. – Michael Snow, January 1993

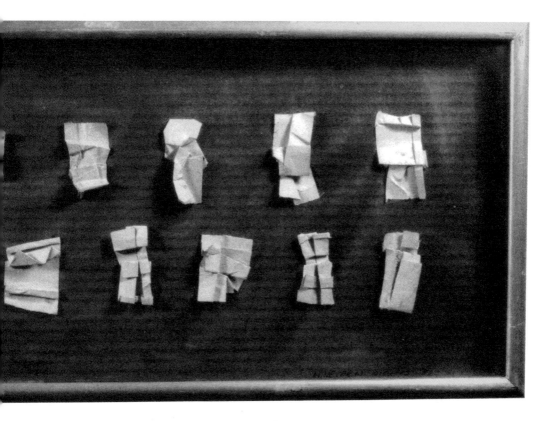

The Recorded Music of Michael Snow
by Raymond Gervais

Translated by Jeffrey Moore

The Recorded Music of Michael Snow
Partition 1 Music Snow

by Raymond Gervais

The musical works of Michael Snow may be divided roughly into two categories: improvisation and composition. Into the first category we may place his early Dixieland jazz, his ESP period in New York, his work with Artists Jazz Band and CCMC, a work for piano like *Around Blues* and, finally, *2 Radio Solos*. His solo albums, *Musics for Piano, Whistling, Microphone and Tape Recorder*, *The Last LP* and *Sinoms*, belong to the second category, the realm of the composer.

Musics for Piano, Whistling, Microphone and Tape Recorder is a double album released on the Chatham Square label in 1975. It was a solo project, conceived and composed in the privacy of the artist's own studio. Michael Snow, it should be remembered, became a composer through his work in film, where the elements of composition, the visual syntax and rhetoric, were all structured in advance. This practice led him to reflect upon the relationship between sound and image, and to transpose some of his cinematic ideas to "pure" music, in particular to the three works we will consider in due course: *W in the D*, *Falling Starts* and *Left Right*.

Another reference point for these three compositions, apart from cinema, is the minimalist art of the 1960s, both in terms of its visual nature and its repetitiveness. Snow was well acquainted with the pioneers of the genre, including Steve Reich and Philip Glass, having experienced their works first-hand in New York. Nevertheless, Snow would seem to us to be more of a "dissident" minimalist; his art in these albums is less "beautiful" or seductive than most of the minimalist works

of the period. Snow's brand of minimalism is raw, dissonant and radical. The three compositions analyzed below fall outside the realm of spectacle, of entertainment – they are far too blunt or direct for that. There is also an ethical question at play here, a moral choice. In this respect, Snow in some ways joins the likes of Glenn Gould, the "last puritan."[1]

Better than anyone else, it seems to us, Snow has managed to fuse hard, stark free jazz with the fragile, experimental minimalism of the era. With remarkable flair, intuition and precision, he achieves a perfect symbiosis in *W in the D* (1970), *Falling Starts* (1971-72) and *Left Right* (1972). As works for piano, these last two pieces are a kind of autobiographical embodiment of Snow's creative continuum, in terms of both composition and improvisation.[2]

The Chatham Square album must be approached from all sides, as an object, giving equal attention to the visual aspect of the jacket and to the text – so essential, unavoidable – before even approaching the music. The text, in fact, serves here as an important visual component. The works are not hidden inside the jacket. On the contrary, they cover the four surfaces of the double album, printed in a character which, starting very large and graphic on the front cover, systematically diminishes in size on the back, without losing its legibility. A minimalist visual process is thus at work here, the textual changes mirroring, in a kind of conceptual counterpoint, the musical path of *Falling Starts*.

Beyond its content, then, the text functions as image, graphic art, decoration, illustration, ornamentation. It extends, without divisions into paragraphs or sections, over the entire space. One looks at this text long before actually reading it. And it works! It fascinates, attracts, intrigues. One must begin by reading this text as image, Snow is implying (following the expression, "to read an image"). This jacket-projection screen is reminiscent of a film that Snow was to make years later called *So Is This*, composed entirely of white or lightly tinted words or punctuation marks against a dark background.

Needless to say, the album text is also meant to be read; in some ways it is indispensable. Snow even suggests a method of reading it: either without hearing the

1 Glenn Gould, *Le Dernier Puritain* (Fayard, 1983).

2 There are other objects that can be regarded as "keyboard" instruments in the works of Snow: the typewriter, for example, or even the shortwave radio used in *Two Radio Solos*. "I'm self-taught on piano, trumpet and typewriter," says Snow in the liner notes of Chatham Square album LP1009-10.

music or only half-listening to the music, or reading a specific passage, and so on. This interplay, he states, is similar to the role of certain characters in his films, such as *Rameau's Nephew by Diderot (Thanx to Dennis Young) by Wilma Schoen*.

Understood in this sense, the album jacket becomes a kind of reading script, as it were, for the public. Snow transforms his reading audience into actors playing out the scenes from one of his imaginary films, an untangible, unfinished film that is open-ended since it is reinvented with each new listening and each new circumstance, site, cast. The jacket, then, is not a passive packaging device, but rather an active — albeit unusual — artistic element. It encourages the reader to reflect upon the complex and diverse relationships between sound and image, text and film, as well as other disciplines (the notions of accompaniment, simultaneity, etc.). And of course it is a document as well. "The text and the record are records both," says Snow.

Michael Snow has often written about his music, his art — and has done so exceedingly well. The fascinating liner notes on this album, at once joyful, inventive, precise and articulate, provide ample testimony of this. It is a work unto itself, and impossible to summarize in a few words. It must be experienced. Nothing is concealed, nothing is left out; it unfolds as clearly as a minimalist sequence by Steve Reich. Reading it and understanding it are thus relatively simple procedures, at least at the beginning. But "the music is more important," says Snow (since it gave rise to the text and not vice-versa) and it demands much more from the listener. The technical quality of the recordings, moreover, are not perfect. "The original tapes," Snow explains, "are home tapes and not studio quality recordings [...] I felt that I could not re-make them in a studio. They partake of a certain time and place."[3]

W in the D (1970)

The title stands for "Whistling in the Dark" and also suggests "Wind." It has many other possible connotations as well. *In the Dark*, for example, is the title of a work for piano by Bix Beiderbecke, the Dixieland blower-whistler of almost mythical proportions. The work could thus be seen as a kind of veiled tribute from one pianist (formerly Dixieland) to another, now gone, "in the dark" (or *In a Mist*...).[4] Other

3 *Ibid*. We may add that these three works share certain affinities with other artists and musicians of the era to which Snow alludes. There are parallels of conception and intuition, for example, between such composition-processes as *Slow Motion Sound* and *Pendulum Music* by Steve Reich and *Falling Starts* and *Left Right* respectively. There are many other associations that could be discussed as well, which the present study has left unexplored. The science of acoustics, for example, could prove fruitful in analyzing *Falling Starts*, and certain works of John Cage, Nam June Paik, Robert Ashley, Alvin Lucier, etc. could provide parallels in discussing such themes as the "denatured" piano, altered-speed records, repetition processes, recording techniques, and so on. The Chatham Square album, then, lends itself to multiple interpretations through comparisons and analogies. And one may also see in it a reflection and echo of the space and time in which it was created.

echoes include "We in the Dark," "Win the Dark," "Whistling in the D" (open to all words beginning with "d"), and so on.

Though the album was not publicly issued until 1975 as the notes attest, work on it started in 1970. That new decade marked the beginning of a second wind for Michael Snow. With the exhibition catalogue – in a square format – called "A Survey"[5] (which could also be called a "Record"), he had taken stock of his life, his career as an artist and musician, in a mosaic of diverse visual documents dating from his birth to 1970, in a manner predicting this album text.

Significantly, *W in the D* is his first solo recording of the new decade, and it is not jazz. It thus signals the start of a new phase in his musical evolution, a new breath. Michael Snow explains:

> It's a recording of me whistling and breathing. There are no electronic alterations in the sound. It's documentary, real time. I held the microphone in my hand and moved it into and out of the air stream of the whistled phrase (sometimes it's just air, no notes). The air intake preceding each phrase brackets them all. The length of each phrase was determined by how long I could whistle on the amount of air I'd stored. I tried to make each phrase a distinct event in itself although there are some repeats with slight variations [...]. For my ear-mind the air blowing on the microphone produces an aural picture plane [...]. "W in the D" is about 23 minutes long and you can breathe along with it [...] Here comes the ending now, sort of Beethovenesque in an airy way. The dee dee dee dee dee dee dee dee repeated note motif is repeated sans note, just air, and is followed by a long exhalation. That's it.

"I'm always thinking of making a form with time," says Snow.[6] In this case, the overall form of the work has been prearranged, inside of which each whistled intervention is improvised. The result is a veritable lexicon of whistling: legato, staccato, glissando, screeching, repetition, variations in diverse registers. The body as instrument here becomes a kind of whistler's keyboard – a living, breathing keyboard. This inhaling and exhaling as a natural technique is reminiscent of the alternating movement of the piano in *Left Right* (although without a regular beat), as well as the back and forth movement of the camera in Snow's film ← → . In a

4 *In a Mist*, a composition by Bix Beiderbecke (1903-1931).

5 *Michael Snow/A Survey* (Toronto: The Art Gallery of Ontario, 1970).

6 Michael Snow, Interview with Jean-Pierre Bastien, *Rétrospective Michael Snow* (Montreal: Cinémathèque québécoise/ Musée du cinéma, March 1975, p. 12).

conceptual sense. Similarly, the distortion in *Left Right* echoes the sound of the air whistled deliberately into the microphone in *W in the D*. In both cases there is an attempt to define the extreme limits of a mechanism (by extension, of an aesthetic as well) through a minimal sound, and to make us reflect, by means of the "faults" and physical limitations of the instruments, upon the limits inherent in our own body, mind, culture, self.

In this first solo composition, as in the entire record, Snow does what is forbidden. The forbidden here becomes the norm (distortion, subverted time, etc.), the pretext and even the subject of the work: testing the limits allows one to reevaluate one's identity.

Normally, one tries to minimize the audible presence of recording devices when producing a record so that the illusion of pure music transcends the object — music as an absolute, as "God." Snow questions this whole notion. He allows us to hear as much the machine as what it records. He reintegrates the technical aspect of the work, the mechanics of the apparatus, into the magic of the work of art. The rational and irrational. Nothing is concealed, camouflaged; everything is audible — and all the more mysterious as a result. Evidence and Misterioso.[7] At the same time he deconstructs the music, stripping away the sacred aura of the record as a precious object of representation.

Other avenues of reflection suggest themselves. Snow develops the notion of inspiration, of the "inspired" work of art. Here the work is played physically, biologically, through inspiration and expiration; it also suggests, on another level, an "Inspiration" from a more lofty source, from beyond the immediate body, along with an "Expiration" in the tragic sense, evoking the idea of death. These words must be understood on different levels, then, on both the corporeal and existential planes. This is true of all the works of Michael Snow, where there are unending fluctuations in meaning, in the variants of signifier and signified, in transfers of identity.

In *W in the D*, for example, it is sometimes a human we hear whistling, other times some sort of bird or wolf or other animal; they are the potential doubles in each of us whose identity — behind the sounds, the activity, the culture — can only

7 Titles of two compositions by Thelonius Monk, an adept of stride on occasion and a musician much admired by Michael Snow. Snow played many of his works in a quartet in the early sixties.

be guessed at. The body is thus depicted in its manifold forms: the human body, the animal body, the machine body (tape recorder or microphone body via the air that is projected into them). A projection of air, breath, sounds, ideas: the body-cinema.

A parallel may be established between the air we breathe and the "Air" played by the musician – the physical air that makes the musical Air audible (just as there is inspiration with a small "i" and a capital "I"). The same duality exists with Expiration, with its double meaning of exhalation and end. In the "Grand Finale" of the work, the breath exhaled into the microphone, the sound of air and wind, signifies the end, the death of the work, with the last gasp of the machine as counterpart (as opposed to the "expiration" with a small "e", invisible by definition, whose traces can only be captured on tape: the wind).

There is thus a second "nature" to *W in the D*, a nature manifested in the body and stemming from a nature-culture polarity, a conceptual back-and-forth swing perceived while listening. Snow presents the very nature of the recording, of art, of the body. Later on, with *The Last LP*, Snow returns to direct his microphone towards nature. But this is another story. The same story. Later... Snow also whistles in *The Last LP* and with the Artists Jazz Band...

Breathing is a fundamental act, at the base of life itself. Of art as well. And whistling is the most natural thing in the world. "Whistling alone," says Snow, "affirms the self, blowing forth some company and thus de-alones"[8]. Whistling aimlessly is like doodling, a kind of immediate audible graffiti, a spontaneous aural portrait sketched out from almost nothing. The so-called "primitive" man must have done some sort of whistling. In jazz, Meade Lux Lewis comes to mind, the whistler par excellence who also played the celeste.[9] Whistling is also celestial... Some have made a career out of it (like the American Ron McCroby, who records with Concord Jazz).[10]

Michael Snow, however, is perhaps the first to have made an elaborate work based entirely on whistling. In parallel with the world of his films, it functions like two zooms in reverse directions, a zoom from within via inhalation and zoom from without via exhalation. Inside and outside: the question of identity emerges again.

8 Michael Snow, "Larry Dubin's Music," *Impulse Magazine*, vol. 7, no. 1, 1978, p. 15.

9 Meade "Lux" Lewis, famous specialist in boogie-woogie (1905-1964). An excellent record on which he plays the celeste was recently re-issued: *The Blues Artistry of Meade Lux Lewis*, Fantasy/OJC 1759. He had already recorded on the harpsichord as well, like Jean-Phillipe Rameau...

10 Ron McCroby, *Plays Puccolo*, Concord Jazz CJ-208. Ron McCroby, *The Other Whistler*, Concord Jazz CJ-257.

Breathing is the measurer of things, of space and time, of existence.

Whistling in the dark is whistling without seeing, whistling in order to see. Each whistled phrase, says Snow," is a different image".[11] Here whistling is both the image and the activity which is made visible, simultaneously. Whistling in a dark room allows the image to emerge, to be imprinted. A breath print, an identity record: "I breathe therefore I am." *W in the D* is thus a reflection upon the photographic process in its relation to sound recording, in the same line as Snow's "*New York Eye and Ear Control*" begun earlier.

Finally, *W in the D* makes three-dimensional space perceivable. One can measure, with the ear, a certain depth through various microphone displacements. One measures space by time here, by the gesture (this action with the microphone has definite parallels with certain camera movements in Snow's films).

In addition, this whistling is analogous to the throat games of Canada's Inuit peoples.[12] This minimalist game of vocal give-and-take, of voices which overlap, superimpose from left to right and back again until the participants are exhausted, is also based on breathing and the testing of one's limits. And it is like jazz as well, like the jazz "battles" of yore, the famous wind duels. In this respect, one could conceive of a whistler's race or steeplechase in which contestants would test the limits of breath, invention, wit.[13]

Dating from 1970, *W in the D* in some ways anticipates the world of *The Last LP* of 1986-87 (whose working title was "The Last Gasp"). An excerpt from *W in the D* would not be out of place on *The Last LP* in its representation of a traditional practice of the region of Toronto. We have thus come full circle, breathing has become circular... like a record.

By way of introduction to the second piece on the album, *Falling Starts*, it might be helpful to discuss the influence of film on the music of Michael Snow.

One of the classics of silent films is Louis Lumière's *L'Arroseur arrosé*. With the three works recorded on these albums, one can almost speak of "the recorder recorded"; intentionally or not, they constitute a kind of techno-poetic wink at the early days of cinema and the rudimentary equipment of the time, the projectors

11 Michael Snow, *About 30 Works by Michael Snow*, Centre for Inter-American Relations, catalogue published by the National Gallery of Canada (Ottawa, 1972), p.31.

12 *Inuit Throat and Harp Songs*, Music Gallery Editions MGE28. *Inuit Games and Songs*, Unesco, Philips.

13 *Steeple-chase*, theme associated with Charlie Parker who recorded it on the Savoy label in 1948. Nicknamed "Bird," Parker reminds us that many jazz musicians had nicknames, many taken from animals ("Rabbit," "Hawk," "the Lion," etc.), an interesting notion in the context of this text on identity in music. Concerning the "chase," these veritable jousts involving two or more soloists (including the popular sax duels), we recall that the stride pianists loved these "cutting contests."

"almost visible on the screen," almost as visible – in their deficient mechanics, their jumping and turbulence – as the action in the films they projected (like the recording equipment and microphones in the Chatham Square album).

Again, it was through film that Michael Snow became a composer. Cinema led him to reflect upon the functional characteristics of the sound/image recording equipment, on the possible parallels between recording sound and recording images, between the turntable and the projector, the language of music and the language of film. He began to think about how some of the terms and functions of film could be transposed to music. What would be the audio equivalent of a zoom, for example, or a pan, a travelling shot? Is there a counterpart to slow-motion, fast-motion, depth of focus, stationary camera, out of focus, dissolve, high angle shot (high sounds?), low angle shot (low sounds?), and so on.

The record itself may be regarded as a film of sounds: one projects a record disk in space as one projects a film, except that with music the screen in within us, invisible; one sees with one's ears. The space is inside. And when the film is as unusual as *Falling Starts*, one rubs one's ears in disbelief. The experience is perplexing, disorienting. What exactly is going on here? What is passing in front of us?

With regard to film audiences, Snow has remarked, "They want to be shown something in the film and not the film itself".[14] *Falling Starts* shows us the music and not something represented in the music. Snow describes the work as follows:

It's a piano and tape recorder piece made in 1972 (first version, 1970) and is dedicated to Baron Von Kayserling. [...] Those first groups of high sounds that you are hearing [...] are sped-up re-recordings of a piano phrase which at its "normal" speed should be heard soon, just has been heard, will be, etc. This phase was composed by myself for its use as a subject of tape recording compression and elongation. [...] Several phrases were tested out, this one seemed to have an internal fitness for its intended use. As you can hear, it starts very low, the right hand with slight acceleration rises and falls and rises and falls to the top of the keyboard while the accompanying bass figure revolves in the same low tonal area. The right hand phrase covers almost the entire range of the keyboard and the bass provides a reference for

14 Michael Snow, Interview with Jean-Pierre Bastien, op.cit, p. 12.

this aural space. The Chordal clusters and the requisite amount of resonance in performance generate new inner vibrations and re-reveal their original ones when slowed down [...] Falling Starts continues its descand descent on Side 2 with the final and lowest version which is a fundamental experience of sound generation and reception as tactile. Membrane to membrane to brain.

Michael Snow is thus offering us an unusual acoustic sensorial experience using a piano phrase that is drawn out and then compressed in systematic fashion, like a gradual minimalist process.

We notice right away that the work is centered around the piano, Snow's instrument of choice. In fact, the majority of the American minimalists were pianists, from such precursors as John Cage and Morton Feldman to Philip Glass, Charlemagne Palestine, Steve Reich, Terry Riley and La Monte Young. Michael Snow is the (North American) pianist missing from this list.

Since the end of the 1940s, the piano has underlied all of Snow's artistic activity. For him it is the most immediate, most personal instrument. Here, however, Snow's treatment of the piano is rather unorthodox; it is not the "beautiful sound" of the conventional piano we hear but rather the sound "between the notes" — just as one must read between the lines to discover the hidden dimension of things.

At first we cannot clearly identify the musical phrase because it is reproduced at a highly accelerated speed. Around its sixth treatment, however, we begin to recognize something. At its seventh (always a bit slower), it sounds like a harpsichord (Rameau playing in another dimension?). In its tenth exposition, the phrase is in focus, at its normal, initial speed of execution. It is the sound of the standard piano.

Since everything is measured and assessed in terms of this initial phrase played at its normal speed of execution, all that which precedes it (namely, the accelerations) is bound up with the notion of "ascension," played in reverse. What follows, slowed down, constitutes the "fall." Conceptually, the piece vacillates between these two poles; concretely, however, the experience of the work is dominated by a sense of progressive fall (the twilight of the Western piano?).

This gradual descent of the piano into the low notes, into an uncharted aural

domain, proceeds by steps until the initial phrase occupies almost an entire side of the record, each note compressed or stretched to its maximum to reveal an acoustic universe impossible to imagine or feel in any other way.

Any music or action which is slowed down to this extent becomes foreign, unrecognizable. That which is exceedingly slow seems to shake our very foundations, the nervous, productive, efficient, hyper-rapid rhythms of our civilization. Slow seems almost forbidden, like a rebellious, heretical act. Almost a terrorist act. It takes away by force the rare and precious commodity of time. Snow warns us against making a quick or partial listening:

> In other words, most readers of the first page of a text would be in quite close agreement concerning its nature, qualities and meaning. However, it can without doubt be stated that someone who read only the last passage or only the first and last passage of a work of literature would be apprehending an "object" which would seem in an almost infinite number of respects radically different from that passage apprehended by someone who had read the entire text from beginning to end. Such is the modifying power of the prior experience in a temporal work that the significance of the ending can only be truly apprehended against the record of the voyage towards it. In isolation it is not an ending is it?[15]

Falling Starts is thus a voyage in time, towards the unexpected, a veritable sound odyssey. Like going through the looking glass, we pass over the wall of sound. We descend into the nether realms, into the unknown, into the dark, unexplored areas of the musical psyche; we are entering into the "death of music." In some ways, it is like witnessing a gradual collapse of the meaning of music, of being left in some aural no man's land that is difficult to inhabit, to decode and thus to translate into words.

Decades ago, in the context of concrete music or pre-electronic music, such musicians as Edgar Varèse, Darius Milhaud, Pierre Schaeffer and John Cage experimented with diverse studio techniques, including modifications in record speed. Partly because of inadequate studio equipment, however, they did not extend their intuitions and research as far as they might have. And their perspective was not the one Snow would adopt years later. Snow's brand of systematic minimalism

15 Michael Snow, Chatham Square album notes.

would obtain results that were unheralded in the history of piano music — or any other acoustic instrument. It would be difficult to imagine *Falling Starts* with any other instrument. Snow's choice of the piano was certainly not haphazard, and the structures and signposts of the piece were meticulously worked out and perfectly balanced.

Again, how to describe what one hears? How can anything be pinned down when one is, as it were, outside the notes, the meaning? Snow is here questioning the limits of our auditive machine, of our mechanics of perception. Do we need a "Hearing Aid" to understand all this?[16] What does the ear perceive and understand? What is its tolerance threshold beyond which the nature of the material is no longer "recuperable"? And what is going on exactly? What is the ultimate limit of our ability to identify this material, a material in a state of metamorphosis that is fast losing its own identity, before we become totally disoriented, lost, our cultural compass broken? For the transformation of this material (timbre, pitch, amplitude, duration, envelope) is concommitant with a transformation, a questioning of the identity of all those who experience this process.

Falling Starts is thus a work through which the listener himself may lose his identity. "Where am I?" becomes "Who am I?" There is a point of no return in this evolving musical material. At what point does the listener become listened to? And his auditive memory hobbled, rerouted, confused? Does one remember *Falling Starts* in all its permutations after one or two listenings? Can one sing or whistle the short initial phrase for piano in its final phase on side B?

What is especially surprising here (and particularly pertinent in its relation to the visual arts) is that this final phrase, which becomes a muted rumbling, a kind of infra-music, begins to take on visual resonances: a helicopter, for example, or a motorboat, a rainstorm, a distant explosion, and so forth. These "tactile" images, in Snow's words, bring us back to the real world, to nature (a nature revivified by memory, our memory of concrete noises of technological origin which appear to obliterate the "cultural noise," in this case the piano and its entire historical baggage. The sound generating the image, then, recreates the world, the tangible environ-

16 *Hearing Aid*, installation by Michael Snow (1976-1977).

ment: the sound record projects a visual film within us. How can a simple piano phrase played in a private studio transport us into rain, into nature... To describe these images, just as to describe these sounds, requires words that will do them justice. This strange and singular music leaves us searching for the right words. It generates its own text, its own vocabulary, its own liner notes.

Again, traditional acoustic instruments (and the human voice as a natural, organic instrument) would be unable to play music like *Falling Starts*. It is therefore not a piano that plays it but an entirely different instrument, the recorder-interpreter. Snow is giving the recording apparatus a central role here, more important than that of the piano. He is conferring upon it the role of performer and appealing to its specific mode of operation: the recording tape acts out a part that Snow stretches and transforms at will through a methodic manipulation of speed and compression.

Starting with piano and ending in another world, *Falling Starts* takes a highly unorthodox path. As a result, the work becomes in some ways the measure of all music, the standard by which other music is compared, regardless of the category. One does not listen to music in the same way after a careful and complete listening of *Falling Starts*. And repeated listenings are amply rewarded.

Falling Starts is a reflection on change, on death, on switching identities, on the passage from one state to another. Is it the pianist who is still playing or is it the tape? Is it an audience listening or a microphone? Is it music that one hears or a speaker vibrating? Is it our imagination that is turning or a record player? Is it our emotion that is surging or an amplifier? Who is who or what? Who represents whom or what? Who is playing whom or what? As in all the works of Michael Snow, identity and representation are at the heart of the matter.

Falling Starts can also be examined in its relationship with the world of Land Art. One of the key works in Snow's cinematic oeuvre that questions the site, the environment is, of course, *La Région centrale*. Here the camera turns 360 degrees around an axis in all possible directions. It turns therefore horizontally as well, like a turntable, capturing the visual ambiance within its sphere (this slice of the

environment on film perhaps corresponds to a "record disc"). Like the tape recorder in *Falling Starts*, the camera here is the actor — whose technique is as much the material and subject of the work as the natural landscape.

The site chosen — remote, wild, uninhabited — is significant as well. "I want to convey the impression of absolute solitude, a kind of Farewell to the earth that I think we are going through right now," said Snow prophetically in March of 1969, concerning *La Région centrale*.[17] How can one refrain from making a link here with Glenn Gould and his work for radio (on the theme of isolation) entitled *The Idea of North*[18], not to mention his own hermetic life and his invention of characters and voices (just as Snow would do elsewhere, in different ways, in his second solo album *The Last LP*)? There seems to be a distant, secret dialogue between these two Torontonians, an affinity of spirit despite appearances. For the "jazzman" dwells in Gould as well, as manifested in his trademark mutterings while he played (in common with several jazz pianists, including Bud Powell, Oscar Peterson, Keith Jarret, etc.), and his ability to improvise with the best of them, when the time was right, despite his admitted reluctance to do so. Within Michael Snow, similarly, there resides the interpreter in the almost classical sense of the term who at the beginning of his career emulated the American models of jazz piano (Jelly Roll Morton, Earl Hines, Jimmy Yancey, etc.) before breaking away completely as an autonomous soloist. In his liner notes to *Falling Starts*, moreover, Snow cites Bach and *The Goldberg Variations* as reference points. Both Snow and Gould, finally, were fascinated by the apparatus and techniques of recording.

Concerning this notion of artistic solitude that both musicians were drawn to, one might say that *Falling Starts* leaves the listener alone as well; it is like a gentle, slow-motion pilgrimage to the very matrix of sound.

As for its relationship with Land Art, one may suggest that the work of Snow, like Robert Smithson's *The Spiral Jetty*,[19] engraves on two sides of vinyl an immense spiral furrow within culture, culture as environment. While listening, one circles within this immense disc as one circulates within this work by Smithson, confronted with one's own history, one's own memory like an open disc, one's life as a

17 Michael Snow, *About 30 Works by Michael Snow*, *op.cit.*, p. 35.

18 Glenn Gould, *The Idea of North*, a radio production from 1967, the first part of the *Solitude Trilogy* documentary. A televised version was produced in 1970.

19 Robert Smithson, *Writings* (ed. Nancy Holt, New York University Press, 1979), which includes a section on *The Spiral Jetty*, pp.109-116.

process, a continuum. In this respect *Falling Starts* is a self-revelatory, existential work which redefines — differently for each person — the notions of space and time. It is an unfinished work as well, which may theoretically extend beyond the end of the record since its structure and operation contradict the very idea of a fixed end point (just as the ear in the form of an organic spiral embedded in the skin denies, symbolically, the idea of irrevocable death, substituting instead the idea of change).

If one were to convert the time encapsulated in *Falling Starts* into space, one might see a kind of vast spiral incursion in the environment, a kind of negative-image of "Spiral Jetty" (also, by analogy, a rupture with the Western musical culture, the culture of the "noble piano" and sublime musical forms). In this respect, the piano in *Falling Starts* is much more denatured and transmogrified than the prepared piano works by John Cage, for example, even if the themes and objectives are different. Cage's prodigious *Sonatas and Interludes* for prepared piano[20] seems almost like a divertissement beside the gravity and austerity of *Falling Starts*. With Snow, it is not the instrument that is prepared but rather the machine that records it; its normal mode of functioning is deviated by a "prepared concept" that is perceivable during both the execution and experiencing of the work (the machine is "listening" to itself as well).

Such Land Art works as *The Spiral Jetty* were often created in isolated sites, far from the turbulent activities of urban centres. Along its grooves, *Falling Starts* similarly leads us towards a kind of desert. The idea of a desert, in fact, pervades our technological culture — it symbolizes a vital need, a lack, a fantasy. In music, the desert is also central: one goes to the desert to listen, to listen in a mystical way that is thus closer to prayer than entertainment. In 20th century music, from Edgar Varèse to Steve Reich via Arnold Schoenberg, Olivier Messiaen and others, the metaphorical desert has had powerful resonances. With its inexpressible time, its impossible space, *Falling Starts* leads us all into the desert, a site of synthesis where one questions one's very existence and identity. With *Falling Starts* we become nomads again, nomadic listeners in a free-fall through the universe.

20 John Cage, *Sonatas and Interludes* for prepared piano, 1946-48. In this work the piano has on occasion a double identity. It sometimes sounds like a gamelan, for example. The period 1946-58 corresponds to Snow's apprenticeship in traditional jazz and the the recording of his first 78s of traditional jazz piano solos (such works *Mamie's Blues*, *Pallet on the Floor*, *At the Jazz Band Ball*, *Gin Mill Blues*, etc.). These fascinating — and fragile — recordings are sometimes so crackly that they seem to "prepared" jazz piano. These unintended alterations of the "pure" sound, like a humorous wink, seem to presage the more experimental piano works to follow, such as *Left Right*.

Left Right (1972)

Chronologically, this piece was the last of the three works recorded on this album. In the notes, Snow describes in detail the materials and techniques employed, along with possible interpretations and critical ramifications of the work. The notes are exhaustive but they do not limit our experience of the work or our ability to create other, more personal readings. On the contrary. Here is what Michael Snow has to say:

> *Left Right* was taped in '71 and is also a tape-piano piece because it was recorded in a way that made a part of the recording process a part of the music. In other words it wasn't only a "documentary" recording of the piano being played. [...] The piano music was recorded by laying, lying the microphone on its side on the top of my old upright piano with the recording volume way past its proper maximum. This was done to a nice tape recorder, a Uher which seems to have survived the strain. The percussive playing of the chords smackrattled the microphone against the piano top. Other sounds you will hear [...] are a metronome tick tick tick ticking and a telephone ringing. [...] I didn't answer it because I'd spent several hours getting the sound that I liked and the performance was going well and after my first dismay I hoped that the bell would sound well... ring, rrring, ring ring... it does, it fits, même famille. Who called? [...] Right now the music has just left being alternately a chord in the right hand and a single note on the left. It is essence of "oompah," a ragtime of "stride" left hand strain. I've played Jelly Roll Morton, Earl Hines, stride and ragtime-influenced piano for many years so this piece comes out of that but also it is kin to a film I made in '68-69 called — wherein the camera pans back and forth at different tempi in sync with a percussive machine sound which emphasizes the arrival of the picture at each left or right extreme with a thump thump thump thump thump... to return to the music, now it's changed to a single note in the treble alternation with bass chords. I played this piece with alternating right and left hands, a backhanded compliment to Paul Wittgenstein. barm barm. Those are alternating chords in both hands brark breek brarch breekkeek bracque back to top single note bottom chord crash ping crash ping crash ping crash ping. It certainly is a slow tempo. One of the reasons for that is that it enables one to have time to hear all the

music that is emanating from the sounding of each note or chord. [...] The long slow tempo section is followed by a faster tempo coda [...] "Left Right" gets pretty fast racing ahead of the metronome beat vers la fin. Lots of merging of the sustained "distortions" both here and there.

At the beginning of *Left Right* one hears a metronome (the time before the music), and this same metronome is heard in solo at the very end (the time after the music). It acts as a parenthesis that closes at the point of origin — not at the end. For in some ways this piece begins for the listener after it ends on the disc. Its impact is felt gradually, via the memory, the memory of "shock," the trauma of distortion acting as a kind of forbidden, outlaw, clandestine "music" whose disturbing echos reverberate in our memories.

And this music comes through the piano, traverses the piano to reach us. A piano-filter, piano-medium, piano-observer/observed, the instrument suffers a kind of identity crisis. The piano seems to "microphone" the distortion in order to manifest itself, to project itself — as if there were a transfer of identities, the piano revealing the distortion and vice-versa, paradoxically. Piano as sound-box, screen, backdrop for this distortion. And piano-mirror as well, a piano lens simultaneously warping sound and meaning.

Since 1945 the piano has been the crucible for Snow's artistic experiments, and its every element has had a part to play. As a catalyst and medium for Snow's reflections, it has been a highly personal instrument of expression; but it is also a symbol of the entire Western culture (through the achievements of Bach, Beethoven and Paul Wittgenstein, for example, three names cited in the liner notes). On one level, the "left-right" dynamic in this work is thus between the individual and the group. On another level, there is a sort of antinomy, a "natural" and cultural rejection of distortion on the one hand, and its affirmation on the other. A complex back and forth results.

The stride style chosen by Snow recalls his early days in jazz. But he is not content to paraphrase or reproduce history, to quote the original model in *Left Right*. He transcends it, propelling the stride style of Afro-American music to a universal

form, to the level of the archetype. In doing this, Snow offers various paths by which the work may be read/listened to, beginning with an exploration of the relationship between the instrument (the piano) and the style chosen (stride) on the one hand, and the metronome on the other. Snow seems to associate the pendulum-like movement of stride (the left hand pounding out the rhythm, the right embroidering according to the whims and virtuosity of the performer) with the metronome's intrinsic mode of operation. The metronome's nature is "stride" by definition (albeit mechanical, rigid and therefore less poetic). Stride is an open game, not an object, but the metronome is not just any object. Its pendulum movement cuts time into regular rhythmic sections, as does the human heart. It is anthropomorphic (or rather "anthropo-rhythmic"). By combining the stride style with the metronome, the piano is transformed into a gigantic metronome-hybrid, a hybrid which creates the initial "distortion" here, a distortion of sense and function.

This piano-metronome, piano-heart, piano-body is also reminiscent of Man Ray's metronome with the photographed eye on the pendulum, the famous *Objet à détruire* (1923) and its double *Objet indestructible* (1958).[21] In these works there is a "Left-Right" oscillation from destruction to indestructibility and back again, mirroring the movement of the metronome. In this strange, surreal work Man Ray also suggests a kind of "Eye and Ear Control",[22] a regular pulse from the eye to the ear and back, a complicitous back and forth between two indissociable sense organs. Interestingly, the creation of Man Ray's first *Objet*, in 1932, was coincidental with the invention of the stride style. And in *Left Right* one may almost speak of a "music to be destroyed," to paraphrase Man Ray, and of habits and routines to be destroyed as well, to be rethought, revised via distortion.

And the telephone, which breaks into the music so unexpectedly (like a wink from John Cage), seems to convey a note of mystery, intrigue, something beyond banal routine.[23] For this ringing — along with its figurative or narrative role — was unplanned and unforeseen. It was an actual call which will in a sense ring forever, like an "Unanswered Question"[24] inserted into the music for posterity.

When we listen to this piece we are in a way automatically answering the phone

21 Giuliano Martano, *Man Ray Clin d'Oeil*, catalogue published by the Il Fauno and Martano galleries in Turin, 1971. It includes photos of the works cited here as well as a new work for two metronomes entitled *Perpetual Motive* (1970).

22 The expression "Eye and Ear Control" is drawn from Michael Snow's film *New York Eye and Ear Control* and its soundtrack (originally released on the ESP label and recently reissued). Snow, incidentally, was the graphic artist on this legendary album.

23 The accidental presence of the telephone in *Left Right* (1971) reminds us that the film *Rameau's Nephew by Diderot (Thanx to Dennis Young) by Wilma Schoen* (1972-74) was dedicated to the telephone's inventor, Alexander Graham Bell. Bell's efforts to "make the deaf hear" are in some ways echoed in the Chatham Square album.

24 *The Unanswered Question* (1906), a work by Charles Ives in which the trumpet (an instrument played by Michael Snow) repeatedly poses the "question of existence."

since we are answering the call of the music, the call of the artist. *Really* listening to music — actively, attentively — is always a commitment, a risk, Snow implies in his notes:

A passage can push you back into yourself so that its benevolent force reinforces your integrity and you momentarily become a core of concentrated yourself. Such a passage might modulate into an arrangement of elements that might draw yourself out into an edifying dialogue of equals and then transform into a constellation that might invoke analysis or criticism of itself only to become that more familiar but often welcome Svengalism which provokes total identification sans corps with the "reality" of the observed/recorded/recounted and tilts one off the edge of the bed of regular mind-time into an ancient and honorable lunacy, surfacing with real tears of laughter which were fathered by the ghosts of the artist's gesture.

In *Left Right* this gesture of the artist relates also to the recording process (as it does in *W in the D* and *Falling Starts*), namely, with the microphone lying directly on the piano with the volume askew and the resulting distortion. We hear the microphone as much as the piano, the recording process as much as what was actually recorded: a piano, a metronome and distortion.

"Distortion has a moral tone," says Snow justifiably. "Doesn't seem right but probably has to be used."[25] *Left Right*, in fact, cannot really serve as entertainment in the normal sense of the word. Distortion is not a simple acoustic curiousity here, an adjunct or "amenity." Its committed purpose is to reduce our deafness — deafness to ourselves, to others, to the universe. Too much of our music serves as a pleasing musical background which merely helps us to forget. *Left Right*, on the other hand, seeks to makes us more present. We cannot choose to ignore it, be indifferent to it. This music which is "beside music," which is disturbing in its staticky sonorities, its deliberate defects and failure to appear "beautiful" or pleasant, embodies a musical aesthetic based on the need for arousal, for awakening — the same sense of awakening and urgency which pervaded the free jazz of bygone eras and which still summons us today, twenty-years later.

Distortion, paradoxically, serves to makes us see and hear things more clearly.

25 Michael Snow, liner notes to Chatham Square album.

Inspired by jazz and ragtime as much as stride (a style of jazz), *Left Right* reminds us that most great innovative jazz was a radical questioning of society as well as a celebration, an affirmation. While not quite jazz, *Left Right* shares in this spirit with great force and conviction. For the first time on disc, Snow joins the brotherhood of great free jazz pianists (Cecil Taylor among them) in a space all his own, without imitation, without concessions.

The distortion in *Left Right* pushes the historical stride style towards free-form jazz. It bridges the two worlds. Stride swings into free while maintaining its essential form (making in the process a summary and bizarre synthesis of the history of the jazz piano). *Left Right* is not organic free jazz, of course, in the sense of total improvisation. Nor is it stride in the strict sense. But when stride becomes strident, almost excessive, shot through with raw distortion, it merges with the scream, the free.

Left Right also invites parallels with certain pieces by Annea Lockwood or Ben and La Monte Young (of Fluxus), wherein the piano is "mistreated" in various ways: burned, nailed, pushed against a wall, and so on.[26] Other cases could be cited in which the piano is aggressed in its representation... *Left Right* thus pushes music towards its very limits, from low to high and vice-versa (minimalist music in form and free in sonority, like *Falling Starts* and *W in the D*, although these two works are not directly related to jazz). There is a striking unity of conception and perspective in this Chatham Square album with its metronome that closes, in solo and ever so briefly, the entire adventure. A little before this, Snow accelerates the tempo on the piano in an almost caricatural coda signalling the imminent end of the album, of the story, the film. This idea of "the end" is played with a frenzy and jubilance and determination until the last groove — almost, since the piano slows down and passes on the baton to the solitary metronome.

Originality, rigour, humour, virtuosity — all conspire to make *Music for Piano, Whistling Microphone and Tape Recorder* a prominent signpost in the history of 20th-century music.

A dozen years after this album, two other entirely composed solo records followed:

26 Annea Lockwood, *Piano Transplants* (1968-82), cf. Sound by Artists (Toronto-Banff: Art Metropole and Walter Phillips Gallery, 1990), pp.217-18 (including *Piano Burning* and *Piano Drowning*).

The Last LP in 1987 [27] (a masterly work from all points view – conceptually, musically, textually, graphically – and a beacon of end-of-century modernism); and *Sinoms*[28] in 1989 (also a remarkable artistic achievement, with very different material and methods yet with similar themes of identity and representation). In these two albums the voice has a central role: feminine, masculine, spoken, singing, polylingual, polycultural, invented or otherwise.

From eye to ear, image to sound, film to music (instrumental or vocal, composed or improvised, group or solo, acoustic or electronic), everything is harmoniously integrated into a poetic whole. Both concentrated and centrifugal, this music is testimony to the multiple identities reconciled within one and the same person: Dixie Snow, Classic Snow, Folk Snow, Free Snow, Solo Snow, Music Snow.

27 *The Last LP* (Toronto: Art Metropole, 1987).

28 *Sinoms*, a composition by Michael Snow for the exhibition "Territoires d'artistes: Paysages verticaux" at the Musée du Québec in 1989. Available in the exhibition catalogue or at Art Metropole in Toronto.

The Recorded Music of Michael Snow
Partition 2 Free Snow (Michael Snow and CCMC)

by Raymond Gervais

After witnessing first-hand the beginnings of free jazz in New York, and after several years with the Artist's Jazz Band, Michael Snow was one of the founders of a new free improvisation collective in 1974-75. This group was to be very different, one which would shake up the jazz scene in Toronto: it was called CCMC, originally the Canadian Creative Music Collective. It was unlike any other experimental jazz group — then or now.

Affiliated with the Music Gallery from January 1976, CCMC established its own network for the creation and distribution of a new form of musical improvisation, one which aimed to be specifically Canadian, unfettered by the American and European models which then held sway (from A.A.C.M. in the United States, for example, to Incus, F.M.P., I.C.P. in Europe). Thus, the underlying aesthetic and commitment of CCMC were clearly defined: all of its music would be totally improvised. No prearranged themes, patterns or harmonic signals — everything was to be spontaneous and newly invented. After recording, the participating musicians would listen to the sessions and evaluate them in a process that would lead free music onto completely new avenues.

This music was also to be rooted in the reality of the local culture (Toronto, Canada) while at the same responding to international stimuli. It is on this identity quest that CCMC has led us since 1976. Various phases in their development can be distinguished from their released albums (since CCMC has recorded all their

sessions for the last fifteen years, we have access only to a fraction of their creations). In more or less arbitrary fashion, we can divide this development into three phases. The first, more acoustic, spans the years 1974-1978, when Larry Dubin was the regular drummer. This period saw the release of three discs on vinyl, as well as a triple album tribute to the drummer. Six records in all, then, where the drums reign.

The second phase extends approximately from the death of Larry Dubin in 1978 to the end of the 1980s. Without a regular drummer the group headed in new directions, where electronics became more and more important. The improvised language thus strayed from jazz, becoming more abstract, more difficult to classify according to vocabulary, style, form. Volumes four and five appeared in this period.

The third phase covers the period from the end of the 1980s to the present day. In the new territory explored, the human voice in all its forms is king, imposing its own visceral law. Two cassettes, in particular, clearly document this period: *CCMC '90* (to which one must add another cassette which accompanied *MusicWorks* magazine, no.54: CCMC, 1992). In all these recordings, the voice is paramount: the voices of Paul Dutton and Nobuo Kubota, heard both separately and together.

Again, these divisions are not meant to be rigid or mutually exclusive. The electronic aspect, for example, appears in the first phase, as does the voice, and the drums resurface in the third phase with Jack Vorvis, and so on. The divisions are mutable and debatable, serving merely to facilitate analysis.

Phase 1

This phase, as mentioned, centers around drummer Larry Dubin. As Dubin explained in an interview with critic Mark Miller, it was Michael Snow who led him towards free music, towards playing without constraints or concessions.[1] It was with CCMC, moreover, that both were able to grow as improvisers, Snow becoming a maturer pianist in the process (he was already an accomplished composer), and Dubin staking out his highly personal and original ground. We will not retrace the career of Larry Dubin here; Michael Snow has already done that in two beautifully written tributes to his drummer-friend.[2] Suffice it to say that Dubin was a "natural,"

1 Mark Miller, *Jazz in Canada — Fourteen Lives* (University of Toronto Press, 1982), pp.139-40.

2 Michael Snow, *Larry Dubin's Music*, Impulse Magazine, vol.7, no.1, 1978; Michael Snow, notes on *Larry Dubin and CCMC* (Toronto: Music Gallery Editions, MGE15, 1979).

a born drummer and passionate improviser. The first six albums of CCMC provide ample testimony to his skills.

CCMC Volumes 1 and 2 are special in that they unite three improvisational fields: Graham Coughtry of the Artist's Jazz Band (who does not reappear in subsequent albums); Bill Smith (musician-critic-promoter associated with Coda magazine); and the regular members of CCMC, i.e, Michael Snow and Nobuo Kubota (also affiliated with the Artist's Jazz Band), along with Peter Anson, Al Mattes and Casey Sokol. In its early history, then, in 1976, the CCMC and the Artist's Jazz Band – the only free collectives in Toronto at the time – united. Gradually, CCMC would distance itself from the Artist's Jazz Band.

With *Volume 3* (1977), CCMC is made up exclusively of its core members. The music is still entirely improvised and the album jacket, more than a simple illustration, reads as its textual equivalent. In Michael Snow's graphic design one sees nothing but words: illustration and text become one. The text is made up of a chain of four words corresponding to the four letters CCMC, forming a long enumeration which takes up all of one side of the jacket and one-third of the other. (Notes by Peter Anson on CCMC and its music takes up the other two-thirds.)

All members of CCMC participated in this word collage; here are a few examples: Cross Canada Musical Cruise, Careless Crew Misses Craft, Chansons Cris Mélange Constamment, Cries Crashes Murmurs Clanks, Canadian Composition Making Continuum, Completely Canadian Monster Circus, Clever Crescendos Mundane Chords, Céleri Champignon, Mayonnaise Cornichons, Chapeau Chemise Mouchoir Cravate, Canadian Cool Music College, Coherent Chaos Manifest Creation, Computer Caught Memorizing Chords, Canadians Collect Mistakes Casually, Crazy Composition Music Cult, Courage Courage Musique Cessera, Cynthia Can't Marry Chuck...

In total, more than two hundred of these combinations are reproduced in a kind of long dadaist poem that defines and redefines CCMC almost ad infinitum. Once again, the question of identity is raised: musical identity, artistic identity, Canadian identity. Michael Snow thus touches upon one of his fundamental concerns with humour (as usual) and a sense of harmony: all the members were involved in this

thematic, their voices joining in one expression reminiscent of the voices uniting in a choir in the later work *Sinoms*. These miscellaneous definitions of CCMC "explain" the collective's musical approach, implying an openness to all manner of improvisational forms. The cover encapsulates the music.

Larry Dubin died in 1978. As a tribute, CCMC issued a three-record set in 1979 which included moving testimonials written by Michael Snow and Paul Haines (*Larry Dubin and CCMC*, Music Gallery Editions, MGE15). The cover, designed by Michael Snow, depicts Dubin's snare drum, whose circularity evokes a record (which in fact lies directly behind this photograph). The snare thus represents a drum kit, a record, and Larry Dubin at the end of his path. This record set contains some of the best moments of CCMC in its first phase: thirteen improvisations of varying duration and personnel, from duets to sextets. All titles were drawn from a poem written specially for this project by Paul Haines entitled "Larry's Listening." These titles have a strange poetic justice: "Larry's Listening," "Upon Arriving," "A Postponement," "Circuitry," "Down the Street," "Yourself Elsewhere," "Radio in a Stolen Car," "Uncalledforness," "Silky Times," "Back to Timmons," "Leaves Shed Their Trees," "One of Your Lips," "Qui ne sert qu'à nous faire trembler."

This superlative music is CCMC at its most creative, typifying its search for the roots of jazz, of Toronto jazz. Each piece would merit a detailed analysis. From beginning to end, Larry Dubin injects a continuous swing rhythm; he engenders and propels the music in his own inimitable way.

All of the musicians play several instruments here. Michael Snow, for example, plays acoustic and electric piano, trumpet, synthesizer, percussion, and even copper tubophone. Whatever instruments he uses, his playing is fully integrated into the whole, into the organic jazz that unfolds. "You can hear the nervous systems," says Snow concerning this electrifying music. "When it's good, it's beyond any composition; it simply couldn't have been conceived in any other way."[3]

In the first piece, *Larry's Listening*, one can already "hear the listening" among the musicians, sense the burgeoning energy. *Upon Arriving*, which follows, is a brief aural self-portrait by Dubin, in solo, at the peak of his powers. *Circuitry* is a

3 Pierre Théberge, *Conversation avec Michael Snow* (Paris: Centre Georges Pompidou, Musée National d'Art Moderne, 1978), p.45.

duet with Michael Snow for synthesizer and drums, recorded at the Music Gallery on June 14, 1977. Here Snow use the synthesizer as a piece of machinery, as a multiple-speed engine. In dialogue with this machine is a human dynamo, Larry Dubin, the other "engine." This face-to-face encounter — instrumentalist with machine — is a fascinating meeting of potential "doubles," and the drummer's response is extraordinarily inventive. The work combines jazz with conceptual art, as if Dubin is improvising from one of Michael Snow's installations. His fluid acoustic playing, in opposition with the more rigid electronic repetitions of the synthesizer, creates a stimulating and highly provocative listening situation. The sound of the synthesizer is not initially beautiful in itself; on the contrary, it is rather upsetting, on the jagged edge of music. Once again, Snow is setting up a musical device which forces the participants to define or reveal their identities through confrontation, through a synchronic dialogue in real time, with a machine. (A similar type of situation occurs in *Left Right*, in which the piano confronts the metronomes.) It is not a question of making "beautiful" music here, but rather being true, authentic, at one's very limits — "on the edge," "existing only to play," to quote Michael Snow.[4]

Throughout this album set Larry Dubin gives everything of himself (as do all the musicians). He is effervescent, feverish, dynamic, nuanced, transported by his own enthusiasm. His "trans-jazz" or "trans-free" style, in turn serene, playful and at the edge of a scream, is the hallmark of CCMC.

Phase 2

Through the intense, pulsating, polyrhythmical drumming of Larry Dubin, CCMC maintained its links with Afro-American jazz. At the same time, however, the collective managed to forge its own distinct brand of jazz, a personalized Toronto jazz.

After the death of Larry Dubin, CCMC (without a drummer for the next three years) was to change considerably. It would embody the new Toronto improvisational sound which distanced itself from historical jazz and its insistent rhythms, and which sought out new influences (like getting lost to find oneself, to redefine one's identity.) This quest is what is documented, in part, by Volumes 4 and 5 of

4 Michael Snow, *Larry Dubin and CCMC*, op.cit.

CCMC. Volume 4, in particular, reflects the group's new direction without Larry Dubin. Time is not experienced in the same way here; the rhythms are more discontinuous, abstract. The sonorities, textures, harmonies and vocabulary have all changed in a number of ways. The electronic instruments used (the Buchla synthesizer among others) give rise to new modes, new electro-organic combinations.

Volume 4, *Free Soap*, represents a dramatic change, an important transition for this "group in progress." The three pieces – quartets with varying instrumentation – were recorded on three different occasions between February and November 1979. Each musician plays several instruments, in the manner of an "Art Ensemble of Toronto," thereby forming a post-free, electro-acoustic, electro-concrete mini-orchestra. Through instinct and intuition of the moment, they attempt to discover a new language of improvisation, a new aural territory, an uncharted sound landscape.

A.K.A. February 13th (recorded February 13, 1979 and lasting 24'33") exemplifies this uncompromising approach. The lineup is as follows: Casey Sokol on acoustic piano and steel drum; Al Mattes on marimba, acoustic bass, electric bass, drums, bells, and steel drum; Michael Snow on marimba, trumpet (with and without mutes), siren, electric piano, aluminum foil; Nabuo Kubota on siren, whistles, strange horn, alto saxophone, duck, bass drum, crackle box and marimba. With this bewildering variety of instruments the four musicians weave a tapestry of sonorities, colours, timbres and unusual hybrid sounds which distances itself from the American or international jazz then in vogue. There are new subtleties in this music; the frequent pauses, like islands of reflection, evoke in the listener an inner space unlike any other. The music oscillates between an intense form of renewed free jazz and fragments constructed around silence (including the magnificent siren used by Snow, perhaps a nod towards Varèse, which briefly polarizes the music). There are no solos here, no virtuoso flights in the usual sense, but rather rich and complex four-way interplays punctuated with "holes" or oases which provide the necessary "pitstops" to re-energize and relaunch the music. *A.K.A. February 13th* contains the number thirteen, in numerological terms the number of change – highly appropriate for CCMC in this stage of its evolution.

Volume 5, entitled *Without A Song*, is even more electronic and explosive. It contains four songs played by Michael Snow, Casey Sokol, Nobuo Kubota and Al Mattes, including the eponymous *Without A Song*, recorded on January 18, 1980. We hear a very brief quotation from the famous song of the same name, a name in keeping with the credo of CCMC. For the collective never plays standards, never plays jazz classics or popular melodies upon which they embellish and improvise. Invariably, they launch directly into raw improvisation, without a net, "without a song" as initial springboard. They are thus always on a tightrope, where the only variables are inspiration, instruments and participants. CCMC rarely cites or paraphrases other musical cultures or traditions. It has always sought its own natural voice, avoiding facile references and clichés out of respect for these other cultures. As a result, CCMC has surpassed other hybrid improvisational groups.

In his more recent works, however, Snow quotes American jazz piano: stride and original blues. But it is as much his own history that he is quoting – his past as a jazz musician. An example is *Interpretation of Dreams*, a duet with Al Mattes recorded in December 1989 (issued on the yellow cassette CCMC '90, tape 1). With this music we enter the third phase of CCMC.

Phase 3

This phase is chronicled by two commercially distributed cassettes: *CCMC '90*, tape 1 (yellow) and tape 2 (blue). The first contains, on Side A, three magical duets featuring Michael Snow on piano and Al Mattes on guitar-synthesizer: *Interpretation of Dreams*, *Time of the Essence* and *Chips and Hammers* (all recorded December 6, 1989). Michael Snow and Allan Mattes are old friends and have worked together for some fifteen years; the listener can sense their closeness. In a duet, where there are fewer simultaneous voices, the interaction is modified, the reduced format allowing the listener to follow each line – acoustic and electric – with greater ease. Michael Snow is here evoking the blues and stride style of his early days but it is now an almost surreal blues; taken up by the futurist guitar of Al Mattes, the aptly titled Interpretation of Dreams builds gradually as in a waking dream, strange,

caricatural. *Time of the Essence* also begins slowly. (Listening is different when two musicians play; the music doesn't seem as hurried, as busy as it is with a group.) Everything falls into place in this work, as if it were mysteriously preconceived, in another dimension; once again we hear fragments of jazz piano, virtuoso piano. And the agile guitar, in parallel, responds like an echo, extending, commenting upon, punctuating the conversation. In short, this work is a quintessentially free duet — fiery, dream-like, physical, paradoxical. This perfect two-way communion, in which humour has its place, continues with *Chips and Hammers*. In this last duet the interplay is nervous, alert, rapid, capricious, the guitar-synthesizer sometimes sounding like an organ. It thus adopts a new identity, a common theme of Snow and CCMC.

It is the three works on Side B, however, that signal a new direction for CCMC: *Chants Meeting*, *Wonzentoozenthreez* and *Kohe Dances* (all recorded October 11, 1989). The human voice, that of Nobuo Kubota, is now at the heart of the improvisations. Pure enchantment is the only way to describe this irreducible voice without words.

In *Chants Meeting* the voice conjures up a kind of enigmatic theatre, a free theatre for three actors in which voice is pitted against instruments, and in which voice often prevails. Snow discretely reintroduces his siren into the landscape (the siren-muse?) and in particular his piano. But it is the voice that dominates: plaintive, Japanesque, yet speaking an invented language. (Influenced by Japanese opera or music of the court, this voice transcends all genres.) It murmurs, gesticulates, moans, belches, shouts, sighs, races — in short, it embraces everything to its bosom like a lover.

Wonzentoozenthreez begins with a beautiful duet for string bass and Snow on trumpet (a "strangled" trumpet which sounds more like the human voice than a conventional trumpet). Then the voice of Nobuo Kubota emerges, as if from another planet, from a forbidden zone of the psyche. It is an impossible voice, free from the shackles of the body, of meaning, launching into its own demented scat, an incisive "space bop" against the terrestrial piano of Snow (the piano groove) and the Martian guitar of Mattes. This three-way invention is elusive, evanescent; it slips gradually

towards an urgent vocal cry, to which Snow and Mattes reply at the end with a grand romantic final gesture.

Kohe Dances, as its name indicates, is a choreography for voice. The voice becomes the rhythm here: it dances, gestures, leads the instruments into its groove. The result is stark, excessive, on the edge. It is impossible to capture in its constant state of reinvention, its perpetual ebb and flow. It blurs the lines of memory. Voice and memory become linked: inseparable from the body, the voice too is ephemeral and mortal. It thus lends a tragic cast to this end-of-millennium music and poses, in even more existential terms, the question of identity: What voices? What music? From what space? Towards which time?

The voices that Snow invented for *The Last LP* in 1986 have links and affinities with Nobuo Kubota's brilliant work here, as they do with the blue cassette *CCMC '90*, the second tape which unites Michael Snow, Paul Dutton, Nobuo Kubota, Al Mattes and John Kamevaar. A member of The Four Horsemen for almost two decades, Paul Dutton is a specialist in sound poetry, in vocal improvisation. His approach, however, is very different from that of Nobuo Kubota. The two can be compared in three long pieces: *Sounding the River* (recorded June 20, 1990), *Things Go* and *Memory Bank* (both from October 10, 1990). Two voices combine here with the instruments, threatening on occasion to swallow them whole. This is not to suggest the instruments are relegated to an accompanist's role; it is simply that voices which transgress all the codes have more elements of the irrational, and this feeling tends to dominate here. It is difficult, once again, to isolate the individual contributions in this dazzlingly complex and emotionally-charged music, this amorphous and ever-changing ocean of sound.

Paul Dutton's contribution, however, is special since he introduces a text into the music, energizing the music with spoken words. He thus links CCMC with such groups as Ambiances Magnétiques in Montreal (cf. Michel F. Côté, Les Granules...), or Bruit TTV from Quebec City, or similar creators of poetic aural landscapes from around the world.

What is unique about CCMC is that everything is extemporized, without scores,

without preconceived itineraries. There is no post-recording tinkering in the studio, no recomposition, no manipulation of the tracks. CCMC thus assumes all the risks inherent in direct, spontaneous music. This artistic option is a demanding and difficult one, requiring considerable courage; while not necessarily better than other approaches, it does guarantee a certain "truth" or authenticity — in keeping with the totally free music that Snow envisioned in the early 1960s in the United States.

Apart from the European brand of aural poetry, CCMC is here influenced by an entire tradition of American-based jazz poems, from the Beat Poets of the 1950s, the Last Poets of the 1960s, to the subsequent free-form poets (among whom John Cage). Paul Dutton and Nobuo Kubota are part of this movement seeking to liberate the human voice, a movement which finds its complement in the free-form Dixie piano of Michael Snow.

Lastly, in a piece entitled *Things Go*, Paul Dutton and Nobuo Kubota translate, in several registers, various spiritual states by means of "para-literary" voices, from whispers to screams. These sounds are on the edge of words, between the lines — clashing, broken, cracked, veiled, erratic, hoarse, mocking, baiting, delirious, stammering, fragmented. They generate their own shifting landscapes of multiple moods and identities. Dutton and Kubota are the quirky and whimsical marginals, trans-modern troubadors playing our their destined roles in an unpredictable poly-free sonodrama. The sustaining backdrop to all this is a mixture of blues piano, sublimated jazz, autobiographical chords, unexpected quotations stored up in the memory of John Kamevaar and released into the music at opportune moments: bells, a ringing telephone, a blues singer, the theme from Beethoven's Fifth, etc. These disparate elements seek their meaning in the imagination of the listener, seek to establish their own memory bank. *Things Go*. Words go. Sounds go. Memory goes... on.

Today, through their aesthetic of total improvisation, CCMC is pursuing its search for undiscovered worlds of sound. It has certainly not uttered its last word, its last sound, far from it. A project to be followed closely, then, this Canadian Creative Music Continuum: CCMC.

The Recorded Music of Michael Snow
Partition 3 Jazz Snow

by Raymond Gervais

Michael Snow recorded his first solo 78s in 1948, when American jazz was his main source of inspiration, his major influence and passion. "It was the only thing in my life," he would say years later. In a way, it is this spirit of jazz, its libertarian and experimental aesthetic, that permeates Snow's entire multiform oeuvre.

Under the title *Early Michael Snow*, the artist privately issued three cassettes of old recordings from 1948 to 1950 for solo, duet and small group. In the context of Snow's work as a whole, these works are fascinating documents. They represent, in fact, the very beginning of Snow's artistic adventure. Sound, then, preceded sight. The first cassette contains piano solos from 1948, piano and trumpet duets from 1949, as well as a piece produced in Chicago in 1950 with legendary clarinetist Pee Wee Russel. We recall that the LP was invented in 1948, when Michael Snow was making his first 78s ("the last 78s?"). His influences were obviously the great Afro-American jazz pianists from New Orleans, Chicago and New York who played ragtime, blues, stride and boogie (from Jelly Roll Morton to Earl Hines, Jimmy Yancey, Meade Lux Lewis and company)[1]. Over the years Snow extended this list to include many other renowned pianists in both jazz (including Thelonius Monk) and classical music (Dinu Lipatti, Wanda Landowska, Glenn Gould, Bela Bartok, Paul Wittgenstein, etc.).

Records played an extremely important role in the life of Michael Snow. They allowed him to explore the history of jazz, and encouraged him to become a prac-

1 The first recordings of jazz piano were done on piano rolls played by player pianos. Jelly Roll Morton (whose music Michael Snow has played), James P. Johnson, Fats Waller and others have all made this type of recording.The player piano here acts like a phonograph and the roll of perforated paper like a cylinder. In replaying the music, the player piano also substitutes for the player, a bit like the tape recorder taking the place of the performer in *Falling Starts*. But the fact that it is the instrument itself that substitutes for the instrumentalist, rather than a more remote machine, makes this game of substitution more problematic. The piano adopts the identity of the pianist, and extends the theatrical illusion of the double. Obviously, the player piano cannot do all that the tape recorder does on *Falling Starts*, although the player pianos of American composer Conlon Nancarrow, which alter the output, speed, touch and parameters of sound, puts this into some doubt. Conlon Nancarrow has shattered the limits of the player piano just as Michael Snow has pushed back those of the acoustic piano. From this perspective, one may glimpse an affinity between the two artists, reinforced through jazz: certain of Nancarrow's *Studies for Player Piano*, for example, are directly inspired by jazz and blues, including Boogie Woogie Suite. Nancarrow's first study of this kind, incidentally, was composed in 1948, the year of Snow's first records. Like Michael Snow, Nancarrow was a jazz trumpetist (in the 1930s) before experimenting with the player piano. If the functioning of the player piano subtly evokes the wind-up gramophone, the bell of a trumpet, on the other hand, recalls the old horn of the gramo-

tising musician himself. His passion for records was so strong that as an adolescent at school he would even produce his own imaginary 78s. On the "Classic Jazz" label, these fictional discs (at fifty cents each, two for sixty cents) featured various lineups invented by Snow: Sidney Bechet and his Reedtet, The New Orleans Veterans Association, the Dixieland Classicists, Mutt Carey and his Bobby Soxers, Don Ewell and his White Bottom Stompers...

As a self-taught pianist at the end of the 1960s, Snow consciously adopted a style based on the American models of the era.[2] Over the years, however, he gradually became a wholly autonomous improviser and composer. The spark, though, was and still is traditional jazz. The 1940s, we recall, was the time of the New Orleans revival in the U.S., simultaneous with the emergence of more avant-garde bop. In Canada, Toronto was the shrine of this Dixieland revival, and Michael Snow was among its leaders.[3] In the 1948 recordings we can hear his fervent and emotional renditions of such jazz classics as *Mamies Blues* by Jelly Roll Morton, *Pallet on the Floor* associated with Jimmy Yancey, and *Gin Mill Blues* by Joe Sullivan. Some of the works are his own, although clearly based on American styles, techniques and referents. His titles, in fact, allude to this influence: *Victory Club Stomp, Basement Chords, Montana in Toronto*. The music, for all that, is no less striking and pleasant to listen to. We must wait until his records of the 1970s – such as *Left Right* – to discover the extent of Michael Snow's originality and individuality as a composer.

The 1948 records are rather poor recordings, even primitive in some respects, filled with static and surface noise. But emerging from this noisy backdrop is very beautiful music, all the more so perhaps because it is so distant, mysterious, unwittingly doctored. With these records we are almost witnessing the birth of concrete music![4]

Let us look at these recordings from the perspective of representation, starting with Jelly Roll Morton's *Mamie's Blues*. Morton too was concerned with the question of identity, being from a family with French roots and perhaps seeking his paternity in jazz. Twenty-five years after Morton made his first recordings in 1923, Michael Snow retells his story, appropriating it for himself through improvisation.

phone (a "cornet" in French). But all this is by the way... See Conlon Nancarrow, *Complete Studies for Player Piano*, 1750 Arch Records.

2 When Michael Snow was cutting his first 78s in Toronto in 1948, pianist Paul Bley was playing in Montreal jazz clubs. The following year he was to replace Oscar Peterson at the Alberta Lounge. There is an interesting parallel between Snow and Bley starting from this time. In 1949-50, for example, Snow was in Chicago while Bley was in New York, both pianists perhaps searching for the truest jazz possible at its source (Snow tracing the roots through Jimmy Yancey and Pee Wee Russell, Bley through the modern boppers). Both pianists would eventually end up in free jazz. Their paths crossed in New York, furthermore, at the beginning of the sixties.

3 Regarding Dixieland jazz in Toronto and Michael Snow's role, see Jack Litchfield, *Toronto Jazz 1948-1950* (Toronto, self-published, 1992).

4 Concrete music, in fact, appeared in France circa 1948-49 and it too made use of improvisation. The late 1940s, when Snow first recorded, is an important period in the history of jazz, and in many ways set the stage for the later free jazz. So-called "cool" jazz emerged during this period. Gil Evans, who was originally from Toronto, worked in New York in 1948-49 with Miles Davis on a new orchestral concept which led to the famous Capitol sessions, *Birth of the Cool*. At the same time, in 1949, Lennie Tristano (also associated with cool jazz) made the first experiments with free jazz in a collective with such works as *Intuition* and *Digression*. As a solo

This game of mirrors extends to other jazz classics in his repertoire, including *At the Jazz Ball Band*. This theme, which most associate with the Original Dixieland Jazz Band (who made the first jazz recording in 1917), again poses the question of origin, of the paternity of jazz and its progenitors, white versus black.

In 1949 Snow recorded a series of duets with renowned trumpetist Ken Dean (*Royal Garden Blues*). This type of duet has a celebrated tradition in jazz: King Oliver and Jelly Roll Morton, for instance, or Louis Armstrong and Earl Hines (*Weather Bird*). It has been often said that Hines plays his piano like a trumpet. Snow, also a pianist, wasted little time in mastering the trumpet, adding it to his panoply of instruments in the 1950s and later doing original research into sonorities using various mutes as filters. Piano or trumpet, each instrument allowed Snow to express a different facet of his personality.[5]

In Chicago in 1950 Snow recorded with legendary clarinetist Pee Wee Russell, with James Jones on trombone. Like Snow's, Russell's artistic path was unusual to say the least. This unique, inimitable stylist, affiliated with Chicago jazz of the 1920s, went on to record with Thelonius Monk in 1963 and even added a few Ornette Coleman themes to his repertoire. At the end of his life he became a painter (like his colleague, drummer George Wettling). An engaging character and incomparable musician, Pee Wee Russel was the first free jazz clarinetist and, for Michael Snow in 1950, a musical collaborator of the highest order. *Ja Da*, for example, is an exquisite encounter between two great painters of sonorities.

Eight years later, in 1958, Michael Snow made his first professional recording in a studio, a 33 1/3 LP with the Mike White Jazz Band entitled *Dixieland Jazz with Mike White's Imperial Jazz Band*. This Raleigh Records album features Mike White on cornet, Bud Hill on trombone, Ian Arnott on clarinet, Michael Snow on piano, Peter Bertram on bass and Ian Halliday on drums. The sextet recorded eleven pieces in all, Dixieland classics and originals alike, ranging from Louis Armstrong and New Orleans jazz to swing and blues (even including Cole Porter's *I Love Paris* with a brief quotation from *La Marseillaise* along the way).[6] Collectively, the orchestra plays an infectiously exuberant and vibrant jazz and unrestrained swing. Everyone

pianist, Tristano ventured into free jazz starting in 1953 with a work like *Descent Into the Maelstrom*. Curiously, some musicians associated with Dixieland, such as Bud Freeman and Bob Wilber, studied with Lennie Tristano. Again, there is a connection between Dixieland and modernism (which Pee Wee Russell and Michael Snow would each confirm years later). Russell, incidentally, played in a duet with clarinetist Jimmy Giuffre, another free jazz pioneer, who played in a trio in 1961-62 with Paul Bley). The musicians, schools, styles, tendencies all mysteriously cluster together in the history of jazz: Toronto, Montreal, New York, Dixie, cool, free... See Lennie Tristano, *Live in Toronto 1952* (Jazz Records); Robert Hilbert, *Pee Wee Russell: The Life of a Jazzman* (New York: Oxford, 1993).

5 Pianists who play the trumpet are fairly rare in the world of jazz. Certain trumpetists, on the other hand, have on occasion played piano: Bix Beiderbecke comes to mind, and Roy Eldridge, Dizzy Gillespie, Don Cherry, Bill Dixon... Michael Snow combines these two practices; not only does he play both instruments but he has accompanied on the piano several great trumpet players, including Clifford Brown, Rex Stewart, Wingy Manone, Cootie Williams and Buck Clayton.

6 Art Hodes, a well-known Chicago pianist, wrote the liner notes to this first album of the Imperial Jazz Band. Hodes himself was a great specialist in New Orleans and Chicago blues and jazz. He also made two solo recordings in Toronto in 1983 and 1985 for the Sackville label, as well as a duet with saxophonist Jim Galloway for Music and Arts. Hodes died recently, in 1993.

is on top of their game here in a festive spirit seemingly transmitted from the origins of jazz. And Michael Snow demonstrates his perfect mastery of the traditional idiom, while adding at the same time a modern touch or more daring accents in his solos. Snow is already mixing bebop into his Dixie, just as he will begin adding free jazz to his dixie-bop in the 1970s.[7]

Dixieland, in fact, has links with free jazz.[8] Albert Ayler, for example, who was filmed by Michael Snow in 1964, felt that his music had more in common with early New Orleans jazz than with the highly personal bop of more recent times. Other avant-gardists such as Steve Lacy or Roswell Rudd played a lively Dixieland before progressing into free music. (Conversely, such traditionalists as Kenny Davern or Pee Wee Russell have only occasionally veered towards free music). Lacy and Rudd, moreover, became fervent admirers of Thelonius Monk. Michael Snow often played Monk as well at the beginning of the 1960s, in a quartet in Toronto with Larry Dubin on drums. (One of his collage works, from 1960, was entitled *Blue Monk*.)[9]

In 1962 Michael Snow left Toronto for New York. A 45 r.p.m. disc (recorded July 17) in some ways seals this period of his life. His playing, captured in a phase of transition and liberation, is even more modern and under the admitted influence of Miles Davis and John Coltrane. Two original works appear on this disc, *Theft* (by Snow) and *Sunset Time*, with Mike White, Alf Jones, Ian Arnott and a trio consisting of Michael Snow on piano, Terry Forster on bass and Larry Dubin on drums. Two points of view collide here: Mike White's authentic Dixieland style with Michael Snow's new post-bop harmonies. Despite this new direction, Snow was no doubt far from imagining that shortly thereafter, around 1962-63, he would be at the heart of the free-form jazz movement, the most radical movement in the entire history of jazz.[10]

Thus it was that the soundtrack of Snow's film *New York Eye and Ear Control* was released in New York on the ESP label, the record company of the avant-garde and free music.[11] The album, recorded on July 17, 1964, contains three improvisations, *Don's Dawn* (one minute long), Ay and ITT (around 20 minutes each). The

His biography, entitled *Hot Man*, has just been published by Bayou Books. Concerning Michael White's presence in Mike White's band, Hodes wrote in his liner notes: "And something new has been added ... we have a pianist instead of the banjo ... and that makes me smile; you see, I'm prejudiced." Art Hodes, who maintained essentially the same style throughout his life, would never have imagined, in 1958, the path that Michael Snow was to take.

7 This 1958 album contains the following compositions: *Down in New Orleans, Sweet Georgia Brown, Anything Goes, Yellow Dog Blues, The Preacher, I Love Paris, Basin Street Blues, Steam Boat Stomp, I Found a New Baby, Savoy Blues,* and *Things Ain't What They Used to Be.* From the sturdy trombone of Bud Hill to the sinuous and fluid clarinet of Ian Arnott, the solo and collective work of this six-member Dixieland band is highly impressive. In the same year, in California, Paul Bley was working with Canadian trumpetist Herbie Spanier (active in Chicago in 1949-50 and in Toronto from 1950 to 1954). Also in 1958, this time in Los Angeles, Bley added Ornette Coleman and Don Cherry (whom Michael Snow would later film in *New York Eye and Ear Control*) to his quintet.

8 Jelly Roll Morton is a traditional composer who is much admired by avant-garde musicians. Record tributes were paid to him by the likes of Charles Mingus, Sun Ra, the group AIR, and Alexander von Schlippenbach.

9 Apart from *Blue Monk*, other visual works by Michael Snow that carry musical references

lineup is the nec plus ultra of free jazz of the time: Albert Ayler on tenor sax, Don Cherry on cornet and trumpet, John Tchicai on alto sax, Roswell Rudd on trombone, Gary Peacock on bass and Sunny Murray on drums.

What is interesting here is that, at the request of Michael Snow, the music is totally improvised, emphasizing teamwork, with neither solos nor preconceived themes. This same attitude, in which improvisation becomes instantaneous collaborative composition, prevails today with CCMC in Toronto. Snow's intuition, then, of the unlimited potential of this radical and liberating approach (not to mention its demands) came ten years earlier in New York. Although he did not participate in this particular session as a musician (he did engineer it), this record has an important place in the discography of Michael Snow. His concept of free interplay is here executed by some of the preeminent free form musicians of the time. Snow was also responsible for the album's graphic design, introducing his famous *Walking Woman* figure. This legendary record in the history of free jazz was recently reissued in compact disc, with the original cover reproduced in miniature. The music – raucous, visceral, volcanic – has lost none of its impact, none of its expressive power.

Snow participated in another ESP album, Paul Bley's freest work entitled *Barrage*. He designed the album cover, again inserting his *Walking Woman* silhouette. This figure, incidentally, inspired Carla Bley's composition of the same name, played here by Paul Bley. Over the years, for many record collectors, the *Walking Woman* has become a veritable icon of free jazz. In their imagination this woman is still walking, and will walk forever...

New York Eye and Ear Control is the only Michael Snow film score to have been released as an album. Its free jazz is particularly intense and urgent, like a slow zoom inside a scream. The free music of Snow's later periods with the Artist's Jazz Band and CCMC is perhaps more playful, or at least less savagely existential, while equally creative and vital.

We would have to wait until the 1980s to hear Michael Snow's solo piano music, on unissued tapes recorded in public.[12] Thirty years earlier, we recall, Michael Snow

in their titles include *Woman with a Clarinet* (1954), *Piano* (1956), *Downbeat* (1959), *Blues* (1959), *Trane* (1959), *Carla Bley* (1965), and others. The relationship between the visual arts and jazz in the 20th century is a complex and fascinating subject which cannot be dealt with here. Suffice it so say, from Picasso to Mondrian, Matisse, Pollock, David Stone Martin and a host of others, there is ample material for analysis. Michael Snow is also a figure in this list.

10 Concerning Michael Snow's New York period (about ten years beginning in 1962), it might be helpful to briefly describe the context in which his work evolved. We will limit ourselves to two distinct sectors of music: new jazz (called free form or New Thing), and Minimalist Music. When Snow moved to New York in 1962, Paul Bley had just recorded an important album, in a trio, on the Savoy label (playing works by Ornette Coleman and Carla Bley, among others). Snow had just left behind a fascinating trio in Toronto with Terry Foster on bass and Larry Dubin on drums. This enigmatic threesome, who would also liked to have recorded, played works by Thelonius Monk, Charlie Parker and Miles Davis, among others. Be that as it may, the liner notes for Paul Bley's album were written by Paul Haines, a writer and friend of Michael Snow, his neighbour in New York. These "iconoclastic" and uncategorizable notes, which have a place in the history of liner notes, deserve a separate analysis (which space does not permit here). They do not explain the music of Paul Bley; they function on a different level, as a kind of free verse, a harbinger of the free music to come. (Paul Haines also wrote the libretto to the Carla Bley's

recorded his first solo 78s with rudimentary technical equipment. The duration of each piece was limited in the 78 format and the repertoire was modelled on the American archetypes. Each solo was thus very short and succinct. Three decades later, however, the situation was very different. There were no longer any time limits to improvisations. And the quality of recording was obviously much better as well. Thus we finally discover Snow's trademark piano sound: a hard touch, muscular and percussive. Beyond the material and technical constraints of the medium, it was now the human and creative limits that were being extended. From his early days as an interpreter, Michael Snow went on to become an autonomous, independent improviser. He has, however, retained connections with his past. A work like *Around Blues*, recorded live in 1986 and which will eventually be released on a record,[13] is an eloquent example.

In an interview conducted by Pierre Théberge, Snow explains his reluctance to make solo performances:

> Perhaps I'm an extremist but for me the miracles of improvisation are produced by the meeting of people and events over which no one has any control. They cannot be repeated. In solo, there isn't necessarily any difference between improvisation and composition because one is entirely responsible for what happens, even chance [...] When I improvise at home I play bits that are individually linked to specific material and that's really not radical enough. I can never surprise myself as much as other lines of thought crossing through my own.[14]

One might suggest here that when Michael Snow plays solo in front of an audience, it is this audience that provides the crossing "lines of thought," its presence and intensity creating an energy, concentration, alertness and tension within the pianist.

Be that as it may, a work like *Around Blues* illustrates the maturity that Snow has acquired over the years as a soloist. It is a long improvisation of about forty-five minutes, performed in one stretch, a magnificent autobiographical solo which summarizes the artist's musical path in the context of the history of jazz and improvisation. As its title suggests, *Around Blues* is a meditation on the blues underlying

opera *Escalator Over the Hill*, on the recording of which Michael Snow would briefly appear.) In New York at this time, Michael Snow lived in a loft with a piano, a loft in which many avant-garde musicians performed, including Paul Bley, Archie Shepp, Giuseppi Logan, Milford Graves). It was also in this artist's studio that one of the most important groups in the history of free form jazz would rehearse: the New York Art Quintet (which included a friend of Snow's, trombonist Roswell Rudd, who would appear in Snow's film *Wavelength*). It was at this same site that the Jazz Composer's Orchestra met to go over the first orchestral scores in the history of free jazz. Very much involved in the visual arts at the time, Snow admits that he listened more than he played. He did, however, accompany Pharoah Sanders in concert, for example, among others. Which brings us to the second sector, New Music. In addition to all this jazz activity, Michael Snow was involved in the New Music (or Minimal Music) scene. The so-called minimalist musicians also had close links with both visual arts and progressive jazz. Michael Snow, artist and jazz musician, would play in private with the likes of Philip Glass, for example. He also participated in the work-process *Pendulum Music* by Steve Reich. (A photograph from his film *Wavelength* would later illustrate a Steve Reich album issued by the French label Shandar, which included *Four Organs* and *Phase Patterns*.)

11 The innovative catalogue of ESP records has been partially reissued in Europe in compact disc form, including the Paul Bley album *Barrage*. The six pieces on it, including *Walking*

all jazz, with a few well-integrated quotations along the way (*Sophisticated Lady,* *Honky Train Blues, Easy Living*).[15]

With the piano (his acoustic palette), Michael Snow deconstructs the blues into abstraction. With a burning, indefatigable energy, he summarizes here his entire life as a jazz musician, as an improviser.[16] When one compares his first (more naive) solo recordings of 1948 with this immense flight of shock lyricism, "filmed" some forty years later, one is simply bewildered at the ground covered by this remarkable artist. From Dixieland to free music and after, Michael Snow has lived first-hand the various phases in the evolution of jazz. He has constructed a kind of synthesis of all his experience in this incisive self-portrait *Around Blues*, Around Jazz, Around Snow.

The Michael Snow Project | The Recorded Music

Woman, are all composed by Carla Bley, surely the dominant female figure in New York free jazz of the 1960s. A *Walking Woman* photo-work made in 1965 and using the image of Carla Bley was recently shown in Snow's solo exhibition at the Claire Burrus Gallery in Paris. Founded in 1964, the company ESP embodied the spirit of the 1960s, in America and elsewhere. The New York Art Quartet and Albert Ayler both recorded important albums for ESP. In addition, several free form pianists made their debuts on the ESP label, including Lowell Davidson, Don Pullen, Call Cobbs, Ran Blake, Burton Greene, and Bob James. European free form also appeared in the U.S. under the ESP label: Gunther Hampel, Peter Lemer, Karel Velebny, and others. Standing for the universal language of Esperanto, ESP (a precursor of the current "World Music"?) issued an album entitled *Let's Sing in Esperanto*. Alternative rock was represented on ESP with the Fugs, psychedilicism with Timothy Leary, beat poetry with William Burroughs and new jazz at its most radical with Ornette Coleman, Steve Lacy, Henry Grimes, Sunny Murray, and Giuseppi Logan. This brief overview of the ESP catalogue allows us to situate the album *New York Eye and Ear Control* (with Albert Ayler) in its proper context; it was one of the most important sessions in the free form music of the 1960s.

12 Michael Snow's first solo concert took place in Montreal, in March of 1977, as part of a multi-disciplinary event called *032303*. He played both piano and trumpet. In terms of his path as artist-musician-soloist, this performance would appear to have been a turning point for him.

13 *Around Blues* (1986) was performed in public at Toronto's Music Gallery and broadcast by CBC for a program entitled "Two New Hours." Regarding this gallery, a compact disc anthology was issued in 1992 called *Masterpieces from the Music Gallery*. It contains fourteen pieces by as many ensembles, recorded between 1989 and 1991. Apart from CCMC, it contains a trio improvisation featuring pianist Bob Fenton, another inveterate "Monkian."

14 Pierre Théberge, *Conservation avec Michael Snow* (Paris: Centre Georges Pompidou, Musée national d'art moderne, 1978), p.45.

15 In *Around Blues*, among distant echos of Thelonius Monk or the year 1948, are a number of clear quotations: *Sophisticated Lady* (Duke Ellington), *Honky Tonk Train Blues* (Meade Lux Lewis) and the standard *Easy Livin*. In one's imagination, a complete narrative, an entire program may be invented from these three titles.

16 From Thelonius Monk to Cecil Taylor, there are a certain number of inimitable, unclassifiable pianists in the history of jazz. Call Cobbs, who accompanied Albert Ayler, is one of them. In Canada, the names of Michael Snow in Toronto, Paul Bley in Montreal and Al Neil in Vancouver come readily to mind as examples of those pianists who have gone well beyond their initial aesthetic to achieve a highly experimental and free music. There are very few pianists, however, who were heavily into Dixieland at the beginning of their career and ended up in avantgarde jazz or more abstract and complex musical forms. Apart from Michael Snow, there is Mel Powell who went from Dixieland and swing to more modern compositions. Unlike Snow, this pianist-improviser has remained more traditional (as reflected, for example, in his 1987 Chiaroscuro release *The Return of Mel Powell* (with Benny Carter and Milt Hinton). Such a "return to jazz" would seem implausible or unlikely on the part of Michael Snow. Other examples are Herbie Nichols (a Monk specialist who played Dixieland with Roswell Rudd while composing his own avant-garde music), or Mary Lou Williams (from stride and boogie to free form at the end of her life, recording with Cecil Taylor and composing works for choir and orchestra). Finally, there are a number of pianists who were not initially associated with Dixieland but who went back to the early Afro-American traditions for inspiration, integrating elements of ragtime, stride or boogie into a more free form style. Fitting into this category are American musicians Jaki Byard (who even recorded with Earl Hines), Richard Abrams (who is into ragtime as much as free), Sun Ra (a pioneer in this explosive jazz based on Jelly Roll Morton or Fletcher Henderson), Dave Burrell, Horace Tapscott, Don Pullen, and others. European exponents include Misha Mengelberg, Friedrich Gulda, Georgio Gaslini and Stan Tracey. Michael Snow is an integral part of this worldwide jazz-piano synthesis. Much like Richard Abrams with A.A.C.M. in Chicago, he has been the catalyst for CCMC in Toronto. As a soloist, his playing is remarkable in that it is never predictable, never banal or routine; on the contrary, it is in a state of constant redefinition, always open to experimentation, ever seeking new identities. Although his music does not really resemble that of the pianists cited above, he belongs to this separate group of special innovators in jazz piano. *Around Blues* provides ample proof of this, as do a number of brilliant and incisive duets played with drummer Jack Vorvis at the Music Gallery in 1992. In the context of the L.P., Russ Freeman with Shelly Manne in 1954 or John Mehegan with Kenny Clarke in 1955 are undoubtedly the pioneers of this kind of duet for piano and drums. However, drummer Milford Graves (who played in Michael Snow's loft in New York) and pianist Don Pullen were likely the first to have played, beginning in 1966, music that was genuinely free (i.e. where the drums do not only accompany the piano). Near the end of the 1970s, such pianists as Cecil Taylor, Borah Bergman, Irene Schweizer, Alexander von Schlippenbach, Misha Mengelberg and Paul Bley all experimented in duets with drummers. Michael Snow is part of this movement. With Jack Vorvis, he reveals the percussive side of the piano that was so long concealed in pre-20th century music. Energy, lyricism, invention, "sports and entertainment" (as Erik Satie would say): these are the some of the qualities of these prodigious gymnastics for two: piano and percussion. This duet extends the Snow-Dubin dialogue of former years. Then, now, differently. (An album of this music by Michael Snow and Jack Vorvis should be released in Toronto, eventually.)

Addenda (The Last Notes)

In the course of reviewing these notes with the artist, a number of interesting points came up. In keeping with the spirit of this book-collage, we thought it appropriate to mention them in this random addenda.

A group that played a very important role in improvisational music in Toronto was the Artists Jazz Band. Their recordings are mentioned in the discography of Michael Snow.

The contribution of the Artists Jazz Band should be placed within the context of the history of visual artists music, the history of jazz and the history of improvisational collectives. Concerning artists music, an interesting connection may be made between the approach of the Artists Jazz Band and that of Jean Dubuffet in his improvised *Expériences musicales* of 1961. With respect to jazz, one parallel (among others) may be made between the Artists Jazz Band and Ornette Coleman's Atlantic album *Free Jazz* of 1960 (whose cover associated the art of Coleman with that of Jackson Pollock). As for improvisational collectives, analogies may be drawn between such open European collectives as AMM, Scratch Orchestra (with Cornelius Cardew), Il Gruppo di Improvisazione Nuova Consonanza, New Phonic Art, Musica Elettronica Viva, Globe Unity Orchestra, Music Improvisation Company, among others.

In the context of Canadian free music of the era, affinities exist between the Artists Jazz Band and the Toronto New Music Ensemble (with whom Snow played on occasion in 1966-67), with the Quatuor de jazz libre du Québec in Montreal, and with the Al Neil group in Vancouver. A recording was made by the Toronto New Music Ensemble in Toronto in December 1966, with Jim Falconbridge on tenor sax and Ron Sullivan on percussion (two ex-Dixieland musicians who also participated in Michael Snow's *Sense Solo* at Montreal's Expo 67).

Formed in 1962, the Artists Jazz Band boldly created over the years its own version of free form music — total, communal, direct — that had the verve of confrontational dadaism, the truculence of pop art, the lyricism of abstract dance, and the playfulness of happenings or performance art.

As mentioned earlier, Pee Wee Russel was a marvellous painter (and friend of Stuart Davis, another American painter). One of his paintings is reproduced on an Impulse album which he made with Oliver Nelson in 1967. George Hoefer, in his liner notes, mentions that "Russell implicitly agrees with Canadian painter Mike Snow who after admiring some of the musician's work, advised him against taking art lessons."

Michael Snow, who recorded with Pee Wee Russell in Chicago in 1950, met up with Russell again in Toronto in 1959, when the clarinetist was a special guest of Mike White's Jazz Band (with Snow on piano). Unfortunately, no recordings exist from these ad lib sessions. (Snow recalls that a friend of Pee Wee's, Kenny Davern, "met Mike White's wife in Toronto and she later became Sylvia Davern in New York.")

Saxophonist Jim Galloway, who recorded with Art Hodes, also called upon cornetist Ken Dean on occasion. Thus we find Ken Dean with the Metro Stompers (his first commercially released session) in a Sackville release in 1977. In addition, Ken Dean had the honour of playing the role of Buddy Bolden, "the first jazzman" in the dramatic version of *Coming Through Slaughter* by Michael Ondatjee. This is another rich field to explore in terms of identity and representation.

The blues has always had considerable importance in the music of Michael Snow. *Around Blues* (1987) is a typical example (with references to the chords of Thelonius Monk's *Bemsha Swing* though not the melody, specifies Snow). The blues is also present — at least on a visual level — in such works as *Blues* (1959), *Blues in Place* (1960) and *Light Blues* (1978).

The Snow/Forster/Dubin threesome, reinforced by trombonist Alf Jones, often played in Toronto in 1960-61 under the name of the Michael Snow Quartet or the Alf Jones Quartet. This same quartet appears in the NFB film *Toronto Jazz* (1962) directed by Don Owen. A few stills are reproduced in the first pages of this book *Music/Sound*.

With respect to the trio, it is interesting to note that each of its members eventually moved towards free jazz: Snow in New York (with Milford Graves, Steve Lacy, Roswell Rudd, among others; Forster in Toronto (with the Artist's Jazz Band); Dubin, also in Toronto, either on his own or later with the Artist's Jazz Band, CCMC, Fred Stone, Don Pullen... Larry Dubin, inci-

dentally, was a friend of painter-percussionist George Wettling. Visual arts was thus linked with the music of each member of this unique Toronto trio.

It was Paul Haines, Snow points out, who was the recording engineer for *New York Eye and Ear Control*. He also wrote a poem for the film. Paul Haines is an astute jazz-enthusiast and talent scout. In 1953, for example, he recorded Tony Fruscella and Brew Moore in a nightclub (tapes which have been since released by Spotlite). Haines also wrote the liner notes for albums by Derek Bailey and Evan Parker, two of the most original musicians in the new European improvisational music, who played in concert with CCMC in both Toronto and Amsterdam. Their direct, unrehearsed and unstructured approach is similar to that of CCMC. A poem by Paul Haines on Derek Bailey, "Off the Bribed Path," was published by *Parachute* magazine in Montreal (no.5, p.31).

Michael Snow recalls buying the piano for his loft in New York from neighbour Roswell Rudd — for $50. It was this very piano that was used in *Left Right*. Rudd, by the way, can be heard playing piano on a record released in Italy on the Horo label called *The Definitive Roswell Rudd*. Recorded in Rome in 1979, Rudd plays piano, trombone, bass and does vocals as well.

Regarding Michael Snow and the history of free jazz, the following works contain some interesting information: Denis Levaillant's *L'improvisation musicale* (Paris, 1981, pp.80-81); Valerie Willmer's *As Serious As Your Life: The Story of the New Jazz* (Westport, Connecticut: Lawrence Hill and Company, 1980, p.165).

Among those musicians Michael Snow played with in New York in the 1960s is clarinetist-saxophonist Kenny Davern. A friend of Pee Wee Russell and Roswell Rudd, Davern is usually associated with Dixieland swing (despite an experimental album with Steve Lacy and Steve Swallow in 1978). Michael Snow recalls playing in a quartet with Kenny Davern, Ahmed Abdul Malik on bass and a drummer of unknown identity in a club in Greenwich Village. Malik is one of the more enigmatic and fascinating characters in the history of jazz, a veritable precursor to today's "world jazz." Born in Brooklyn in 1927, he learned to play the oud (his specialty), the quanun, viola, tuba, piano and bass violin. In 1967-58 he accompanied Thelonius Monk both in concert and on record. He has made several exotic albums for RCA, Riverside and Prestige, combining the music of Africa, Asia, and the Caribbean with Afro-American jazz — well before this became common practice. Malik is a mysterious character who could have appeared on *The Last LP*. The recordings of this genuine pioneer, which are now somewhat neglected and gradually disappearing, are well worth rescuing from oblivion.

Michael Snow points out that he created a photographic work containing the image of Carla Bley. She is also visible in *New York Eye and Ear Control*. Today, Bley collaborates on a regular basis with Steve Swallow (whose loft Snow rented in New York). Swallow, we recall, used to play with Paul Bley and Jimmy Giuffre in one of the first free form trios of the 1960s. Carla Bley's compositions were an integral part of their repertoire.

Concerning the devices for recording and sound reproduction as it relates to the artistic practice of Michael Snow, there is a perhaps a parallel between the *Walking Woman* of the 1960s and today's user of the Walkman, the post-modern, end-of-century wanderer. Isolated by ear-phones, traversed "ear to ear" by the music, the "walking man" walks in search of his identity...

The cassette by Michael Snow entitled *2 Radio Solos* (which would be appropriate to listen to while walking with a Walkman), contains two works: *Short Wavelength* and *The Papaya Plantations*. It documents, in the manner of a performance, a sound event, a game with the radio (the machine here being the instrument). These solos are not necessarily conceived for radio broadcast; they are non-stop extemporaneous compositions made directly from the radio set, in real time, from diverse sonic material from around the planet at a specific moment in time. The short-wave radio used here is a World Band Radio, a name already suggesting the idea of a "world orchestra" interacting with a radio. It is Michael Snow who here embodies this World Band. Alone with a tape recorder, he has created a sort of improvised media jazz from inside the medium (in much the same way Christian Marclay plays the turntable, for example). The radio plays its own part here and no one else's. It is simultaneously emitter and receptor. A box of

sounds, words, inexhaustible noises which Snow draws upon at will. This direct mining of planetary signals and sounds represents a forceful questioning of the notion of identity, as much for our globetrotting minstrel Michael Snow as it is for us, the listening public.

This radio also functions as a kind of "short-wave keyboard" for Michael Snow, who plays freely upon its stations,wavelengths, volume, tonalities, multiple sonorities. There was no editing, mixing or electronic manipulation after the fact, Snow specifies. Creation thus becomes a function of attitude, alertness, openness to sounds. It challenges the traditional notion of virtuosity, of previously-acquired technique. The music is in a constant state of flux, crossing borders, defying laws, schools, academies, accepted ideas. Another kind of "technique" is required, another viewpoint (and another listening point, an ear that can glide between categories, genres, cultures).

This music, despite its multicultural appearance, has nothing to do with the aesthetic of "New Age". It is a radical experiment that does not provide a listening experience which is comfortable, relaxing or entertaining (in the normal sense). Therapeutic perhaps, *2 Radio Solos* surprises, provokes, rejuvenates.

The near-mythical story of the first appearance of radio in Canada at the beginning of the 20th century (with such legendary figures as Reginald Aubrey Fessenden and Guglielmo Marconi) may provide a preliminary context for discussions of *2 Radio Solos*. From a conceptual perspective, certain affinities suggest themselves between *2 Radio Solos* and works by John Cage (*Imaginary Landscape no.4*, for example), or Karlheinz Stockhausen (*Telemusik*, *Kurzwellen*). Michael Snow, however, is on a different plane, owing to his background in jazz and improvisation. To Glenn Gould's *Idea of North*, Snow responds with an "Idea of Earth," which transforms quickly into an "Idea of Snow."

"The tapes were made at night," Snow explains in an accompanying text blurred by visual interference, "in a remote North Canadian cabin lit by a kerosene lamp." This sounds like a description of a piece from *The Last LP*. The text is not without humour. Thus, this galvanizing dialogue with the universe (an eminently modern activity), is undertaken under the light of a pioneer lamp! There is a parallel surely between the act of manipulating a radio and that of "creating light." Snow is playing in the dark in order to see. "Listening well" signifies "seeing well": one implies the other. It is an ethical question expressed through an aesthetic choice.

By travelling further along these same waves, from this same radio "circa 1982", Michael Snow might well hear one day the voices of Gould, Fessenden, Marconi, Bell, Edison or McLuhan — or even his own musical voice (from Tibet, perhaps, or beyond) which may in turn serve as material for the invention of a new music, ad infinitum.

The Last LP

As its title indicates, *The Last LP* (Art Metropole, Toronto, 1987) is a vinyl "long play." It contains, we are told, "unique last recordings of the music of ancient cultures, assembled by Michael Snow." On the front of the double album cover is an illustration of two monk musicians playing trumpet by fireside. In the bottom right-hand corner is a superimposed colour photograph of Dr. Misha Cemep (alias Michael Snow) standing in a field, microphone in hand, in the process of recording (or else on the lookout, like a hunter of sounds on an acoustic safari).

On the back of the album are two texts written by Michael Snow: "An Introduction" concerns the history of sound recording and its impact on traditional music; "Re: the Cover," explains the origin and significance of the supposedly "authentic" cover drawing.

Inside are detailed notes on each of the eleven pieces on the album (six on Side A and five on Side B). At the very end is a short addenda by Michael Snow, printed backwards, entitled "Further Reflections." To be read, it must be placed in front of a mirror. It confirms what we had already suspected through a number of hints in the notes: that this music, supposedly from different cultures around the world, is in reality completely invented, played and sung by Michael Snow himself (via multi-track recording). Once again, Michael Snow conceals nothing: he tells all and yet still preserves the mystery.

Each piece has its own specific narrative, its own sound scenario set in Russia, China, Canada, India, Africa, Finland... Each is a short "sonic film," Snow creating an illusion of truth "truer" than reality through the manipulation of environmental sounds, sound effects re-recorded from albums, sound levels, and acoustic perspective. Michael Snow plays all instruments, invented or otherwise, and does all the vocals as well. The result is astonishing.

An entire book could be written on this strange and unique album, an album full of humour, vitality and invention. The artist here broaches the subject of truth and falsehood in art, what is in front and what is behind the mirror (another subtle playing with the notion of identity). *The Last LP* is a reflection on death as well, on disappearance, the end, "the last song, the last sound."

In the the liner notes of the Artists Jazz Band double album (1973), Michael Snow had already spoken of his interest in Ravi Shankar, in Gagaku, in folklore. Fifteen years later, his interest in foreign music is translated into an original form that reminds us forcefully what we really are: an endangered species. Without attempting to resolve this existential dilemma, *The Last LP* proposes a line of thought which goes beyond the "local versus international" polarity. For Snow, the local is global.

Under this light, one could also analyze *The Last LP* in the context of the history of sound recording in Canada, from Emile Berliner and the early 20th century to the present time. The oldest sound document, we recall, comes from Toronto (a cylinder recording of a speech by Baron Stanley M. Preston for the opening of the Toronto industrial exhibition on September 11, 1888). And in 1904, the first Canadian performer was recorded (the baritone Joseph Saucier singing *L'improvisateur*. One could also evoke the 78s recorded by the Mohawk chief Os-Ke-Non-Ton in 1920. And so on. (See Edward B. Moogk, *En remontant les années: l'histoire et l'héritage sonore au Canada, des débuts à 1930*, Ottawa, Canadian National Library, 1975.)

This is just one of the many contexts in which *The Last LP* could be placed for fruitful analysis. Michael Snow summarizes his intentions when he declares to have created "a new music in memory of the old," an authentic music despite appearances, one that must be really listened to. Here fable and life intertwine, providing a "second wind" to all who listen (the last listeners?).

Sinoms

Produced in 1990, *Sinoms* constitutes Michael Snow's "first CD," a recording without a cover, illustration or text (save on the record itself). About fifty minutes long, it utilizes no other instrument but the spoken voice: twenty-two narrators, male and female, anglophone and francophone, captured in Toronto and Quebec City, reciting the names of all the mayors in the history of Quebec City (34 in all, from 1833 to 1989). In simple enumeration, in alternation or in various combinations and permutations, these voices harmonized by Snow go from male to female, English accent to French, solo to group or choir (Michael Snow, the jazzman, taking a series of choruses?) *Sinoms* is above all a work composed in the studio, once again centering on the notion of identity. To the multiple variations of identity correspond as many vocal sonorities.

Space does not allow us to make a detailed analysis of this austere work, a work which has a place of its own in the production of Michael Snow. It juxtaposes the human voice and names, the body and its designation. Is the voice a synonym for the name it pronounces? Whose voice is it? Whose name? As in *The Last LP*, Michael Snow raises the issue of truth and falsehood. The nomadic name travels both ways. The name-number multiplies its identities, establishes the nomenclature of its potential doubles.

Sinoms, in the same spirit as *2 Radio Solos* and *The Last LP*, operates between languages, accents, tones, cultures, eras. Borders are crossed. It is ethnic music in its fashion. Each voice, each language is a "music" potentially subject to change, threatened with eventual extinction. The last language? The last voice? *Sinoms* is obviously a logical extension of *The Last LP* (in anticipation, one may already give it the subtitle "The Last CD"). This work was created specially for the Musée du Québec for the exhibition "Territoires d'artistes: Paysages verticaux."

These brief notes on *The Last LP* and *Sinoms* obviously do not do justice to the rich complexity of these works. They simply prepare the ground for more in-depth analysis. Suffice it to say, there is a common thread running through these works, a unity of thought within multiple modes of expression.

Raymond Gervais (Montreal, 1946-) is a visual artist who works with music and sound. Since 1973 he has presented numerous installations and performances and organized new music concerts, including the Artist's Jazz Band in Montreal in 1974 for the Institut d'art contemporain under Normand Thériault. His interviews and critical texts have appeared in several magazines, including *MusicWorks* and *Parachute*. His first text on the music of Michael Snow appeared in *Parachute* no. 3 in 1976. In addition, Raymond Gervais collaborates on jazz programs for Radio Canada. He is presently writing an essay on the music of artist-writer Rober Racine.

Colophon

Editing: Karen MacCormack

Design: Bruce Mau

Design Associate: Kathleen Oginski

Design Team:
 Kathleen Oginski, Kevin Sugden
 and Greg Van Alstyne

Film and Print Coordinator: Guy Poulin

Colour Separations: Bowne Imaging Network

Bookbinding: York Bookbinders

Printed in Canada by Bowne of Canada, Ltd.

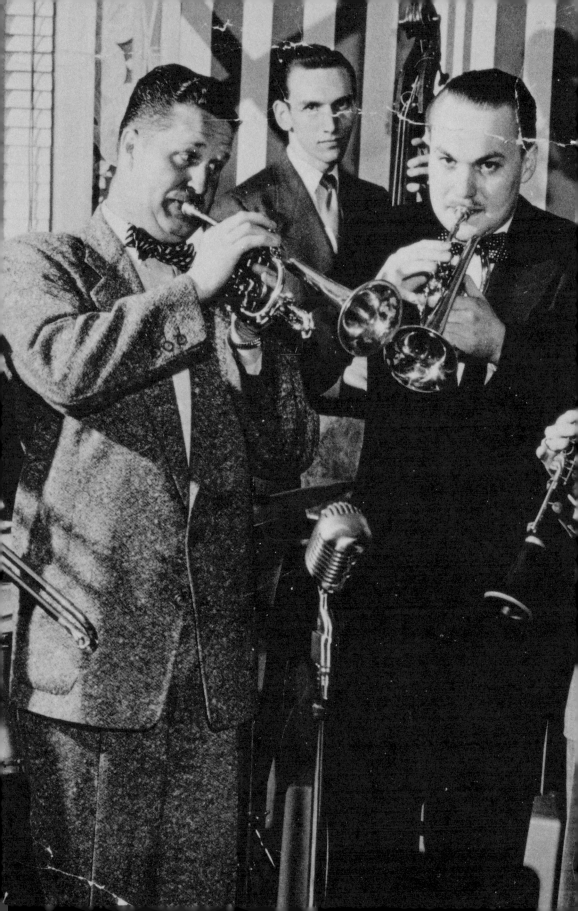